The Winking Owl

The Winking Owl

Art in the People's Republic of China

Ellen Johnston Laing

UNIVERSITY OF CALIFORNIA PRESS

BERKELEY LOS ANGELES LONDON

University of California Press
Berkeley and Los Angeles, California
University of California Press, Ltd.
London, England
© 1988 by
The Regents of the University of California

Library of Congress Cataloging-in-Publication Data

Laing, Ellen Johnston.
 The winking owl: art in the People's Republic of China/
Ellen Johnston Laing.
 p. cm.
 Bibliography: p.
 Includes index.
 ISBN 0-520-06097-0 (alk. paper)
 1. Art, Chinese—20th century. I. Title.
N7345.L35 1988
709'.51—dc19 87-12528
 CIP

Printed in the United States of America

1 2 3 4 5 6 7 8 9

To Richard Alan Laing

Contents

Preface and Acknowledgments

The art of the People's Republic of China has had a poor reception in Western non-Communist countries. It is often dismissed wholesale as pure propaganda or routine socialist realism. It is also sometimes assumed that the Chinese should be a part of the modern (i.e., Western) art world and create works along the lines of abstract expressionism or minimal art or pop art or op art. There is little evidence, though, that the Chinese are much interested in satisfying such Western expectations. The art of the PRC has its own functions, aspirations, and criteria. Our denigration and scorn has often done little but inhibit our understanding and appreciation of what the Chinese see as the role of art in their particular system of things. To understand their art, we must first try to see it from the point of view of their concerns, not ours.

This book concentrates on the period from 1949 to 1976. The initial chapter, however, is on Lu Xun's woodcut movement of the 1930s, which leads naturally into a consideration of woodcut art in Communist Yan'an during the 1940s and under the PRC during the 1950s. The final chapter is a political and artistic analysis of the Chairman Mao Memorial Hall. I conclude with this because the death of Mao Zedong in 1976 and the subsequent arrest of the Gang of Four marked the end of an era. It is logical to conclude at this point because to discuss art in the PRC after 1976 would require a fundamental reorientation and necessitate starting all over again defining a new political atmosphere to explain new art policies. As such it lies beyond the scope intended for this book and is best left for a subsequent study.

Although the chapters treat selected topics and thus are not meant to provide an exhaustive account of art in the PRC, it is hoped they, nonetheless, will enhance our general understanding of culture in contemporary China and will ultimately stimulate explorations into other facets and questions of art in the PRC.

I wish to thank Professor James Cahill who first suggested that I convert a series of lectures I gave at the University of California, Berkeley, in 1983, into a book, and my colleagues who have read and provided valuable comments on parts or all of this book in an earlier draft: Professors Ralph Croizier, Joseph Esherick, Karen Gernant, Richard Kraus, Wendy Larson, Lothar Ledderose, and Frederic Wakeman, Jr. I am indebted to two of my students: Ju-i Yuan, for her work in contributing to my comments on the anti-rightist drive of 1957, the Cultural Revolution, and the "Hotel School," and Ann Wetherell, for her help in preparing the final draft. I wish to thank Carol Cogswell for her care in producing the photographs used for the illustrations in this book.

Abbreviations

BR	*Beijing Review*	NCNA	New China News Agency
CL	*Chinese Literature*	PC	*People's China*
CP	*China Pictorial*	PR	*Peking Review*
CR	*China Reconstructs*	RMRB	*Renmin ribao*
JMJP	*Jen-min jih-pao* [cited in translation]	SCMM	*Selections from China Mainland Magazines*
KMJP	*Kuang-ming jih-pao* [cited in translation]	SCMP	*Survey of China Mainland Press*

By the 1930s the Chinese artistic horizon had expanded beyond its own indigenous heritage to embrace many new ideas and diverse currents from the West. Since Michael Sullivan's overview of art in twentieth-century China was published in 1959,[1] three somewhat more specialized studies have contributed immensely to our knowledge of the many trends, currents, schools, masters, and even controversies which animated artistic life in Shanghai, Beijing, Nanjing, Canton, and elsewhere.

Chu-tsing Li's catalogue of the Drenowatz collection of twentieth-century painting, along with pointing out the Chinese utilization of Western ideas and technology to disseminate art images and ideas, focused on developments in the traditional medium.[2] Mayching Kao's description of the impact of Western art on Chinese artists and the Chinese public is particularly valuable.[3] She explored the initial exposure of the Chinese to Western painting techniques in about 1900, then described the escalating interest in Western art, the eventual inclusion of art classes in the school curriculum, the establishment of art schools proper,

art societies, art journals and pictorials, public museums and exhibition galleries—all concepts imported from the West. By the 1920s, perhaps as a result of the May Fourth Movement, more and more artists were studying art in Europe. There and at home they were exposed to the varied trends and "isms" of the contemporary European art world. Finally, the 1930s saw the polarization of art and the rise of opposition to the goals of art as personal expression or art for art's sake. This opposition came as young artists, some of them under the influence of Marxist-Leninist interpretations of art, began to insist that art reflect social realities. This new attitude was also fostered by Lu Xun, who was instrumental in the 1930s in introducing European woodblock prints into China. The woodcut movement is the subject of a study by Shirley Sun.[4]

The Japanese bombing of Shanghai and the Japanese occupation of Beijing and other northern and coastal cities during the Sino-Japanese War of 1937–1945 brought about the damage or destruction of many private art studios, public art schools and teaching facilities, and art works; artists and teachers scattered. Xu Beihong (1895–1953), the noted academic oil painter, and others moved inland with the Nationalist government to Sichuan in southwest China. There they reconstituted ver-

1. Michael Sullivan, *Chinese Art in the Twentieth Century* (London: Faber and Faber, 1959).
2. Chu-tsing Li, *Trends in Modern Chinese Painting* (*The C. A. Drenowatz Collection*), Artibus Asiae Supplementum 36 (Ascona, Switzerland: 1979).
3. Mayching Margaret Kao, "China's Response to the West in Art: 1898–1937" (Ph.D. diss., Stanford University, 1972).

4. Shirley Hsiao-ling Sun, "Lu Hsün and the Chinese Woodcut Movement: 1929–1936" (Ph.D. diss., Stanford University, 1974).

sions of the art schools they had abandoned in the face of the Japanese invasion. Some artists, like the master of traditional-style painting Qi Baishi (1863–1957), famed for his direct, often witty, depictions of gourd vines, insects, and other humble subjects, elected to remain in the occupied zone. Among those who stayed behind, some, like Qi, simply refused to do the bidding of the new Japanese rulers. A large number of woodblock print designers went to the Communist-controlled Yan'an in remote Shaanxi. Many artists apparently wandered throughout China for the duration, with no specific goal in mind except to keep ahead of the Japanese invaders and out of the lines of battle.

At the conclusion of hostilities in 1945, artists returned to the major cities to resume their teaching and art careers either in association with the art schools or in independent studios. Despite the massive disruptions of the war years, by 1947 the arts had begun to recover. In the *China Art Yearbook* for 1946–1947, the biographies of some 1,760 contemporary artists are recorded. Among them are representatives of all walks of art: calligraphy, traditional-style Chinese painting, oil painting, watercolor, sculpture, photography, commercial art, design. In addition, during 1946–1947 alone, 152 public exhibitions of art were held throughout the country.[5]

In 1949, at the end of the conflict between the Nationalist Government and the Communists (the War of Liberation), the Chinese Communists were victorious. They had already established control over the arts in Yan'an, their isolated village, wartime capital. Now they had to exert this control over all artists throughout the entire, vast country. On the positive side for their purposes, the Communists inherited a system of art schools and trained teachers. They also inherited a receptive attitude on the part of the public toward the art exhibition and the exhibition review, as well as the acceptance of art journals as useful vehicles for the dissemination of art and art information. On the negative side for the Chinese Communists, most of the artists, both Western- and traditional-style, were largely unsympathetic to or ignorant of Communist ideological goals. Regardless of what their orientation might have been during the 1930s, both traditional- and Western-style artists still often saw the goal of art as art for art's sake or

as a means of personal expression. Socially, both Western- and traditional-style artists were often scions of elite, gentry bourgeois stock, ordinarily contemptuous of the worker or peasant. The Communists were committed to changing this.

For readers unfamiliar with Chinese Communist ideas about art, the following comments will help provide a foundation for understanding the chapters in this volume.

In Chinese Communist eyes, artists belong to the intellectual class. This class is considered likely to harbor independent ideas. Further, most artists have bourgeois ideas because artists do not depend upon their own physical labor for their livelihood. To safeguard against the emergence of bourgeois ideas and attitudes, artists in China are expected to forego their prior privileged status and align themselves with the peasants and workers. Artists must be in tune, therefore, with workers and peasants and should have the same political and ideological viewpoint. In China, artists along with intellectuals generally must, through firsthand experience on farm or in factory, comprehend the life, the thought, and the political stance of the worker and peasant. It is believed to be very easy for intellectuals and artists to stray from this position and to promote the ideas and sentiments of the bourgeois class, such as those "old habits and incorrect ideas" which "propagate the ideals of individualism, the cult of the outstanding personality and self-complacency; they inculcate the ideology of indifference to the fate of the country and the people, and disbelief in the success of the struggles of the masses."[6]

Because of this belief artists and intellectuals are periodically subjected to rectification campaigns and programs to eradicate these ideas and to educate artists and intellectuals along Communist ideological lines. It has to be understood, claims John Starr, that the Chinese

> have greatly expanded the realm of the political. As a result, social life for the Chinese *is* political life.... The public realm in China is now perhaps as broad as it is in any contemporary society. Concern for private pursuits and private interests is regarded as characteristic of the bourgeois class and is denounced. Selfishness is regarded as a quality that must be rooted out and replaced with public-mindedness.[7]

5. Wang Yichang, ed., *Zhonghua minguo sanshiliunian Zhongguo meishu nianjian China Art Yearbook 1946–47* (Shanghai: Shanghai Municipal Cultural Movement Committee, 1948).

6. Chow Yang, "For More and Better Works of Literature and Art," PC, 1 Nov. 1953, 5.

7. John Bryan Starr, *Ideology and Culture: An Introduction to the Dialectic of Contemporary Chinese Politics* (New York: Harper and Row, 1973), 118–119.

Further, says Starr, "the small groups to which everyone in China belongs... effectively reduce the individual's ability to retreat into a private world." [8]

Before 1949, undoubtedly the most significant Chinese Communist rectification campaign designed to purge intellectual writers and artists of errant views was the 1942 Yan'an Forum on Literature and Art. Mao Zedong used this two-week-long workshop as a vehicle not only for disciplining the urban, Westernized writers who veered from the Marxist stance, but also as an opportunity to set forth his ideas on the place of art. Mao's two speeches at this forum, especially his concluding oration, given on May 23, 1942, contained the basic guidelines for art under the PRC. An explanation of a few of the major points in Mao's Yan'an *Talks* will make clear the origin of most of the attitudes taken toward art in the PRC.

Mao pointed out the class basis of art and insisted that art must serve the masses: the workers, peasants, and soldiers. [9] As is apparent from the above comments, the notions of the "masses" and the "collective society" are basic tenets of communism. In this context the art of the bourgeois and intellectual (because of its pronounced "individualism") and of "self-expression" (because of its tendency to portray only the bourgeoisie) cannot serve the people, because it neither depicts them nor educates them. On one hand, Mao said that the "rich legacy and the good traditions" in literature and art from China's past and from foreign countries should be taken over as long as these serve the masses. The old forms should be "remoulded and infused with new content" to "become something revolutionary in the service of the people." On the other hand, he pointed out that the artists have failed to serve the workers, peasants, and soldiers because artists generally ignore them and consequently cannot understand them, like them, or portray them. Further, the artists largely have overlooked the "nascent literature and art" of the workers, peasants, and soldiers, such as folk songs, folk tales, or murals. The

source, the origin of all art, according to Mao, is the life of the people: everyday phenomena, contradictions, and struggles. Based upon the life of the masses, art should "awaken the masses, fire them with enthusiasm and impel them to unite and struggle to transform their environment." In other words, art is to be inspirational and educational; it should be a means of instructing the masses that they can and should strive to improve their lot—for example, by casting off the old habits which kept them bound and destitute, economically subservient to the landlord class. What is demanded in artwork, however, is not that it merely parallel life; to be effective it must "be on a higher plane, more intense, more concentrated, more typical, nearer the ideal, and therefore more universal than actual everyday life."

Mao also addressed the question of whether artists should either, on the one hand, strive for popularization or, on the other hand, work to raise artistic standards. According to Mao, neither should be done in isolation, because they are interdependent. One cannot raise the artistic standards of one's audience until one understands the base (workers, peasants, soldiers) from which the standards are to be raised. The raising of standards means raising the standards in the correct class direction, not along lines of bourgeois art, but along the "direction in which workers, peasants, and soldiers are themselves advancing," that is, the political and ideological advances of the workers, peasants, and soldiers. "Only by starting from the workers, peasants and soldiers can we have a correct understanding of popularization and of the raising of standards and find the proper relationship between the two." So again, artists must learn from the people. [10] "Popularization means popularization for the people and raising of standards means raising the level for the people." "Raising ... is based on popularization, while popularization is guided by the raising of standards." There are "specialists" and "popularizers." They have a symbiotic relationship: The specialists must pay attention to the "fine arts of the masses" and "should help and guide the popularizers"; at the same time, the specialists should learn from the popularizers and, "through them, draw nourishment from the masses to replenish and enrich themselves so that their specialities do not become

8. Ibid., 119.

9. I have used the translation of the revised 1953 version of the Yan'an *Talks*, in Mao Tse-tung, *On Literature and Art* (Peking: Foreign Languages Press, 1967), 1–43. I am not concerned here with questions of the originality or the sources of Mao's ideas. For some of these, plus a comparative analysis of the first and revised texts of the *Talks*, see Bonnie S. McDougall, *Mao Zedong's "Talks at the Yan'an Conference on Literature and Art": A Translation of the 1943 Text with Commentary*, Michigan Papers in Chinese Studies, no. 39 (Ann Arbor: University of Michigan, Center for Chinese Studies, 1980).

10. Arnold Chang takes the view that since 1949 the history of art in the PRC can be largely explained on the basis of alternating periods of "popularization" and "raising of standards." *Painting in the People's Republic of China: The Politics of Style* (Boulder, Colo.: Westview Press, 1980).

'ivory towers,' detached from the masses and from reality and devoid of content or life." Thus, again Mao stressed that the artist must be linked with the masses. Art, however, is not independent of politics, and Mao insisted that art work has "a definite and assigned position in Party revolutionary work" and "is subordinated to the revolutionary tasks set by the Party in a given revolutionary period." Artists do not act or work on their own, for politics are rooted in class struggle.

A final point to be noted in Mao's Yan'an *Talks* is the question of the criteria of criticism, political and artistic. It is especially important to understand his position on the question of the political content and on "the unity of motive and effect." If the motive or intent is not good, the art will be incorrect. The subjective intention of the creator is judged not by what he says about his intention, but rather on the result of his work and the perceived effect it will have on the audience. This is why paintings and other art works are carefully analyzed in the PRC for their political message, and this is also why they are critiqued for the way in which that message is conveyed visually. The form must be correct for the content. This is Mao's demand for "the unity of politics and art, the unity of content and form, the unity of revolutionary political content and the highest possible perfection of artistic form."

The "teeth" in Mao's statements came in the middle of his speech when he declared:

> If everyone agrees on the fundamental policy [of serving the workers, peasants, and soldiers and of how to serve them], it should be adhered to by all our workers, all our schools, publications and organizations in the field of literature and art and in all our literary and artistic activities. It is wrong to depart from this policy and anything at variance with it must be duly corrected.

Cultural and artistic policy in the PRC is set by the Department of Propaganda of the Chinese Communist Party. The Ministry of Culture and its various departments and bureaus is the state administrative organ responsible for implementing the policies. The Ministry of Culture guides art professionals in accordance with the current principles and policies, promotes artistic creation and production, discovers and trains talented writers and artists, and the like. Cultural bureaus or sections are found in government organizations at the provincial, municipal, autonomous regional, prefectural, and county levels. They are one of the

channels through which art policy reaches the artist.

The Chinese Artists' Association, along with other professional literary and art associations (such as the Chinese Writers' Association, the Chinese Musicians' Association, the Chinese Dancers' Association) are under the umbrella of the China Federation of Literary and Art Circles, founded (with a slightly different name) in July 1949. The Federation and its subsidiary associations are "people's organizations." As such, they are not properly connected with either the Department of Propaganda or the Ministry of Culture, but are under the supervision of the Central Committee of the Chinese Communist Party. The Chinese Artists' Association is the agency most directly involved in fostering the professional life of its members. Membership is not automatic, however, but through application only. There is a nationwide network of branches of the Chinese Artists' Association on every administrative level: province, city, autonomous region, and prefecture.[11]

Professional artists in the PRC include not only painters of scrolls done in the traditional medium of ink or color on paper or silk, but also experts in Western media and styles: oils, watercolors, graphics, as well as sculptors working in wood, clay, and stone. Professional artists are paid by the state and are assigned work by the state. Examples of jobs include assignment to the art editorial department of a publishing house or to the art staff of one of the many pictorials. An artist might illustrate stories or the popular "comic" book serials. Craft factories need skilled professionals to design pictures to be rendered into embroidery or tapestry or cut into jade or ivory by artisans. Artists might be assigned to teach and create in one of the art institutes or academies, such as the prestigious Central Art Academy in Beijing, the Lu Xun Academy in Shenyang, the Jiangsu Painting Academy in Nanjing, the Shanghai Chinese Painting Academy. Various museums and specialist research institutes use professional artists to provide pictures supplementing exhibitions of artifacts. Local cultural halls also may have trained artists on their staffs. The products of the professional artists, regardless of their jobs, technically belong to the

11. Information in these two paragraphs is based on Bai Liu, *Cultural Policy in the People's Republic of China: Letting a Hundred Flowers Bloom* (Paris: UNESCO, 1983), 26–30. During the Cultural Revolution (1966–1976) the Ministry of Culture ceased to exist and the Chinese Artists' Association was suspended.

state, to the people. For the professional artists associated with the art academies, their works generally are seen by the public in the juried annual national exhibitions of art and in the many theme and commemorative art shows that are hung every year. Basically, every work of art publicly exhibited or reproduced in the media must meet the current art policy standards and must be approved for exhibition or publication by the appropriate authorities.

China during the 1920s and 1930s was beset with a multitude of serious economic and social problems. There was almost constant warfare between petty warlords and between the Nationalists and the Communists. Floods and famines ravaged large parts of rural China, reducing peasants to grinding poverty and sending them into the overpopulated cities already clogged with beggars and the destitute. The problems were of such magnitude that the Guomindang (Nationalist) government's efforts to alleviate these conditions were often ineffective. The infant Communist party, fighting for its survival against GMD campaigns to eradicate it, was relatively powerless to effect any practical changes of immediate consequence. To add to China's troubles during this time of instability, the Japanese began their military incursions into Chinese territory.[1]

Lu Xun (1881–1936), modern China's most influential writer, social critic, and intellectual, spent the last years of his life amidst this turmoil. Lu Xun's literary reputation is solidly grounded on his early short stories attacking moribund Confucian society and on his later cutting, satirical essays. Further, he was instrumental in bringing a constant stream of Western literature to the Chinese intellectuals through his translations, which appeared in the many journals that blossomed and died in rapid succession during the 1920s and 1930s. Because of his outspoken views on the bleakness of China's future and because of his sympathies toward Marxist literary theory, he was forced in 1927 to seek refuge in the Japanese concession in the foreign-settlement area of Shanghai, where he remained in hiding until his death.[2]

Among his many interests and achievements, he is renowned for his introduction of Western graphics into China during the 1930s and for his promotion of woodcuts as a vital mode of exposing China's social and economic evils. Lu Xun was not the first, of course, to introduce Western graphics into China. Western prints were known in China from the time of Matteo Ricci (1552–1610). In 1604 four engravings of Christian subjects, originally from a larger set brought to China by Ricci, were copied into a book on inkstone

I

1. Two substantial studies of the conditions during this era are Lloyd E. Eastman, *The Abortive Revolution: China under Nationalist Rule, 1927–1937* (Cambridge: Harvard University Press, 1974), and James E. Sheridan, *China in Disintegration: The Republican Era in Chinese History, 1912–1949* (New York: Free Press, 1975).

2. There is an enormous bibliography on Lu Xun and the May Fourth Movement, including the classic by Chow Tsetsung, *The May Fourth Movement: Intellectual Revolution in Modern China* (Cambridge: Harvard University Press, 1960; Stanford: Stanford University Press, 1967). More recent studies are Jonathan D. Spence, *The Gate of Heavenly Peace: The Chinese and Their Revolution* (New York: Viking Press, 1981), and Leo Ou-fan Lee, ed., *Lu Xun and His Legacy* (Berkeley and Los Angeles: University of California Press, 1985).

designs, the *Chengshi moyuan*,[3] and many peculiarly Western artistic devices as seen in Western prints were absorbed into the Chinese popular print. Lu Xun was the first, however, to advocate that Chinese artists imitate Western print styles directly.

To understand Lu Xun's contributions to the history of graphics in twentieth-century China, as well as to comprehend the subsequent development of graphic forms into the 1960s, it is necessary first to briefly survey the graphic tradition in China.

Prints in Traditional China

Prints made in China before the 1930s fall into four general categories: illustrations to books intended for an elite audience, pictures printed for popular consumption, illustrations for journals, and propaganda or protest prints. The rich heritage of the Chinese tradition thus runs the gamut from the aesthetically elegant illustrated book to the lowly, crude political broadside.

The illustrated book has a long history in China. Technical heights in book illustration were attained in the late Ming and early Qing dynasties (seventeenth century) when monochrome illustrations, such as that to *The Lute Story* (fig. 1) showing two lovers by a willow stream, were produced.[4] This era also saw the publication of the lovely floral pictures of the *Ten Bamboo Studio Painting Manual*, the subtle, tastefully ornamented letter-papers of its companion volume (plate 1), and the well-known *Mustard Seed Garden Painting Manual*.[5] Executed in color, the prints in these

volumes are characterized by soft hues, graded tones, wide grey lines, and sharp black lines superimposed on color areas to denote details. Such books, manuals, and letter-papers were not for the common man, but for the educated, and the moneyed, elite. In the 1930s when Lu Xun became interested in traditional Chinese prints, these were primarily what attracted him: artistically sophisticated and elegant prints associated with books and writing.

The second category of print, more clearly folk and popular, was the New Year's picture: inexpensive single-sheet prints which decorated the house, urban and rural alike, at New Year's time. Such prints stayed on the walls or doors all year long, to be replaced annually at the holiday season. These plebian prints cover a wide range of subjects: protective door gods; auspicious wishes for prosperity and happiness; pretty women; theater scenes; contemporary sights (such as landscapes of famous places and even, in the late nineteenth century, the Shanghai Railroad Station); or on rare occasion contemporary events, such as, in 1900, the Boxer uprising. All New Year's prints were colored with water-based pigments, some more crudely than others, through a variety of techniques: by printing or stenciling or by brushing the color on by hand. Some eighteenth-century architectural-landscape New Year's prints from the well-known center in Suzhou reflect influences from Western engravings.[6] The best known of the New Year's prints in general are those which—through a wide range of images and motifs—convey popular, Confucian aspirations for many sons, happiness, longevity, wealth, and prosperity. These prints share intricate decorative patterns, many bright colors, and a wealth of symbols. In the New Year's print *Five Sons Successful in Examinations* (plate 2), the visual message, reinforced by written phrases (a common feature in New Year's prints), is hoped-for success of five sons in official examinations. Here the main figure, in a frontal view, is large in scale; auspicious symbols include the bat for happiness; colors are many, bright, and unmodulated. In another, more delicate New Year's print (plate 3) four boys are surrounded by symbols of the four gentlemanly accomplishments of chess, music, poetry, and calligraphy. The two children in the center of the picture hold aloft a large basket containing rare fruits and flowers symbolic of seasonal wishes, a harvest of peaches (for longevity),

3. Hsiang Ta, "European Influences on Chinese Art in the Late Ming and Early Ch'ing Periods," trans. Wang Te-chou, in *Renditions*, no. 6 (Spring 1976), citation to p. 157. Michael Sullivan, "Some Possible Sources of European Influence on Late Ming and Early Ch'ing Painting," *Proceedings of the International Symposium on Chinese Painting, National Palace Museum* (Taipei, National Palace Museum, 1970), 603–610.

4. A standard history of Chinese graphics is Wang Bomin, *Zhongguo banhua shi* (Shanghai: Renmin meishu, 1961). Prints of Buddhist subjects as well as charms and tokens are also part of the Chinese tradition.

5. Basic studies on these painting manuals include K. T. Wu, "Colour Printing in the Ming Dynasty," *T'ien-hsia Monthly* 11 (1940): 30–44; Pierre Jaquillard, "Gravures chinoises du XVIII^e siècle," *Études Asiatiques* 23, no. 2/3 (1969): 89–117; Robert Treat Paine, Jr., "The Ten Bamboo Studio: Its Early Editions, Pictures and Artists," *Archives of the Chinese Art Society of America* 5 (1951): 39–54; A. K'ai-ming Ch'iu, "The Chieh Tzu Yüan Hua Chuan (Mustard Seed Garden Painting Manual): Early Editions in American Collections," *Archives of the Chinese Art Society of America* 5 (1951): 55–69. The *Mustard Seed Garden* was translated by R. Petrucci as *Encyclopédie de la peinture chinoise* (Paris: H. Laurence, 1918) and is the basis for several modern books on the techniques of Chinese painting.

6. See "Soshū hanga tokushū," *Yamato Bunka*, no. 58 (Aug. 1973): 38.

pomegranates (for many offspring because of the numerous seeds), the peony (for wealth), the citron (for happiness and wealth), and so on. The plump, healthy children are dressed in expensive, beautiful brocades. Such traditional prints were a vital part of popular culture in China and continued to be produced through the 1940s and even later.[7]

Standard accounts of traditional prints in China rarely go beyond the two categories described above, the book and painting-manual illustrations and the popular New Year's prints. Yet other types of prints were made for other purposes, such as journalistic reporting, a category largely ignored in the art historical literature. Illustrations of current events and human interest stories were occasionally carried in the popular press in the nineteenth-century newspapers, or *xinwenzhi*. These papers were not dailies, but appeared as newsworthy events warranted. Although none of these illustrations seems to have survived, one source informs us that an account of events in the Opium War (1839–1842) was available in a set of four pictures accompanied by descriptions. This set was hawked in the streets for next to nothing.[8] As late as 1916 a woodcut depiction was made of the troops of the bandit Bailang ("White Wolf") storming a city.[9]

In 1884 an enterprising press in Shanghai began to publish the pictorial *Dianshizhai huabao*. This lithographed journal appeared every ten days and continued publication until 1895. Each issue usually had eight leaves. The *Dianshizhai huabao* contained some fiction and light belles lettres, but was mostly a marvellously varied assortment of illustrations. It included pictures of news or human interest items, local or world events: floods and famines; technological developments such as underwater divers; scenes of foreign lands; a picture of Western men at their easels in the studio of the Hong Kong Art Society; the wedding of Grover Cleveland and Miss Folsom; naval battles and the signing of the peace protocol ending the Franco-Chinese hostilities; or scenes of the Sino-Japanese War of 1894, such as the sinking of a Chinese troopship.[10] These depictions of contemporary events apparently were not intended as political or social criticism.

Completely overlooked in discussions of Chinese print traditions are the purely propaganda items. Three examples discussed below reveal that in one case Western prints were the basis for the Chinese versions, and in the other two the prints adhered to indigenous models. In the first example a set of three pictures from the series of forty-eight prints depicting the life of Christ presented by Adam Schall to the Chinese court in 1640 were appropriated for anti-Christian propaganda purposes. Heavily sinicized in a recutting, scenes of the crucifixion, among others, were included in Yang Guangxian's (1597–1669) anti-Christian treatise, *Budeyi shu*, to support Yang's view that "all people in the world know that Jesus was put to death as a convicted criminal...[and that] Jesus was not an orderly and law-abiding person, but a subversive rebel leader, who was convicted and executed."[11]

During the early 1860s a set of anti-Christian, anti-Western woodcuts was published in book form. They derived not from Western prints but from the indigenous tradition (figs. 2 and 3). One shows the Thunder God destroying a goat (Westerner) and two pigs (Jesus and a disciple). In another print, the King of Hell has condemned three sheep Westerners to death by decapitation, while Jesus as pig is shot full of arrows. (Sheep and goat represent foreigners because the pronunciation of the Chinese character for these animals, *yang* 羊, is the same as the pronunciation for the character used for "foreign," 洋. The sound for the character for "pig," 猪, is similar to that for the character used for the Christian God or Lord, 主, *zhu*.) Both the Thunder God and the King of Hell derive from imagery associated with popular Buddhist lore. The black outlines, the bright flat pigments,

7. Shops for the manufacture of popular prints existed all over China, giving rise to local and regional styles. Certain centers, however, were acclaimed for their popular prints; in addition to Suzhou, the town of Yangliuqing was a major center for the production of popular prints. There is a sizeable literature on these prints, along with many volumes of reproductions published in both Taiwan and the PRC. Among the most recent are *Zhongguo meishu quanji, Huihua bian*, vol. 21, *Minjian nianhua* (Beijing: Renmin meishu, 1985)—pl. 166 of this volume reproduces the picture of the Shanghai Railway Station; Tianjinshi yishu bowuguan, *Yangliuqing nianhua* (Tianjin: Wenwu, 1984)—pls. 15 and 16 in this volume show scenes of the Boxer uprising; *Banhua congshu*, vol. 1, *Yangliuqing banhua* (Taibei: Xiongshi, 1976); *Zhongguo chuantong banhua yishu tezhan, Special Exhibition Collector's Show of Traditional Chinese Woodblock Prints* (Taibei: Council for Cultural Planning and Development, Executive Yuan, 1983), also includes book illustration prints.

8. Roswell S. Britton, *The Chinese Periodical Press 1800–1912* (Shanghai: Kelly and Walsh, 1933), 5–7.

9. Wang Shucun, "Guanyu Bailang guo Qinchuande yifu banhua," *Wenwu*, 1964, no. 10:31–32.

10. The *Dianshizhai huabao* was just one of twenty or thirty lithographed pictorials current in the late nineteenth and the early twentieth century; see Zhang Tiexian, "Lüetan wan Qing shiqide shiyin huabao," *Wenwu*, 1959, no. 3:1–3. It has recently been reprinted: *Dianshizhai huabao*, 2 vols. (Hong Kong: Guangquejing, 1983).

11. Hsiang Ta, "European Influences on Chinese Art," 159–160.

the decorative clouds under the Thunder God's feet, and the explanatory inscriptions all come from the New Year's print style. The message in these offensive but effective prints is plainly evident, even to the unlettered, for it is presented by employing traditional images in a standard, accepted, and popular visual fashion easily comprehended by all. Such inflammatory prints contributed immensely to waves of anti-Christian and anti-foreign fervor, which swept across parts of China in the late nineteenth century and which resulted in attacks upon Christian mission establishments, the murder of missionaries, and anti-Christian riots, all of which culminated in the Boxer uprising of 1898–1900.[12] These prints are solid evidence of the power and impact that the traditional Chinese folk idiom could have when dexterously exploited.

A third example of a propaganda print relies primarily upon the Chinese black-and-white book illustration. Done in April 1910, *The Starving People Seize the Grain* (fig. 4) depicts peasants in patched garments wielding sickles and hoes and attacking a landlord, and the quelling of this outbreak by the landlord's braves armed with pikes and spears. Here the style is derived from the romantic book illustration but is more coarse in design and execution.

The Starving People Seize the Grain, although it may arouse feelings of sympathy for the peasants, is visually considerably less effective as social protest than the anti-Christian woodcuts of the 1860s, since it does not convey the strong sense of outrage and indignation necessary to provoke direct action. *The Starving People Seize the Grain* and those prints depicting the Boxer uprising or the sinking of Chinese troopships by the Japanese during the Sino-Japanese War of 1894, as shown in the *Dianshizhai huabao*, are all comparatively straightforward visualizations of current events. Nevertheless, it might be expected that exactly such prints contained the seeds for development of the indigenous woodblock print into a medium for social protest. But this development never took place.

Lu Xun and His Introduction of Western Graphics into China

Although Lu Xun's role in the development of woodcuts in twentieth-century China has been

detailed elsewhere,[13] some of the basic facts need repetition here, for a number of misconceptions and misunderstandings should be laid to rest.

Even as a youngster, we are told, Lu Xun was fascinated by illustrated books and woodcut illustrations; he was also interested in the New Year's pictures of popular culture and later was aware of the *Dianshizhai* prints. But in general it is apparent that, as an adult, his attention was captured most quickly and lastingly by things of polished elegance or antiquarian appeal. He assiduously studied the motifs and the inscriptions on ancient stone steles and amassed an extensive collection of rubbings of steles.[14] In collaboration with the bibliophile and antiquarian Zheng Zhenduo (1898–1958), he was responsible for republishing the exquisite colored woodcut decorative motifs of the *Beijing Letter Papers* and the *Ten Bamboo Studio Letter Papers*. The latter, as was mentioned earlier, was the companion volume to the well-known *Ten Bamboo Studio Painting Manual* originally published in the seventeenth century. For the 1934 replica of these stationery designs, the blocks were cut by craftsmen at the famous book and stationery shop in Beijing, Rongbaozhai.[15] Despite his supposed interest in New Year's prints, Lu Xun owned but a few of these and apparently never had plans to exhibit them.[16] He seems to have been unaware of the overall richness of the graphic tradition in China and of the use of the popular-print style as a powerful weapon in combating the inroads of Christianity a generation earlier. There is no evidence he knew that a print had been used to depict current bandit events little more than a decade earlier.

Lu Xun became interested in Western graphics in 1928 when seeking appropriate illustrative material for a journal he edited of translations of Western literature and literary theory. Over the next several years and through various means he acquired some four hundred prints by artists in Europe, England, the United States, the Soviet Union, and Japan. Lu Xun appreciated the linear qualities of Western graphics. He also had the understanding that Western graphic artists both designed and cut their own prints, and so he came

12. *The Cause of the Riots in the Yangtse Valley: A "Complete Picture Gallery"* (Hankow, 1881); Paul A. Cohen, *China and Christianity: The Missionary Movement and the Growth of Chinese Antiforeignism 1860–1870* (Cambridge: Harvard University Press, 1963), app. 2: 277–281; Frederic Wakeman, Jr., *The Fall of Imperial China* (New York: Free Press, 1975), 183.

13. Shirley Hsiao-ling Sun, "Lu Hsün and the Chinese Woodcut Movement: 1929–1936" (Ph.D. diss., Stanford University, 1974); Shirley Sun, *Modern Chinese Woodcuts* (San Francisco: Chinese Culture Foundation, 1979).
14. Sun, "Lu Hsün," 22–30.
15. Sun, "Lu Hsün," 151–153; Sun, *Modern Chinese Woodcuts*, 11.
16. Wang Shucun, "Lu Xun yu nianhuade shouji he yanjiu," *Meishu yanjiu*, 1982, no. 1:55–58; Ye Wenxi, "Lu Xun yu minjian muban nianhua," *Banhua yishu*, 1980, no. 1:23–24.

to believe that the woodcut was totally the creation of one individual (this was true primarily of Western artists of the expressionist school; those working in other styles followed the older procedure of having another artisan cut and print the blocks).

It is claimed that Lu Xun promoted the imitation of Western graphics in China for several reasons. He believed that graphics were an ideal medium through which to expose the social and other evils the Chinese should be striving to overcome. He also felt that because woodcuts were inexpensive to produce, they were a perfect mode of reaching the masses with such messages.

Contrary to what is usually claimed, however, not all of the Western graphics owned by Lu Xun seethed with political or social discontent; indeed, the content of most of them was quite bland. Further, and rarely noted in the literature on these graphics, they were done in a mind-boggling array of styles: a few examples of abstract art and cubism; the witty, sly, slightly sardonic pictures of Felix Vallotton (1865–1925); the supple, glib lines combined with elegant forms and shapes of A. Beardsley (1872–1898) and his imitators, such as the Frenchman Charles Corlegle and the Japanese illustrator of women's magazines Tsuyutani Kōji (b. 1898); the descriptive effects of some of the Soviet masters; the shattering, explosive styles of the European expressionists whose figures so effectively convey outrage and anger against society and its injustices.

Käthe Kollwitz's (1867–1945) prints of downtrodden peasants had a profound influence on Lu Xun, as did the dramatic story of *One Man's Suffering*, the struggles of a worker told in pictures only, by the Belgian Frans Masereel (1889–1971), because Lu Xun saw in them parallels with the unfortunates of China. Lu Xun did everything possible to help popularize the graphic medium as an art form and as a form of revolutionary art.

To educate young Chinese artists about Western woodcuts and to promote the practice of woodcuts and graphics, Lu Xun undertook three major projects. First, between 1929 and 1936 he published nine volumes of Western prints from his collection. Second, between 1930 and 1933 he sponsored three exhibitions of these prints in the Japanese concession in Shanghai. Third, in 1931 he organized a week-long workshop to teach young artists how to cut woodblocks. In the reprinting of selected works of Western graphics in his possession, he demanded perfection in all respects. Consequently, these publications were often extremely costly. In reality, they were not readily available to the general public (had this public even been aware of them); the Chinese art students, many of whom were not wealthy, must have found their purses sorely taxed. The exhibitions of prints from his collection were held almost in secret in obscure locations in the Japanese settlement where Lu Xun was residing. They were poorly attended, sometimes primarily by Japanese. It is amazing that despite these drawbacks, Lu Xun was successful in attracting many youngsters to the art. When some Chinese students in their eagerness to learn the techniques of woodblock printing turned to seal carvers for instruction, Lu Xun arranged for a week-long workshop and hired a Japanese woodblock carver as a teacher. Ultimately, a large number of woodcut clubs and societies were formed in China's major cities. These served, among other things, to stimulate interest in woodcuts, even though many organizations, for political and other reasons, were short-lived.[17]

In his promotion of this art, Lu Xun sometimes proffered advice to the beginning woodcut artist: when he felt that the imitation of Western styles was too dominant, he suggested returning to Chinese traditions for inspiration. His idea was to combine Western styles with what was most familiar to him in his own heritage: the line of Han dynasty reliefs, the exquisite techniques of Ming and Qing book illustrations, and finally "paying attention to the 'New-Year pictures' appreciated by the people, and amalgamating these with modern European techniques."[18]

We are sometimes told that from the beginning Lu Xun's woodcut movement was directed toward furthering the revolution.[19] Yet despite Lu Xun's acquaintance with China's printing history, there seems to be no evidence that he knew that in the past the Chinese had already, at least once, adapted elements of the traditional woodblock to forge a potent political weapon.

Whatever the reason, Lu Xun did not seriously promote traditional Chinese woodblock prints, and so it remains to evaluate what was done and how woodcut styles and subjects changed and evolved in China. This evolution can be seen in three major stages: during the introductory era of the 1930s there was heavy reliance upon foreign models; then during the years of the war against Japan (1937–1945) artists working in the Com-

17. Sun, "Lu Hsün," 52–58, 79–83, 86–87, 76–102; Sun, *Modern Chinese Woodcuts*, 13–14, 48–50. Lu Xun's print publications have recently been reissued: *Lu Xun bianyin huaji jicun*, 4 vols. (Shanghai: Renmin meishu, 1981).
18. "Letter to Li Hua," CL, 1978, no. 8:106; Sun, "Lu Hsün," 155–156; Sun, *Modern Chinese Woodcuts*, 12.
19. "Art: Szechuan Woodcuts," PR, 18 June 1965, 31.

munist areas and behind Japanese lines in particular were forced to recast their styles to serve propaganda needs; and finally, there was the development of a purely Chinese woodcut style by the late 1950s in the People's Republic of China.

From the 1930s to 1949

Through his print collection and his efforts to publicize Western prints, Lu Xun introduced a plethora of subjects and styles to the Chinese artist. Many of the subjects depicted by the Western graphic artists were completely apolitical in nature, as were those depicted by the Chinese printmaker. A sleeping *Cat* and a peaceful *Landscape* done by Li Hua (b. 1907) in the 1930s have no political messages whatsoever, nor does *Nude* by Tang Yingwei. In terms of style, the Chinese graphics are sometimes more closely related to European paintings: Tang's *Rest*, which shows two naked sleepers, is based on a Picasso painting; and *The Long Road*, by someone identified only as Lin, is highly reminiscent of Edvard Munch's *The Shriek*, with some visual allusions to Van Gogh.[20]

Lu Xun particularly favored and promoted the styles of Käthe Kollwitz, Frans Masereel, and various Soviet printmakers: Vladimir Favorsky (1886–1964), Alexei Kravchenko (1889–1940), and Pavel Pavlinov (b. 1881). In the case of Kollwitz and Masereel, he seems to have appreciated them as much for their own political beliefs and their championing of the common man as for their art. Nonetheless, he admired Kollwitz's accomplished drawing in her lithographs and etchings of downtrodden peasants, as well as, in her woodcuts, a powerful expressionist style. He recognized Masereel as a master of his craft and, as was noted earlier, was especially impressed by his *One Man's Suffering*, told in pictures only, without accompanying text. In the works by Soviet masters, Lu Xun saw precision and technical perfection of visual description based on careful observation.

Although Lu Xun repeatedly cautioned Chinese artists against the copying by rote of these European masters, their influence on the Chinese neophytes is blatantly obvious. The Chinese stylistic dependence on Kollwitz and Masereel has been briefly explained by Shirley Sun,[21] but it is worth repeating and expanding here to illustrate

these connections. The general composition and some of the figures in Li Hua's well-known print *Arise* made in 1935 (fig. 5) were lifted from Kollwitz's etching *Outbreak* from her *Peasant War* cycle done in 1903 (fig. 6). Similarly, in Kollwitz's *Memorial for Karl Liebknecht*, done in 1919–1920 (fig. 7), the figure of the assassinated Marxist leader provided the formula for Zhang Wang's (b. 1916) *Martyr*.[22] The gaunt faces of Liebknecht's mourners are echoed in the brutalized features of China's oppressed in *Figures* by Li Hua (fig. 8). Masereel's style, as seen in his *One Man's Suffering* (published by Lu Xun in 1933) or in *My Book of Hours* (fig. 9), is characterized by severely simplified figures with jagged dagger or lightning-like highlights. It found a host of imitators in China, such as Chen Tiegeng (1908–1970) in his *Under the Threat of Bayonets* (fig. 10).

Interestingly, the Chinese debt to the Soviet artists has often been mentioned,[23] but never explained, even though the influence of the Soviets on Chinese woodblock cutters equaled, and eventually even surpassed, that of Kollwitz and Masereel. The Soviet printmakers, such as Favorsky, Kravchenko, and Pavlinov, worked in an approach distinctly different from that of either Kollwitz or Masereel. In general, the three Soviet artists prefer detailed, descriptive pictures, utilizing multiple, fine lines to establish shadow and solid forms; compacted linear units are often set at angles to each other. Scenes, if not of buildings or cityscapes proper, are sometimes framed with architectural elements and often include meteorological phenomena like clouds in the sky, billows of smoke, steam, or vapors. Doubtless, the *Sluice on the Dnieper River Dam* (fig. 11) by Kravchenko (a print owned by Lu Xun) provided the stylistic prototype for *Searching in the Ruins* (fig. 12), made between 1937 and 1945 by the Chinese artist Huang Yan (b. 1921).

During the 1930s woodcut portraiture in China also leaned heavily upon Soviet inspiration. In Soviet prints, the bust-length portrait was common: the face either full-face or three-quarters view. The curvilinear shapes of the heads were often placed against backgrounds of rectilinear designs. Occasionally, secondary vignette motifs were introduced in the background, functioning as "commentary" on the individual portrayed. Thus in A. Soloveichik's (b. 1901) *Portrait of*

20. These woodcuts are reproduced in *Meishu shenghuo Art and Life*, August 1934.
21. Sun, "Lu Hsün," 131–136, 124–125; Sun, *Modern Chinese Woodcuts*, 18–21.

22. Reproduced in *Zhongguo xinxing banhua wushinian xuanji* (Shanghai: Renmin meishu, 1981), vol. 1, 28.
23. Sun, "Lu Hsün," 120–123; Sun, *Modern Chinese Woodcuts*, 17; Wang Chi, "Modern Chinese Woodcuts," PC, 1 May 1953, 24–25.

Stalin, airplanes and factory chimneys seen on a curtain backdrop indicate technological and industrial achievements under Stalin. Urns and columns in the moonlight behind *Byron* in A. Kravchenko's depiction of the poet tell of his fascination with Greece.[24] Pavlinov's portrait (fig. 13) of the literary critic Belinsky (1811–1848), also in Lu Xun's collection, was perhaps the model for Li Qun's (b. 1912) portrait of *Lu Xun* in 1936 (fig. 14). Here, the lineament defining the facial features, the zigzag lines used as a filler, and the motif of the bookshelf background could have been taken from Pavlinov's work. Another type of Soviet portraiture presents the subject in the center of the picture surrounded by smaller figures. In Vladimir Favorsky's portrait of *Orlov* (fig. 15), the actor is surrounded by smaller depictions of himself in presumably four of his stage roles, and in imitation of this, in the portrait of *Lu Xun* (fig. 16) by Ma Da (1903–1978), the Chinese writer is enclosed by four of his short-story characters (?).

An adaptation of Favorsky's figure depiction as seen in his *Portrait of Dostoevski* (fig. 17) is evident in *Call to Arms* (fig. 18), done in 1936 by Huang Xinbo (1916–1980). Even though one figure is passive and the other active, the manner of depicting the garments is nearly identical.

Huang's *Call to Arms* is from his *Lubei*, which appeared in 1937 and contains thirty prints made between September 1935 and March 1937. A survey of these prints reveals that Huang moved freely between the Soviet model and the expressionist mode. This vacillation and a corresponding seeming lack of interest in developing a personal idiom seems typical of Chinese graphic artists during this period.[25]

After the outbreak of the Sino-Japanese War (1937–1945) and throughout the duration of this conflict, China was divided into three political spheres. The Japanese held most of the northeast and the coast, including such cities as Beijing, Shanghai, and Canton; the Guomindang (GMD) Nationalists held some of the inland cities and had their wartime capital at Chongqing in Sichuan; the Communists, with their administrative center in Yan'an in Shaanxi, carried on guerrilla warfare behind the Japanese lines wherever possible.

Throughout the Sino-Japanese War the im-

ported woodcut styles, regardless of how diluted, simplified, modified, or debased, dominated Chinese woodblock print production in the GMD-controlled cities of Chongqing, Kunming, Guiyang, and elsewhere. Through their foreign-inspired woodcuts, the Chinese documented the gruesome horrors of war, death, destruction, the effects of war on the civilian population. They also used prints as a means of keeping up the spirit of resistance against Japanese aggression through images of air raids, destitute refugees, overcrowded cities. During the civil war between the Nationalists and the Communists, 1945–1949, printmakers with Communist sympathies living in GMD-controlled areas used Western print styles to expose social and political practices that existed there. Zhang Yangxi's (1912–1964) *Human Market in Chengdu* (fig. 19), made in 1947, for example, depicts the deplorable selling of a woman as a wet nurse. Shao Keping's (b. 1916) *Late at Night When Everything Is Quiet* (fig. 20) continues the Soviet device of secondary vignettes, now in ghostly pale lines, visualizing the woman's thoughts of husband or son, mistreated in the army and lost on the battlefield, as she does her nightly sewing.

The situation was quite different for the Communists, both in their headquarters in Yan'an and in the guerrilla propaganda war they carried on behind enemy lines. In 1937 and later many woodcut artists moved from the sophisticated cities of the coast, such as Shanghai, to Yan'an. Here, the political and social realities were totally different from those which prevailed elsewhere in China. In Yan'an the artists were organized and controlled by the government. The Communists, recognizing the important role of art in propaganda, wanted to train their people accordingly. To accommodate the artists coming from the cities and to provide schooling for them and others, the Lu Xun Art Academy was established in Yan'an in 1938. This Academy provided short courses in literature, drama, and art, especially woodcuts. As art workers, the graduates were charged primarily with helping to keep alive anti-Japanese sentiment and helping to mobilize peasant resistance to the Japanese invaders. Art students who came from the coastal areas naturally brought with them the styles of woodcuts they had learned in their home cities. They probably expected to be able to continue to employ these styles in the hinterlands of Shaanxi. But this was not to be the case; they quickly found that they were ill prepared to deal with the local needs.

24. These two portraits are reproduced in *Sulian banhua ji Soviet Graphics* (Shanghai: Liang You, Fook Shing, 1940), 48, 60.

25. Huang, it turns out, will be an exception. By 1943 he had come under the sway of the American printmaker Rockwell Kent and was later to work in a distinctly individual style, although his debt to Kent remains always apparent.

In 1938 some Western-style woodcuts previously shown in Wuhan were exhibited in Yan'an. In general, the rural viewers disliked them because they lacked color or significant content, because they were monotonous in subject, or were insufficiently lifelike, or were unpleasant to look at, or were ugly.[26] Other peasants mocked foreign-style woodcuts as "light and dark faces" because of the strong highlights and deep shadows on the faces, elements not customarily seen in Chinese figure depictions.[27]

After a short stint of schooling at the Lu Xun Art Academy, the young artists were sent out to do propaganda work in the army or in the villages or behind enemy lines. Their prints were posted on market walls, in towns, in barracks, and in other public places. They provided illustrations for serial stories and cartoons for newspapers and magazines. The north China edition of the *Xinhua Daily* had a regular supplement, *Woodcuts from the Enemy Rear*, "devoted entirely to engravings describing the heroic actions of the Eighth Route Army and exposing the atrocities of the Japanese invaders."[28]

The reminiscences of a number of woodcut artists who served the Communist cause in the base areas in north China have been published. The most lively and engaging of these is by Yan Han (b. 1916), whose vivid recollection of the tribulations and triumphs of the Woodcut Artists' Team is the basis for the comments below, augmented by information from other sources. In January 1939 the Woodcut Artists' Team went behind the Japanese lines into the Taihang Mountains. There, although printing conditions were difficult, they placed their woodcuts in the newspapers as illustrations, cartoons, or serials. The team worried because their influence was limited to the newspaper readership, and they were not really reaching the illiterates. Consequently, they decided to publish the *Woodcuts from the Enemy Rear* pictorial. At this time the Japanese forces began to make "sweeps" through the area; issues of the pictorial had to be completed between "sweeps." The artists managed to get out three issues, but just as they were about to print the fourth, another sweep cost them some workers and equipment. The pictorial died. In the

winter of 1939 the Woodcut Artists' Team was transferred to the "Lu Xun Branch School" in the southeast of the guerrilla area. Once again they tried to formulate plans to get woodcuts to the people but were at a loss as to what to do. They felt that black-and-white woodcuts should broaden and expand the peasants' interest, but they recognized that on the level of form such prints had many limitations. In December the Field Government called a meeting of literary and art cadres; the commander-in-chief, Zhu De (1886–1976), and the director of the Propaganda Department, Lu Dingyi (b. 1906), urged literary and art workers to intensify their artistic struggle. At this meeting, says Yan Han, they saw an example of enemy propaganda—the Japanese had appropriated the traditional Chinese Buddhist "Judges of Hell" pictures in order to sway the people of the areas under their control. Everyone at the meeting who saw this propaganda was "aroused to incomparable wrath and wanted to retaliate." After the Woodcut Artists' Team heard this report, they decided to avail themselves of the Chinese traditional New Year's pictures, to take advantage of the coming 1940 New Year's festival and begin a New Year's propaganda movement. But because they wanted to print colored New Year's pictures, they had first to master the techniques of color printing, yet another seemingly insurmountable problem. It was learned from the locals that the divination tallies in the temples were woodcuts printed with water-based pigments. The team finally located an old monk and from him learned that in a nearby village the peasant Zhao the Fourth once was a printer. They went through many complications and finally invited him to come to the work team, but there were difficulties with the printing, so that ultimately this problem was not yet solved. Finally, through the Xinhua newspaper they sought out a former printer of New Year's pictures, a man named Wang. He taught everyone the techniques of color printing using water-based pigments. The local paper was unsuitable for this type of printing, but eventually both appropriate paper and pigments were brought in through enemy-occupied areas with the help of the underground. The first batch of New Year's pictures totaled eight titles stressing opposition to the Japanese and continued agricultural and cottage-industry production. Since they wanted the new New Year's pictures to be issued before the holiday, work went on daily until deep into the night. The new New Year's prints were a

26. Luo Gongliu, "Luyi muke gongzuotuan zai dihoufang," *Banhua*, 1960, no. 3 : 39.
27. Chen Shuliang, "Huiyi Luyi," in *Jiefangqu muke*, ed. Zou Ya and Li Pingfan (Beijing: Renmin meishu, 1962), 3.
28. Wang Chi, "Modern Chinese Woodcuts," 24; Li Hua, "Modern Woodcuts in China 1931–1949," CP, 1962, no. 3 : 36.

great success: they sold out to an enthusiastic market.[29]

These experiences of the Woodcut Artists' Team are important for at least two reasons. The reports reveal first that artists had begun to use popular folk-art forms. This may have been in response to Mao Zedong's comments in his 1938 *The Role of the Chinese Communist Party in the National War*, where he states: "Foreign stereotypes must be abolished ... they must be replaced by the fresh, lively Chinese style and spirit which the common people of China love."[30] Second, the woodcut reports indicate that woodcut artists had begun to use the age-old technique of water printing.

Later, Mao was not only to sanction the concept of adopting folk literary and art forms, but also to accelerate their acceptance through his *Talks at the Yan'an Forum on Literature and Art* in 1942. Two pertinent guidelines were stressed in his speeches at the 1942 forum. First, art must serve politics and the masses. He pointed out that the audience in Yan'an was not the relatively sophisticated one of the urban areas from which artists hailed, but provincial peasants to whom a foreign-based art had no appeal. For any political or social message to be conveyed to the masses through art, the statement had to be in an idiom the peasants could understand. Second, art should convey the positive aspects of life under the Communists.[31] Mao's call for the popularization of art and for an art which was an effective political tool affected art in Yan'an itself in theme and style.

In general, the prints produced in Yan'an differ from those produced elsewhere in China. Depictions of guerrilla warfare and pictures urging popular support for the army continued to be made. Otherwise, however, rural scenes predominated, along with optimistic themes of socialist cooperation or education (reflecting health and literacy campaigns). These were in contrast to the subjects of human degradation which so often characterized prints from the GMD areas. Further, the reliance upon direct copying of Western art models declined in Yan'an but was still closely followed in other parts of China. The expressionist mode with its extensive use of black and its exaggerated or distorted figures, so effective in conveying violence and frustration, was replaced in Yan'an by a new style of white backgrounds for more realistic figures, rendered in simple forms and lines, with a sparing use of depressing black. The striking differences between Gu Yuan's (b. 1918) two depictions of *Divorce Registration*, one done before and one after the Yan'an *Talks* of 1942, provide dramatic evidence of the changes that took place in Yan'an after 1942. The earlier print (fig. 21, right) is primarily black, faces are heavily covered with black lines, some figures are not immediately apparent, while a cat is indicated by means of a white silhouetting line only. In the later version (fig. 21, left), white predominates, faces are wrinkle-free and lines of folds in clothing are reduced to a minimum, there are fewer figures (and the cat is eliminated), so that the main protagonists are clearly discernible, and the confrontation between the young woman and the recorder is less violent in tenor. Thus through simplifying the technique, reducing the number of lines used, and clarifying the composition, Gu Yuan devises a picture of great impact and directness of message.[32]

In Yan'an, Wo Zha (1905–1974) is credited with having designed the first print based on New Year's print style. For the 1939 Spring Festival he created a *Spring Ox* showing a sturdy peasant boy leading an ox pulling a plough; the images were done in simple silhouette, and the title occupied an otherwise blank area of the paper; apparently it was hand-colored. It won high praise from the artist's colleagues in Yan'an.[33] Later, others in Yan'an continued to design woodcuts in the fash-

29. Yan Han, "Yi Taihangshan kang Ri genjudide nianhua he muke huodong," *Meishu*, 1957, no. 3:33–35; other accounts include those by Luo Gongliu (see n. 26) and Chen Shuliang (see n. 27), as well as those by Yang Han, Zou Ya, and Xu Ling, published in *Jiefangqu muke*, and Hu Yichuan, "Huiyi Luyi muke gongzuotuan zai dihou," *Meishu*, 1961, no. 4:45–48; Xu Ling, "Zhandoude nianhua—huiyi Jin-Cha-Ji kang Ri genjudide nianhua chuangzuo huodong," *Meishu*, 1957, no. 3:37–38; Xu Ling, "Kangzhan shiqi Jin-Cha-Ji dihou meishu huodong," *Meishu yanjiu*, 1959, no. 4: 49–53. These reports contain many inconsistencies in data, presumably because of faulty memories.

30. Noted by Chen Shuliang in *Jiefangqu muke*, 3; see Mao Tse-tung, *On Literature and Art* (Peking: Foreign Languages Press, 1967), 50.

31. "Talks at the Yenan Forum on Literature and Art," in his *On Literature and Art*, 1–14.

32. Li Qun, "Tan banhuajia Gu Yuan," *Banhua yishu*, 1980, no. 1:3–4, notes that these two versions are different, but talks primarily of the different cutting technique involved: the earlier version was a wood engraving with the lines incised in intaglio into the wood; the later version was done in relief, with the lines standing above the cut-down surface of the block.

33. Chen Shuliang, *Jiefangqu muke*, 4; [Chen] Shuliang, "Cong Yan'ande xinnianhua yundong tanqi," *Meishu*, 1957, no. 3:36. For traditional prints of the spring ox, see Tseng Yu-ho Ecke, *Chinese Folk Art in American Collections, Early 15th through early 20th Centuries* (New York: Chinese Institute in America, 1976), 82–83.

ion of traditional New Year's pictures, employing the visual vocabulary and stylistic idiom of the masses.[34] Li Qun, who in 1936 in Shanghai had done Lu Xun's portrait in a modified Soviet style, in 1944 in Yan'an created *Well-clothed and Fed* (plate 4). In this work almost every element has its roots in popular New Year's prints: the four children, happy and chubby, as was common in old prints; a basket of ordinary vegetables in place of the earlier expensive fruits and flowers. The attention given to decorative designs of cloth patterns in the garments, and the use of many flat bright colors—red, green, blue, yellow—also derive from the traditional New Year's print. Thus, by using an old idiom, one the peasant was completely familiar with, the artist conveys the message of new prosperity and security of the peasant family in the Communist areas.

In *Hygiene Model* (fig. 22) Luo Gongliu (b. 1916) used the traditional frontal pose for the hero, placed, like a god in one of the old New Year's prints, in the center of the composition, flanked by cranes (an ancient symbol of longevity), and incorporating written expressions to reinforce the visual message: "Hygiene Model: Life as long as the Southern Mountains," thus continuing yet another aspect of folk art. In addition, the fret designs and the reduction of the hero's sheepskin coat, his sash, and his honorific pompom to flat patterns are also in keeping with traditional popular arts of both New Year's pictures and papercuts.

What needs to be emphasized here is that prints like *Well-clothed and Fed* and *Hygiene Model* bear no resemblance to the Western print, but are entirely based upon Chinese popular arts.

From 1949 until 1960

After the Communist victory in 1949, energies were turned to reconstruction of the economic, agricultural, and industrial sectors of the country. A report written in 1953 claims that the production of woodcuts dropped after 1949 because woodcut artists were called upon to produce New Year's picture paintings. Apparently, this situation was remedied by 1953 when a department of graphics was established in the Central Art Academy in Beijing.[35]

Between 1949 and 1956 several changes occurred in the styles and themes of woodblock prints. Prints reflecting traditional Chinese New Year's pictures declined in number. The expressionist style, so effectively used for social criticism and rousing the populace in the past, was largely abandoned; now that social and political criticism was forbidden, this style was reserved primarily for posters supporting popular revolts and the like in other countries. On the other hand, the Soviet fine-line descriptive mode, being eminently suitable for depictions of construction and industrial scenes and even landscape in a highly representational presentation, became one of the leading styles of the era. Gu Yuan's *Rehabilitation of the Anshan Steel Works* (fig. 23) has basically this approach, but with the elimination of excess linear complexity and with the addition of flat orange, yellow, and red hues. (Color woodblock prints, rare before 1949 for economic and practical reasons, had become more frequent.)

By 1955 the emphasis on depicting industrialization and construction was balanced by the appearance of more lyrical themes, as in Gu Yuan's *Clearing a Path in the Snow* and especially in his *Boulevard in the Beijing Suburbs*.[36] The latter was the hit of the 1955 National Graphics Exhibition in Beijing. In its praise reviewers said:

> ... a pleasantly lyrical print of some new buildings under construction, viewed from a distance between the branches of some willows...[37]

> [It] strikes an entirely new note. This delicately coloured print of a suburban landscape conveys the atmosphere of peace, quiet and prosperity of Peking in spring.... The artist has succeeded in producing a print whose harmony and range of colour is entirely satisfying.[38]

A dramatic new development in woodblock prints took place in about 1956–1957. At this time the government demanded the development of the national artistic and craft legacy. Its own efforts are seen in the revitalization of the old stationery printing shop, Rongbaozhai, in Beijing.

According to one source, during the late nineteenth century there were some thirteen stationers in Beijing specializing in color prints along with fine poem and letter paper. The most famous of these establishments was Songzhuzhai. It was

34. Other accounts of life and art in Yan'an include Zhang Wang, "Yan'an meishu huodong huigu," *Meishu yanjiu*, 1959, no. 4:54–58, and the report of a panel discussion, "Huiyi Yan'an," *Meishu*, 1962, no. 3:21–24.
35. Wang Chi, "Modern Chinese Woodcuts," 27.

36. Reproduced in CR, 1956, no. 2, back cover, and CP, 1954, no. 11:20.
37. Liu Yi-fang, "Chinese Woodcuts—Old and New," CR, 1955, no. 3:15.
38. Li Chun, "New Chinese Woodcuts," PC, 16 May 1955, 25.

forced to close during the Boxer uprising in 1900, and when it reopened it took the name under which it is known today, Rongbaozhai. Before 1949 its fortunes had declined, and only five workers were employed in the firm. In 1952 it became a state-owned enterprise and by the mid-1950s was producing reproductions of antique and modern paintings by the ancient method of "water-printing color woodcuts."[39]

When the woodcut artists responded to the call for developing the national heritage, they turned to the fine, elegant woodcuts of the seventeenth century: *The Ten Bamboo Studio* and *The Beijing Letter Papers*, both for stylistic elements and for printing techniques using water-based pigments, as was practiced at Rongbaozhai. It might also be remembered that Lu Xun had reissued the seventeenth-century prints in 1933 with Rongbaozhai as the printer, and that he, when advocating learning from China's past, repeatedly specified the Ming and Qing woodcuts as sources of inspiration.

In the late 1950s two of the first prints to use "water-printing color" techniques were Wu Fan's (b. 1924) *Dandelion Girl* (plate 5) and Jiang Zhenghong's (b. 1936) *New Settlement in the Forest* (fig. 24), both exhibited in the Fourth National Graphic Art Exhibition of 1959. Of them, the reviewer Mei Tang said: "Both [artists] have succeeded charmingly and without any feeling of artificiality in making this traditional technique serve new themes.... These two woodcuts suggest the big possibilities still unexplored in using traditional techniques adapted and developed for the treatment of modern themes."[40]

In *Dandelion Girl* socialist content is negligible (perhaps only the concept of a carefree childhood possible under the Chinese Communist Party), but the style is more important, for it is unmistakably Chinese in all respects. The wide, grey lines with splintered edges which contour the figure, the muted blue of the child's apron, the sharp accents of black in her hair and in the woven basket and hoe are adopted from prints in such earlier works as *Ten Bamboo Studio Letter Papers*

(plate 1) or *The Beijing Letter Papers*. In *New Settlement* overlaid planes of green and grey are used for foliage, and orange for the clearing. Buildings and tree trunks are drawn with rich black lines and provide the structure of the composition. All of these techniques have predecessors in, for example, *Ten Bamboo Studio Letter Papers*.

The final step in the evolution of Chinese woodcuts came in the early 1960s. By 1964 artists not only were employing the already absorbed techniques of wide grey lines (now used in a way similar to but distinct from the *cunfa* of painting), the black accents and muted colors from such earlier examples as *Ten Bamboo Studio*, but now added a final touch: color gradation to suggest both brilliant sunlight on a rock massif in *Autumn on the Plateau* (fig. 25), by Zhang Xinyou (b. 1932) and Zhu Qinbao (b. 1934), or the mists clinging to hills in Liu Zonghe's (b. 1928) *After a Downpour*.[41] In keeping with the relatively liberal art of the early 1960s these two lyrical works are so low-key in social content that they might have been produced someplace other than the People's Republic of China, were it not for the fact that the technique is uniquely Chinese.

In this chapter, the history of woodblock prints in China, and particularly in twentieth-century China, has been traced. The indigenous Chinese tradition used woodblock prints for a variety of purposes: book illustrations, New Year's pictures, social criticism, and illustrations of current events. The styles ranged from the expensive, elegantly designed, pastel-colored prints seen in the seventeenth-century albums like *Ten Bamboo Studio* to the inexpensive, lively, brightly colored popular New Year's print. Although indigenous prints of social protest appeared sporadically, use of the native woodblock-print medium as a vehicle for generating political action never took place. A wide array of modern Western graphic styles, including those preeminently suited for expressing social protest, were introduced into China in the early 1930s under the aegis of Lu Xun. During the Sino-Japanese War woodcut artists in the areas held by the GMD relied exclusively upon imported graphic styles for their pictures of the horrors of war and other scenes designed to arouse anti-Japanese sentiment. The foreign styles continued to be employed by the artists in the GMD areas after the conclusion of the Sino-Japanese War, to expose the dismal living and political conditions there. On the other hand, woodcut artists working under the Communists in north China

39. Yeh Sheng-tao, "Chinese Colour Wood-block Printing," PC, 1 Sept. 1954, 25–28; Yi Niu, "New Wood-block Prints by Jung Pao Chai," PR, 9 Feb. 1960, 19–20 (on technique); "Bringing Great Art to the People," PC, 1 Dec. 1955, 40; Yi Bo, "Rongbaozhaide muban shuiyinhua," *Meishu*, 1955, no. 10:20. For an extensive description of these printing techniques, see Diana Yu, "The Printer Emulates the Painter—The Unique Chinese Water-and-ink Woodblock Print," *Renditions*, no. 6 (Spring 1976): 95–101.

40. Mei Tang, "Graphic Art Exhibition," PR, 8 Dec. 1959, 17.

41. Reproduced in CP, 1964, no. 4:22.

Woodcuts in Twentieth-Century China

had little success with the foreign styles because their audience was not the relatively sophisticated urbanite, but the artistically naive peasant. In 1939 the failure of the Communist propaganda woodblock-print team operating behind Japanese lines to communicate with the peasants through foreign-based images forced the artists to adopt the indigenous, popular New Year's picture style. These new Near Year's woodcuts, along with pictorially drastically simplified versions of Western graphic modes, then became standards in the Communist capital Yan'an during the 1940s. Immediately after the Communist victory in 1949, the few woodcuts that were produced stressed economic recovery and largely followed the Soviet linear descriptive style of presentation. In about 1956–1957 the quest for a "national" style in woodblock prints resulted in the development of a uniquely Chinese mode rooted in the soft colors and delicate techniques of the seventeenth century, like *The Ten Bamboo Studio*. Final additional stylistic refinements upon these old woodcut techniques occurred by 1964. The colored-woodblock print style as evolved in the late 1950s and early 1960s became a favorite one for woodcut artists to use in later years.

2

After the founding of the People's Republic of China in 1949, the Communists strove to consolidate their victory in all sectors: economic, industrial, and ideological. To carry their politics to the intellectuals in particular they embarked on unrelenting programs of thought reform. According to Theodore Chen:

> The Communist revolution is a "total revolution," which aims to bring about radical changes in the entire social structure and in the pattern of human behaviour. It sets out to replace the old way of life with a new "working style," to substitute new allegiances for old loyalties, and to introduce a new code of personal and social ethics.... The most fundamental of all is the ideological reform. An ideologically correct person...is likely to overcome old habits of thought and action and to become a successful worker for the proletarian revolution; whereas a person committed to bourgeois and reactionary ideology is bound to fall into serious deviations in action and in thought.[1]

This reeducation was necessary because, since the work of artists "affects the thought of people, their own thinking must be free from ideas unfavourable to the proletarian-socialist revolution."[2] The thought reform programs included reading and discussion of ideological writings, mass study meetings, criticisms and self-criticisms, examination of family background, confessions. Participants made actual trips, for example, to the countryside to gain deeper understanding of the life and thought of the peasants, as well as of new policies and processes, such as land reform. Such campaigns as land reform and Resist-America Aid-Korea, in addition to their specified, practical goals, also involved ideological goals. The land reform program, for instance, inculcated opposition to imperialism and feudalism, and the Resist-America Aid-Korea movement also was anti-imperialist.[3]

The intellectuals also were under almost constant tensions stemming from ideological battles directed primarily at the literary world, but meant for all. In 1951 there was a campaign against the film *Life of Wu Xun*. Wu Xun was a nineteenth-century educator born of a poor family, who became a moneylender and established schools for poor children. The Chinese Communist Party felt that Wu was an inappropriate example because, among other things, he "sought to change China through education and reform rather than through class struggle." In 1954 Yu Pingbo was criticized for persisting in his 1920s view that the classic eighteenth-century novel *The Dream of the*

1. Theodore H. E. Chen, *Thought Reform of the Chinese Intellectuals* (Hong Kong: Hong Kong University Press, 1960), 9.
2. Ibid., 34.

3. Ibid., 21–27; Ouyang Tsai-wen, "Intellectuals and Land Reform," PC, 31 August 1950, 22–23.

Red Chamber was "an autobiographical novel of its author," and for refusing to accept the Marxist interpretation that the novel showed "the decay of the whole society," not just one family.[4] In 1955 an all-out campaign was mounted against the writer Hu Feng (1903–1986) for his opposition to the thought reform programs and for his beliefs that literature was above politics, that it should depict not only the bright side of life but the dark as well, and other ideas.[5] All such campaigns were designed to curtail the public expression of thoughts unapproved by the Party and to ensure that intellectuals understood that the Party was unwilling to tolerate subversive dissidents.

In art, for several years immediately after the founding of the new nation, much government support was given to New Year's prints because they were a people's art,[6] because they reached the largest percentage of the population, and because through them the new ideology and socialist goals could be quickly conveyed to the population at large. The Ministry of Culture sponsored New Year's picture competitions in 1950 and in 1952, and there were many exhibitions of New Year's pictures. In 1950, 400 New Year's picture designs were published; in 1952, 570 new pictures were issued in 40 million copies.[7] Artists from all media participated in creating the pictures: oil painters, cartoonists, woodcut artists, illustrators such as Cheng Shifa (b. 1921), and traditional-style painters such as the noted landscapist Li Keran (b. 1907). Some of these New Year's prints relied heavily upon traditional forms but with new messages. Other prints, depicting new subjects, bore little or no relationship to the earlier pictures except perhaps for a stress upon many bright colors and an emphasis upon significant, if somewhat "busy," detail. Some New Year's prints were done in the socialist realist style.

Socialist Realism

Throughout 1951, 1952, and 1953 Zhou Yang (b. 1907), the vice-minister of cultural affairs and a leading spokesman for official policies on the arts, repeated the need to develop the national forms of art. At the same time he gave increased attention to socialist realism, a theory borrowed from the Soviet Union. In 1951 he said ancient Chinese culture should be reevaluated as "a necessary prerequisite for the development of our new national culture." The Chinese also "must learn from other countries and especially from the Soviet Union. Socialist realistic literature and art," he continued, "are the most beneficial spiritual food for the Chinese people and the broad ranks of the intelligentsia and youth."[8] In 1952 Zhou Yang said socialist realist works were "good at combining the reality of today with the ideals of tomorrow."[9]

In 1953 Zhou Yang's utterances about the national cultural heritage continued, and the nature of socialist realism was amplified in his report delivered at the Second All-China Conference of Writers and Artists. Zhou said that "socialist realism . . . demands that [writers] be familiar with the new life of the people, that they portray the advanced representatives of the people, their new thoughts and emotions." He quoted the Soviet theorist Malenkov, who pointed out that realistic art must "bring to light the lofty spiritual qualities and typical positive features in the character of the ordinary man and woman, and create vivid artistic images of them, images that will be an example to others." To bring this into the Chinese context, there is a reminder about Mao's statements in the 1942 *Yan'an Talks* that art should "portray the bright side," "the real heroes," "the new people," "the new world."[10]

Aside from indicating that figural subjects should be those of today's people (but only the politically correct people), in the setting of their new life, there is nothing else in these statements to indicate precisely how socialist realism was to be realized in art through content or form.

The term *socialist realist* is frequently employed in reference to art produced under the PRC. It is imperative to understand what a socialist realist painting looks like, to indicate the visual components of socialist realist art as practiced in the PRC, not only to enable us to understand the art of this era, but also because it is often asserted that all art produced under the PRC is of this type.

The content of socialist realist paintings is often couched as narrative or anecdote, for such pictures are sometimes intended not only to be seen

4. Merle Goldman, *Literary Dissent in Communist China* (Cambridge: Harvard University Press, 1967), 91, 116.
5. Theodore H. E. Chen, *Thought Reform*, 38–42, 81–83, 85–90; Goldman, *Literary Dissent*, 129–157.
6. Tsai Jo-hung, "New Year's Pictures—A People's Art," PR, 16 Feb. 1950, 12–18.
7. Yu Feng, "New Year Pictures," PC, 1 March 1953, 14; "'New Year Pictures', An Old Custom Serves the New China," CR, 1953, no. 2:26.

8. Chou Yang, "Mao Tse-tung's Teachings and Contemporary Art," PC, 16 Sept. 1951, 7.
9. Perry Link, ed., *Roses and Thorns: The Second Blooming of the Hundred Flowers in Chinese Fiction 1979–1980* (Berkeley and Los Angeles: University of California Press, 1984), 6.
10. Chow Yang, "For More and Better Works of Literature and Art," PC, 1 Nov. 1953, 8.

but also to be "read" and the content duly reflected upon. (Examples of this aspect of socialist realist painting will be given later.)

There are a number of keys to recognizing works done in the socialist realist style, all of which have their origin in European pictures, since socialist realism has its roots in French and German nineteenth-century academic and realist art. For figural subjects, the principal individuals are placed at or near the center of the composition, they usually are highly colored and detailed, and they often are spotlighted with natural or artificial light, which throws into shadow the secondary surrounding figures, necessarily rendered in darker tones and less detail. Attention is focused on the main figures not only by their central location in the composition, by the color and lighting, but also by their placement at the apex of a triangular ground plane the diagonal sides of which are formed by lesser figures or by objects. The triangle also creates a wedge into depth from the foreground to the midground. In some cases the figures, in active poses and gestures, may be in a compact pyramidal grouping. In landscapes a common feature, perhaps associated not so much with academic work as with the elementary lessons of perspective, is a serpentine or curving line of figures curling into the distance with the figures diminishing in scale as they recede.

In the particular case of the Soviet Union, socialist realism (which became dogma there in 1934) was based on the works of Ilya Repin (1844–1930) and his fellow "Wanderers" of the late nineteenth century. Their art in turn was based on European academic formulae mixed with influences from Rembrandt, Frans Hals, Rubens, and other European masters.[11] One of China's most accomplished oil painters, Xu Beihong, excelled in this style, which he studied, not in the Soviet Union, but in Berlin, Paris, and elsewhere in Europe in the 1920s. He then introduced the style into China as early as 1928 in his large oil painting *Tian Heng and His 500 Retainers* (fig. 26), illustrating the story of the second-century B.C. ruler of Qi who, along with his retainers, preferred suicide to capitulation to the first Han emperor. In 1949 Xu was appointed head of the Central Art Academy in Beijing.[12] Between 1949 and 1957 Chinese art

students went to study in the Soviet Union and Soviet masters taught in China. This exchange reinforced the practice of socialist realism in the PRC. The socialist realist style was sometimes used for the Chinese New Year's pictures, frequently for oil paintings, and occasionally for traditional-style works.

In addition to promoting the national art and socialist realism, cultural leaders like Zhou Yang also claimed that they "encourage the free competition of various artistic forms. Far from restricting the freedom... in selecting themes, forms of presentation and personal style, socialist realism helps... to secure such freedom to a maximum extent, so that ... creative spirit and initiative can be displayed to the full."[13] Hu Qiaomu (b. 1912), deputy head of the Propaganda Department of the Central Committee of the Communist Party, promised: "A creative artist is free to choose his subject matter, theme and form of presentation according to his desires and talents."[14]

These directives help explain the complex situation in regard to traditional Chinese-style painting, which was considered a "national artistic heritage." Apparently, well-known doyens of Chinese-style painting, such as the landscape painter Huang Binhong (1865–1955) or the bird-and-flower specialist Yu Feian (1888–1959) or the most famous of all twentieth-century masters, Qi Baishi, noted for his swiftly executed pictures of humble subjects, simply were unaffected by influences of socialist realism. They continued to work in the personal idioms they had developed before 1949. Yu and Qi did occasionally bow to current political demands and make commemorative pictures of flowers or birds traditionally signifying peace or longevity or the like, to celebrate peace campaigns or patriotic anniversaries. On the other hand, some traditional-style artists incorporated Western features into their landscapes to suggest, for instance, more realistic recession into space than is usually found in traditional-style pictures. Wu Zuoren (b. 1908), for example, a student of Xu Beihong's in oil painting, and equally proficient in traditional-style painting, easily fitted the Western convention of receding arcs into his Chinese painting of a snow scene of 1954.[15] Figure painting, however, for the most part neglected by traditional-style painters in the twentieth century, had to be developed and revitalized. This revital-

11. Fan Parker and Stephan Jan Parker, *Russia on Canvas: Ilya Repin* (University Park and London: Pennsylvania State University Press, 1980), 70–74; see also Elizabeth Valkenier, *Russian Realist Art, The State and Society: The Peredvizhniki and Their Tradition* (Ann Arbor, Mich.: Ardis, 1977).
12. For Xu Beihong, see Li Chu-tsing, *Trends in Modern Chinese Painting* (*The C. A. Drenowatz Collection*). Artibus Asiae Supplementum 36 (Ascona, Switzerland, 1979), 91–93, 98.

13. Chow Yang, "For More and Better Works of Literature and Art," 8.
14. "Second All-China Conference of Writers and Artists Closed," NCNA Peking, 6 Oct. 1953, SCMP, no. 663: 15.
15. Reproduced in CL, 1964, no. 7, opp. 94.

ization was achieved sometimes by employing Western techniques of shading and chiaroscuro, sometimes by utilizing techniques closer to a New Year's print style in what are essentially colored drawings.

What was happening in the world of traditional-style painting was made public in the First National Exhibition of Traditional Chinese Paintings, held in the fall of 1953, and in the Second National Art Exhibition of 1955. The 1953 exhibition, sponsored by the Chinese Artists' Association, had 245 items by more than 200 artists; the subjects included landscapes, genre-painting, portraits, and natural life subjects.[16] The styles ranged from the *xieyi* "sketch" approach of a *Day Lily* by the woman Shao Yiping (1910–1963) to the near-monochrome *Forest* by Li Xiongcai (b. 1910), which shows logs being floated down a forest river,[17] to the colored-ink drawing by the woman artist Jiang Yan (1919–1958), *Examination for Mama*, where a schoolgirl teaches her mother to read. *Day Lily* and *Examination for Mama* (fig. 27) especially "moved visitors to the exhibition deeply."[18] The exhibition showed the results of the remoulding of artists: "During the four years since the liberation, Chinese painters have been struggling to meet the fresh tasks and opportunities that now face them. They have worked hard to shake off the deadening influences of the old society and to respond to the demands of the times."[19]

The Second National Art Exhibition held in 1955 in Beijing had more than 1,000 works by more than 600 artists, works done in all media since 1949. A traditional-style painting, *Outside the Great Wall* (fig. 28), done by Shi Lu (1919–1982) after his trip to the Wuxiao Mountain construction site of the Lanzhou-Xinjiang Railway, was lauded in a review of this exhibition as having a landscape theme "from the new social and industrial life of the country." The painting

shows the happy excitement of a group of herdsmen as the railway, with all that it implies, advances into their home district. They shout their welcome as a train approaches through a gap in the Great Wall. The train itself is not seen in the picture, but its approach is heralded by a flock of scared sheep scampering up a slope. The painter has tried to see

this event as it were through the excited eyes of the herdsmen.

This is painted with Chinese brush and paints, but with an unusual fullness of detail and treatment and using modern principles of perspective, treatment of forms in the round and light and shade.[20]

Not only is this Chinese-style painting done with such Western techniques as those mentioned above, but also the pyramidal group of gesticulating herdsmen is plainly visible, silhouetted as they are against the sunlit valley. In the background the zigzagging Great Wall leads the eye off into the distance. Moreover, as is evident from the quotation above, it also has a substantial anecdotal component. In addition to such evidence of socialist realism, other indications of the use of Western techniques are seen in the traditional-style painting by Zhou Changgu (b. 1929) *Two Lambs* (fig. 29), where a Tibetan girl stands at a fence quietly watching two lambs. Here the deep shadows on her skirt and a flush of pink on her face bespeak the absorption of Western painting methods.

Not every critic, however, was satisfied with the amalgamation of Chinese and Western techniques. One critic pointed out that Chinese and Western painting techniques often conflicted because the Western techniques had not been totally and smoothly assimilated. This awkwardness occurred particularly in cases where new-style figures were added to old-style landscapes: the figures looked as if they had been cut out and pasted on the painting.[21] In contrast to all this influx of Western methods into traditional Chinese painting, Qi Baishi's *Eagle and Pine Tree*,[22] also shown in the 1955 National Art Exhibition, owed nothing at all to Western art.

A description of Dong Xiwen's (1914–1973) oil painting *Spring Comes to Tibet* (fig. 30) in one of the reviews of this exhibition, succinctly conveys the idea that it, like *Outside the Great Wall*, was a model of socialist realist art: "In the foreground are apricot trees in bloom; a group of Tibetan women, working in a sunlit field, follow with their eyes a line of lorries on a newly built highway winding its way beneath mountain peaks capped with snow."[23] In every respect this painting meets the criteria both narrative and visual for socialist realist paintings. In terms of the sub-

16. "Exhibition of Chinese Painting in Peking," NCNA Peking, 16 Sept. 1953, SCMP, no. 653:22.
17. Reproduced in CR, 1954, no. 2:24 and 27.
18. Wang Chao-wen, "Traditional Painters Find New Themes," CR, 1954, no. 2:25.
19. Ibid., 24.

20. Li Chi-yen, "Second National Art Exhibition," PC, 1 Sept. 1955, 15, 17.
21. "Wei zhengqu meishu chuangzuode gengda chengjiu er nuli," *Meishu*, 1955, no. 5:10.
22. Reproduced in PC, 1 Sept. 1955, 15.
23. Li Chi-yen, "Second National Art Exhibition," 14.

ject and its interpretation, the blooming apricot trees foretell an abundant harvest; the Tibetans, a minority group once oppressed, now flourish under Communist rule, the sunlit field glows with the brightness of their new life. The artist presents life through their eyes: they look toward (and appreciate) the improvement in transportation wrought by the government in the form of the new road, the trucks which ply it, and by extension, what they will bring as cargo. Stylistically, the painting also adheres to socialist realist precepts. The ground plane is pushed well back, allowing space for a flat area where the arching row of women field-workers leads the eye back into the distance; there the movement is picked up by the curving road and the trucks.

But this period was also beset with conflicts that surfaced in the last half of the 1950s. Some of the problems facing the intellectuals were reported by Premier Zhou Enlai (1898–1976). Later, additional grievances were aired by intellectuals during the Hundred Flowers Campaign of the spring of 1957. This was followed by a massive anti-rightist drive, which engulfed thousands of intellectuals. Immediately following this campaign came the Great Leap Forward in production and culture when professional artists as well as peasants were expected to produce more, better, and faster; further pressures on the professional artists came when, for a brief time, they were shunted aside in favor of, or at least forced to share the artistic limelight with, peasant amateur painters.

The Hundred Flowers Campaign of 1956: Liberalization

Underneath this deceptively productive artistic atmosphere of the early 1950s, however, it is clear that the intellectuals in general were being ideologically demoralized into silent submission.[24] The abuse and neglect of the intellectuals was discovered when it was suddenly decided that they were vital for continued socialist construction and especially to help lift the nation into a modern and self-sufficient economic, industrial, scientific, and technological state. Zhou Enlai's important report on intellectuals in January 1956 called for a general upgrading of their professional and personal lives through improved research and work facilities, employment commensurate with education and training, greater availability of data, and the like.[25]

In May Mao declared a time to "Let a Hundred Flowers Bloom, a Hundred Schools of Thought Contend." Although the ultimate motives for this new policy may be interpreted in different ways,[26] there is no doubt that it was meant in part to relax pressures toward conformity imposed by the government on the intellectuals, artists included. The text of Mao's Hundred Flowers speech, presented on May 2, 1956, has never been published, but the scope of the Hundred Flowers policy was explained later that month (May 26) by Lu Dingyi, director of the Propaganda Department of the Party Central Committee. For art, as seen in the following excerpts from Lu's speech, the Hundred Flowers allowed for greater latitude; Lu played down socialist realism, spoke out strongly in favor of indigenous and national art forms, and warned against overreliance on the Soviet Union. Lu Dingyi said:

> With regard to works of art and literature, the Party has only one point to make, that is, that they should "serve the workers, peasants and soldiers," or, in terms of today, serve the working people as a whole, intellectuals included. Socialist realism, in our view, is the most fruitful creative method, but it is not the only method. Provided he sets out to meet the needs of the workers, peasants and soldiers, the writer can choose whatever method he thinks will best enable him to write well, and he can vie with others. As to subject-matter, the Party has never set limits to this. It is not right to lay down such dicta as: write only about workers, peasants and soldiers; write only about the new society; or write only about new types of people. If literature and art are to serve the workers, peasants and soldiers, it stands to reason that we must praise the new society and positive people. But at the same time we must also criticize the old society and negative elements; we must praise what is progressive and criticize what is backward. So the choice of subject-matter in literature is extremely wide. Creative writing deals not only with things that really exist, or that once existed, but also with things that never existed—the gods in the heavens, animals and birds who talk, and so on. One can write about positive people and the new society, and also about negative elements and the old. Furthermore, it is difficult to show the new society to

24. Goldman, *Literary Dissent*, 158; Maurice Meisner, *Mao's China: A History of the People's Republic* (New York: Free Press, 1977), 170–171.
25. *Communist China 1955–1959: Policy Documents with Analysis*, foreword by Robert R. Bowie and John K. Fairbank (Cambridge: Harvard University Press, 1962), 128–144; see also Theodore H. E. Chen, *Thought Reform*, 104–107.
26. Meisner, *Mao's China*, 177.

advantage if we fail to describe the old, hard to show the positive to advantage if we leave out what is negative. Taboos and commandments about choice of subject-matter can only hamstring art and literature, and result in writing to formula and bad taste. They can only do harm. As for questions relating to the specific characteristics of art and literature, the creation of the typical, and so on, they must be the subject of free discussion among writers and artists, letting them freely hammer out differences of opinion till they gradually reach agreement.[27]

Much time was also spent on the question of the national heritage:

China has a rich heritage.... There is still [an] attitude of belittling our national heritage.... We suggest that in dealing with our cultural heritage the principle should be: Carefully select, cherish and foster all that is good in it while criticizing its faults and shortcomings in a serious way. At present our work suffers because we do neither well. There is a tendency to reject offhand even what is good in our cultural heritage. At present that is the main trend. ... At the same time, we can also see a tendency not to criticize, or even to gloss over shortcomings in and blots on our cultural heritage. This attitude is neither honest nor sincere, and that we must alter, too.... Take music and painting. Not enough attention has been paid to our national heritage in these two spheres of creative activity. Wherever there are such tendencies they must be corrected.[28]

On the international level, Lu Dingyi explained:

We must have our national pride, but we must not become national nihilists. We oppose that misguided attitude known as "wholesale Westernization." But that does not mean that we can afford to be arrogant and refuse to learn good things from abroad.... Nevertheless, in learning from the Soviet Union we must not mechanically copy everything in the Soviet Union in a doctrinaire way. We must make what we have learned fit our actual conditions.[29]

In September, when the Hundred Flowers policy was accepted at the Eighth National Congress of the Chinese Communist Party, Zhou Yang reinforced the encouragement of the national artistic heritage, including the folk arts, and said that the "tendency to belittle, reject or deal roughly with our national tradition remains the chief error in artistic and literary circles today."[30]

27. Bowie and Fairbank, *Policy Documents*, 157.
28. Ibid., 161.
29. Ibid., 161.
30. Chou Yang, "The Important Role of Art and Literature in the Building of Socialism," CL, 1957, no. 1:184.

In the art world proper, in July, meetings were held in the cities to air opinions about the Hundred Flowers. As was reported in *Meishu*, some artists felt that an atmosphere conducive to contending had to be established, since Chinese painting artists traditionally did little "contending." (Another factor in their reluctance to speak up was undoubtedly the shadow of the recent, rather brutal sessions criticizing Hu Feng.)[31] It was also pointed out that there still were some artists who were unwilling to either bloom or contend. To encourage "blooming," it was argued that artists should be urged to use every form and method to describe life. The need for individual style was emphasized. Zhang Anzhi (b. 1911), a professor in the Department of Painting and Drawing at Beijing Normal University, took the Central Art Academy sculptor Hua Tianyou (b. 1901) as an example. Zhang claimed that before Hua went abroad he had a personal, distinctive style. But now, looking at the relief sculptures prepared for the Monument to the People's Heroes (on which Hua apparently worked, along with others in a collaborative effort), all the relief panels look pretty much the same, and it cannot be distinguished who did what. Other participants felt that art and artists should have greater exposure through more exhibitions and reproductions of works. Liu Haisu (b. 1896), head of the East China Branch of the Central Art Academy in Hangzhou, wanted more exhibitions of antique scrolls and even exhibitions devoted to one master's oeuvre. One sculptor said that aside from economic problems, artists needed studio space. The People's Art Press was criticized for not giving enough attention to Chinese painting; for example, its journal, *Serial Pictorial*, rarely used Chinese paintings on its covers, and there was no representative of Chinese painting on the committee of directors.[32]

The Second National Traditional Chinese Painting Exhibition (including works done since 1949) was held from July 11 to July 23 in Beijing. Reviewing it allowed a number of people to both praise and blame. The traditional-style painter Pan Jiezi (b. 1915) discussed the exhibition at length, concentrating on the variety of subjects and style represented there. The largest number of paintings were landscapes, both scenery and industrial, done in techniques ranging from monochrome to heavily colored. Pan claimed that landscape as a combination of praising nature and praising the relationship of man to nature was historically the basis

31. See Goldman, *Literary Dissent*, 158, 161.
32. "Chang suo yu yan hua 'zhengming,'" *Meishu*, 1956, no. 8:11.

of a realist tradition in Chinese landscape painting. This, of course, can also be applied to industrial landscapes or those depicting construction sites where man seeks to control nature for his own welfare. Next in number were bird-and-flower paintings. Especially lauded were Qi Baishi's ink *Peonies* and a *Magnolia* painting by Yu Feian. Both artists were veteran masters who worked in opposite techniques: Qi's being fluid and free ink, Yu's being careful, meticulous line and color. Pan justifies bird-and-flower paintings on the basis that they can indeed serve the masses because the people appreciate what is beautiful in life and what raises their spirits. Figure paintings, represented by the smallest number of examples in the exhibition, included themes of killing sparrows (part of a campaign to rid China of destructive pests), harvest scenes, and illustrations to Tang dynasty poetry. Pan points out that figure painting is still the weakest genre and should be developed. He notes that the new figure painters lack training in traditional techniques and that a Western flavor pervades their works. He claims, moreover, that a certain hostility between old and younger painters inhibits learning.[33]

It is significant that both Pan's review and one prepared for a Western audience are devoid of any hint of socialist realism. The latter review was as sanguine as Pan's about the successes of the Second Traditional Chinese Painting Exhibition, saying, "The artists are able to give realistic and charming portrayals of the new life and new people of our country; but they also create beautiful landscapes, they paint flowers and animals, they give us visualizations of ancient folktales."[34] Here, as in Pan's review, Qi Baishi's ink *Peonies* (apparently unpublished) and Li Xiongcai's *Flood Control at Wuhan*[35] were considered two of the outstanding works.

Hu Peiheng (1892–1962), an elderly Chinese-style landscapist who was on the screening committee for the exhibition, was less enthusiastic about the caliber of the paintings. He categorized them into four groups. The best were those created by acknowledged masters; they excelled in every respect: content, composition, brushwork, color; Li Xiongcai's *Flood Control at Wuhan* was given as an example. In the second category were those works which used traditional techniques well but were lacking in thought or content. Their themes were antiquated or obsolete: Buddhist figures or other "worthless" subjects. Some paintings in this category relied on ancient masters and, although they displayed technical proficiency, lacked creativity. Some were "from ten or twenty years ago," indicating that no progress had been made. In the third category were paintings utilizing Western techniques. These Hu lambasted. Some were too rigid in adherence to Western styles; others, he claimed, look like things done by foreign artists visiting China, who paint using Chinese paper and brush. The final category included scrolls which simply were naive and amateurish. Hu asserted that the reasons Chinese painting had developed so slowly since Liberation were that so little work had been done on its behalf, that Chinese painting was not given sufficient attention, and that there still existed an attitude of belittling the national legacy.[36] The complaints voiced in the July meetings, by Pan and by Hu, are all rather cautious and mild and certainly well within the parameters implied in the speeches by Zhou Enlai and Lu Dingyi.

Accompanying the greater relaxation of artistic policy came a number of improvements and benefits for the artists. Pan, for instance, mentioned that as a result of the more lenient Hundred Flowers policy, some Chinese painting artists who had quit painting picked up their brushes once again.[37] Zhou Enlai's call for better treatment of intellectuals on a professional basis and the repeated emphasis on fostering traditional arts affected artists in very practical ways. Some hint of the lowly status of the artists and then what was done to mitigate this is given in a notice that authorities in Shanghai and Suzhou were beginning to solve problems of remuneration for Chinese-style painters there (some 300 lived in Shanghai alone). Some of them had organized a mutual-aid team to paint exportable aloeswood folding fans for a living; their average monthly income was 27 yuan. As of August 1956 their remuneration would be increased. Other artists would be assigned to take up teaching or research work in the soon-to-be-established Shanghai Chinese Painting Academy; artists of middling talent were to go to cooperatives producing handicraft arti-

33. Pan Jiezi, "Rang huar kaide gengmei gengsheng," *Meishu*, 1956, no. 8:14–18.
34. "Exhibition of Traditional Painting," CL, 1957, no. 1: 191–192.
35. Reproduced in *Meishu*, 1956, no. 8:16, and 1957, no. 2:33.

36. Hu Peiheng, "Dierjie quanguo guohuazhan pingxuan gongzuozhongde ganxiang," *Meishu*, 1956, no. 7:9–10. The basis of the conflict between Chinese and Western painting and painters during the 1950s deserves further study and elucidation.
37. Pan Jiezi, "Rang huar kaide," 17.

Art during the 1950s

cles.[38] In addition to the Shanghai Chinese Painting Academy, similar professional quarters were planned for Beijing and Jiangsu; the former was formally inaugurated in May 1957 and the latter was in place by 1958.[39] Further, the Central Arts and Crafts Academy in Beijing was opened on November 1, 1956. The tasks of this institution were "to study and develop the splendid heritage bequeathed by our ancestors . . . , to investigate foreign advanced experiences in this field and to create new socialist arts and crafts."[40]

Discussions and critiques of histories of Chinese art and painting, as well as of ancient essays on landscape painting, appeared in issues of *Meishu*. And there was a veritable outburst of shows of art both foreign and domestic, old and new. These exhibitions, of course, served two purposes. First, they provided artists and the general public with opportunities to encounter different types of visual experiences, and second, they provided artists with outlets to display their own artistic accomplishments. Foreign art came from Japan, Vietnam, Greece, and Mexico in shows that "contained something new, something entirely different from anything we had seen before."[41] A show of British graphic art featured Hogarth, Rowlandson, Gillray, Richard Newton, and John Tenniel, as well as modern works by Paul Hogarth and Harry Baine.[42] An exhibit of recent Mexican graphic art was widely appreciated, we are told, and China's print masters Gu Yuan, Li Hua, and Li Qun, among others, studied it avidly.[43] There was also a display of oils, watercolors, and woodcuts by Hong Kong Chinese: still lifes, portraits, landscapes, and seascapes.[44] Most surprising was the exhibition of works by French artists. These were in the form of reproductions of twenty-seven paintings purposely collected for the Chinese by Jean Lurçat after his visit to the People's Republic of China. Jack Chen believed

that this was the first exhibition seen in Beijing of works by Picasso, Matisse, Bonnard, Rouault, Dufy, Marquet, Léger, Utrillo, and Lurçat. The Chinese audience was most attracted by Utrillo's *Moulin de la Galette* and by the "lighthearted" Dufys, but found the sombre Rouault and the "reconstituted reality" of Picasso's still lifes much more difficult to comprehend.[45] The November and December issues of *Meishu* listed exhibitions around the country. In Beijing alone for the month of October there were six art exhibitions: the National Graphics Exhibition; works by overseas Chinese from Indonesia; a one-man show of paintings by the traditional-style master Chen Banding (b. ca. 1875, d. 1970); paintings done by the oil-painter Ai Zhongxin (b. 1915) on his trip to Germany; another show of works by traditional-style artists Guan Shanyue (b. 1912) and Liu Mengtian (b. 1918) on their visit to Poland; and a display of Ming and Qing dynasty portraiture.[46] According to the lists in *Meishu*, there were during the fall of 1956 exhibitions of antique and contemporary Chinese-style paintings in Nanjing, Chengde, Xi'an, Yangzhou, Lüda, Canton, Gansu, and Shanghai. Many of these had titles which indicated that they were the first exhibitions of such materials.[47]

All this lively artistic activity, plus the increased attention given to art and to traditional-style artists, as well as the more open, lenient, and dynamic art policy, created an atmosphere of optimism under which artists flourished, if only briefly. And, of course, the continued stress upon the national heritage produced the impetus for the attractive *Dandelion Girl* woodcut by Wu Fan (plate 5).

Nevertheless, opposition to the ruling on national art persisted, for in October, Qian Junrui (b. 1903), a vice-minister of culture, at a meeting at the Capital Theater in Beijing, questioned the wisdom of replacing the Department of Chinese Painting at the Central Art Academy with a Department of Color and Ink Painting which taught only Western drawing as a basis for Chinese painting. (The lack of traditional training was one of the bones of contention put forth by both Pan Jiezi and Hu Peiheng in the summer of 1956.) Qian scolded the Central Art Academy for its suppression of the national legacy of Chinese

38. "Shanghai Starts to Solve Labor Remuneration Problem of Artists of Chinese Painting," NCNA Shanghai, 23 Aug. 1956, SCMP, no. 1372:17–18.
39. "Peking Studio of Traditional Painting Opens," NCNA Peking, 14 May 1957, SCMP, no. 1533:2; "Studio of Traditional Painting Opened in Peking," CL, 1957, no. 4:179–180.
40. "Academy of Arts and Crafts Inaugurated," NCNA Peking, 1 Nov. 1956, SCMP, no. 1405:12.
41. "Foreign Art Exhibitions in Peking," CL, 1957, no. 1: 195–198.
42. "Exhibition of British Graphic Art," CL, 1956, no. 3: 206–207.
43. "Exhibition of Mexican Graphic Art," CL, 1956, no. 3:209–210.
44. "Chinese Paintings from Hongkong," NCNA Peking, 20 Dec. 1956, SCMP, no. 1439:39.

45. Jack Chen, "Picasso in Peking," PC, 1 Jan. 1957, 41.
46. "Beijing meishu zhanlan jianshu," *Meishu*, 1956, no. 11:12.
47. "Gedi meishu zhanlan xiaoxi," *Meishu*, 1956, no. 11:14; "Gedi meishu zhanlan dongtai," *Meishu*, 1956, no. 12:58.

painting and suggested implementing a double-track system where both Western and traditional drawing techniques would be taught.[48] In December an editorial in *Renmin ribao* reechoed Zhou Yang's words that "the nihilist tendency to belittle the fine and rich cultural legacy of our nation is still most serious and it is the great enemy to the creation of a new socialist and national culture."[49]

The Hundred Flowers Campaign of 1957: Rectification and the Anti-Rightist Campaign

During the first months of 1957 the Hundred Flowers campaign was quiescent. When it was revived in the spring of 1957, it was recast and redirected as a rectification campaign. It now asked non-Party intellectuals to voice their criticisms of Party cadres at the higher levels. The Hundred Flowers campaign was the outcome of many factors. One of these was the growing awareness of a split between the bureaucracy and the masses. Another was recognition of the necessity to regain the support of the heretofore repressed intellectuals whose brains and technological knowledge were now needed to help strengthen China's economy.[50] Many scholars believe that Mao reacted to the intellectual anti-Communist ferment in Hungary during the fall of 1956 by pushing the Hundred Flowers as a means of preventing a similar outbreak in China, as a sort of safety valve. Because of the ensuing crackdown on intellectuals, it has also been proposed that the whole movement was a deliberately set trap for unwary disloyal intellectuals who, through their criticisms of the system, could be identified and eliminated.[51]

The progress of the Hundred Flowers and the subsequent anti-rightist campaign in the art world apparently differed somewhat from the sequence of events in the world of literature. In the latter, after an initial period of blooming through criticism during the spring, with the reversal into the anti-rightist campaign in June, the critics became the criticized, the targets of criticism.[52] This pattern seems only partly true for the art world. Here many who voiced complaints during the spring blooming were indeed declared rightists in the summer. But the major targets in the spectacle were first identified through criticism in the spring, and they continued to be criticized in the summer and later.

The criticism of the spring blooming was to help identify instances of improper work style among higher levels of the system: evidences of bureaucratism, doctrinairism, and sectarianism. According to MacFarquhar, bureaucratism meant "red tape, longwinded reports, never moving from one's office and issuing orders without checking on their feasibility"; doctrinairism or subjectivism included the dogmatic application of Marxism strictly according to the book without regard for the circumstances and empiricism or the ignoring of theory entirely; sectarianism meant discrimination against non-party people.[53]

With these guidelines at hand, artists responded in the symposia from May 18 through June 4 (organized for this purpose) with a steady stream of complaints about bureaucratism in the form of art administrators' insensitivity toward artists and creativity, about the denigration of traditional-style painting and its practitioners, of decisions that revealed dogmatism and evidence of anti-Party ideas and activities on the part of administrators. On June 8, 1957, an all-out attack was launched against those individuals who the criticisms had revealed opposed the Party and its policies. They were termed "rightists," and additional evidence of their erroneous ways was presented in meetings.

Shao Yu (b. 1919), for example, a Party member since 1938 and the editor-in-chief of the People's Art Press, was accused of having a hostile attitude toward artists. It was claimed that to demonstrate his commitment to the Party emphasis on the national legacy, he closed an oil painting studio associated with the Press where painters could study with the Soviet artist K. M. Makesimov. He deprived artists of opportunities to publish their work; those whose works were pub-

48. "Beijing meishujia jihui piping wenhuabu ji meixie lingdao," *Meishu*, 1957, no. 6:8; "Jiang Feng shi meishujiede zonghuo toumu," *Meishu*, 1957, no. 8:11.

49. D. W. Fokkema, *Literary Doctrine in China and Soviet Influence 1956–1960* (London, The Hague, and Paris: Mouton and Co., 1965), 96.

50. Meisner, *Mao's China*, 169–171.

51. Goldman, *Literary Dissent*, 187–188. There was some opposition to the Hundred Flowers campaign. The best study of the Hundred Flowers and the anti-rightist campaigns is Roderick MacFarquhar, *The Origins of the Cultural Revolution*, vol. 1: *Contradictions Among the People, 1956–1957* (New York: Columbia University Press, 1974), which largely supersedes his *The Hundred Flowers Campaign and the Chinese Intellectuals* (New York: Frederick A. Praeger, 1960).

52. Goldman, *Literary Dissent*, 187–205. Another useful book on the subject of the campaigns is Naranarayan Das, *China's Hundred Weeds: A Study of the Anti-Rightist Campaign in China [1957–1958]* (Calcutta: K P Bagchi and Company, 1979).

53. MacFarquhar, *Hundred Flowers*, 35–36.

lished were poorly paid. He was careless and lost manuscripts on the deceased painter Tang Yihe (1905–1944) submitted to the Press by Lu Dingyi and Xu Beihong.[54]

Jiang Feng (1910–1982), a woodcut artist with Yan'an experience and a Party member, now the vice-director of the Central Art Academy in Beijing and a vice-director of the Chinese Artists' Association, bore the brunt of the outrage over the denigration of traditional Chinese painting and its artists. He reputedly refused to support Chinese painting, because it was unscientific, backward, and unable to serve politics.[55] The traditional-style painters in Beijing had a long list of charges. They claimed that the Chinese Artists' Association was administered by people with a strong Western orientation in their art, implying that this was partly the cause of their bias against traditional-style artists; for example, some traditional-style artists took working field trips to famous scenic spots but received no financial assistance from the Association. Further, some traditional-style artists had given up painting, others were jobless, others were compelled to accept trifling employment such as painting bookmarks that sold for nine cents each. The recent (suicide?) deaths of two traditional-style artists, Chen Shaomei (1909–1954) and Wang Qingfang (b. ca. 1900, d. 1956), were attributed to their rough treatment at the Central Art Academy.[56] The latter, it was asserted, although he had done his utmost to politicize his art, had had his paintings torn up in front of his face, and this, it was implied, contributed to his death.[57] Li Kuchan (1898–1983) also suffered from being unable to please those in command with his paintings; ousted from the Academy, his salary reduced to eight yuan a month, he found it necessary to sell his belongings, and nearly became an alcoholic when he was unable to support himself by vending movie tickets.[58] But perhaps the most damaging situation was that which prevailed in the Central Art Academy in regard to the teaching of traditional Chinese painting techniques. Much of this goes back to 1953 when the poet Ai Qing (b. 1910) wrote a critique on Chinese painting and stated

that it was incapable of expressing the new socialist state. Rebuttals of his comments by leading masters in traditional style were suppressed by the editors of the journal and did not appear in print until 1956 (this was construed as another slap at traditional painters). By this time the Department of Chinese Painting at the Central Art Academy had been abolished and replaced by the Department of Color and Ink Painting where, as was mentioned above, the basis of the art was Western drawing, rather than the traditional mode of teaching through copying of old traditional-style masterpieces. Fears were expressed that traditional Chinese painting would languish unless younger artists could be trained in its techniques, but because Chinese painting was not given high priority, it attracted few younger people. It was claimed that there were only sixteen students in the Department of Color and Ink Painting at the Central Art Academy.[59]

On the other hand, support for Jiang Feng appeared when Wu Zuoren and other oil painters pointed out that they too had been denied opportunities to lecture at other art schools, and traditional-style painters had been sent instead. Wu and Xu Beihong's widow, Liao Jingwen, condoned the teaching of Western drawing in a Chinese painting class, especially since Xu, consonant with his European academic training, regarded drawing as the fundamental skill for good art. Wu Zuoren and others even suggested that the conflict between Chinese painting and Western painting was an academic one to be settled by objective discussion.[60]

Throughout the summer of 1957, Jiang Feng, along with the director of the recently established Central Academy of Arts and Crafts, Pang Xunqin (b. 1906), and the head of the also recently founded Beijing Academy of Chinese Painting, Xu Yansun, were linked together as an anti-Party group on the basis of alleged refusals to implement the Party policy of furthering national art, of stirring up conflicts in the art world, and urging others to oppose Party leadership in the administration of art schools.[61] Reports summarizing forums convened to criticize Jiang, Pang, and Xu appeared in the August issue of the art journal *Meishu*. Also in July, Wu Zuoren withdrew his support of Jiang by admitting he had committed

54. "Beijing meishujia," 6, 7. The intricacies of the charges and rebuttals as well as the factions involved in the antirightist campaign deserve a thorough study, as do Jiang Feng's connections with Ding Ling and Ai Qing, which go back to pre-Yan'an days.

55. "Jiang Feng shi meishujiede zonghuo toumu," 11.

56. "Beijing Zhongguohua huajiade yijian," *Meishu*, 1957, no. 6:4–6.

57. MacFarquhar, *Hundred Flowers*, 191.

58. Ibid., 191–192.

59. "Beijing Zhongguohua," 4; Chang Chih-ching, "A Hundred Schools Contend," CR, 1957, no. 1:7; "Forum on Traditional Chinese Painting," PC, 1 Sept. 1956, 38–39.

60. "Beijing meishujia," 6, 8; "Beijing Zhongguohua," 4, 6; "Jiang Feng shi meishujiede zonghuo toumu," 11, 12.

61. "Art Institute Director Denounced," NCNA Peking, 28 July 1957, SCMP, no. 1598:49–51.

mistakes and was guilty of shortcomings in the implementation of the rectification campaign; Wu intended to draw a line between himself and Jiang Feng.[62] Otherwise, a spate of articles written by leading artists appeared in *Meishu* criticizing Jiang and his followers. By August there were more than a hundred meetings of teachers and students of the Central Art Academy and representatives of art circles throughout the country to criticize Jiang Feng. He and the others were now connected with the outstanding rightists of the literary world, Ding Ling (1909–1986) and Ai Qing.[63] Rightist disciples and followers of Jiang Feng were ferreted out in the branch art academies in Hangzhou and Shenyang, as well as in art circles in Chongqing, Xi'an, and elsewhere.[64] Liu Haisu was branded a rightist for complaining that New Year's pictures and serial picture books (or "comics") were being considered as serious art and for his objections to the overemphasis placed on socialist realism.[65] Scores of other artists were swept up in the anti-rightist campaign, and stigmatized as rightists, their careers were ruined. As disciplinary action, Jiang Feng apparently was demoted to being one of a pool of art workers in a large studio or art hall. Estimates of the number of individuals from all areas of intellectual and artistic endeavor who were labeled as rightists range from 300,000 to 400,000.

As the anti-rightist campaign entered its last phase, large numbers of artists from urban centers like Beijing and Shanghai went to the countryside to live, work, and learn from the peasants and workers. This part of their "reeducation" was intended to eliminate any further possible lingering bourgeois or anti-Party ideas. For example, from Beijing, Wu Zuoren, Ye Qianyu (b. 1907), Huang Yongyu (b. 1924), Li Hua, and Hou Yimin (b. 1930), all painters and woodcut artists from the Central Art Academy, went to the countryside. Led by Guo Moruo (1892–1978), they spent two weeks in Jangjiakou (Kalgan) in north China, where, as the report put it, they were "riding out on horseback to look at flowers"; that is, they paid hurried visits and did not have the time to dismount and linger over the flowers. Wu Zuoren, Ye Qianyu, Shao Yu, and others were so impressed with the achievements and enthusiasm of

the peasants that they often stopped to paint murals on the village walls for the peasants, "depicting how the peasants fight and subdue nature."[66] From Shanghai some hundred artists went to the countryside to reform themselves into being "both red and expert" (meaning "both revolutionary and expert"). Of the thirteen people named in one list, three were women, and most of those "sent down" were in their late fifties or early sixties.[67] Some artists, like Cheng Shifa, Jiang Hanting (1903–1963), and the woman Li Qiu (1899–1971), went from Shanghai to Yixing to work in the ceramics factory.[68] In March 1958 Lin Fengmian (b. 1900), Guan Liang (b. 1900), and Shao Keping went to a cooperative in the eastern suburbs of Shanghai to participate in labor there.[69] A mini-movement to foster closer relationships between Chinese painting and the industrial crafts (as well as, of course, to learn from the workers) sent eleven artists from the Shanghai Chinese Painting Academy, including Cheng Shifa, Wang Geyi (b. 1896), Tang Yun (b. 1910), and Li Qiu, to the Shanghai Enamelware Factory,[70] where they worked together with the craftsmen to improve the decorative motifs on utilitarian goods. "Every morning they don overalls and learn to make wash-basins and drinking mugs. In the afternoon they work at the drawing board creating new designs for their decoration, and on some evenings they teach classes in Chinese painting to young workers in the factory."[71] The published reports do not reveal the true severity of the punishments, for it is known that other artists were "sent down" for twenty years.

The Great Leap Forward, March 1958 to December 1959

After the anti-rightist campaign started, Mao launched the Great Leap Forward in production and culture. In the rural areas communes were established, private property was confiscated, and peasants were mobilized. Communes were to sup-

62. Ibid., 51.
63. "Chiang Feng's Anti-Party Group Unmasked," NCNA Peking, 14 Aug. 1957, SCMP, no. 1607:13–15.
64. A steady barrage of notices fingering rightists appeared in *Meishu* issues from September through December of 1957 and on into 1958.
65. "Jiangsusheng wenyijie jiefa pipan youpaifenzi Liu Haisu," *Meishu*, 1957, no. 11:40–41.
66. "Looking at Flowers," PR, 17 June 1958, 5; "Xiaxiang xiaoxi," *Meishu*, 1958, no. 3:35; a photo of Shao Yu, Ye Qianyu, Wu Zuoren, and Jiang Zhaohe painting murals at a village in Hebei was published in CR, 1958, no. 11:16.
67. "Shanghai meishujie xianqi shangshan xiaxiang rechao," *Meishu*, 1957, no. 12:10.
68. "Gedi meishujia xiafang canjia laodong duanlian," *Meishu*, 1958, no. 2:46.
69. "Meishujie dayuejin," *Meishu*, 1958, no. 3:5.
70. *Meishu*, 1958, no. 4:29, 30; "Traditional Painting Is Linked with Industrial Art," CL, 1958, no. 5:140–141.
71. Liu Yi-fang, "Artists Go to the People," CR, 1958, no. 11:17.

ply food, clothing, and nursery and health care so that the commune peasants could be self-sufficient. Peasants were not only to work in the fields but also to provide the labor brigades to work on dams and other gigantic projects and were even to produce steel in backyard furnaces as a sort of cottage industry. The Great Leap also reached into the factories, where production was to meet inflated goals for speed and quantity.

Aside from production goals, other aims of the Great Leap Forward included those of blurring the distinctions between city and country, between manual and mental labor, and moving forward, primarily through Mao's faith in the peasant masses and the communes, along the road toward the new society in which "everyone will be a mental laborer and at the same time a physical laborer; everyone can be a philosopher, scientist, writer and artist."[72]

To implement the Great Leap Forward in culture, in the spring of 1958 literature and art personnel were also supposed to participate in dam construction projects, railroad building, and the like, and especially to provide visual records of the progress. The Ming Tombs Reservoir was the showpiece. Built by 100,000 laborers, it was completed in 160 days *and nights* and became a "symbol of what mass action can do when led by the Communist Party."[73] All leaders, from Mao on down, did a work stint on the Ming Tombs Reservoir. In May 1958 fifty-eight Beijing artists went to the site to take part in the construction.[74] In their off-time they did sketches and preparatory studies for larger works; after they returned to Beijing the next month, they produced 220 works in various media, which "were later exhibited at the reservoir construction site, and gave a big boost to the morale of people working there."[75] Not only was the professional artist expected to produce more art faster, but so was the factory worker amateur painter (who as early as 1950 had organized art training available to him). Now the peasants also joined the ranks of creativity; they were expected to compose songs, plays, poems, paintings, and woodcuts to extol the achievements of the Great Leap.

Early in 1958 it was announced that an exhibition of art work of twelve socialist countries would be held in Moscow in 1958, and so in April 1958 the Ministry of Culture and the Chinese Artists' Association called on artists to go out to villages and factories and construction sites "to get up-to-date material for pictures reflecting the building of New China."[76] The works were to be done along the lines of a new art theory: the combination of "revolutionary realism and revolutionary romanticism." Revolutionary realism apparently meant socialist realism, but as a warning against any slipping toward bourgeois ideas like those espoused by Hu Feng or the rightists, realism was to be revolutionary in import.[77]

The phrase "revolutionary romanticism" requires some explanation. The term was used in 1956 by Zhou Yang, who lamented that whereas realism was accepted, romanticism was refused its due. He said:

> We love all great works of art, whether they are realist or romanticist. Many outstanding realistic works in the past are imbued with a spirit of fervent romanticism, while many outstanding romantic works often contain a rich vein of realism.... In depicting life, our classical artists and writers seldom indulged in photographic, naturalistic representation of reality but devoted themselves to bringing out the essence and the inner spirit of things. Their works are full of bold fantasy and imagination. Socialist art and literature must be rich in ideals and must to a high degree combine truthfulness and revolutionary fervour. Revolutionary romanticism is what we need.[78]

Other definitions of "revolutionary romanticism" say it means "the glorification of 'new things, new men'"[79] or "lies in seeing what is new in life, reflecting it with success, helping it to grow."[80] Although a rather superficial essay by Guo Moruo is usually cited as the primary Chinese source for explaining "revolutionary romanticism,"[81] remarks by A. A. Zhdanov, who

72. Meisner, *Mao's China*, 234. Chapters 12–14 of Meisner's book give a thorough and balanced account of the economic, political, and ideological motivations behind the Great Leap Forward.
73. Yu Feng, "Art of the Socialist Countries," PR, 9 Dec. 1958, 21.
74. "Beijing meishujia huoyue zai shisanling shuiku gongdi," *Meishu*, 1958, no. 6:3–4.
75. Ho Yung, "Art and Artists in 1958," PR, 6 Jan. 1959, 25–26.
76. Yu Feng, "Art of Socialist Countries," 20.
77. Cyril Birch, "The Literature of the Great Leap Forward," in *This Is China*, ed. Francis Harper (Hong Kong: Dragonfly Book, 1965), 36.
78. Chou Yang, "The Important Role of Art and Literature," 183.
79. Birch, "Literature of the Great Leap Forward," 35.
80. Lin Mo-han in 1961, "Raise Higher the Banner of Mao Tse-tung's Thought on Art and Literature," quoted in Robert Jay Lifton, *Revolutionary Immortality: Mao Tse-tung and the Chinese Cultural Revolution* (New York: Vintage Books, 1968), 81.
81. Kuo Mo-jo, "Romanticism and Realism," PR, 15 July 1958, 7–11. (First published in *Hongqi* [*Red Flag*], 1 July 1958.)

directed Soviet cultural policy for many years, are much more cogent. In 1934 Zhdanov said: "The whole life of the working class and its struggle consist of combining the most severe and sober practical work with grand heroics and great prospects...[and hence] Romanticism, a new type of Romanticism, a revolutionary Romanticism, cannot be alien to Soviet literature."[82] Apparently then, "revolutionary romanticism" included ideas of supreme courage in the face of overwhelming odds and of achieving the impossible. As such, there was little or no provision for scenic landscapes or bird-and-flower genres, and the liberal basis for art of the Hundred Flowers of 1956 evaporated.

Again, as in the case of socialist realism discussed earlier, the question arises of how the theory of "revolutionary realism and revolutionary romanticism" is to be translated into painting. This was not so much of a problem for oil painters, who had long worked in the realist style, but for traditional-style painters it meant a severe realignment.

In 1958 Song Wenzhi (b. 1918) and Jin Zhiyuan (b. 1930) showed, in *Digging a Canal through the Mountains* (fig. 31), the superimposition of socialist realist elements of serpentine lines of workers moving back into depth on an otherwise traditional Chinese landscape painting including the tipped up background and view looking down from a height. Li Shiqing's (b. 1908) *Moving Mountains to Fill Valleys* (fig. 32) also presents a traditional Chinese landscape scene with masses of workers "slicing and laying a way for the lines [of the Yingtan-Amoy Railway] on cliff-like slopes of mountains and across deep gorges."[83] Stylistically this painting has less to do with socialist realism in terms of composition, but everything to do with revolutionary romanticism as the thousands of workers flow over the rocks like foliage conquering nature. Perhaps the most successful of the "revolutionary realism and revolutionary romanticism" paintings was Wei Zixi's (b. 1915) *Undaunted by Wind or Snow*, also done in 1958 (fig. 33). "Revolutionary realism" is present in the magnified line of figures swinging back into the distance. For "revolutionary romanticism" these people urgently continue working during a blizzard, even though inadequately dressed for such weather and such work. Other paintings depict "battles" for steel or for the completion of a construction project by working at night, so that

overall there is an underlying current of frenzied (perhaps verging on the frantic) work and energy.

When the 280 oil paintings, sculptures, graphics, and traditional-style paintings destined for the Moscow exhibition had a preview showing in Beijing, the traditional Chinese paintings received glowing attention because they demonstrated that the traditional-style painters were at last coming to grips with the realities of the new society; they were going to the people for their subjects and were inspired by the progress made since Liberation.[84]

In a general review of art and artists for 1958, the author claimed that the professional artists, on the basis of their debates on art during the anti-rightist campaign, their stints in the countryside, and participation in Great Leap projects, now understood that "politics must be in command."[85] The pictures made during this era clearly reflect that politics dictated both the subjects and their mode of presentation.

Peasant Painting in 1958

While professional artists were creating "revolutionary realism and revolutionary romanticism" paintings, they were temporarily eclipsed by workers' art and especially by that of artistically untutored peasants. A directive from the Ministry of Culture in January 1958 urged that culture be brought to the countryside and that "cultural and recreational activities should be launched relating to the construction and maintenance of water conservancy projects, the accumulation of manure, the struggles against the four evils (rats, sparrows, mosquitoes, flies) and similar tasks."[86]

Although peasants throughout China were mobilized to paint, those from the county of Pixian in Jiangsu province and those from Zhejiang province (both in south China) received the most attention. Drawings, paintings, and photographs of peasant wall paintings were exhibited in Beijing in September 1958.[87] Artistically, the peasants did exactly what might be expected: they largely continued those traits found in the art with which they were most familiar. *Big Fish* by Cai Jinbo (fig. 34) utilizes an age-old motif of fish symbolizing "plenty," now so gigantic that it fills an entire boat, which is poled by a woman using a huge wheat stalk. Such exaggerations are meant to

82. John E. Bowlt, "The Virtues of Soviet Realism," *Art in America* 60 (Nov.–Dec. 1972): 104.
83. Yu Feng, "Art of the Socialist Countries," 21.
84. Ibid., 20.
85. Ho Yung, "Art and Artists in 1958," 25.
86. Fokkema, *Literary Doctrine*, 150.
87. Ko Lu, "New Peasant Paintings," PR, 23 Sept. 1958, 18.

indicate the vast bounty of the new society. The anonymous *More Gears to the Wheels, More Water to the Fields* (fig. 35) stresses a technological advance which promises a greater harvest. In this cartoon-like picture, a girl reads as she pedals the irrigation mechanism, a peasant runs toward her shouting "Hey, stop the water, the field is full already!" and a bit of doggerel inscribed down one side of the scene carries through the theme: "More gears to the wheels/more water to the fields/more rest, greater yields." In Hu Guilian's *Catching Moths* (fig. 36) and Jiang Yonggen's *Killing Sparrows* (fig. 37) (on the anti-four-evils campaign to exterminate destructive insects and creatures), there is no horizon line, no focus, and every space is filled. In *Killing Sparrows* the figures are all the same size. In these respects the peasant artists have simply transferred the folk artistic preference for overall, decorative patterns (as seen in traditional New Year's prints, in papercuts, in textile designs) to their pictures. In addition, all peasant paintings in 1958 were done with many and bright colors, unmodulated in tone, a feature also typical of the folk arts.

The works included in the exhibition in Beijing were praised by the editor of *Meishu*, Ge Lu (b. 1926), for their fresh subjects, their exuberance, their "remarkable originality and boldness in challenging old artistic conventions and inventiveness in devising forms they think best suited for their themes." Ge Lu continues, "These pictures reflect the fact that what was believed to be impossible yesterday is happening today.... This is an unselfconscious integration of revolutionary realism and revolutionary romanticism—the essential ingredients of socialist realism."[88] Elsewhere he avers that professional artists could learn much from these peasant endeavors.[89] And Wang Zhaowen (b. 1909), a leading aesthetician, closed his review of the Pixian peasant-painting exhibition with the assertion that "the artistic creation of the masses, as represented by the Pi-hsien wall paintings, has an unlimited future. It will certainly occupy an important place in modern Chinese art."[90]

Wang's optimistic prediction was premature, however, for, ironically, this major excursion into the popularization of art and the propelling of the peasant into the vanguard of creativity was brief. As was mentioned above, China's entries for the art exhibition of twelve socialist countries which opened in Moscow on December 26, 1958, were the efforts of professional artists. After January 1959 peasant paintings rarely appear in the art journal *Meishu*, and by the autumn of 1959 pictures of subjects associated with the Great Leap are no longer found in that art magazine.

88. Ibid., 18.
89. Ge Lu, "Pixian bihua xinshang duanpian," *Meishu*, 1958, no. 9:22.
90. Wang Chao-wen, "Wall Paintings by Peasant Artists," CL, 1959, no. 1:198.

Art during the 1950s

Art between 1960 and 1965

Part One: Between 1960 and 1962

In December 1958 Mao Zedong resigned as chairman of the People's Republic of China, although he retained his position as chairman of the Party. Liu Shaoqi (1898–1969) replaced Mao as chairman of the People's Republic.

By this time it was evident that the policies of the Great Leap Forward and its mobilization of manpower to achieve economic goals had largely failed. The large-scale transfer of peasants from fields to construction projects led to a shortage of labor to harvest the crops. In some areas improper planting procedures resulted in crop failures and food shortages. The pressures for laborers and field hands to work as rapidly as possible overtaxed their physical capacities, leaving them exhausted. On the industrial side, the cottage-produced steel was so low in quality that it could not be used in machine plants, and there was a dearth of raw materials. The Great Leap Forward was followed by a period of privation and demoralization for the Chinese peasant and worker alike. To this, in 1960, nature added a series of typhoons, floods, and droughts throughout the country.

Further, the Great Leap, by angering the Soviets because the Chinese abandoned the Russian model, contributed to a festering deterioration of Sino-Soviet relations. The situation came to a head when in April 1960 the Chinese broke with the Soviet Union and in August 1960 Khrushchev recalled Soviet scientists and specialists working in China.[1] This recall left China severely crippled, but the Sino-Soviet split undoubtedly fostered a surge of nationalism in China expressed in art with an emphasis upon "national" style.

As chairman of the People's Republic of China, Liu Shaoqi took a practical approach to the economic situation. Under his guidance, many liberal policies in agriculture and industry were implemented in an endeavor to cure China's economic ills. In addition, technological expertise, specialized skills, and professional knowledge were again acknowledged as a means of building the country into a modern socialist state in industry, agriculture, science, and culture.

By 1962 Mao was disgruntled over the way things were going. He saw the lowering of political ideals as undermining the achievements of the CCP under his leadership and thereby endangering the future. He called for the Socialist Education Campaign to help reverse these tendencies. Mao also intensified the cultural activities of the People's Liberation Army (PLA), apparently with the assistance of his wife, Jiang Qing (b. 1913), and certainly with the backing of Marshal Lin

1. Maurice Meisner, *Mao's China: A History of the People's Republic* (New York: Free Press, 1977), 248–249; Stanley Karnow, *Mao and China: From Revolution to Revolution* (New York: Viking Press, 1972, Viking Compass paperback), ch. 5. Additional political and historical background is in Meisner, *Mao's China*, chs. 15, 16.

Biao (1907–1971). Ultimately, the PLA gained domination of the art world in 1965 in what can now be recognized as a prelude to the Cultural Revolution.

A New Art Policy

By the time the Great Leap Forward was halted, a good deal of damage had been done to the morale and prestige of the professional artists. Only a year earlier they had been required to force their art into a narrow, highly political framework along the lines of revolutionary realism and revolutionary romanticism, only to suffer a few months later from the indignity of being relegated, for a time at least, to a position below that of rustic amateurs.

Efforts to reverse the demoralizing effects of the anti-rightist campaign and the Great Leap Forward by establishing a more benign intellectual and cultural climate were afoot in 1959. As was noted at the conclusion of the preceding chapter, after January 1959 peasant paintings rarely appear in *Meishu*, and by the autumn of 1959 pictures of Great Leap subjects had disappeared. As additional indicators of the changing artistic milieu, two art exhibitions stand out from a host of routine shows. First, the annual exhibition sponsored by the Beijing Research Society of Chinese Painting in June 1959 "was even more varied in subject matter than the 1958 exhibition which showed that traditional Chinese painting was becoming more diverse in content and closer to contemporary life."[2] Included were monochrome and colored landscapes, mythological subjects and still life themes, birds and animals, some done with the free, sweeping brushwork associated with Qi Baishi, the first chairman of the society when it was established in 1949.[3] In other words, on display were many paintings with low political content. This exhibition was quickly followed by one of works in various media presenting a similar breadth of subjects: landscape and still life, along with genre scenes of industrial and commune activity.[4]

These indications of change culminated in the Third National Congress of Literary and Art Workers held in Beijing from July 22 to August 13, 1960, and the 1960 National Art Exhibition presented in conjunction with this meeting.

This Congress, attended by more than 2,300 cultural representatives, evaluated the artistic achievements of the past eleven years and outlined the goals for the future. Important policy-setting addresses were given by members of the cultural and propaganda bureaucracy: Guo Moruo, chairman of the China Federation of Literature and Art Circles; Lu Dingyi, in his capacity as alternate member of the Political Bureau of the Central Committee of the CCP and vice-president of the State Council; and Zhou Yang, vice-president of the China Federation of Literature and Art Circles. In his opening-session speech, Guo Moruo made it clear that one positive result of the anti-rightist campaign was to establish without a doubt the absolute authority of the Party over art.[5] In this speech, and in his closing speech, Guo, echoed by Lu in his speech on opening day, did not ignore the requirements set forth by Mao in his Yan'an *Talks*: that artists must absorb the best of foreign art and of old Chinese art, and should let new things emerge from the old, that artists must go into the midst of workers, peasants, and soldiers to create art for the masses, and the like. In the messages by Guo and Lu, however, there is considerable stress upon more recent art guidelines: revolutionary realism and revolutionary romanticism, and especially the plurality seen as the heart of the Hundred Flowers Bloom, Hundred Schools of Thought Contend policy of 1956. To them, the Hundred Flowers in both its phases had proved to be the correct road to follow; it guaranteed a unified political stance and ensured that "writers and artists will be able to develop their individual creative spirit…in many styles, modes and forms."[6]

Zhou Yang echoed the basic ideas found in these speeches in his own, titled "The Path of Socialist Literature and Art in China." In this lengthy presentation, he elaborated on these ideas. Under the banner "Let A Hundred Flowers Blossom, Let A Hundred Schools of Thought Contend," Zhou's rhetoric is strikingly different from that of the 1950s. He said, for example:

Monotonous life and monotonous art alike are frowned upon by people. Since the people's life is rich and varied, the literature and art reflecting their

2. "Biggest Peking Traditional Chinese Paintings Exhibition Opens," NCNA Peking, 22 June 1959, SCMP, no. 2044:3.
3. Ibid., 4; Wu Pin, "Traditional Chinese Paintings," PR, 28 July 1959, 19 21.
4. Wang Leh, "Peking's Art," PR, 3 Nov. 1959, 20–21.

5. "Full Text of Speech by Kuo Mo-jo, Chairman of the China Federation of Literary and Art Circles, at the 3rd National Congress of Writers and Artists," NCNA Peking, 22 July 1960, SCMP, no. 2311:3.
6. Ibid., 5.

life should be rich and varied too. In our society, as the material life of the labouring people is getting daily better and their spiritual life is getting richer every day, naturally their demand for material and intellectual products will also increase daily. They ask not only for greater amounts of these products but for a greater variety and better quality. Since people's needs, interest and tastes are different, the greater variety the better. Only art rich in variety can satisfy the masses' continuously increasing and varied intellectual needs, and can enable writers and artists with different individuality and talent to attain full development.... Each writer and artist can, according to his sense of political responsibility, his personal experience of life, his interest and special talent decide what theme to choose and what forms of expression to adopt.... The new age requires more and better paintings of revolutionary history, revolutionary genre paintings and figure paintings, but shouldn't the new-style landscape paintings and flower-and-bird paintings also have a place in our galleries? The people need inspiration and encouragement in their spiritual life, but they also need things that give pleasure and delight. Provided these do not run counter to...the socialist path and the leadership of the Communist Party, works of art of all forms, themes and styles can be allowed to develop.[7]

Later in his speech, after insisting upon the need for study of Marxism-Leninism and the work of Mao Zedong, of "going deep among the masses of workers and peasants," of doing physical labor, all in order to improve ideologically, Zhou Yang states:

We should...improve our art by increased practice, raising our artistic skill unceasingly.... Artistic technique is a product of highly skilled and meticulous labour, a means with which the writer or the artist, based on his world outlook, his general culture and profound observation of life, gives artistic representation of reality. Contempt for technique means contempt for human labour and wisdom, and is utterly wrong. Only by means of a highly developed technique can correct political ideas be integrated with beautiful artistic forms to the greatest perfection, can the moving power of art be produced.[8]

And:

Our literature and art should, on the one hand, cultivate communist moral qualities among the people

and on the other, enrich their spiritual life, to increase their wisdom and their appreciation of beauty. Our literature and art should make people become nobler, wiser and finer.[9]

These policies, enunciated in 1960 by cultural spokesmen at the highest level, are extremely lenient in tone and intent. Inviting individual creativity and the catering to individual tastes, they simultaneously promoted professionalism and aesthetics rather than political fervor as the key standards in art.

In addition to Zhou Yang, artists and others came to the defense of landscape and bird-and-flower pictures. Both subjects, but especially the latter, are difficult to imbue with socialist content. They were approved now because they rested upon a deep appreciation of nature (perhaps now escapist in view of the economic situation, and because they could rouse nationalistic sentiments in the face of the Sino-Soviet split). Traditional-style landscapes and bird-and-flower paintings are uniquely Chinese in their forms, styles, and symbolic content. Thus Pan Jiezi, the traditional-style painter, continued to champion these genres and said that "warm appreciation is also shown for traditional landscape and 'flower-and-bird' paintings. Our artists continue to study nature and expound its beauty with a new viewpoint—to stir in people a deep love of life and their motherland."[10] Cai Ruohong (b. 1910), head of the Chinese Artists' Association, in 1962 stated: "Our paintings of flowers and birds are no longer pretty toys for the leisured class, but express our people's love of life and their artistic sense."[11] And Cui Zifan (b. 1915), himself a noted flower painter and vice-president of the Beijing Academy of Traditional Chinese Painting, justified bird-and-flower painting as being "a unique genre in the oriental school of painting," as being "rich in national color and decorative effect," as having popular appeal, as being the result of "love of nature closely observed." He admitted that the bird-and-flower subjects did not depict the "struggles of real life, but nevertheless, like all works of art, they do participate in and reflect those struggles. One of their roles is that through them the artist arouses in his audience a love of beauty, of life and of the land of their birth."[12]

7. Chou Yang, "The Path of Socialist Literature and Art in Our Country: Report Delivered to the Third Congress of Chinese Literary and Art Workers on July 22, 1960," CL, 1960, no. 10:34–35.
8. Ibid., 61.
9. Ibid., 62.
10. Pan Chieh-tzu, "Traditional Painting Reflects Today's Life," CR, 1960, no. 9:24.
11. "New Vitality in Traditional Chinese Paintings," NCNA Peking, 24 May 1962, SCMP, no. 2750:22.
12. Tsui Tzu-fan, "Two Flower-and-Bird Painting Exhibitions," PR, 11 Aug. 1961, 20.

Between 1960 and 1962

Deng Wen (b. 1932) wrote at length about landscape painting:

Because it depicts mountains and rivers, some people think that such painting is a form of escape from the struggles of real life, but such a view is undoubtedly one-sided and therefore erroneous. All who have made any study of the history of Chinese art know that landscape painting has always held an important position in it. When men enjoy and extol natural beauty, they usually link it with their imagination and associations in life, considering certain features of natural scenery as the personification of the human spirit. Thus when people admire the sublimity of mountains, the breadth of the ocean, the enduring quality of the pine, the loftiness of the stork, they are admiring the spiritual qualities of man which coincide with these characteristics of nature. This is even more strongly apparent in our new landscapes, many of which embody the ideas and feelings of the laboring people.[13]

As an example of new landscape, Deng cites the huge panorama in the Great Hall of the People by Fu Baoshi (1904–1965) and Guan Shanyue, *This Land with So Much Beauty Aglow* (fig. 38), an illustration to Mao Zedong's poem *Snow*. Deng hails it as representing the grandeur of China's land, but also as expressing the people's spirit and confidence.[14] Guan Shanyue himself and others provide additional explanations. It has political content although it depicts neither people nor construction (two elements insisted upon in landscapes done during the Great Leap and to satisfy the requirements of revolutionary realism and revolutionary romanticism). The undulating mountain ranges are those of north China; there are the spring colors of the south; there is the Yellow River; and beyond the boundless plains is The Great Wall. To the west, are the snow-covered mountains of the western border; on the east, the rising sun. As in the song "The East Is Red, the Sun Is Risen," *This Land with So Much Beauty Aglow* symbolizes the victory of communism under the leadership of the CCP and Mao.[15] According to one commentator, "It invokes in the viewer a feeling of love for and pride in the motherland."[16]

Zhou Yang's emphasis upon professional training was repeatedly noted in several general essays on art written during this period and was the primary subject of an article by the Beijing landscape painter Li Keran. Li's essay was formulated on the basis of his own experience and on that of other painters and artistic friends, such as the Beijing opera star Gai Jiaotian (1888–1971). Li insisted that constant practice and training are requisite for art. He claimed that art is a "specialized field with its own comprehensive body of theory and knowledge." He admitted that "ideological steeling and the search for theoretical knowledge" are necessary; "however, these alone cannot make an artist." Later in the essay he said, "To imagine that an artist who has ideas, experience of life and some technical skill can paint anything as easily as taking something out of his pocket is an over-simplified view of artistic creation." This essay is, at one and the same time, a disapproval of the Great Leap policy when thousands of peasants and workers were suddenly and briefly artists, poets, and writers because it was believed they alone had the proper "red" molding, and an endorsement of Liu Shaoqi's call for the utilization of professional expertise in all areas, cultural as well as economic and industrial. Li states his case for the trained artist, who, completely devoted to his craft, daily practices his skill and hones his expertise in a task that demands both mental and physical labor. Li's essay is a statement supporting "expert" over "red."[17]

In 1961 Premier Zhou Enlai endorsed the more liberal side of the prevailing attitudes, also calling for variety of subject matter, saying that art is a means of enriching life, that "we need things that are lyrical and entertaining." He opposed heavy-handed intervention of politics and crude or ill-advised judgment of art by those unqualified to make such judgments.[18]

But all of these pronouncements made during 1960 and 1961 were mild compared with the astoundingly liberal proposals embodied in a statement drafted and reworked during 1961 and 1962 by Zhou Yang, Lin Mohan, Cai Ruohong, and others in the Propaganda Department of the Central Committee. This policy statement presumably was to replace Mao's Yan'an *Talks*, for not

13. Teng Wen, "The Chinese Style in Art—A Review of the National Exhibition of Art," CL, 1960, no. 10:181.

14. Ibid., 181.

15. Guan Shanyue, "Dui Zhongguohua chuangzuo guanche baihua qifang, tuichen chuxinde fangzhende tihui," *Meishu*, 1960, no. 8/9:37–39; Zhang Wenjun, "'Jiangshan ruci duojiao,'" *Meishu*, 1960, no. 8/9:51.

16. Chang Wen-tsun, "Fu Pao-shih's Paintings," CL, 1962, no. 7:99.

17. Li Ko-jan, "Art Is Achieved by Hard Work," CL, 1961, no. 7:120–125. (First published as Li Keran, "Tan yishu shijianzhongde kugong," RMRB, 26 April 1961. Reprinted in *Renmin ribao wenyi pinglun xuanji*, vol. 1. Beijing: Renmin ribao, 1962:14–15.)

18. "Zhou Enlai on Literature and Art," BR, 30 March 1979, 9–16, citation to 14. For a full translation of the text, see "Zhou Enlai's 1961 Speech on Literary-Art Work," Peking NCNA, in *Daily Report*, 8 Feb. 1979, E2–E20.

Art between 1960 and 1965

only does the content differ substantially from the *Talks* in fundamental and cogent ways, but the *Talks* themselves are never even mentioned. Known as "Opinions on Current Literary and Art Works" (sometimes also given the name "Ten Points on Literature and Art," later reduced to eight points), this policy was formally adopted and transmitted to the whole nation in April 1962.[19]

The "Ten Points," for instance, advocated a much lighter political hand in art and encouraged individuality and variety of subject matter, themes, and style. It also proposed that artists should keep in contact with the working masses, but it clearly sets the artist apart, indicating that participation by artists in manual labor be in accordance with specific conditions and requirements of the individual artist, taking into consideration his artistic endeavor as well as his age and health. The "Ten Points" would guarantee that artists had enough time to be creative and called for moral incentives for art creations, along with material ones to be paid in the form of honoraria and better living conditions. In the "Ten Points" the broad principles of the guidelines for art enunciated in the Yan'an *Talks* were accepted, but clearly the more rigid strictures were dropped, along with most of the political rhetoric (for instance, nothing was said about art as a weapon in the class struggle or about the masses being the sole source of art).[20] The fact that Mao's Yan'an *Talks* were not quoted or named indicates that these twenty-year-old guidelines were considered invalid or at least inappropriate in the new socialist context of the early 1960s.

Even essays commemorating the twentieth anniversary of the Yan'an *Talks*, published in 1962, speak of the Yan'an *Talks* in the past tense, suggesting that it is a historical document containing formulae useful for solving problems pertinent only to the circumstances of that place and time. The essays then follow a pattern of reviewing artistic achievements during the past twenty years and move on to discuss ramifications of the more recent policies of revolutionary realism and revolutionary romanticism, but especially of the Hundred Flowers formulations, along with their offshoots, such as individuality, variety, and professional expertise.[21]

19. "Before and After the Publication of 'Ten Points on Literature and Art,'" *Issues and Studies* 9, no. 1 (Oct. 1972): 71.
20. "'Ten Points on Literature and Art,'" *Issues and Studies* 8, no. 10 (July 1972):98–104; no. 11 (Aug. 1972): 73–83.
21. For example: Ho Chi-fang, "Guide for China's Revolutionary Literature and Art," CR, 1962, no. 5:2–5; "Serve the Broadest Masses of the People," *Jen-min jih-pao* editorial," 23 May 1962, *Current Background* no. 685:1–6.

The new, more liberal policies in art directly affected the lives and activities of the professional artists. For them, in many respects, the period from 1960 until about mid-1964 was a golden era. Many of their activities, exceptional during the 1950s, were now commonplace. Artists traveled extensively both inside and outside China; their works were shown in numerous group or even in one-man exhibitions and reached a yet wider audience through reproduction in art journals and in quality monographs. As they had during the 1950s, they wrote about aesthetics and about each other's art, they attended and contributed to symposia in conjunction with exhibitions or workshop debates on artistic questions, and they participated in the making of works of art for special occasions or purposes.

The changes in the directions set for art were not superficial or cosmetic. They extended into the education system, where students were to receive training to make them technically proficient as well as politically aware. By this time most of the best artists were assigned to official art academies, many of which were also teaching institutions. In Beijing, at the Central Art Academy (established in 1950), one of the biggest art schools in the country, courses were given in portraiture, landscape, and bird-and-flower painting in traditional Chinese painting style. Students majored in one of these genre but also acquired a working knowledge of the other two subjects. Oil painting, graphic art, and sculpture were also taught here. In addition, there were programs in the allied arts of music and drama, and a department of history and aesthetics of both Chinese and foreign art. Members of the staff included Wu Zuoren (also serving as director), who studied oil painting with Xu Beihong, but also does traditional Chinese painting; Gu Yuan, the noted woodcut artist; and Ye Qianyu, a traditional-style painter.[22] The Zhejiang Academy of Fine Arts, located on West Lake in Hangzhou, was the successor to an art school founded in 1928. In 1962 the Zhejiang Academy offered a five-year course of study, including instruction in traditional Chinese painting, oils, graphics, sculpture, and handicrafts. A four-year middle school attached to the academy provided fine-art training preparatory to the academy. Pan Tianshou (1897–1971), one of China's most gifted bird-and-flower painters and presi-

22. "China Training Young People in Fine Arts," NCNA Peking, 26 Sept. 1961, SCMP, no. 2590:16.

dent of the institution, also taught in the traditional painting department, where portraiture and landscape were also part of the curriculum.[23] Staff and students of both institutions were expected to spend from one to three months a year in the field on painting trips to rural or minority areas, to factories, or to scenic spots famous for their artistic associations, gathering materials and making sketches for future art works. Students at the Central Art Academy were also to join workers and peasants in their labors for about a month each year. One of the youngest of the academies was the Jiangsu Academy of Traditional Chinese Painting, which was organized in 1957 but not officially inaugurated until 1960. At its head was the famous landscape painter Fu Baoshi. The members of the Academy were expected to engage in theoretical art studies and the actual creative work of painting and to encourage new talent in the field of traditional Chinese painting. According to one report, they had "more than a score of advanced students, all of whom have had previous training in art or were previously connected with art work." In addition, the members of the Academy helped amateur artists among peasants and workers through lectures, classes, art exhibitions and discussions, and consultations.[24]

The artists' tours were arranged through the Chinese Artists' Association and were usually financed by the Association and its branches in the locations visited by the artists, or by local art institutions. Sometimes upon their return home the artist-tourists shared their experiences in discussion format.[25] But equally important, the artistic works produced as a result of the experiences gained on these excursions were made available to the public through the exhibition format. Apparently one of the most impressive of these was the exhibition of works done by members of the Jiangsu Chinese Painting Academy during an extended tour of the country. This trip often took the artists to places where they had never been before. Artists welcomed and greatly appreciated the journeys, for such travels expanded their acquaintance with China's peoples and scenery. Yu Feng (b. 1916), for example, explains that she knew only of the south where she was born and that

> whenever my thoughts turned to the beauty of our land, ... I visualized ... my home province—white-

washed houses under roofs of black tile against a background of green mountains and clear waters.... As to our northwest, I didn't know it.... [After a trip there] that experience opened for me a new world of landscape beauty.[26]

Another result of these tours was a documentary color film, *Landscape Painting*, made in 1962. It showed the artists sketching at scenic spots and transforming these preliminary studies into finished paintings in the studio. The film opened with a shot of the veteran painter Pan Tianshou at his desk and then introduced works by several major artists in the traditional Chinese painting mode: Fu Baoshi, Guan Shanyue, Li Keran, and others.[27]

The debates during 1961 focused on questions such as whether bird-and-flower paintings have class relevance, the relevance of the "meticulous" *gongbi* style and the "spirit of the times," the truthful portrayal of historical events, and the choice of artistic forms open to painters. The debates on the question of beauty as reported in one journal indicate a prevailing atmosphere of mutual respect for alternative views, but with no consensus forthcoming.[28]

Providing art works for the Chinese Revolutionary History Museum was a major project, which came to completion in 1961. Sculptures and paintings of appropriate subjects are used to enhance the exhibitions of memorabilia, artifacts, and documents relating to the history of communism in China. Among the nine art works known to have been selected, five had Chairman Mao as the main subject, another depicted the July 1850 uprising at Jintian at the beginning of the Taiping Rebellion, another the Huai-Hai battle in late 1948 and early 1949 in which Communist troops under the command of Chen Yi (1901–1972) crushed the Nationalist armies; a sculpture dealt with land reform; and one oil painting depicted Liu Shaoqi with the workers in the Anyuan mines. The last seems to have been singled out for special attention, since in the issue of *Meishu* that reproduced these works and some essays about them, two articles are specifically on the painting of Liu Shaoqi at Anyuan. In one report, Hou Yimin, the man who made the painting, described some of the problems encountered in history painting: such as, if one attempts to be historically accurate in portraying a living person as he looked several decades ago, few viewers of the painting

23. "Graduates from Academy of Fine Arts in East China," NCNA Hangchow, 26 Aug. 1962, SCMP, no. 2811 : 10.
24. "Kiangsu Academy of Traditional Chinese Painting," PR, 17 March 1961, 18–19.
25. Cheng Ming, "Art Tours," PR, 15 Dec. 1961, 28.

26. Ibid., 28.
27. "'Landscape Painting,'" PR, 13 July 1962, 18.
28. "On the Question of Beauty," CL, 1961, no. 8 : 112–120.

would be able to identify him; or the problem of how to depict the ideologically correct relationship between the leader and the masses. A preliminary version of the painting had Liu in profile at one side of the painting, leading a file of workers to a negotiation meeting to resolve the miners' strikes in 1922. In the second version of his *Liu Shaoqi and the Anyuan Miners* (fig. 39), the artist gave greater visual prominence to Liu by now placing him as seen from the front, in the center of the painting, and surrounding him on three sides with youthful miners as they make their way to the negotiations.[29] As we shall see, this painting was, during the Cultural Revolution, once again a center of attention.

In 1963 the People's Art Publishing House and the Chinese Artists' Association proudly announced the printing of eight albums of reproductions of paintings by one artist each, with a brief biographical note and a preface "by a well-known critic or the artist's intimate friend." The selection included artists young and old working in various media.[30] Even more indicative of the extremely lenient policies was the publication of an album of paintings by Wu Zuoren, including some of his early nudes.[31] Aside from these volumes, a large-scale program carried out by the art publishers brought the talents of major artists to wider public notice during this period.

29. Hou Yimin, "'Liu Shaoqi tongzhi he Anyuan kuang-gong' de gousi," *Meishu*, 1961, no. 4:21.

30. "Albums of Contemporary Artists," PR, 11 Oct. 1963, 22–23.
31. "An Album of Wu Tso-jen's Paintings," CL, 1963, no. 2:121.

Art between 1960 and 1965

Part Two: Art and the Appreciation

of Beauty, 1960–1965

4 The works of art which can be associated with the liberal trend from 1960 to about 1964 all attest to the wide latitude accorded the artist. Examples in all media and a wide range of style were selected for exhibitions and were illustrated on the pages of the leading art journal, *Meishu*, as well as in the popular magazines for Western consumption: *Chinese Literature, China Reconstructs, China Pictorial*. The breadth of subjects depicted was enormous: birds-and-flowers, fruiting branches, chickens, rural scenes of grain or fruit harvest, feeding hogs, construction and industrial sites, dams, bridges, factories, cityscapes, scenes of foreign countries, minority peoples, Chinese historical and revolutionary sites—almost every conceivable subject except violence and conflict in the new society, social criticism, and nude figures.

The reviews of exhibitions and other writings illuminate additional attitudes toward art at this time. Most reviews are balanced mixes of descriptions of the subjects depicted, explanations of socialist messages, and comments on style, all couched in reasonable and rational language. Sometimes the reviewer gives only short descriptions of paintings and then discusses style and technique exclusively. No reviewer addresses the socialist content to the exclusion of style and technique.

The new art policies enunciated in the summer of 1960 obviously were circulated earlier, for the paintings, woodcuts, and sculptures included in the National Exhibition of Art held in Beijing on the eve of the Third National Congress and later shown in Shanghai were visual demonstrations of these new guidelines.

A comprehensive review of this exhibition written by the traditional-style artist Deng Wen highlighted artistic achievements made along the lines of previous requirements, as well as those which embodied the new qualities now expected to enliven the art. Among the former was the idea of developing new techniques, often achieved through an outright borrowing from another medium. Deng uses as an example Xia Zhu's oil *Making Fans*, depicting two girls quietly making leaf fans, surrounded by banana-plant leaves and completed fans.[1] According to Deng, the artist adopted the effective use of blank background from traditional-style figure painting to emphasize the subject. Otherwise, Deng's comments are strikingly different from those of the late 1950s, which insisted on the presentation of feverish activity, mandatory for any painting to be approved. Deng makes it clear that two new aesthetic qualities are now in demand. The first is the "decorative," said to derive from traditional art (meaning folk art). It is evident from a number of examples discussed by Deng that what is meant by "decorative" is not just a mechanical repetition of a single design motif but something with subtle variants in the pattern. The second desirable quality touched on by Deng is the "poetic," and the

1. Reproduced in CL, 1960, no. 10, opp. 184.

"poetic" becomes a major hallmark of the best paintings of the era. Deng also spends considerable effort in his review discussing style and technique.[2]

Wang Xuyang's (b. 1932) *On the Canal* (fig. 40), a traditional-style painting in this exhibition was particularly admired for its subject and presentation because it delineated the new prosperity of land and waterway. It also showed youths from near and far on their way to participate in a big construction project. Especially laudable was the figure of the young man in the bow of the foreground boat: even though his face is not visible, his high morale, his daring, and his energetic heroic spirit are conveyed in his pose as he stands braving the wind.[3] Both the picture and the commentary reveal that, compared with figure subjects of the late 1950s, more subtlety was now appreciated. Peasants and others shown at leisure rather than engaged in dynamic action or frenzied activity were also acceptable.

Although the achievements of a large number of professional artists were recognized through special exhibitions of their art and in having reproductions of their paintings published, it is the works and sometimes the words of a handful of older, revered masters, especially those working in the traditional medium, which seem to carry the greatest significance. These elders include primarily men born before 1912: Pan Tianshou (1897–1971), He Tianjian (1890–1977), Qian Songyan (1899–1985), Fu Baoshi (1904–1965), Li Keran (b. 1907), Wu Zuoren (b. 1908), and Guan Shanyue (b. 1912). At the same time, a certain degree of attention was accorded the maverick Lin Fengmian (b. 1900) and, among the younger artists, Huang Zhou (b. 1925).

The Appreciation of Diversity, Individuality, and Style

The preoccupation with style and technique is very old and deeply ingrained in Chinese artistic criticism. As continued in the early 1960s, it echoed the new call for greater diversity, for culling the old to create the new, and for individual style. Three features characterize comments on style in the art writings. First, they report artists' successes in incorporating techniques typical of other media into their own. Second, more narrow in scope, the reviews praise traditional-style artists who abandoned their overreliance upon old brushwork formulae by converting them into a modern idiom. Third, they describe and distinguish artists' personal, individual styles, along with comments on their originality. The following summaries of some reviews of art exhibitions will demonstrate these points.

The anonymous reviewer of an exhibition of two hundred sketches by four artists held in Beijing in 1961 adroitly distinguished the particular characteristics of each man's approach to drawing. Ye Qianyu, for example, used "a few rapid strokes" to bring "to life a human figure," whereas Lu Zhixiang (b. 1910), who once used "heavy, forthright lines," now had a dancing, pulsing rhythm where "light and movement set the tone." Shao Yu was "a tireless explorer of the poetic, of rhythms in the contrast of colours and the possibilities of modern design or compositional innovations based on the national traditional style," whereas Huang Zhou displayed "an assured command of his tools in arresting the subtlest changes in expression of face or gesture."[4] Another unsigned review, this time of landscape and figure watercolors by three artists, contrasted their color preferences in sometimes unusual descriptive vocabulary. It was pointed out, for example, that Zhou Lingzhao (b. 1919) liked "sumptuous subtropical colours: brilliant blues, greens, reds, yellows," while Gu Yuan (better known as a woodcut artist) uses "low-toned, tender colours." Gu is commended for infusing "Western water colour technique with elements of Chinese traditional style painting—such as in his use of white blanks of paper to create the impression of space, or light or the veils of mist that bathe...southern lands in a characteristic light."[5]

Undoubtedly the highlight of the 1961 season was "The New Face of Our Land" exhibition of paintings by Jiangsu traditional-style artists who, led by Fu Baoshi, toured "six provinces, covering over twenty thousand *li*" in the autumn of 1960. As told by Fu, they traveled to far-off places, not to engage in physical labor, but to draw inspiration from the changes in the land wrought by socialist achievements, and to record these accomplishments in their paintings.[6] In one review of this exhibition, written by Yu Feng, little was said

2. Teng Wen, "The Chinese Style in Art—A Review of the National Exhibition of Art," CL, 1960, no. 10:179–184.
3. Jin Kejun, "'Yunhe shang,'" *Meishu*, 1960, no. 8/9:53.
4. "Sketches by Four Artists," PR, 8 Sept. 1961, 18–19.
5. "New Water-Colour Paintings," PR, 21 July 1961, 21.
6. Fu Pao-shih, "The New Face of Our Land," CL, 1961, no. 8:121–124; Fu Baoshi, "Sixiang bianle, bimo jiu buneng bubian—da yourende yifengxin," RMRB, 26 Feb. 1961, reprinted in *Renmin ribao wenyi pinglun xuanji* vol. 1 (Beijing: Renmin ribao, 1962): 362–369. English translation in PR, 17 March 1961, 14–17, under title "A New Ideology Needs a New Brushwork."

Art and the Appreciation of Beauty

about revolutionary or socialist content (although much of this is implicit both in the title of the exhibition and in the titles of the paintings). The emphasis was upon artistic concerns, and artists were praised for their special talents. For example, Qian Songyan was lauded for his use of color, for his striking compositions, and for his absorption of techniques of watercolor and oil painting into his traditional-style art. Yu Tongfu was praised for basing his brushwork on that of seventeenth-century masters, but modifying these old techniques to achieve new results, as well as for integrating architecture and construction sites into a landscape background. Ya Ming (b. 1924) was extolled for his skillful use of color and empty white spaces of paper in his rendering of a steel factory, a subject which, the reviewer noted, need not be reserved for oil painting. Song Wenzhi was acclaimed for incorporating watercolor techniques into the Chinese-style painting in many of his works. His unpublished *Great Changes in Mountains and Streams*, depicting a worksite at the Three Gorges, however, received scant praise, interestingly, because it did not meet the criterion of "poetry." The reviewer claimed that this work "does not attract, it is neither beautiful nor new, but is a bland, straightforward report, lacking poetic feeling."[7]

Yu Feng also authored a remarkable review in 1963, this time of the "New Spring" exhibition. In it she stresses style almost to the exclusion of content. Her concluding section, headed "Our Motto," is worth quoting at length.

> In practically every branch of art, one can find side by side radically differing styles and approaches. Our motto is: Our art must satisfy aesthetic tastes of all kinds among our people building socialism. The flower-and-bird paintings at this show well exemplify this spirit. Among them, *Late Autumn* by Lin Feng-mien has aroused unusual interest. The foliage is drawn right up to the edge of the painting on all four sides; just a few spots of white represent where the sky casts its light through the leaves. Some have said that this doesn't look like a traditional Chinese painting, but others dispute that bald statement. It is true that Lin Feng-mien studied oil painting in France 40 years ago. There, as a young student, he cultivated an admiration for Matisse and painted in oils as well as gouache. But for many years now he has used Chinese ink and colours and absorbent bamboo-pulp paper as his special medium. With these means he has produced many paintings which derive something from oil painting and are unlike

ordinary works in the traditional style of painting. In these works you see something of the styles of Chu Ta (17th century) and of Chi Pai-shih; you also see something of Cezanne and Gauguin, as well as of the Tunhuang murals and Giotto. But, strictly speaking, you see none of them—just Lin Feng-mien. He has created a style that is singularly his own. People may argue whether his paintings are in the traditional style or not, but in this argument, one thing is definite: Chinese traditional painting has never excluded influences from outside. Thus it has kept on enriching itself by constantly drawing on fresh sources of inspiration.[8]

Yu's comments again stress recognition of individual styles, even if heavily influenced by European art, and even if unique.

Despite the diversity of medium and style, there are a number of artistic traits common to the more interesting pictures done in this era. These are important not only because they are shared by many works, but also because they are clues that help us to identify undated works of art as having been done during this period. One of these traits is the effective use of a few large areas of colors, and another is, as is noted by the Chinese writers, a decorative quality.

Qian Songyan, working in the traditional Chinese painting mode, is particularly adept at using large areas of clear colors—yellow, green, red—to suggest, for example, vast fields of ripe grain, sugarcane, or cliffsides, and then delineating in black ink telling details of stalks, canes, and small figures of harvesters, or architecture. This approach of using broad areas of color is especially effective in the woodcut medium, and numerous examples exist. Xu Leng's (b. 1929) *Night in the Wanda Mountains* (fig. 41) shows transportation men working in the frozen northern regions. This extraordinary print consists of three colored planes in silhouette: in the foreground, the white of the snow-covered ground (with men and truck); then in the midground, black groves of night-shrouded trees; and finally the violet sky with a large yellow moon. In another woodcut, Dong Qizhong's (b. 1935) *Autumn Colors on the Plateau* (fig. 42) depicting apple harvest on a terraced orchard, color planes are combined with a decorative effect. The print uses a subdued color scheme on buff-colored paper. Staggered rows of trees on the hillside are reduced to large silhouettes of sage green, punctuated with ochre fruits; three oxcarts are done primarily in black and sage

7. Yu Feng, "Kan 'Shanhe xinmao' huazhan suiji," *Meishu*, 1961, no. 4:63.

8. Yu Feng, "New Things in an Old Art," PR, 22 March 1963, 27.

green; the small figures of the peasants loading the carts are in green, black, and white; the baskets of harvested fruit are in green with black accents. The horizon line is at the very top of the format, and in accordance with rules of perspective, distant trees are smaller, more numerous, and closer together than those in the immediate foreground. But the ultimate effect is one of visually pleasing, flat, decorative patterning. This is an example of relatively simple patterning based upon tree forms. Much more intricate and complex designs based upon tree trunks and branches are also found, as in the woodcut *Springtime* by Zhu Qinbao, *Green Everywhere in South China* by Zhu Qinbao and Zhang Xinyou, and *Village Scene* by Ren Yi (b. 1925).[9] The repetitive undulating patterns of the terraced fields of the Chinese countryside immediately lend themselves to decorative treatment, as in two woodcuts by Xiu Jun (b. 1925) and Chen Jiayong.[10] Even massed junk sails are given a decorative treatment.[11] The use of such decorative elements was not restricted to woodcuts, as is indicated in the handling of the palm trees in Guan Shanyue's painting *Spring Sowing Time* and those in Lin Ximing's (b. 1926) *Day Begins.*[12]

More subtle in overall effect is the use of trees in the immediate foreground of a picture to create a sort of perforated or openwork screen from the bottom to the top of the format. The subject of the depiction is then seen through the tree screen. The trunks and branches may be dark silhouettes against blank paper and figures, as in Huang Yongyu's color print *Joining the Army* of 1961,[13] or white against the mauve, brown, and pale lilac tones of an escarpment in the oil painting by Wu Guanzhong (b. 1919), *Spring Dressed in Snow* (fig. 43). The tree screen not only constitutes a decorative pattern in each of these works, but also breaks up the background images into fragments, thereby relegating the announced subject to a secondary level because these images are obscured.

The obscuring of images further ties such works to the "poetic," a concept to be discussed below. A lyrical feeling is certainly evoked by the portrayal of nature in soft, subdued images and colors. Throughout this period, although more cheerful colors are not always avoided, there is a preponderance of muted hues (sage green, violets, grey, slate blues), and red is sparingly used.

In the works mentioned above and in dozens of other oils, Chinese-style paintings, woodcuts, and watercolors, the figures in the landscapes are small, some even sketchily or indistinctly rendered. Many landscapes have no figures, factories, villages, or railroads in them at all. Some scenes are so neutral in context that they might be placed in Japan or Southeast Asia, as in Tang Jixiang's (b. 1939) *Spring Drizzle* (fig. 44).

Many other pictures are purely descriptive of the land. This is particularly true of a series of Chinese-style paintings by Fu Baoshi and Guan Shanyue done on their travels to Manchuria in 1961. This trip obviously was a major revelation to these two artists, not the least because both hailed from the densely populated south with its warm, subtropical climate, lush vegetation, and flat land contoured by centuries of agriculture and crisscrossed by miles of carefully channeled waterways. In Manchuria they encountered a vast virgin wilderness where deer and other animals still roamed in snowy pine forests, where in the harsh cold, streams and waterfalls cascaded down mountain sides, and where huge volcanic craters pitted the land. They clearly responded with an appropriate, almost emotional, awe, as is indicated by the title given by Fu Baoshi to one of the paintings made on this trip: *Goodbye, Great Snowy Mountains.*[14] On this journey Guan and Fu did depict some of the factory complexes, harbors, and mines built there as part of the project to open up this land. But most unusual, and again indicative of the high degree of toleration allowed, were the pictures of the pure wilderness, such as, for example, Fu Baoshi's rendition of an extinct volcano in the snow, a handscroll in white, pale blue, and grey, with no evident political value whatsoever (plate 6).

A large number of depictions of peasants and workers show them at their tasks, albeit in a distinctly glamorized view of labor. An equally large number of figure depictions, however, show peasants and workers at their leisure. These are of considerable importance in understanding the art of the period 1960–1964. A frequent motif in figure painting is the back view, as in *On the Canal* (fig. 40) or in the oil painting *We All Drink from the Same River* (fig. 45) by Fan Xueli, showing a minority woman, along with her two children, pausing in filling buckets with river water to gaze

9. Reproduced in *Meishu*, 1960, no. 4:25; 1963, no. 2:57; 1963, no. 1:57.
10. Reproduced in *Meishu*, 1960, no. 8/9:46 and 47.
11. Reproduced in CL, 1965, no. 5:74.
12. Reproduced in CL, 1964, no. 2:111, and CL, 1965, no. 8, opp. 112.
13. Reproduced in *Meishu*, 1961, no. 6:18.

14. *Fu Baoshi Guan Shanyue Dongbei xiesheng huaxuan* (Shenyang?: Liaoning meishu, 1964), 42.

Art and the Appreciation of Beauty

across to the distant shore where other, indistinct figures stand waving. People gazing into the distance is a common pose; it is found in both *On the Canal* and *We All Drink from the Same River*. This pose is explicitly considered a positive feature in a critique of a woodcut by Chao Mei (b. 1931), *The Break*,[15] which depicted "an interval during the storing of grain . . . people were hard at work . . . but now they are resting in comfort in different ways. . . . A young man and a girl . . . [are] gazing quietly into the distance."[16] In Shi Lu's *Under the Willows*,[17] "the cowherd resting there and the cattle enjoying the cool induce a sense of ease and happiness."[18] Wei Zixi's *Harvest* (fig. 46), made in 1962, shows five women relaxing during a work break: four of them are lounging on grain sheaves, two are casually chatting, the other three watch men heaping grain in the distance. Three of these women are presented from the back or side, so that their faces are not entirely visible, and the fifth woman stands to one side gazing at the distant scene.

From these observations and statements, it is clear that the worker and the peasant in particular are hardly portrayed as the embodiment of an energetic, vibrant, or inspirational commitment to a revolutionary ideal. The figure gazing into the distance, so frequently encountered in these pictures, is an old motif seen in hundreds of ancient traditional-style paintings. Thus it comes as no surprise to find that in the 1960s, traditional-style painters, such as Fu Baoshi and Guan Shanyue, also depicted scholars in landscapes gazing at waterfalls, at far-off mountains, or just into the distance.

The Poetic in Landscape and Bird-and-Flower Painting

Although natural and industrial landscapes were sometimes depicted as being in full sunlight, a preference for subdued weather conditions (mist or rain, for example) and for the somber times of day is also evident, and these are perhaps more important as indicators of the prevailing artistic climate than are the sunny scenes. Mist and rain not only diffuse the clarity of the images, but also lower the color values, so that such scenes can

have blurred images and very pale tones. Three extreme examples are Yang Taiyang's (b. 1909) watercolor titled *Rain* (fig. 47), Lin Ximing's painting *Day Begins*, and Liu Zonghe's woodcut *After a Downpour*.[19] Evening and nighttime scenes, for obvious reasons, are cast in muted tones of grey, black, violet, blue, and green. The images are often generalized into silhouettes, and details of buildings, figures, trees are indistinct or omitted entirely. There are even a few moonlight scenes, such as Xu Leng's *Night in the Wanda Mountains* (fig. 41), but more often the incandescent light from buildings or ships, or the glow of furnace fires, is reflected in paddies or harbor water. The sparkling, scattered points of light and their irregular shimmering reflections lend visual interest to the depiction.

Sometimes the vocabulary used in the reviews of art shows is extraordinary and imaginative. For example, the artist Zhou Lingzhao, according to one report of his visit to Guilin, was "attracted by the strange and romantic: the *karst* landscapes of Kweilin with their bizarre-shaped rocks and mountains soaring with dramatic unexpectedness out of a plain or lake. . . . [He] seems to be viewing the scene before him through a highly romantic vision, storing up the memory of strange scenes for new visions."[20] Of a woodcut by Zhang Zuoliang (b. 1927), *Shipping Grain on the Ice*,[21] it was said: "The people's feeling of joy at their last harvest is closely woven into that moonlit world of crystal."[22]

The observations made above about misty, rainy, or nighttime landscapes, and the exuberant terms used by the Chinese in describing some of the art of this period, reflect the current demand that a work of art must convey "poetic feeling." This whole idea of the "poetic," barely kept alive during the 1950s, surfaced in the middle of 1959, when Zhang Geng published a lengthy article in *Renmin ribao* on aesthetics and, among other things, delighted in the scenic beauties of Guilin, quoting ancient poems inspired by this scenery.[23] This was backed up by a long series of articles, based upon discussions of the topic of poetry in painting, published in *Meishu* in 1961. From this and other literature on the subject, it is clear that

15. Reproduced in CL, 1961, no. 3, opp. 96.
16. Yu Wen, "Labour and Painting—The Exhibition of Art from the Northern Wasteland," CL, 1961, no. 3:154.
17. Reproduced in CL, 1962, no. 1, opp. 96.
18. Hua Hsia, "The Paintings of Shih Lu," CL, 1962, no. 1:93.

19. Lin's painting reproduced in CL, 1965, no. 8, opp. 112; Liu's woodcut in CP, 1964, no. 4:22.
20. "New Water-Colour Paintings," 21.
21. Reproduced in CR, 1962, no. 5:22–23.
22. Chang Lu, "Art Grown in Virgin Soil," CR, 1962, no. 5:21.
23. Chang Keng, "The Scenic Beauties of Kweilin—and Some Thoughts on the Beauty of Nature," JMJP, 2 June 1959, SCMP, no. 2037:1–9.

"poetic feeling" was a major guiding principle for judging quality in art and remained so through 1964.

"Poetic" quality is mentioned in evaluations of the work of Lin Fengmian, Li Keran, Fu Baoshi, Pan Tianshou, Guan Shanyue, and Qian Songyan; it is the subject of an essay by Wu Zuoren. Sometimes the word "poetic" is not used, but other terms and phrases convey the same concept, such as "expression of the artist's ideas and feelings," or "mood." In whatever guise, "poetic" feeling as a sought-after quality replaced the earlier criterion of "revolutionary realism and revolutionary romanticism."

Wu Zuoren provided perhaps the most eloquent statement on the subject of poetry in painting when he noted: "Step by step man comes to appreciate natural beauty and love it; this makes him want to depict various aspects of nature—morning and evening, day and night, summer and winter, rain and sunshine—and from that he goes on to the attempt to integrate natural beauty with his own feelings." Wu went on to talk about China's ancient landscape painters and their use of scenery to convey feelings and personal emotions and mentioned the traditional connections between poetry and painting. He continued:

> The essence of painting and of poetry is hard to differentiate.... In addition to painting what he actually sees, [the artist] wants to express the invisible world of feeling.... A painter can transform an actual landscape into a landscape expressing his own mind and impart feeling to something insentient.... Chinese artists and poets do not try to create natural beauty on the base of their feelings, but use natural beauty to give vent to their feelings.[24]

Wu himself, we are told, "inscribed" poems on his oil paintings by using the expedient of writing out the poems on separate sheets of paper.[25]

In 1961 Mi Gu (b. 1919), a noted cartoonist, published an appreciation of Lin Fengmian's art titled "I Love Lin Fengmian's Paintings." The article itself is an astounding document to come from an artist who graduated in the 1940s from the Lu Xun Art Academy in Yan'an where students and faculty alike had it drilled into them that art was subservient to politics, that it must be educational, that it must shed outmoded or foreign notions of art for art's sake or for personal expression. Lin Fengmian, born in 1900, studied oil painting in Paris during the early 1930s and was especially influenced by the Impressionists and the Fauves. He is considered one of the pioneers in introducing Western art styles into China. Although he reverted to using traditional Chinese media, he steadfastly refused to conform to CCP policies concerning art, even though this meant general neglect by Chinese officialdom, if not by the Chinese artistic world.

Near the beginning of the essay, Mi says of Lin's paintings, "Like a glass of fine and fragrant grape wine they transported me into a realm of beauty and fantasy." A few lines later, he speaks of the poetic world of Lin's paintings and then describes the poetic aspects as he perceives them. To do this, he describes several of Lin's works, including *Night*, *Autumn Geese*, and *Night Mooring*.

Of *Night* (apparently unpublished) Mi Gu said, "Hazy evening shadows interlacing both banks of a small river; calm, clear waters reflect the last rays of the sun, a few wild ducks...fly into the limitless distance." *Autumn Geese* (fig. 48) suggested to Mi Gu a type of "autumnal mournfulness and desolation." Of *Night Mooring* (fig. 49) he writes: "On the river a drizzling rain makes mountain and water indistinguishable; several fishermen in the evening shadows drift between mountains and water, heightening the effect of a tranquil world." What Mi Gu appreciated was the mood of quiet, calm evening scenes.[26]

The landscapes of Li Keran are also placed in the poetic category by his champion Fang Chi, who expounds upon Li's "creative conception" thus:

> Chinese landscape painters have always laid great stress on the importance of the total creative conception of the painting, as that which determines the life of the painting. This attitude is the same as that of the Chinese poet to classical Chinese poetry. In both cases, "creative conception" connotes both the ideas and feelings expressed and the art by which they are materialized; in landscape painting it is what the ancients called "sentiments embodied in a scene."[27]

24. Wu Tso-jen, "A Reflection on Landscape Painting," CL, 1962, no. 7:102–103. Inscriptions on most traditional-style paintings done in the PRC are terse. They give the bare facts about the work: title, date and place of execution, artist's name. Sometimes longer inscriptions expand in prose upon why or when the picture was done. Some artists, like Pan Tianshou, regularly inscribed poetry on their paintings.

25. Tso Hai, "The Painter Wu Tso-jen," CL, 1964, no. 7:102–103. Professor Wendy Larson has suggested that the search for poetry during the early 1960s might reflect a nostalgia for "things Chinese."

26. Mi Gu, "Wo ai Lin Fengmiande hua," *Meishu*, 1961, no. 5:50–52; English version as Mi Ku, "Lin Feng-mien's Paintings," CL, 1963, no. 1:101–108.

27. Fang Chi, "A Myriad Hills Tinged with Red—Introducing Li Ko-jan's Ink and Water-colour Landscapes," CL, 1963, no. 11:81.

"Poetry" in painting is not restricted to landscapes. Of the flower paintings by Pan Tianshou, one critic said he "delights in the laconic metaphor and symbolism typical of classical Chinese poetry and painting."[28] The painter Ni Yide (1901–1970) also wrote a long article on Pan's bird-and-flowers and landscapes. Ni's article is replete with implicit and explicit references of poetry: "special charm," "a bold touch of originality," "reveals a world of strange beauty with fantastic rocks, rushing water and wild plants."[29] Or more explicitly:

> Many of Pan Tien-shou's paintings are rich in poetry though no poem is inscribed on them.... His painting *Bathed in Dew* [plate 7]... is like a poem describing the lotus pond wrapped in morning mist, with its flowers, heavy with dew, swaying gently on their stems and only partly visible. Another painting, *After the Rain*, gives us a poetic scene of sunshine after a storm, of distant hills still wrapped in clouds, of newly washed trees greener and lovelier than usual, of unknown mountain flowers heavy with rain-drops and streams gurgling louder than ever. Everything here seems refreshed by the rain, clean and vigorous. His lotus paintings evoke an even greater variety of mood and sentiment: whether swaying in the breeze, glistening with dewdrops or brightly reflecting the sunlight, the crimson flowers with their stately leaves appear pure and noble, lovely and gentle and above all lyrical in their beauty.[30]

As late as 1964 the older artists still received approbation, and "poetic" quality was still invoked as a necessity even in paintings that depicted peasants working or construction scenes. Chih Ko, an art critic and teacher at the Canton Institute of Fine Arts, wrote the following about paintings by his colleague Guan Shanyue:

> *When the Rain Is Over* [fig. 50] is representative of the artist's style at its most magnificent. A grand and rocky mountain dominates the vertical scroll, its peak soaring up and out of the picture space. "A mountain is not high if the whole of it is visible," said an ancient Chinese painter. Here, the mountain with its invisible peak induces in us a sense of grand and sublime beauty.

> One of Kuan Shan-yueh's favourite themes is the poetic feeling for nature that comes from a knowledge of the fruits of labour. His *Spring Sowing Time*, depicting a typical village scene in southern China,

vividly expresses the artist's warm feelings for the countryside. The composition and conception of this painting strike a note very different from the traditional paintings on the same subject. Rows of graceful palms give strength and variety to its composition. A few strokes suggesting their inverted reflections bring out the limpid clarity of the water in the paddy fields. A group of commune members are taking rice seedlings out to the paddies. A peasant guides a buffalo pulling a plough. Small as the figures are, they add buoyant life to the scene.[31]

Two rather different reviews of Qian Songyan's one-man exhibition in Beijing in early 1964 are available; one was written by Zhang Anzhi, the other by Wang Jingxian. Zhang Anzhi was well qualified to review Qian's exhibition. A noted painter in traditional style who once studied in Europe, Zhang in 1964 was the deputy head of the Department of Traditional Painting at the Central Art Academy in Beijing. His approach to the review is similar to that of Chih Ko: description of a painting and discussion of technique, and as in the following excerpt, an implied "poetic feeling." Qian Songyan's

> *New City in the Mountains* [plate 8], done in 1960, shows serrated, snow-covered mountain peaks rising out of the picture space. These are the rugged, majestic Chinling Mountains which divide the headwaters of the Yellow River from those of the Yangtse. Opening up new roads and erecting new buildings at such heights was unthinkable in the old days and there is an air of wonder in the way the artist depicts a newly opened road winding through the mountains and impresses us with the labour and difficulties involved in creating it. In the foreground, rocky peaks rise sharp into the air, flanked by terraced fields. In the middle ground groups of houses appear, a new city risen with the progress of the road. This landscape is not just a picture of magnificent natural scenery but a testimony to the great deeds of man in taming nature. It is a graphic representation of the Chinling Mountains after the building of the Paochi-Chengtu Railway. The artist's choice of a snow scene as background to the new city contrasts the lonely, icy peaks with the bustling new life of construction. There is also an arresting contrast between the simple, sparse lines in the upper part of the picture and the complex, compact scene below, and between the light colouring above and the heavier colours beneath. These contrasts and variations enhance the sense of space and rhythm of the painting. Although the new city is the main theme of the painting, it is not completely revealed.

28. Kai Hsieh, "Pan Tien-shou's Art," PR, 30 Nov. 1962, 37.
29. Ni Yi-teh, "Pan Tien-shou's Paintings," CL, 1961, no. 10:101.
30. Ibid., 103.

31. Chih Ko, "Kuan Shan-yueh's Paintings," CL, 1964, no. 2:111.

Only sections of it are visible projecting from behind the cliffs in the foreground. This avoids monotony and stimulates the imagination. With the city partly hidden, the viewer senses that it must be of a considerable size.[32]

The connections between poetry and painting have a history that extends back to the Sung dynasty at least. According to Susan Bush, in the eleventh century when the poet-statesman Su Shi declared "that poetry and painting were equivalent art forms," he may have been reflecting widespread current understandings embodied in such popular phrases as "poems are formless paintings, paintings, poems in forms" or "soundless poems" and "paintings with sound."[33] It is instructive to remember that even as late as the eighteenth century, the relationship between poetry and painting was succinctly stated by one connoisseur, who said: "Both poetry and painting are scholars' occupations which help to express human moods and feelings. Therefore what can be a subject of poetry can also be a subject of painting, and what is vulgar in painting is like bad verse. It is important to avoid it."[34]

One cannot help suspecting that the emphasis upon poetry in painting during the early 1960s was one means of making an otherwise offensive subject more palatable. Seeing power lines, factories, or the new industrial city sprawling in a once deserted and lonely mountain valley, through a poetic guise, served to bring these modern motifs within the domain of traditional sensibility.

The second review of Qian's exhibition, by Wang Jingxian, contrasts with that by Zhang Anzhi because Wang, after declaring the Qian's works are fine, feels compelled to enumerate and explain three basic reasons for this. Some of these reasons are, of course, implicit in Zhang Anzhi's comments, but Wang is much more specific about them. First, Qian sees the potential of landscape to reflect contemporary socialist life. As an example, Wang uses *New City in the Mountains* and compares it with old, traditional depictions of Sichuan mountains: "Among the peaks and valleys are new construction and high tension wires, a train replaces the donkey, the new city replaces the village. This is the Sichuan of socialist times." Second, Wang explains that Qian does not always depict figures in his paintings, nor does he depict "struggle." Rather, he uses natural scenery to praise people. His scenery is informed with a love of the socialist spirit because it is the people's labor and struggle which makes natural scenery new and beautiful. He also notes that Qian depicts revolutionary historic sites, and these remind the reviewer of past struggles. Third, Qian has not been bound to old traditional descriptive brushwork formulae, but, since "content determines form" and the old forms are inadequate to express today's subject, Qian has devised new brush techniques to describe today's new society. Only after having spent considerable time on these political justifications for the "goodness" of Qian's painting does Wang turn to discuss in detail technique, poetry, and stylistic evolution.[35]

The prominent placement of the political statements at the very beginning of the essay, and the large amount of space devoted to these arguments by Wang, suggest that the tide of liberalism was ebbing. And so it was. Significantly, these paintings by Qian Songyan were among the last reproductions of landscapes by traditional-style masters to appear in *Meishu* before it ceased publication at the beginning of the Cultural Revolution.

32. Chang An-chih, "The Painter Chien Sung-yen," CL, 1964, no. 9: 107–108.
33. Susan Bush, *The Chinese Literati on Painting: Su Shih (1037–1101) to Tung Ch'i-ch'ang (1555–1636)* (Cambridge: Harvard University Press, Harvard-Yenching Institute Studies 27, 1971), 24–25.
34. Shen Zongqian quoted in Lin Yutang, *The Chinese Theory of Art: Translations from the Masters of Chinese Art* (New York: G. P. Putnam's Sons, 1967), 191.

35. Wang Jingxian, "Xikan Qian Songyande xin shanshui," *Meishu*, 1964, no. 3: 18–21.

Art between 1960
and 1965

Part Three: From Poetry to Politics, 1963–1965

5

After the Great Leap Forward, Mao, no longer head of state, but still chairman of the Party, became deeply distressed about what he saw as erosive and destructive forces threatening his goals for China. He perceived the new agricultural and industrial policies introduced by Liu Shaoqi as containing germinating seeds of capitalism which might grow into "revisionism" like that in the Soviet Union under Khrushchev. Liu's emphasis upon specialized skills of the "expert," Mao believed, undermined "red" ideological purity. He was perturbed about the decline in revolutionary fervor as manifested in demands for a better life, more material goods, and the aping of decadent Western life styles. He was particularly concerned that the youth of China, those born late in the 1940s and after, who had no opportunity to participate in China's revolutionary struggles yet were China's future leaders, lacked the fervor necessary to carry the revolution forward.

The Socialist Education Movement began in earnest in early 1963. The goals of the movement were "to counter the bureaucratization of Chinese political life, reverse socio-economic policies that Maoists condemned as 'revisionist'" because they were seen as possibly creating new forms of capitalism. At the same time, the campaign was to "revitalize a collective spirit and consciousness." The Socialist Education Movement was based upon a speech by Mao before the tenth plenum of the Central Committee in September 1962. In his

speech Mao "set forth the thesis that classes and class struggles necessarily exist in socialist societies, stressed that the class struggle [between the proletariat and the bourgeoisie] in China would continue for a prolonged period, and raised the spectre that the outcome of the struggle could be a 'restoration of reactionary classes.'"[1]

According to Merle Goldman, during the early phases of the Socialist Education Movement Mao endeavored to effect changes through Party channels. He repeatedly complained about the lack of "socialist" art and even called for a reform, but, other than lip service paid to this demand, little genuine effort was made by the Party organizations to rectify the situation.[2]

Be this as it may, on March 9, 1963, Tao Zhu (b. ca. 1906, d. 1969), first secretary of the Central-South region, delivered a lengthy speech at the meeting of Literary and Art Circles of Guangdong and Canton. In it, he called, as Mao had done long ago, for art to serve as an effective weapon in class struggle, now to help counter trends toward capitalist ideas and old ways: speculation and profiteering, superstitions, blood feuds between clans being among the evils mentioned

1. Maurice Meisner, *Mao's China: A History of the People's Republic* (New York: Free Press, 1977), 288 and ch. 17; see also Frederick C. Teiwes, *Politics & Purges in China: Rectification and the Decline of Party Norms 1950–1965* (New York: M. E. Sharpe, 1979), 513ff.
2. Merle Goldman, *China's Intellectuals: Advise and Dissent* (Cambridge: Harvard University Press, 1981), 89ff.

by Tao.[3] In April 1963 it was reported that teams of cultural workers from the theatrical, literary, and artistic professions were sent into the countryside, suggesting a widespread deployment of such people in the campaign. Initially, it would appear that their task, carried out through theater performances, writings, and art, was to reeducate the rural people about the basics of socialism and its goals, about cultural and scientific knowledge, as well as to help the peasant get rid of the influence of "outworn ideas and habits and replace them by new ideas and new customs." In this way art would be serving the workers, peasants, and soldiers. While peasants were reeducated and had "increased cultural recreation," artists had opportunities to reform their outlook on life and to become more closely acquainted with the peasants, "bringing themselves closer to the sources of creative art." [4]

Finally, as the Socialist Education Movement picked up steam in May 1963 the National Conference of Literary and Art Workers recognized that the existing art could not fulfill the functions of art demanded by the Socialist Education Movement. Among the shortcomings of the artistic products were that they did not reflect real struggles, that they were simple in content, that the ties of artists with peasants and masses were weak, and that "harmful bourgeois influences and unhealthy phenomena have developed." [5] Artists were urged to go to the farms, factories, and army units, to be with the peasants, workers, and soldiers, and to participate to a certain extent in labor.[6] Although subject matter, form, and styles were to be varied, content was to have precedence over form.[7]

Rosters of well-known artists from various cities throughout China who went to communes and factories are found in almost every issue of *Meishu* for 1963 and 1964. These lists strongly imply that the early phase of the Socialist Education Movement did affect a large number of upper-level artists. Often they were assigned to neighboring locations, although sometimes to remote destinations to be among minority groups or border peoples. Generally the artists stayed in the countryside for a matter of several months, usually about three. Those who went included Ya Ming, Wei Zixi, Guan Shanyue, Fang Rending (1903–1975), Fang Jizhong (b. 1923), Zhao Wangyun (1906–1977), Wu Fan, Gu Yuan, Huang Yongyu. According to one report, some of these people joined the volunteer cultural groups organized by the city administration for the purpose of going to the countryside.[8]

Upon their return to the cities, the artists held discussion sessions and wrote reports to share their learning experiences with others. One account was written by the chairman of the Shanxi Provincial Branch of the Chinese Artists' Association, Su Guang (b. 1919). He, along with six other artists, spent eight months in a production brigade from the winter of 1964 until the summer of 1965. Although this report reflects some of the policy developments of the summer of 1964, the description of artists' life in the country probably applies in general to the situation in 1963 as well. The men stayed in the homes of commune members, eating and working with them in the fields. For the Spring Festival, Su and the others made window decorations traditionally favored by the peasantry and wrote out the couplets (on themes of raising production and on the revolutionary spirit displayed among commune members) for pasting on door jambs and walls, all part of the traditional New Year's festivities. They also produced pictures of rural scenes today. They set up spare-time art training classes and worked on such projects as blackboard and wall-newspaper layouts, producing pictures showing the struggles of local peasants against rapacious landlords in the past, and created street murals depicting commune militia training.[9]

In addition to discussion meetings and reports, another important way of advertising the results of the "culture to the countryside" movement was through exhibiting the works of art resulting from these sojourns in the country.

Scenes of Rural Communes

In 1963 and 1964 a number of exhibitions were devoted to scenes of rural communes. In the reviews, the reception of their imagery and pre-

3. T'ao Chu, "Literature and the Arts for the Countryside —Speech given at Meeting of Literary and Art Circles of Kwangtung and Canton on March 9, 1963," Canton *Nanfang jih-pao*, 19 April 1963, SCMP, no. 2992:3.
4. "Culture and Art Must Serve the Countryside Still Better," JMJP editorial, 25 March 1963, in PR, 19 April 1963, 21, 22 (also in SCMP, no. 2958:2–6).
5. "Note on Conference of Chinese Writers and Artists," SCMP, no. 2992:20.
6. "National Conference of China's Writers and Artists," NCNA Peking, 21 May 1963, SCMP, no. 2986:4; also in CL, 1963, no. 8, as "A Conference of Writers and Artists—On the Militant Task of China's Literature and Art Today," 7.
7. "National Conference," 4.

8. "Artists, Writers Go to Rural Areas," PR, 10 Jan. 1964, 26.
9. Su Kuang, "Artists in a Village," CR, 1966, no. 6: 20–21.

sentation is not significantly different from that of art during 1960–1962, although of course the subjects are almost exclusively of peasant life. It is significant that whereas the subjects change to focus on rural ones, the approach to art and the criteria for judging quality or appreciation were not substantially modified from that espoused earlier. In the 1963 exhibition, "New Scenes from the Countryside," was a work by Zhou Lingzhao, who, it will be remembered, in 1961 was praised for his penchant for the bizarre landscapes of Guilin done in tropical colors. Now his *Transporting Manure* (unpublished), "a fresh, decorative little panel in rich, pure colours [shows] a bevy of Tung girls from Kwangsi ... sitting in a boat with a dozen buckets of precious fertilizer, while a young man rows them vigorously, singing lustily the while." [10] Despite the reorientation in subject matter, the same reviewer still speaks of paintings of vegetables as "lyrical reminder[s] of the abundance and beauty being created by our farming collectives" and tells of one artist who, "eager to show the peasants at work doubted, when he had made his sketches, whether the stoop or bent back of the toilers had the necessary aesthetic grace." [11]

Even as late as 1964 Su Tianci's (b. 1922) *Autumn Harvest South of the Yangtze* (fig. 51), an entry in the "Commune Scenes" exhibition sponsored by the Chinese Artists' Association, was admired: "[It] shows five girls resting by golden paddy fields. Two of them are reading the newspaper, two others are listening intently, while the fifth, a bowl of water in her hand, is gazing at the scene of abundance all around. The picture radiates happiness and shows the interest of the younger generation of peasants in current events within the country and in the world." From the same exhibition Chao Mei's woodcut *Spring Returns* (fig. 52) "depicts white swans from the south flying high over far-stretching fertile plains where tractors have just started the spring ploughing." [12] In regard to *Spring Returns*, Yu Feng declares that only from the high, tilted, bird's-eye angle can one capture the vastness of the northern land of Manchuria, and the praises the poetic quality of the woodcut. Yu Feng is not uniformly favorable in her comments on paintings in this exhibition, however; one Tibetan scene suffers, she claims, because the figures are too much like those in old Western oil paintings, and she calls attention to the fact that the masses do not always care for

every type of artistic style. Again, it should be noted that she persists in emphasizing style. [13]

Pretty-girl pictures continued, and a spate of attractive young women, usually peasants or members of minorities, all depicted at ease, appeared in the scenes of rural communes exhibitions of 1963 and 1964. Included were single figures, like Wu Qiangnian's (b. 1937) *Commune Girl* leaning leisurely against a fence, her token sickle in one hand, or He Yunlan's (b. 1938) *Girl of the Dong Nationality* whose lovely face is framed by a picture hat, [14] or Song Kejun's (b. 1922) *The Bananas Are Ripe* (fig. 53) where a pert miss holds a branch of bananas, or Ma Xiguang's (b. 1932) *Mountain Village Schoolmistress* (fig. 54), who in her heavy coat rests after sweeping the snow. These women are always presented with an emphasis upon their pretty faces; evidence of other physical charms is smothered in heavy or loose garments or otherwise hidden; they tend to look out of the picture to one side, their averted glances thus modestly avoiding contact with the spectator. They would seem to be updated versions of the "beauty" of "scholar and beauty" figure paintings of old.

Although undeniably there are those paintings depicting peasants at their endless labors, many also show them at ease. Su Tianci's *Autumn Harvest South of the Yangtze* (mentioned above, fig. 51) shares with Wei Zixi's *Harvest* (fig. 46), done in 1962, the theme of pretty girls at lunchtime break: the relaxing women, as well as those seen from the back, who appear to be detached from their colleagues, and who gaze off into the distance. Su's depiction is, of course, a continuation of a presentational mode used in 1960–1962 in such works as *We All Drink from the Same River* (fig. 45) or *On the Canal* (fig. 40), as well as Wei Zixi's *Harvest*, all discussed earlier. Zhang Deyu's (b. 1931) oil *Lingnan Scene*, [15] of fisherwomen idly gossiping while they await the return of the fishing boats, and Huang Wenbo's *Spring Rain* (fig. 55), where peasants shelter from a cloudburst under the eaves of a shed and, leaning against the wall, casually chat while playing with the rivulets of rainwater spewing off the thatched roof, are two more examples of paintings resulting from sending artists to the countryside.

10. "Crop From the Countryside," PR, 3 Jan. 1964, 44.
11. Ibid.
12. "Exhibition of Commune Scenes," CL, 1964, no. 5:123.
13. Yu Feng, "Tan 'Gongshe fengguang' meizhande bufen zuopin," *Meishu*, 1964, no. 2:22, 23.
14. *Commune Girl* reproduced in *Meishu*, 1964, no. 1:61, and in CP, 1964, no. 4:22; *Girl of Dong Nationality* reproduced in CL, 1964, no. 1, opp. 78.
15. Reproduced in *Meishu*, 1963, no. 2:55.

In general, pretty women and idle peasants convey an impression of a society where work is pursued diligently but not frantically, where free time is spent relaxing and at ease. The poetic, lyrical landscapes and the visually pleasing decorative elements introduced into other landscapes indicate an art that was interested more in aesthetic concerns than in political ones. Presumably, it was exactly this pervasive relaxation among the people that Mao Zedong objected to and feared, along with the obviously bourgeois attitudes which tolerated an art notably lacking in socialist content.

The Criticism of Art

In the early 1960s the art scene seemed favorable for the "liberals," but voices of opposition began to be heard in 1963 and became especially loud in 1964. Thus it was possible at one and the same time to have Yu Feng judging art on the basis of style and poetry alongside those who subjected painting to strong criticism when it did not meet a different set of criteria. By this time it must have been becoming clear that the artists themselves needed rectification as much as their peasant audience.

The criticisms reported in the media were directed at specific paintings, publications, art shops. They focused on such topics as clarity of theme, appropriateness of subjects, and accuracy in visual description. In other words, contrary to the "obscure" and the "poetic," everything now was to be immediately evident, and the worker, peasant, and soldier of today, not the scholar-gentleman or damsel of yesteryear, were to be the main subjects.

In one article, the oil painting *Liu Shaoqi and the Anyuan Miners* (fig. 39) received criticism because the background figures of the workers were so generalized they were indistinct. Contrast was made between the quality of "revolutionary optimism" in the film *The Red Detachment of Women* and the uninspired oil painting by the same name where "exhausted" women in "ragged clothing" discuss battle plans in a "dark forest," conveying the effect of "horrors of war" rather than "future victory."[16]

Huang Wenbo's *Spring Rain* (fig. 55) came under fire because, although it could be said that it showed the peasants rejoicing in the timely spring rain through the admittedly striking device of

the young woman "feeling" the rain, the recent water-conservation projects made China less reliant upon the vagaries of nature, and so, by implication, the painting did not extol socialist accomplishments. Also criticized were the postures of the two young women, who seemed to be exchanging intimate confidences rather than discussing communal concerns.[17]

Some ten peasant leaders and representatives from four communes near Beijing toured the "Art from the Northeast and Northwest" segment of the National Art Exhibition held at the Chinese Art Museum in December 1964 and offered their opinions on the paintings they saw. One of these representatives was Li Molin, presumably eminently qualified to judge the effectiveness of art by virtue of his positions and honors: representative to the National People's Congress, National Labor Model, deputy director of Sijiqing Commune, party branch secretary of the Greenhouse Team, and Cucumber Raising Expert. He scoffed at Ma Xiguang's Chinese-style painting *Mountain Village Schoolmistress* (fig. 54) because, he claimed, no one would wear such a heavy coat while sweeping snow. The picture reminded others that people who avoided work might be expected to wear such a thick garment. Some paintings in the exhibition were panned by the peasant-critics for such perceived weaknesses as imprecise or inaccurate depictions of plants, or incompletely rendered human faces. One picture the peasants warmly approved depicted a family gathering where all are completely engrossed in listening to the father tell of his brutal treatment and displaying the scars of his wounds, received from an evil landlord before Liberation. It was praised for depicting class struggle; repeatedly the peasants said that every family should have such meetings, or that those who had forgotten or never knew of bad times in the past should see the painting. The only shortcoming of the scene, according to the commune representatives, was the setting: the room needed a picture of Chairman Mao on the wall.[18]

In 1963 an exhibition of Lin Fengmian's paint-

16. Wang Chunli, "Ping jifu biaoxian yingxiong xingxiangde youhua," *Meishu*, 1964, no. 1: 42, 43.

17. Zhong Ling, "Baihuayuanli xi xin ya—Guangzhou meishuxueyuan xuesheng xiaxiang chuangzuo zhanlan guan'gan," *Meishu*, 1963, no. 5: 22–23. Other questions, such as those about the depth of Huang's understanding of peasant life and spirit, the clarity of the theme of *Spring Rain*, and the relationship between knowledge and creativity, were raised in a lengthy article by Zheng Hongcang, "Tigao renshi yu tigao chuangzuo," *Meishu*, 1963, no. 5: 8–13.

18. Li Lang, "Nongmin kanhua ji," *Meishu*, 1964, no. 6: 3–7.

ings in Beijing drew a range of comments from gallery goers. One visitor, a doctor by the name of Shen Fangxiao, was jubilant and enthusiastic about Lin's work, saying, "He sees forms other people do not see, perceives colors other people do not perceive, discovers interests other people do not discover." He commented on Lin's subjectivity and creativity, his deep, remote style. Lin's three paintings of opera figures, Shen said, "make people pound the table and shout 'bravo.'" Other observers were less thrilled by Lin's art. Many reacted negatively to the somber quality of his landscape in particular as being unhealthy, pessimistic, and depressing. Some felt that foreign influence was too strong. Others believed Lin should spend more time among the masses. Some thought his painting should be more relevant to the times and more responsive to the needs of the workers, peasants, and soldiers.[19]

Dramatic evidence of the shift from the poetic to the political in art came in the form of a communication from a Shi Chongming published in *Meishu* in 1964. In this communication Shi tore into Mi Gu's appreciative essay of 1961, "I Love Lin Fengmian's Paintings." In a preface to Shi's critique, the editors of *Meishu* admitted that Mi Gu's essay had errors and they took the responsibility for publishing it; after the essay was published and readers expressed dissatisfaction with it, the editors realized they were wrong in not organizing a discussion of it; now in printing Shi's critique, the editors believed his basic viewpoint to be the correct one.

Shi's criticism focused upon the type of poetic responses evoked in Mi Gu by Lin Fengmian's paintings. Shi specifically objected to such phrases as in the description of *Night*, "wild ducks... *fly into the limitless distance*" (emphases are Shi's); that *Autumn Geese* (fig. 48) "suggests a type of *autumnal mournfulness and desolation*"; or in *Night Mooring* (fig. 49), the few fishermen "*drifting*" on the water heightening the effect of a "*tranquil*" world." Added to these are such phrases as "reflect the last rays of the sun." The gist of Shi's objections is that such images embodied ideas of solitude, quiet, bleakness, a retreat from society. As such they were reminiscent of lines favored by poets in the degenerate past and of titles of paintings by ancient literati. They carried unhealthy, negative connotations. They were lacking "revolutionary optimism" and were not in accord with Mao's six political criteria

for distinguishing fragrant flowers from poisonous weeds.[20]

Many of the pictures reproduced in a booklet, *Selection of Contemporary Landscapes*, published in 1964 were subject to objections because they were not different from landscapes painted during the feudalistic and capitalistic eras. For example, a temple in deep mountains, among dense groves with thick white clouds, with a monk and a lofty scholar on a path, basically conveys an escapist theme appreciated by artists of old, while the rendition of an elegant scholar in a boat watching birds fly off in the mist is an outright illustration to an ancient poem. Such images, it was asserted, do not reflect people of modern times, and the messages conveyed are not those of healthy revolutionary optimism.[21]

An office worker and devotee of Chinese painting raised objections about the contemporary paintings offered for sale in Beijing's art shop Rongbaozhai. He claimed that paintings put in exhibitions were politically acceptable, but those for sale at Rongbaozhai, such as pictures of opera figures or old-fashioned "beautiful maidens," were not. Bad traditional plays are no longer performed and bad books no longer published, so why is it, he queries, that bad paintings are still on the market?[22]

The negative criticisms expressed about landscape painting can easily be transferred to figure paintings. For example, in harvest scenes such as those by Wei Zixi (fig. 46) or Su Tianci (fig. 51), the overall impression is of quiet tranquility with people gazing into the limitless distance. Some people stand aloof, not joining their companions in chatter or the like, as if wishing to retreat from

19. "Lin Fengmian huazhan guanzhong yijian zhailu," *Meishu*, 1963, no. 4:37–38.

20. Shi Chongming, "Weishenme taozui?—dui 'Wo ai Lin Fengmiande hua' yiwende yijian," *Meishu*, 1964, no. 4:41–44. Mao's six political criteria are:
 (1) words and actions should help to unite, and not divide, the people of our various nationalities; (2) they should be beneficial, and not harmful, to socialist transformation and socialist construction; (3) they should help to consolidate, and not undermine or weaken, the people's democratic dictatorship; (4) they should help to consolidate, and not undermine or weaken, democratic centralism; (5) they should help to strengthen, and not discard or weaken, the leadership of the Communist Party; (6) they should be beneficial, and not harmful, to international socialist unity and the unity of the peace-loving people of the world.
From Mao's "On the Correct Handling of Contradictions Among the People," RMRB, 19 June 1957, 3; here quoted from Lau Yee-fui, Ho Wan-yee, and Yeung Sai-cheung, *Glossary of Chinese Political Phrases* (Hong Kong: Union Research Institute, 1977), 239.
21. Chen Kai, "Dui 'Xiandai shanshuihua xuan' de yijian," *Meishu*, 1964, no. 5:45–46.
22. He Zhen'gang, "Beijing Rongbaozhai kanhua yougan," *Meishu*, 1964, no. 2:39.

society. Because we do not see their faces fully and cannot "read" their expressions, they are mysterious and ambiguous. And certainly their relaxed poses suggest nothing of revolutionary eagerness.

These voices of opposition, coming from cultural unknowns who make reference to the domain of the theater, suggest the increasing power of those who advocated a more stringently political art. Presumably these people were spokesmen for Jiang Qing and her radical ideas. Her artistic formulae coalesced in 1964 with her revamping of the theater with revolutionary operas and performances, of which *The Red Detachment of Women* was one. Here was a policy that apparently was coordinated with Lin Biao's goals for establishing the People's Liberation Army as the ideological and cultural mentor for the Chinese people following the thoughts of Mao Zedong. The Party cultural apparatus may have been lethargic in carrying out Mao's wishes in art, but the PLA was not.

Art and the PLA

In the summer of 1959 the minister of defense, Marshal Peng Dehuai (1901–1974), was replaced by Lin Biao, a man closely allied with Mao and his goals. During the first half of the 1960s Lin Biao forged a new power base for Mao in the People's Liberation Army. Lin helped convey Mao's ideas to the people in a number of ways.

The PLA was undoubtedly the organization best qualified to enforce the political and ideological goals of Mao and Lin Biao. In its early days the army had endured the physical rigors of the Long March of 1934–1936 and life in Yan'an between 1936 and 1947. Concurrently, the army members were taught the fundamentals of Communist ideology and discipline. The army not only fought the military battles that culminated in the Communist victory in 1949, but also engaged in productive labor and acted as ideological agents entrusted with educating and mobilizing the masses. According to Meisner, "The political values and egalitarian traditions which were forged during the revolutionary years remained the PLA's heritage, and it was this heritage that the Maoists began to revive and cultivate in the late 1950s."[23]

It was through the PLA under the leadership of Marshal Lin Biao (as both minister of defense and commander of the PLA) that Mao sought to regain his political power after the disastrous Great Leap Forward. It was also through the agency of the PLA that Mao propagated his ideas and ideals among the people. When Lin Biao took over the PLA, he moved immediately to secure the army's fidelity to Mao and to "indoctrinate the Army along Mao's ideological line."[24] And, in turn, the army was to educate the people.

One way in which education along Maoist lines was carried out was through campaigns, beginning in 1963, urging the people to "Learn from the PLA" or "Learn from Lei Feng," the model "great ordinary soldier" who applied Mao's thought as a guide in his daily life and in his selfless devotion to the people. Among other things, Lei Feng, we are told, never forgot his sufferings during the "feudal" past. This old technique for rousing hatred and keeping it at a high pitch through "speaking bitterness of the old society and realizing the sweetness of the new society" was in 1963 practiced throughout the country as one aspect of the Socialist Education Movement. At meetings on communes and in factories, members of the older generation told those of the younger generation of their terrible and bitter life before Liberation.

The Chinese Communist armed forces had long used art as an effective means of generating hatred for the enemy. In the war with Japan, art was employed to induce peasant cooperation in guerrilla activities. And even in peacetime it was normal to have art associated with the military.

Between 1957 and 1964 there were three art exhibitions connected with the PLA. The one held in 1957 celebrated the thirtieth anniversary of the founding of the PLA. Its exhibits were prepared by professional artists outside the PLA proper on the themes of PLA history and valor. Scenes from the Long March (such as crossing the Great Snow Mountains), life in Yan'an, the guerrilla war against Japan, the War of Liberation (crossing the Yangtze River, the peaceful liberation of Beijing) are examples. Many of the works were cooperative efforts, as a checklist of the exhibition reveals. In one case a group of traditional-style masters, including such famous names as Wu Jingting (1904–1972), Jiang Zhaohe (b. 1904), Dong Shouping (b. 1904), Tao Yiqing (b. 1914), Yan Di (1920–1979), Li Fangbai (b. 1915), along with a

23. Meisner, *Mao's China*, 294.

24. Stanley Karnow, *Mao and China: From Revolution to Revolution* (New York: Viking Press, Viking Compass paperback, 1972), 137.

former member of the Qing imperial family, Pu Songchuang (b. 1912), and others did a long hand-scroll of the Long March.[25] A series of opinions, impressions, and critiques by military personnel was published in *Meishu*.[26] Later, in an obvious move to provide greater historical precedent for the PLA art exhibitions, this 1957 affair was referred to as the First National PLA Art Exhibition.

The so-called Second National Exhibition of PLA Art, held during February 1960 in the Wenhua Hall of the Palace Museum in Beijing, consisted of some 642 items, all by members of the PLA, selected from a pool of 4,500 entries in all media, including cartoons, posters, and even architectural designs for army hostels.[27] Events surrounding the exhibition followed the established pattern of symposia duly reported in *Meishu* along with articles by the PLA amateur artists, who described how they came to paint their pictures. The themes of the 1960 PLA art exhibition "reflected the heroic spirit and high ideals of the men of the People's Liberation Army in their defense of our land and their contributions to socialist construction."[28] The same reviewer also notes among the works those "reflecting the richness of their life, the poetry in it" and "the soldier's love of beauty."[29] Such phrases are, of course, completely consonant with the prevailing attitudes toward art in 1960. An analysis of the published reproductions of art works from the second PLA exhibition of 1960 reveals that while the subjects are usually indisputably PLA in content, some paintings display characteristics seen also in the nonmilitary art of the period. For example, in two Chinese-style paintings showing PLA crews constructing a canal in the mountains[30] and a reservoir,[31] the workers are infinitesimally tiny. Major General Li Yimin's Chinese-style eagle in a pine tree and a bevy of chicks on the ground[32] was done with a flair of brushwork reminiscent of that of the great Qi Baishi.[33]

Significant differences also exist between the 1960 PLA art and that done by the more liberal artists. No misty or rainy scenes and no nocturnal landscapes (all popular in "liberal" art) from the 1960 PLA exhibit are reproduced in *Meishu*. Similarly, the decorative qualities so frequent in "liberal" art are largely avoided in PLA art of 1960. Figural works, contrary to trends in "liberal" art, never depict idleness; from the *Meishu* illustrations: a PLA courier speeds along on a motorcycle to deliver his message; two PLA women intently operate a field communication system; soldiers with telescope and telephone guard the coast; early morning finds the army already at physical training exercises; the PLA raises hogs and trains peasant girls to shoot rifles. But the image of Mao is rarely seen, and as far as can be ascertained, the full spectrum of colors is used, with red not especially in evidence.

The so-called Third National Exhibition of PLA Art was held on the "home territory" of art, the Museum of Chinese Art in Beijing, from July 10 to August 9, 1964. It had some 650 works in all media by PLA professional artists and amateurs. Both the subjects and the reviews were highly politicized: "These pictures projected the proletarian ideology of a revolutionary army, equipped with modern arms, reinforced with communist morale, revolutionary heroism, proletarian internationalism and a comradely, collective spirit."[34]

In 1964 the PLA Art Exhibition themes included "the love and regard of the PLA men for the Party and Chairman Mao,"[35] class struggle, and "the great achievements won by the army in holding high the red banner of Mao Tse-tung's thought,"[36] "the heroic personages, combat life, glorious traditions, new people and new things of the armed forces. The themes are salient and the drawings are unmistakable in meaning." The artists are "red in ideology and clear in orientation."[37]

Here content and message take precedence over style and technique. Interestingly, Li Keran, who in 1961 wrote the article "Art Is Achieved by Hard Work" in which he stressed that ideological understanding is insufficient for good art, that there must also be talent, as well as solid artistic training and constant practice, wrote a review of

25. "Zhongguo renminjiefangjun jianjun sanshizhounian jinian meishu zhanlanhui jiang zai 'bayi' juxing," *Meishu*, 1957, no. 1:51; "The Long March Scroll," PC, 1 Aug. 1957, 42–43. Such cooperative works are not a PRC innovation. In traditional China a few artists might, for instance, collaborate in painting the pine, bamboo, and plum of The Three Friends of Winter theme; groups of Qing court artists worked together on painting projects.
26. *Meishu*, 1958, no. 2:3–12, 31.
27. "Art from the Army," PR, 1 March 1960, 21–22.
28. Tuan Chang, "Art Exhibition of the People's Liberation Army," CL, 1960, no. 7:131.
29. Ibid., 134.
30. Reproduced in *Meishu*, 1960, no. 3:29.
31. Reproduced in *Meishu*, 1960, no. 3:28.
32. Reproduced in PR, 1 March 1960, 22.
33. "Art from the Army," 22.

34. "Revolutionization of Pictorial Art," PR, 14 Aug. 1964, 35.
35. Ibid.
36. "Creating Figures of Contemporary Heroes," CP, 1964, no. 10, n.p.
37. "Another Example of Revolutionizing Literary and Art Work—A Short Commentary, *Jen-min Jih-pao*," JMJP, 2 Aug. 1964, SCMP, no. 3285:16.

the 1964 PLA exhibition. Perhaps he was assigned this task as a result of the increasing pressures brought by Mao for rectification in the cultural sphere and, in a way, to atone for his earlier essay, as an exercise in "rectification." In the review Li is short on stylistic commentary and long on content and significance, with statements bespeaking the "spirit of the socialist age," and virtues of the "revolutionary," and "inspirational."[38]

Ma Keh in his comments on the woodcuts included in the 1964 PLA exhibition was explicit about the role of art:

> The main task of woodcut artists in our socialist period should be the depiction of splendid images of positive characters in order to influence, educate and inspire people with the thoughts, deeds and communist spirit of these characters.... These artists from the army have indeed chosen significant themes— the revolutionary conduct of revolutionary units and individuals—to bring out the resolution and fortitude of the P.L.A. men whom no difficulties can daunt, their courage, heroism, selflessness, willingness to sacrifice themselves, as well as their revolutionary spirit and communist style of work in daily life, in their ordinary drill, combat and study.[39]

Ma Keh continues by discussing several woodcuts and accounting for the success of the woodcuts in the exhibition by the fact that the army artists depict subjects from their own experience, so that "their work seems supremely truthful and natural." He concludes with "they 'pass the test' as soldiers say in ideology, experience and technical skill. And that is why their ... delineation of characters presents not only outward appearances but the inner spirit."[40] But before he reached this conclusion he said, "One artist told me that on entering the exhibition hall he had the sensation that a red-hot wave of revolutionary fervour had risen up to greet him."[41] This is perhaps an accurate reflection of the general visual impact of the exhibition, where, if the published paintings are any guide, the color red predominated and the major subjects were army heroes, Mao in one guise or another, and his thoughts.

The army clearly was of great significance, but perhaps even more important was the specific individual: the unique army hero. Here Lei Feng

was a primary model to be emulated. But apparently his unexciting life and his inglorious death (he was killed by a falling telephone pole) did not lend themselves to inspirational art. Much more dynamic were those PLA heroes who actually risked or sacrificed their lives for the weal of their comrades and the people. Such a hero was Ouyang Hai, killed when he shoved an artillery-laden horse off the tracks of an oncoming train. This was depicted by Yang Shengrong (b. 1928) in a Chinese-style painting where the strong diagonal thrust of the man pushing the frightened horse, combined with the engine looming out of the mists and steam, provides a highly dramatic picture (fig. 56).

The new, stronger emphasis upon Mao is manifested either directly, in portraits of the leader, or indirectly, in his thoughts as embodied in his published writings and poems. Artists went to all lengths to provide interesting ways of underscoring the necessity of learning from the study of Mao's political writings. One well-received Chinese-style painting (fig. 57) at the 1964 PLA Art Exhibition was *The Fountainhead* (or *The Spring*) by the PLA professional artist Han Yue (b. 1933). The title ostensibly refers to the waters flowing into a wooden bucket which the army man has set below the spring, but it really refers to Mao's works, which he reads while waiting for the bucket to fill. This is one of the first paintings on the theme of Mao as the "fountainhead" or "source" of knowledge and inspiration, a theme that was repeated in the art of the Cultural Revolution of 1966–1969. Another 1964 PLA work showing a PLA man studying Mao's writings in his spare moments is Gao Quan's (b. 1936) oil *The Furnace Flames Are Really Red* (plate 9). Here an army cook, who has risen early to prepare his comrades' breakfast, sits in front of the stove he tends, its unseen flames casting a red glow over him. The most intensely red area in the whole painting emanates from his copy of Mao's writing. "It shines on the cook's body and in his heart."[42] Pictorializations of the association of sunlight and Mao also appeared. One woodcut, titled *Sunlight by the Pillows*,[43] showed

> a pin-neat dormitory fresh with sunshine, the light seeming to come from squares of the bright red on the covers of copies of Chairman Mao's writings placed by each of the fighters' precisely-folded quilts.

38. Li Ko-jan, "The Third P.L.A. Art Exhibition: Something New in Traditional Painting," CL, 1964, no. 10:80–85. Here it is said that the exhibition lasted from July 14 until August 10.
39. Ma Keh, "New Images in Chinese Woodcuts," CL, 1964, no. 10:85, 86.
40. Ibid., 89.
41. Ibid.

42. Shen Peng in commentary to Gao's painting in *Xiandai meishu zuopin xinshang*, vol. 4 (Beijing: Renmin meishu, 1965), n.p.
43. Reproduced in CR, 1965, no. 11:11.

From Poetry to Politics

Outside the window, green young trees and sunlight give one a strong sense of the close relationship between the fighters and Chairman Mao's writings.[44]

The use of the color red to convey revolutionary fervor, as might be inferred from the paintings described above, became more important in the art of the Third PLA Exhibition. It was also effectively used in one of the few landscapes from that exhibition: Luo Qi's *On the Coastal Front*.[45] In the foreground of this Chinese-style painting, a women's militia group pauses on its way to morning target practice to look at a gun emplacement perched atop a distant coastal peak, conveniently bathed in rosy dawn light.

In another Chinese-style work Zhang Ping (b. 1934) illustrated two lines from a 1935 poem by Mao:

To see the green hills reeling like waves
And the dying sun like blood.[46]

The painting (plate 10) is a panoramic view of the Long March Loushan Pass battle site. Its files of red banners and especially its red-drenched hills make a stark contrast with a painting like Fu Baoshi's silent, remote, white and grey volcano of 1961 (plate 6), a landscape that would clearly be unacceptable.

A final comparison, between two figure paintings, one done in 1962 and one in 1964, is instructive in elucidating the differences between the art tolerated by the state and that now demanded by the more radical faction. In Wei Zixi's *Harvest* of 1962 (fig. 46) a wedge of attractive women in the lower right foreground of the picture relax during their work break. A blank expanse of yard separates them from their colleagues at the left, who in the distance continue gathering the crop. Compositionally, Qi Deyan's *Harvest* of 1964 (fig. 58) is identical: a wedge at the foreground right formed by girl, baskets, rakes, and other agricultural gear, then a blank of the threshing yard, and finally on the left the basketball hoop and a stash of farm implements in front of distant hills. But in Qi Deyan's picture the girl does not gaze off idly into the distance, nor does she relax during her break; instead, a model student, she takes advantage, just like the soldiers in *The Fountainhead* or *The Furnace Flames Are Really Red*, of this

time to study Mao's thoughts. The volume of Mao's writing lies handily nearby as she makes notes; her gaze and her earnest facial expression indicate how seriously she applies herself to harvesting Mao's thought.

The Third National Exhibition of PLA Art of July–August 1964 was seen as a counterpart to Jiang Qing's Festival of Beijing Opera on Contemporary Themes held in Beijing from June 5 to July 31. They are both spoken of as examples of "revolutionization" in the arts.[47] Jiang Qing's achievement was to rid the theater of nonsocialist characters and themes, such as emperors or ghost stories, and to substitute Communist heroes engaged in struggles against oppressors. In May Lin Biao gave explicit instructions to the literary and art workers in the armed forces. He stated that the object of art was to unite and educate the people, inspire the struggle of the revolutionary people, and eliminate the bourgeoisie. To do this, art must be revolutionized, its content must be militant, it must take Mao's thoughts as a guide, it must reflect real life. To accomplish this, art was to be created on the basis of the "three-way combination" (the leadership, the professional personnel, and the masses) which had been devised in the army. Artists were also to pass the "tests in three respects" of studying Mao's writings, penetrating deep into life, and acquiring basic skills. The General Political Department of the PLA issued a formal notification of these instructions on May 31.[48] The "three-way combination" became a required work pattern in art. It is elaborated in articles reviewing the PLA exhibition both in the Party media[49] and in the professional art journal *Meishu*.[50]

The growing strength of the influence of the PLA, Jiang Qing, and Mao's side of art becomes clear when we realize that the "three-way combination" was recommended in an article urging artists to study the PLA art,[51] and was fostered among the artists who in 1964 went to the countryside, such as Su Guang, whose report

44. Na Ti, "Soldier Artists," CR, 1965, no. 11:12.
45. Reproduced in CP, 1964, no. 10, and in *Meishu*, 1964, no. 5:67.
46. *Poems of Mao Tse-tung*, trans. and annotated by Wong Man (Hong Kong: Eastern Horizon Press, 1966), 28.

47. "Another Example of Revolutionizing Literary and Art Work," 16; "Revolutionization of Pictorial Art," 35.
48. "The Tempestuous Combat on the Literary and Art Front—A Chronicle of the Struggle between Two Lines on the Literary and Art Front (1949–1966) (*Shou-tu Hung-wei ping* [Capital Red Guards] compiled by the Congress of Red Guards of Universities and Colleges of the Capital, June 7, 1967)," *Current Background*, no. 842:20.
49. "Artists of Armed Forces Set Examples of Revolutionization for Literary and Art Circles," JMJP, 2 Aug. 1964, SCMP, no. 3285:14.
50. Na Di, "Budui meishu gongzuo geminghuade daoiu," *Meishu*, 1964, no. 4:6.
51. "Meishujia xuexi jiefangjun meishu," *Meishu*, 1964, no. 4:23–24.

was quoted earlier. In another version of his report, he specifically mentions the "three-way combination."[52] By 1965 a series of articles in *Meishu* devoted to or mentioning this work method reveal that the PLA had successfully invaded and controlled the arts.

Intensified Rectification of Artists, 1965–1966

By the early part of 1966, 160,000 artists in the visual, literary, and performing arts had already been sent to the countryside, to factories, and to the armed forces, some to participate in the Socialist Education Movement.[53] There they were to remold their thinking and their art to bring it into line with Mao's demands. Plans were also afoot for the establishment of a regular system whereby literary and art workers would spend one-third or one-half of their year with workers, peasants, or soldiers.[54]

This was in keeping with new directives which insisted:

Art and literature should serve proletarian politics, the workers, peasants and soldiers, and the socialist economic base. This correct and sweeping line for the proletarian cultural revolution is laid down by Comrade Mao Tse-tung. It demands that literary and art workers should revolutionize themselves and become laborers. It also demands that laboring people should become intellectuals, in this way changing culture into a culture of all the working people. The fundamental path for writers and artists to revolutionize themselves and become laborers is to go deep among the workers, peasants and soldiers and unite with the masses. In particular, they should turn to the countryside and serve the 500 million peasants. They should go to rural areas and temper and remold themselves. [Artists in the countryside were to] attach first importance to these things: go deep into life, learn energetically, take part in actual struggles, and remold themselves. Under no circumstances should they give first place to their own regular work, let alone "experience" the mere superficial-

ities of life or go for the simple purpose of gathering raw materials for creative writing.[55]

As this directive indicates, by going among the peasants and workers, artists now were not simply to learn about the people and their life. The object was to use this experience as a means of transforming themselves and their attitudes. We are also told that through the study of Mao's writings they were to rectify incorrect attitudes, such as cherishing individualist thoughts, feeling scorn for labor, holding laboring people in contempt, alienating themselves from politics, and striving to be technically proficient at the expense of redness in thinking.[56]

Li Baijun (b. 1941), a 1963 graduate of the Shandong Provincial Institute of Fine Arts, tells how her experiences of actually living and sharing the work of the peasants affected her art. Under their tutelage she abandoned her preliminary sketches of women going to the fields at harvest time, which showed the "women with dancing gestures, one holding a wheat stalk between her lips" (fig. 59a), for the figure of the "woman team leader with rolled-up sleeves and a sickle in her hand," another "picking up a stalk of wheat from the ground," and "a young girl hurrying forward with a shoulder-pole" (fig. 59b). The figures were inspired by her friends among the commune workers. When Li showed the sketch to the commune members, they commented, "You've got the team leader's spirit . . . but not her beauty." Li realized that

beauty was a complete unity of noble inner qualities and outward attractiveness. . . . My experience made me realize that in the past I had given my main attention to the technical aspects of painting—outward beauty of form and subtle arrangement of colour. Now I have come to understand that the life, thoughts and feelings of the labouring people are the truly important and beautiful things to be portrayed.[57]

By late 1965 references had already been made in the press to a great, socialist cultural revolution.[58]

52. Su Guang, "Zai shenghoude turangzhong shenggen faya," *Meishu*, 1966, no. 1:45.

53. "Chinese Writers, Artists Live Among People," NCNA Peking, 14 Feb. 1966, SCMP, no. 3641:21–23; "Literary and Art Workers, Go to the Countryside to Temper Yourselves!" JMJP editorial, 22 Feb. 1966, SCMP, no. 3649:2.

54. "Literary and Art Workers Go to the Countryside and to Factories for Participation in the Three Great Revolutionary Movements, Reforming and Revolutionizing Themselves in the Smelting Furnace of Struggle—Acting on Chairman Mao's Instructions and Wholeheartedly Uniting Themselves with the Workers, Peasants and Soldiers," JMJP, 22 Feb. 1966, SCMP, no. 3649:5.

55. "Literary and Art Workers, Go to the Countryside to Temper Yourselves!" 1–2, 3.

56. "Promote Revolutionization of Cultural Forces by Studying Chairman Mao's Works," KMJP editorial, 27 Feb. 1966, SCMP, no. 3654:10.

57. Li Pai-chun, "How I Painted 'Wheat-harvesting Time,'" CR, 1966, no. 1:24–25, after her article in RMRB; a slightly different version, titled "Birth of a New Year Picture," is in PR, 29 Oct. 1965, 30–31.

58. Tien Chu, "Fruits of the Cultural Revolution," PR, 15 Oct. 1965, 5.

Art during the
Cultural Revolution,
1966–1969

6

Attacks in 1965 against a long series of essays and articles by Deng Tuo (1911–1966), Liao Mosha (b. 1907), and Wu Han (b. 1911) published between 1961 and 1964 in various periodicals, as well as attacks against the historical play *Hai Rui Dismissed from Office* written by Wu Han, signaled the beginning of the Cultural Revolution. These literary works, it was claimed, assaulted Mao's thoughts and the Chinese Communist Party by "using historical events and characters to mock, attack and slander the realities of present-day socialism." [1]

In late 1965 the Party, under the direction of the mayor of Beijing, Peng Zhen (b. 1902), attempted to abort an all-out rectification campaign by turning the criticisms of Wu Han especially into academic issues, and in early 1966 efforts were made to have this stance formally accepted by the Party. Mao and his supporters contested this position and publicized their opposition through the agency of the PLA and Jiang Qing's Shanghai Forum on Literature and Art in the Armed Forces (discussed below). In May an enlarged meeting of the Politburo adopted the May 16 Circular, which proclaimed:

> The whole Party must ... thoroughly expose the reactionary bourgeois stand of those so-called "ac-

ademic authorities" who oppose the Party and socialism.... To achieve this, it is necessary ... to criticize and repudiate those representatives of the bourgeoisie who have sneaked into the Party, the government, the Army, and all spheres of culture, to clear them out or to transfer some of them to other positions. [2]

To carry out these goals the May 16 Circular created the Cultural Revolution Small Group, headed by Chen Boda (b. 1904), Jiang Qing, and Kang Sheng (1899–1975). They took control of the Party propaganda. [3]

The Cultural Revolution itself began in earnest in the spring of 1966, when Nie Yuanzi, Party secretary in the philosophy department at Beijing University, posted her "large character" poster attacking the administration of the university and demanding changes. Liu Shaoqi (who was in command in Beijing, since Chairman Mao was in Hangzhou), sent work teams into the university to resolve the problems, but the work teams only

1. Y. T. Hsiung, *Red China's Cultural Revolution* (New York: Vantage Press, 1968), 54; for a solid evaluation of these conflicts, see Merle Goldman, *China's Intellectuals: Advise and Dissent* (Cambridge: Harvard University Press, 1981).

2. Hong Yung Lee, *The Politics of the Chinese Cultural Revolution: A Case Study* (Berkeley and Los Angeles: University of California Press, 1978), 16; "Circular of Central Committee of Chinese Communist Party (May 16, 1966)," PR, 19 May 1967, 6–9.
3. The following is based primarily upon information found in Lee, *Politics of the Chinese Cultural Revolution*; Byung-joon Ahn, *Chinese Politics and the Cultural Revolution: Dynamics of Policy Processes* (Seattle and London: University of Washington Press, 1976), 185–213; and Maurice Meisner, *Mao's China: A History of the People's Republic* (New York: Free Press, 1977), chapter 18.

increased the antagonisms between the students and the administration.

In August 1966 the eleventh session of the Central Committee Meeting approved Lin Biao, the defense minister, as Mao's successor, replacing Liu Shaoqi, who was now blamed for mishandling the Beijing University situation and degraded. With this meeting the Great Proletarian Cultural Revolution got into high gear.

According to a statement issued on August 8, 1966, by the Central Committee, the Cultural Revolution had three major goals. One was to crush Liu Shaoqi (initially only referred to by euphemisms, such as "China's Khrushchev" or "the one in charge taking the capitalist road," he was named as a specific target for criticism in October 1966). A second goal was to eliminate "reactionary bourgeois academic 'authorities,'" ridding educational institutions and curriculum of bourgeois influences in basically an anti-intellectual and anti-expert ("red" over "expert") campaign. A third aim was "to transform education, literature and art and all other parts of the superstructure that do not correspond to the socialist economic base, so as to facilitate the consolidation and development of the socialist system."[4] In other words, the aim was to transform art into an art for the masses; especially it was to be used as a vehicle for educating the masses by, among other things, inculcating the spirit of revolution (since Mao felt that youth in particular lacked the revolutionary spirit to fight capitalist or bourgeois elements in society). The instrument to accomplish these goals was Mao and his thoughts. Concurrently, Lin Biao continued his promotion of the movement to insure unswerving loyalty to Mao through the model of the PLA and through the little red book of *Quotations from Chairman Mao Tse-tung*. The ensuing focus on Mao culminated in a dramatic escalation of the Mao personality cult engineered by Lin Biao.[5]

In August 1966 Mao called upon students to denounce those of their professors, teachers, and staff members who harbored bourgeois ideas. These people and their ideas were attacked through the big-character posters pasted on walls or hung on lines. The students, now "Red Guards," were to be the revolutionary heirs and were to campaign against "the four olds": old ideas, old culture, old habits, and old customs. As the students abandoned the classrooms to undertake this revolutionary task schools effectively closed down.

The Red Guards began to travel throughout China to meet with each other to "exchange revolutionary experiences," but particularly to visit Beijing and participate in the mass meetings on Tiananmen Square. These assemblies, reviewed by Mao, served as a means of demonstrating loyalty to him and his ideology. In November the Red Guards were told by the government authorities to return to their homes, for their incessant traveling at government expense had, among other things, begun to disrupt the transportation system nationwide. The students refused to relinquish this opportunity for travel and adventure. The government then declared that they would no longer be granted free transportation and suggested that if they wished to travel, they should do so on foot. This was encouraged as a means of learning revolutionary fervor by re-creating the Long March of 1934–1935. In December the Cultural Revolution was carried into the industrial sector, and workers started traveling around the country or even going out on strikes.

In January 1967 the January revolution in Shanghai attacked the party structure: Liu Shaoqi and his cohorts. During this month the Cultural Revolution moved to the countryside, while in the larger cities and industrial areas there were skirmishes between rival student organizations and between students and workers. By midsummer of 1967 the PLA was called in to bring things under control, but did not have much success; armed conflicts became common, and throughout the remainder of 1967 and through 1968 the PRC was near anarchy. Meanwhile, the campaign directed specifically against Liu Shaoqi intensified from April through June of 1967.[6] Then, in July 1968 Chairman Mao sent a basket of mangoes to workers and peasants who had sought to be mediators at one of the universities in Beijing. Some of the peacemakers had been injured by the students. This gift was construed as a signal that Mao disavowed the youthful Red Guards and placed his faith in workers and peasants. In October 1968 Liu Shaoqi was purged from the Chinese Communist Party. Finally, in April 1969 Lin Biao's appointment as successor to Chairman Mao was officially ratified by the Ninth Party Congress, the Cultural Revolution was more or less over, and the country began to return to normal.

4. "Decision of the Central Committee of the Communist Party of China Concerning the Great Proletarian Cultural Revolution (Adopted on August 8, 1966)," PR, 12 Aug. 1966, 6.

5. See Helmut Martin, *Cult and Canon: The Origins and Development of State Maoism* (Armonk, N.Y.: M. E. Sharpe, 1982).

6. Lowell Dittmer, *Liu Shao-ch'i and the Chinese Cultural Revolution: The Politics of Mass Criticism* (Berkeley and Los Angeles: University of California Press, 1974), 161.

Art during the Cultural Revolution

During the Cultural Revolution the PLA and the Cultural Revolution Small Group under Chen Boda, Jiang Qing, and Kang Sheng controlled the arts. Jiang Qing's direct involvement with the arts began considerably earlier. In November 1961 she undertook drama reform,[7] persevering in her efforts to cleanse the stage of lingering bourgeois elements until by 1966 only eight performance pieces (five operas, one concerto, and two ballets) had her official approval. These eight theater pieces are referred to repeatedly as major artistic works of the period. In February 1966 Lin Biao requested her to convene a forum on literature and arts in the armed forces in Shanghai. This forum was used to define the position of Mao and his supporters in their conflict with Peng Zhen. Mao's side refused to accept the proposal that the issues involved in the argument over the essays and articles by Wu, Deng, and Liao and over Wu's play were entirely academic. Instead, Mao's group saw them as political, anti-Party, and anti-Mao. They assailed this literature as bourgeois and reactionary, associating it with the anti-Party literature of the 1930s; and finally they condemned those who wrote this type of literature as well as those in the leadership who permitted it to flourish. These people were, to Mao's group, political deviants following the "black line." *The Summary of the Shanghai Forum* convened by Jiang Qing was revised by Mao three times before it was sent down to be circulated at the county level in April 1966 (it was not made public until a year later, in May 1967).[8] On November 28, 1966, at a massive rally of more than 20,000 literary and art workers held in Beijing to repudiate the bourgeois reactionary art line, Jiang Qing was appointed adviser on cultural work to the Chinese People's Liberation Army, thereby receiving formal recognition of her de facto arrangement with the PLA. Further, it was announced that her opera troupes were to be brought under the jurisdiction of the PLA.[9]

Since the Cultural Revolution Small Group and Jiang Qing owed their power and position to Mao Zedong, it behoved them to aggrandize his image and leadership. To this end, Mao's Yan'an *Talks*, largely tacitly ignored for several years, were thrust back into prominence. This was achieved under the guidance of Jiang Qing, whose opening statements in the *Summary of the Shanghai Forum* reaffirmed the need for cultural workers to study Mao's thoughts. The army and party press assisted through their editorials, as in an article (which for all intents and purposes duplicates the content of the *Summary*) printed on April 18 in the *Liberation Army Daily* and also carried the next day in the *People's Daily*.[10] The anniversary of the publication of Mao's Yan'an *Talks* in May 1966 was the occasion for reviewing the circumstances and substance of the *Talks* in a long essay in the *Liberation Army Daily*.[11] And, finally, Mao's Yan'an *Talks* were reprinted in July 1966, in August 1966, in May 1967, and in August 1967.[12] May 1967, the twenty-fifth anniversary year of the Yan'an *Talks*, saw the first publication of Jiang Qing's *Summary of the Shanghai Forum*. The *Summary* capped a series of five short pronouncements and documents on literature and art by Mao Zedong, and it received as much editorial comment as did Mao's own statements.[13] In succeeding years the *Shanghai Summary* nearly became a classic, receiving special attention in 1968[14] and again in 1969. The commemoration published in 1969 was composed by two writers named Hong Wen and Xue Qing. The meaning of their names, respectively "Red Literature" and "Study [Jiang] Qing," reveals the adulation now accorded Mao's wife.[15]

10. "Hold High the Great Red Banner of the Thought of Mao Tse-tung and Take an Active Part in the Great Socialist Cultural Revolution," *Chieh-fang-chün Pao* editorial, 18 April 1966; JMJP 19 April 1966, SCMP, no. 3687:4–15.
11. "Studying 'Talks at the Yenan Forum on Literature and Art,'" CR, 1966, no. 9:10–19.
12. Bonnie S. McDougall, *Mao Zedong's "Talks at the Yan'an Conference on Literature and Art": A Translation of the 1943 Text with Commentary*, Michigan Papers in Chinese Studies, no. 39 (Ann Arbor: University of Michigan, Center for Chinese Studies: 1980), 39.
13. PR, 2 June 1967, 5–27, 33.
14. "Exercising a Powerful Proletarian Dictatorship in the Realm of Culture—Workers, Peasants and Soldiers Commemorate First Anniversary of the Publication of the 'Summary of the Forum on the Work in Literature and Art in the Armed Forces with which Comrade Lin Piao Entrusted Comrade Chiang Ch'ing,'" PR, 21 June 1968, 5–7.
15. Hung Wen and Hsueh Ch'ing, "Always Advance Courageously Along Chairman Mao's Revolutionary Line for Literature and Art—Some Considerations in the Study of 'Summary of Forum on Literary and Art Work in the Armed Forces Convened by Comrade Chiang Ch'ing at the Request of Comrade Lin Piao,'" JMJP, 17 March 1969, SCMP, no. 4384:4–10. (A slightly different translation in PR, 16 May 1969, 9–12.)

7. Wang Chang-ling, "Overt and Covert Struggles between Mao and Liu over Literature and Art," *Issues and Studies* 4, no. 3 (Dec. 1967): 6.
8. "Minutes of Forum on Literature and Art in the Armed Forces Convened by Comrade Chiang Ch'ing on Comrade Lin Piao's Request—Document of the CCP Central Committee (April 10, 1966)," SCMP, no. 3956:1–5; "Summary of the Forum on the Work in Literature and Art in the Armed Forces with which Comrade Lin Piao Entrusted Comrade Chiang Ch'ing," SCMP, no. 3951:10–17, also in PR, 2 June 1967, 10–16.
9. "Literature and Art Workers Hold Rally for Great Proletarian Cultural Revolution," PR, 9 Dec. 1966, 5, 9.

Art during the Cultural Revolution

The major points from Mao's *Talks* stressed in the articles and commentaries were (1) the persistence of class struggle, that bourgeoisie and proletariat are locked in a continuous battle for control of the arts, that the proletariat must constantly be on guard against the inroads of the bourgeoisie, and that art must reflect the class struggle; (2) that art must serve the workers, peasants, and soldiers; (3) that artists must integrate themselves with the masses and study Mao's works; (4) that the materials in the life of the people "provide literature and art with an inexhaustible source, their only source"; (5) the necessity of creating heroic characters that are "on a higher plane, more intense, more concentrated, more typical, nearer the ideal" and therefore more universal than actual everyday life; and (6) that artists must make the old serve the new, the foreign serve China, and must weed through the old to let the new emerge.

In May 1967, coinciding with the publication of Jiang Qing's *Summary of the Shanghai Forum* and Mao's five art documents and as part of the general celebration of the twenty-fifth anniversary of the publication of the Yan'an *Talks*, all five model revolutionary operas, the two ballets, and the symphony were performed in Beijing. These operas include (1) *Taking Tiger Mountain by Strategy*: set in Manchuria during the War of Liberation (1946), the plot involves the heroic deeds of an army detachment and its leader in destroying a Guomindang gang; (2) *On the Docks* takes place in the summer of 1963 and focuses on workers; its theme is the struggle between the proletariat and bourgeoisie to win the younger generation of dockers; (3) *The Red Lantern* describes three generations of a family in north China and their exploits against the Japanese invaders; (4) *Shajiabang* deals with the liberation of the town of Shajiabang in Jiangsu during the war with Japan; (5) *The Raid on White Tiger Regiment* is set in Korea in 1953 and involves the defeat of the U.S. White Tiger Regiment by the Chinese People's Volunteers. The two ballets are *The Red Detachment of Women*, which takes place in 1927–1937 and is about a poor peasant girl on Hainan Island who becomes a revolutionary fighter instead of a slave, and *The White Haired Girl*, also about a girl who, in the late 1930s in a Hebei village escapes from an evil landlord, subsists in the mountains (which makes her hair turn white), and gets her revenge after her village is liberated. The model revolutionary symphony is based on the music for the opera *Shajiabang*.[16]

These performance pieces received so much acclaim because they embodied Jiang Qing's translation of Mao's ideas into actuality. They "enable the heroic images of the workers, peasants and soldiers, who are the makers of history, to occupy the stage. This is a great victory for Mao Tse-tung thought."[17] Basically, their themes were those of class struggle, their heroes were guided by Mao Zedong thought, their political content was clear[18] and educational, their stories came from the people, and they were a practical demonstration (since most of them were based on existing plots) of weeding through the old to let the new emerge; and finally, the Western music and staging incorporated into the operas were evidence of making the foreign serve China. Making the foreign serve China was, of course, patently evident in the ballets and the symphony. Moreover, these operas were reworked and revised on the theory that they could always be improved. In addition, in creating these model revolutionary operas, Jiang Qing followed and developed for the theater the army's procedure of three-level creation involving the authority of the Party (the cadres, who had the greatest responsibility), the experts (the actors, playwrights, musicians), and the masses, who served as teachers and critics.[19] Because these operas had substantial political content and because they were "models" setting standards to be followed, to insure that they functioned as such they were widely disseminated through actual stage performance, through the publication of scripts and scores for use by local troupes, as well as through film and radio.[20]

Two observations originally made about opera and literature also pertain to other arts. First, moving from individual creation of the early 1960s to collective creation in the late 1960s brings art more within the Communist line, for the result is the product of the collective wisdom of the masses rather than the product of an individual mind, a personal and bourgeois concept.[21] Second, the shift from nonheroic figures of the early

16. For the development and synopses of the texts, see, Hua-yuan Li Mowry, *Yang-pan-hsi—New Theater in China,*

Studies in Chinese Communist Terminology, no. 15 (Berkeley: University of California, Center for Chinese Studies, 1973), chapter 5. Other sources include Roxane Witke, *Comrade Chiang Ch'ing* (Boston: Little, Brown, 1977), chapters 16 and 17; Louise Wheeler Snow, *China on Stage* (New York: Random House, 1972). CP, 1967, no. 8, is a special issue devoted to the Yan'an *Talks* and is illustrated with scenes from the operas, which are termed "brilliant models."
17. "Exercising a Powerful Proletarian Dictatorship," 6.
18. "Hail Victory of Mao Tse-tung Line on Literature and Art," NCNA Peking, 27 May 1967, SCMP, no. 3950:11.
19. See Mowry, *Yang-pan-hsi*, chapter 3, for further explanation of how this worked in the theater.
20. Ibid., 21–22.
21. Ibid., 4–6.

Art during the Cultural Revolution

1960s to heroes of the late 1960s "reflected a shift from the recognition of human and economic limitations to the belief that self-sacrificing people could overcome all obstacles."[22]

Initially, the standards for content and the method of creation set by the model operas were the most important; later, in the early 1970s, the presentational methods of the model operas provided guides for the delineation of the heroic in the visual arts.

The Rent Collection Courtyard

The model revolutionary operas had a counterpart in the *Rent Collection Courtyard* sculptures (fig. 60), frequently mentioned along with the model operas. In June 1965 a group of sculptors from the Sichuan Institute of Fine Arts was assigned by the provincial leadership to create a panorama of 114 life-size clay figures depicting peasants bringing their rent into a notorious landlord's residence, his "brutal exploitation" of the peasants, and their "simmering anger."[23] The theme, expounding class struggle, coming from the people, and set in pre-Liberation days, is highly political and educational and parallels those of the model operas. During the actual making of the clay figures the tri-level approach was employed. The Party was represented by the provincial leadership, the experts by the trained sculptors from the art institute. The figures were produced on the very spot where they would be installed: in the open verandas of the landlord's mansion now converted into a museum. The sculptors listened to comments and criticisms of the local peasantry, who often stopped by to see how the work was going. The peasants, some of whom had actually been tenants of this landlord, described the grim real-life situation in the old days, and they suggested ways of improving the figures, such as the use of glass eyes to provide a more realistic facial expression. Thus, the sculptors were educated politically and artistically by the masses. The sculptural panorama also satisfied the demand to make the old serve the new because the figures utilized traditional techniques once used for making religious images.[24] The *Rent Collection Courtyard* doubled as a sort of "speak bitterness," describing the hard lot of the ordinary peasant before Liberation with the implied contrast of post-Liberation sweetness of life, for it is a vital and gripping visualization of the injustices and brutality which often characterized life in China before 1949.

To increase its potential impact as a "model," as well as to spread its educational message, the *Rent Collection Courtyard* was quickly publicized, and just like the operas, it underwent revisions. Shortly after it opened to the public on National Day, October 1, 1965, photographs of it and copies of some of the figures made by sculptors in Beijing were put on exhibition in one gallery of the Museum of Chinese Art in Beijing.[25] By late 1967 replicas of the whole were on display in Beijing (significantly, in the Hall of the Worship of the Ancestors in the former Imperial Palace),[26] and modifications had been introduced. The 114 figures were increased to 119, 16 of which were entirely new; some figures were remodeled, incorporating the ideas of workers, peasants, and soldiers and Red Guards. These revisions gave "bolder expression" to the "great and invincible thought of Mao Tse-tung" and carried the whole work "to a still higher ideological and artistic level."[27] The effect of these changes caused one Westerner to observe, "Whereas in the autumn of 1966 there were still figures who made a tragic impression or aroused one's sympathy, one year later they were all suffused with a relentless fury."[28] The most extensive changes were in the final section of the six-part display, the portion titled "Revolt." Here sculptured figures held placards with political slogans or a volume of Mao's writing, all in keeping with the ongoing Mao cult.[29] This revised version was touted as a victory for Mao Zedong thought.[30]

22. Goldman, *China's Intellectuals*, 103.
23. "New Szechuan Clay Sculptures: 'Compound Where Rent Was Collected,'" PR, 3 Dec. 1965, 26.
24. "A Revolution in Sculpture," CR, 1966, no. 3:30.
25. "New Year Holiday Attractions," PR, 1 Jan. 1966, 31; "Exhibition of the Newly Reproduced Clay Sculptures 'Compound Where Rent Was Collected,'" CL, 1967, no. 4:138.
26. Audrey Topping, "'The Rent Collection Courtyard': Art for Another Public," *Art in America* 62 (May 1974): 70.
27. The Team Which Made the "Rent Collection Courtyard," "First Revolutionize One's Mind, Then Revolutionize Sculpture," PR, 16 Dec. 1966, 23.
28. D. W. Fokkema, *Report from Peking: Observations of a Western Diplomat on the Cultural Revolution* (London: C. Hurst, 1971), 82.
29. "Exhibition of the Newly Reproduced Clay Sculptures," 139. See appropriate illustrations in *Rent Collection Courtyard: Sculptures of Oppression and Revolt*, 2nd ed. (Peking: Foreign Languages Press, 1970).
30. The Team Which Made the "Rent Collection Courtyard," 33. The message of the *Rent Collection Courtyard* was not temporary. In 1977 a picture story booklet, *Hatred from Water Dungeon* (story by Chen Tse-yuan and illustrations by Hsu Heng-yu, Peking: Foreign Languages Press), elaborated on one of the more grim episodes depicted in the *Rent Collection Courtyard*. I am indebted to William Trousdale for bringing this booklet to my attention.

Art and Artists in Disgrace

As a consequence of the constant stress upon Mao's art dictates, the variety of subjects, the innovations, individualism, and "poetry" in art, the travels of professional artists, the one-man shows, the publication of monographs of artists' work, all the practices which characterized a liberal attitude toward art and artists during the previous five years came to an abrupt halt. Professional associations and unions were abolished; professional journals in literature and the arts ceased publication (except *Chinese Literature*).

Although it is known that many painters and others in art circles were falsely accused and persecuted during the Cultural Revolution, specifics are difficult to obtain. The following supplies a rough idea of how and why artists might run afoul of those now in control of culture and art.

In April 1967 Cai Ruohong and Hua Junwu (1915–1982), the heads of the Chinese Artists' Association, were held responsible for the now-despised activities and attitudes of the early 1960s. These two men were scathingly attacked in an article as counterrevolutionary revisionists opposed to Chairman Mao's declaration that art should serve workers, peasants, and soldiers. They generally were accused of taking the "black line." Because they had allowed one-man shows, they had "opened wide the gate for bourgeois 'authorities' and ghosts and monsters" and had permitted the exhibition of "old feudal dregs or bourgeois junk which should have been consigned to the rubbish heap of history" and which in no sense supported Mao's *Talks*, such as "paintings of lemons, cherries, dead fish, girls with flowers, lohans conquering tigers and similar trash." Under the heading "They encouraged pleasure trips but opposed merging with the workers, peasants and soldiers," Cai and Hua were berated, through thinly veiled references to the trip taken by Fu Baoshi and Guan Shanyue in 1961 to the northeast, for "squandering the people's hard-won wealth to satisfy the luxurious tastes of bourgeois 'authorities.'" In another section of the article they were accused of using "high salaries, fat fees and 'liberalization' to corrupt young artists and undermine the ranks of revolutionary art . . . and to push art onto the capitalist road." This included sponsoring one-man exhibitions and permitting the sale of the exhibits. They "spared no pains to help that notorious black artist, the counterrevolutionary Huang Chou." For example, "When Huang Chou rented a sumptuous studio and complained of the high price he had to pay, Hua

Chun-wu told him, 'Never mind. I'll help you sell more of your paintings of donkeys.'" And last, Cai and Hua were accused of trying to "stop workers, peasants and soldiers from mastering the weapon of art."[31]

The Red Guard tabloid *Art Storm* was published in June 1967 at the height of the campaign against Liu Shaoqi. Its editors were various Red Guard organizations from Beijing art establishments: the Central Art Academy, the Central Arts and Crafts Academy, the Chinese Art Research Institute, the Beijing Painting Academy, and the People's Art Publishing House. In the foreword to this publication, the world-renowned grand master of traditional-style Chinese painting, Qi Baishi (1863–1957), and the foremost landscapist of the early twentieth century, Huang Binhong (1865–1955), both of whom had been dead for nearly a decade, were dubbed "rice-valley landlords."[32] Elsewhere Qi was branded a revisionist.[33] In *Art Storm* Jiang Feng and Shao Yu were called "big rightist traitors," while Wo Zha, a woodcut artist prominent in Yan'an during the 1930s and 1940s, was labeled merely a traitor. The calligrapher and art critic Huang Miaozi (b. 1913) was in disfavor and dubbed "secretary of the treasury for the GMD." Other artists were criticized on the basis of their pre-1949 political affiliations. Ye Qianyu, famous for his 1930s cartoon strip "Mr. Wang and Little Chen," had, along with his wife, the noted dancer Dai Ailian (b. 1916), visited the United States under a State Department exchange program in 1946–1947;[34] he was accused of being a "cultural secret agent for the Sino-American Cooperation Bureau." Huang and Ye were further accused of association with the Erliutang, a club of cultural workers formed in Chongqing during the early 1940s. The political platform of this club allegedly was anti-Party and anti-socialism.[35] Also indicted as members of the Erliutang were the cartoonists Zhang Ding (b. 1919), Hu Kao (b. 1912), Zhang Guangyu (1900–1965), his brother Zhang Zhengyu (1904–1976),

31. Chao Hui, "An Art Programme Serving the Restoration of Capitalism," CL, 1967, no. 4:123–127. Further accusations against Cai and Hua are found in Hsin Ping, "Tsai Jo-hung Is the Ring-leader of the Anti-Party Gang in the Field of Art," CL, 1967, no. 4:128–132, and Hung Yu, "Hua Chun-wu Is an Old Hand at Drawing Black Anti-Party Cartoons," CL, 1967, no. 4:133–136.
32. *Meishu fenglei*, Beijing, 1967, 1.
33. Fokkema, *Report from Peking*, 145.
34. Howard L. Boorman and Richard C. Howard, eds., *Biographical Dictionary of Republican China* (New York: Columbia University Press, 1967), 4:26–27.
35. Lau Yee-fui, Ho Wan-yee, and Yeung Sai-cheung, *Glossary of Chinese Political Phrases* (Hong Kong: Union Research Institute, 1977), 94–95.

and the woman oil painter and art critic who once studied in Europe, Yu Feng. They and the cartoonist Ding Cong (b. 1916) were all declared "ghosts and monsters." Three prominent artists, Wu Zuoren, Guo Weiqu (1909–1971), and Huang Zhou, were linked as sympathizers to Deng Tuo, Wu Han, and Liao Mosha as "*Three Families Village* black painters."[36] Huang Zhou was indeed a friend of Deng's, with whom he discussed ancient literature and paintings. During the Cultural Revolution Huang, confined and not allowed to paint, collected night soil, cleaned lavatories, and swept the streets.[37]

In 1968 the Zhejiang Institute of Fine Arts in Hangzhou was pinpointed as "a big dyeing vat," which, when under the control of the GMD, was primarily concerned with political struggles, not art, because army people were sent to the Institute and it was a harbor for reactionary authorities (perhaps because of its associations with anti-Party rightists in 1957). Its president, Pan Tianshou, one of the most gifted bird-and-flower painters of the twentieth century, was branded "a reactionary painter," as was the Beijing bird-and-flower expert Chen Banding. Jiang Qing disparaged a *Bald Eagle* painting by Pan as "very gloomy," and her colleague Yao Wenyuan (b. 1931) explained that this "has something to do with his activities as a secret agent. He personified the secret agent." Qi Baishi was once again defamed, this time as an "old miser," with the story that "at the time of his death he wrapped gold bars around his waist and wanted to take them with him into the coffin."[38]

Art and Artists in Favor

With the professional artist and his work in disgrace, the art done during the Cultural Revolution years is distinctly different from that of the first half of the 1960s decade. The art of the Cultural Revolution is largely anonymous. Occasionally works were done by members of an institution or some other collective group. Rarely, however, is a single individual credited with a painting. The art is largely figural and completely politicized; many of the subjects are bombastic and sloganized. Since much of it is poster art, the messages are obvious: people are shown in dynamic poses; colors are brilliant, bordering on the gauche; and red, the color of revolutionary fervor, predominates.

In some cases the art is purely journalistic reporting: Chairman Mao inscribing his big-character poster *Bombard the Headquarters*, or *Every Mango Shows His Solicitude* (commemorating the gift of mangoes to the workers and peasants).[39] As the people were called upon to criticize and denounce the state's enemies, one picture shows a little girl with a malicious expression on her face, writing a poster declaiming "Down with China's Khrushchev" while grandmother holds the inkstone and encourages the child in her task.[40]

The continued role of the PLA as Mao's spokesmen and interpreters put it again into the fore as a subject during the Cultural Revolution; for example, the army man draws his "source of strength" from Communist writings or from Mao's works. The PLA hero (real or fictitious) also continues as a model to be emulated: Liu Wenzhong and members of the Fourth Platoon who rescue Red Guards caught in a flash flood, or Cai Yongxiang who dies removing a log which had fallen across the tracks before an oncoming train.[41] Ouyang Hai, who pushed a frightened artillery-laden horse off the tracks in front of an oncoming train, remained popular. In 1964 he was depicted by Yang Shengrong (fig. 56) in a picture replete with the necessary narrative details: the man pushing the lunging horse, the tracks, and the engine behind swirling steam; by 1965 and later, dramatically tense representations of Ouyang Hai show only the man struggling to force a massive, powerful horse up off its haunches (figs. 61, 62). Not only is the image much more compact, it is also abbreviated, like a quotation from Chairman Mao's writings; for now there need be only the horse and the man to recall to mind the heroic model Ouyang Hai.

The *Rent Collection Courtyard* was imitated throughout China. One sculptural group in Tianjin presented in vivid detail and color (the latter a feature absent in the *Rent Collection Courtyard*) the pre-Liberation conditions in sweatshops where waifs were coerced and duped into signing "slave bonds."[42] Another sculptural panorama gave

36. *Meishu fenglei*, 1–2.
37. Victor Wu, comp., *Contemporary Chinese Painters* (Hong Kong: Hai Fen, 1982), 1:28–29.
38. "Excerpts from Speech by Comrade Chiang Ch'ing on May 19 in an Interview with Chang Yung-sheng, Vice Chairman of Chekiang Provincial Revolutionary Committee," Canton *Huo-chü t'ung-hsün [Torch Bulletin]*, no. 1, July 1968, SCMM, no. 622, 6 Aug. 1968, 7.

39. Reproduced in CR, 1968, no. 2, front cover, and CL, 1968, no. 11, opp. 12.
40. Reproduced in CL, 1968, no. 2, opp. 96.
41. Reproduced in CR, 1968, no. 3:11, and CL, 1969, no. 3, opp. 84.
42. "A History of Blood and Tears—On the Art Works of the Three Stones Museum in Tientsin," CL, 1969, no. 11/12: 121–140.

visual form to *The Air-Force Man's Family History*.[43] The *Wrath of the Serfs*, depicting life in Tibet, made in 1976, is the last known example of this type of art.[44]

Art exhibitions were vast in scope and were attended in record numbers. In Beijing perhaps the most important of these was "Long Live the Victory of Chairman Mao's Revolutionary Line," which ran in 1967 from October 1 through November 30 at the Museum of Chinese Art. The report devoted to this exhibition claims that the show was seen by half a million people. Some 1,200 art works in all media were presented. Included were a set of eleven woodcuts, *Long Live Chairman Mao*, done by a group of Red Guards at a Beijing Teachers' Institute; it depicted "stormy scenes of major mass movements personally led by Chairman Mao during the long years of the Chinese people's revolution." Another work was *Bombard the Headquarters—My Big-Character Poster*, done by Red Guards at the Central Handicrafts Art Institute. Other entries by Red Guards were *Sunflowers Turn Their Faces to the Sun*, and *Chairman Mao with Red Guards*. Some of the art work on exhibition was done by local workers in cooperation with professional artists. The city of Shanghai also contributed entries to the Beijing show. The report states that "in the January revolution, Shanghai artists produced powerful paintings and sculptures to record the heroism of the city's revolutionary masses who were the first in the country to seize power from the handful of capitalist-roaders . . . and organize their own city revolutionary committee. Those of their works chosen for exhibition met with tremendous interest." Also displayed were paintings illustrating quotations from Chairman Mao—a Shanghai innovation for popularizing Mao's teachings.[45] Paintings by Red Guards were also featured at an exhibition at the Branch of The People's Art Publishers, formerly known as Rongbaozhai, the famous stationers and art-reproduction studio in Beijing, which was taken over by the Red Guards in 1967.[46]

Two exhibitions in Shanghai were titled "The January Revolution" and "Long Live Mao Zedong's Thought!"[47] Exhibitions were normally divided into sections by theme. "The Red Sun" show, for example, was in three parts. The first section dealt "with the revolutionary struggle of the Chinese people under Chairman Mao's leadership to defeat the imperialist aggressors and domestic enemies"; the second portion "shows the love of the revolutionary people of the whole world for their great leader Chairman Mao"; and the last part, "the largest of the three, depicts the unprecedented great proletarian cultural revolution initiated and led by our most respected and beloved great leader Chairman Mao."[48]

Images of Mao as Leader, Pedagogue, and Deity

As is evident from the preceding, throughout the Cultural Revolution images of Mao and his thoughts dominate the art. A number of these depictions are worth examining from the standpoints of subject and style. The subjects, of course, reflect the stress upon Mao's thought and his personality cult which culminate in his apotheosis. In style or presentation, the origins of some images can be identified in much earlier prototypes. Two main streams of visual imagery contribute to the pictorialization of Mao as deity. One source, stemming from the identification of Mao with Lenin, relies upon symbols and images derived from paintings and posters of the Soviet leader; the other source is the Buddhist icon. Visual or stylistic allusions can also convey meaning and significance, although it is impossible to judge how many Chinese viewers were equipped to recognize and understand them.

As was mentioned earlier, art tended to become very narrow in the range of permissible subjects and styles, circumstances that unavoidably led to stereotyping. Interestingly, the greatest amount of stereotyping during this era is found in the images of Mao himself. One sculpture of Chairman Mao, presumably the statue unveiled at Qinghua University in Beijing on May 4, 1967, showed him dressed in a military greatcoat, a figure "full of energy and vitality, with his right arm stretched

43. "Art that Serves Proletarian Politics," CR, 1968, no. 2:20, 24; "Red Artist-Soldiers and the Revolution in Fine Arts Education," CL, 1969, no. 9:90–91; "Forum on the Clay Sculptures 'Family Histories of Airmen,'" CL, 1968, no. 3:106–123.
44. *Wrath of the Serfs—A Group of Life-size Clay Sculptures* (Peking: Foreign Languages Press, 1976).
45. "Art Exhibition Hailed as Victory for Chairman Mao's Revolutionary Line," NCNA Peking, 30 Nov. 1967, SCMP, no. 4072:21–23; "Art that Serves Proletarian Politics"; a shorter report in "Peking Art Exhibition Shows Victory of Chairman Mao's Revolutionary Line," CL, 1968, no. 1:118–120.
46. *Meishu fenglei*, 20.

47. "'The January Revolution'—an Exhibition of Paintings by Workers, Peasants and Soldiers of Shanghai," CL, 1967, no. 10:136–137; "'Long Live Mao Tse-tung's Thought!' Pictorial Exhibition," CL, 1967, no. 12:120.
48. "'The Red Sun' Painting Exhibition," CL, 1968, no. 4:114–115.

Art during the Cultural Revolution

forward and pointing the way of advance for the revolutionary students and teachers and the hundreds of millions of Chinese people."[49] Replicas of this statue were ubiquitous: in the Exhibition Hall in Shanghai, at a factory entrance in Luoyang, in the city plaza of Shenyang. It was the center of demonstrations where young women held aloft paper sunflowers which turn toward the sun, a popular metaphor during this period (fig. 63). The prototype for this gigantic sculpture is the *Monument to Lenin* by Sergei Yevseyev, done in 1924–1926, now in front of the Finland Station in Leningrad (fig. 64). Depictions of Mao in this pose are direct links to the concept current in the Cultural Revolution that Mao was a second Lenin.[50] The obvious gesture of the raised, outstretched arm can also be interpreted as one of imperial authority, as in the famous sculpture portrait of Caesar Augustus found at Prima Porta, near Rome. However, the Lenin connection is perhaps the stronger, for it is emphasized repeatedly in pictures of Mao at all stages of his career, pictures which, reminiscent of images of Lenin seen on propaganda posters during the 1920s,[51] represent the Chinese leader with one arm raised: leading the miners' strikes at Anyuan, lecturing at the Yan'an Forum on Literature and Art, commanding a mighty army to cross the Yangtze during the War of Liberation, to give but a few examples.[52]

Through many Cultural Revolution posters and pictures, Mao is promoted as the great teacher. This is also consistent with his being equated with Lenin the teacher.[53] One poster of Mao indicates that at home his thought illumines the theater: standing in front of a large red sun, he is flanked by the casts of revolutionary operas (fig. 65). The appeal of his thought and of him as a revolutionary leader extends throughout the world, for like the sun, his thought lights up Africa in a poster where an African holding a volume of Mao's works is surrounded by representatives of other African nations.[54] A large sun is frequently asso-

ciated with Lenin, as in a poster commemorating the fifth anniversary of the October Revolution, which shows him standing on a globe, one arm outstretched and the rising sun with radiating beams behind him.[55] Imperial connotations are also present here: in olden days, heavenly grace, the beneficent warmth and light of the sun, along with the color red, were associated with the Chinese emperor.[56]

A second stereotyped depiction of Mao shows him at Tiananmen surrounded by frantic adoring masses of Red Guards and waving his cap. Two paintings of nearly identical composition appeared in 1967 with the titles *Chairman Mao—the Reddest, Reddest Red Sun in Our Hearts Is With Us* (fig. 66) and *Chairman Mao Is the Never-setting Sun in Our Hearts* (fig. 67). These two paintings are nearly identical in composition because they are both based on a photograph of Mao and other leaders mingling with the masses on August 18, 1966 (fig. 68). The pose of Mao waving his cap is strangely similar to that of Lenin in a painting depicting him waving his cap as he addressed a crowd at Finland Station.[57]

Interestingly, this multifigured scene of Mao at Tiananmen could be reduced to a single image: Mao waving his cap. In one billboard picture the secondary figures were eliminated, leaving only that of Mao waving his cap, his figure placed in front of a series of small vignettes.[58] The result is a complex mixture of political, artistic, and religious allusions. This reduction is the visual equivalent of the quotations from Mao's writings: both are removed from context; the single image and the thought both become symbolic references to or stand for the larger idea. The small vignettes in the background serve as commentary upon the main subject. These depict six sites connected with major events in Mao's life: birthplace, National Institute of the Peasant Movement Hall, Jinggang Mountains, Zunyi, Yan'an, Tiananmen. On the one hand, this visual device harks back to woodblock prints done during pre-Liberation days when the Communists were still engaged in armed warfare, and so constitutes an allusion to a

49. "Statue of Chairman Mao Unveiled at Tsinghua University," PR, 12 May 1967, 5.

50. H. C. Chuang, *The Great Proletarian Cultural Revolution: A Terminological Study*, Studies in Chinese Communist Terminology, no. 12 (Berkeley: University of California Center for Chinese Studies and Institute of International Studies, 1967), 31; Fokkema, *Report from Peking*, 16.

51. Nina Tumarkin, *Lenin Lives! The Lenin Cult in Soviet Russia* (Cambridge: Harvard University Press, 1983), fig. 5.

52. Reproduced in CR, 1969, no. 8:9; CL, 1968, no. 5. opp. 88; CL, 1968, no. 6, front cover.

53. H. C. Chuang, *The Great Proletarian Cultural Revolution*, 31–32.

54. Reproduced in CR, 1968, no. 2, back cover.

55. Reproduced in Tumarkin, *Lenin Lives!* fig. 6.

56. Brian E. McKnight, *The Quality of Mercy: Amnesties and Traditional Chinese Justice* (Honolulu: University Press of Hawaii, 1981), 39–40. I am grateful to Richard Laing for bringing this to my attention. For additional connections of the sun and the color red, see Frederic Wakeman, Jr., *History and Will: Philosophical Perspectives of Mao Tse-tung's Thought* (Berkeley and Los Angeles: University of California Press, 1973), 18–20, 86.

57. Michael Pearson, *The Sealed Train* (New York: G. P. Putnam's Sons, 1975), between pp. 160 and 161.

58. Reproduced in CR, 1968, no. 2:18.

Art during the Cultural Revolution

"revolutionary" period. On the other hand, there are strong affiliations with religious imagery, consistent with the fact that some of the Cultural Revolution rhetoric has its roots in religious terminology.[59] The prescribed sequence of the small vignettes, and the large-scale figure in the center, are reminiscent of renditions of the Bodhisattva Guanyin as the savior of travelers. Banners and murals from the Buddhist caves at Dunhuang dating from the seventh to the eleventh century have a gigantic image of Guanyin in the center and an orderly sequence of panels arrayed on either side to illustrate the Bodhisattva's miraculous powers (fig. 69).[60] To return to depictions of Mao, additional evidence of types of restricted motifs is found in the fact that the same six biographical vignettes also appear in the background behind a huge figure of the Chairman in the poster *Sailing the Seas Depends on the Helmsman, Making Revolution Depends on Mao Zedong Thought* (plate 11).

Normally, Mao proclaimed himself one of the people, and in a number of representations he is shown amidst groups of children or factory workers. But as the Mao cult intensified, the images of Mao changed accordingly, and a different relationship to the masses becomes apparent. In both *Chairman Mao on an Inspection Tour during the Cultural Revolution* and *Follow Closely Chairman Mao's Great Strategic Plan*, the half-figure of the Chairman dominates the scene. In *On an Inspection Tour* (fig. 70), a panorama of Shanghai, its minuscule teeming millions blending with massed flags, is spread out below; the view is punctuated by fleecy clouds, and above is Mao. In splendid isolation he looms above the clouds and gazes off into the distance. Godlike, he is totally divorced from the people. In *Follow Closely Chairman Mao's Great Strategic Plan* (fig. 71), Mao in his Lenin-pose seems literally to be borne aloft by the tiny, inconsequential figures of the masses as he emerges from the fluttering red banners, waves of which extend over the land to the mist-filled horizon. These are visualizations of Mao as deity which exceed even the images of the Lenin

cult.[61] Mao's deification was complete when in 1966 in a Protestant church in Beijing the "interior had been completely rearranged, with a larger-than-life white bust of . . . Mao at the center,"[62] and in 1967 when a sculpted figure of Mao occupied a place of prominence in a Buddhist temple in Shanghai.[63]

The Oil Painting Chairman Mao Goes to Anyuan

A final example of Mao portraiture is an oil showing him as a young man, clad in traditional Chinese long robe, carrying a paper umbrella in one hand, the other fist clenched, and purposefully striding across the hills, the breeze billowing his robe: *Chairman Mao Goes to Anyuan* (plate 12). The circumstances surrounding its creation and promotion conform to those of an art "model." In addition, this work politically is perhaps the single most important painting of the Cultural Revolution period.

To understand the importance of this painting, it is necessary to provide some background about early Chinese Communist Party history. Shortly after the founding of the CCP in 1921, efforts were made by the Communists to organize workers, to urge them to strike for improved working conditions, wages, compensation, and rectification of a host of other grievances. A number of young Communists were especially active in forming workers' clubs (unions) and organizing strikes at the complex of collieries and ironworks at Anyuan, Hanyang, and Daye in Hunan during late 1921 and 1922: Li Lisan (b. 1897) and Guo Liang, as well as Mao Zedong and Liu Shaoqi and others.[64] The Anyuan strikes are of major importance in Chinese Communist Party history for the following reasons.

59. Adrian Hsia, *The Chinese Cultural Revolution*, trans. Gerald Onn (New York: Seabury Press, Continuum Books, 1972), 230–232.

60. See Miyeko Murase's study "Kuan-yin as Savior of Men: Illustrations of the Twenty-fifth Chapter of the Lotus Sutra in Chinese Painting," *Artibus Asiae* 33 (1971): 39–74. I owe the idea of the relationship between such political imagery and religious icons to Nina Tumarkin, *Lenin Lives!* 5. See also, Holmes Welch, "The Deification of Mao, *Saturday Review*, 19 Sept. 1970, 25, 50, and the study of Robert Watland Rinden, "The Cult of Mao Tse-tung," (Ph.D. diss., University of Colorado, 1969).

61. Lenin himself never wished to be deified; see Tumarkin, *Lenin Lives!* 67.

62. "Peking Churches Shut and Defaced," *New York Times*, 24 Aug. 1966, 1.

63. Photo reproduced in *Mingbao yuekan* 15 (March 1967): 87. Adrian Hsia also mentions many religious elements in the Mao cult, *The Chinese Cultural Revolution*, 232–234.

64. Lynda Shaffer, *Mao and the Workers: The Hunan Labor Movement, 1920–1923* (Armonk, N.Y.: M. E. Sharpe, 1982), chapter 4; Jean Chesneaux, *The Chinese Labor Movement 1919–1927*, trans. H. M. Wright (Stanford: Stanford University Press, 1968), 188–190; Jerome Ch'en, *Mao and the Chinese Revolution* (New York: Oxford University Press, 1967), 84. See also Angus W. McDonald, Jr., *The Urban Origins of Rural Revolution: Elites and the Masses in Hunan Province, China, 1911–1927* (Berkeley and Los Angeles: University of California Press, 1978), 166–172, where the series of important leaders in the Anyuan affair is given as Mao, Li Lisan, and Liu Shaoqi.

The union organized by the Anyuan miners was one of the four major labor organizations in China. It was the first major one led exclusively by the Chinese Communist Party. After the victorious strike in 1922, it became one of the strongest and most secure Communist bases and recruiting grounds for the early period of the revolution. Anyuan workers were among the Communist cadres at the Whampoa Military Academy, the Peasant Movement Training School, and the Political School in Kwangtung after 1925, the Northern Expedition, the Autumn Harvest Uprising, and the Nanchang Uprising in 1927.... After Mao established his base in the Chingkang mountains, Anyuan became his relay center for all communications with the outside and with the party center.... In 1930 over 1,000 Anyuan workers joined the Red Army. The survivors joined the Long March and fought in the anti-Japanese War.[65]

During the late 1950s and early 1960s several paintings describing Liu Shaoqi's contributions to the CCP were prepared for display in the newly constructed Museum of the Chinese Revolution in the Chinese History Museum on Tiananmen Square in Beijing. One was a large oil painting by Hou Yimin, *Liu Shaoqi and the Anyuan Miners* (fig. 39). In 1967 this oil was labeled as one of five poisonous weeds, along with the claim that this was the earliest evidence in the field of literature and art of Liu's attempt to change party history. Liu, it was asserted, wanted to use the Museum of the Chinese Revolution as a monument to himself by insuring that a large number of the exhibits of photographs, documents, memorabilia, and illustrative material were related to him and his role, for example, in the formative stages of the CCP. In this he was aided by Zhou Yang and in particular by Cai Rouhong, who was in charge of the art exhibits in the Revolution Museum. Cai, it was said, under the instigation of the Liuists not only gave priority to Anyuan but also commissioned Hou Yimin to do the painting. This same publication also claimed that Liu and others resisted or rejected the hanging of Mao's portraits in the Museum of the Chinese Revolution in the early 1960s (on the excuse, for example, that there were already too many portraits of Mao on exhibit in the Museum, or that the technique of the paintings was poor) and furthermore had sharply limited the publication of his portraits. According to the

opposition, the first version of *Liu Shaoqi and the Anyuan Miners* was unsatisfactory because it depicted Liu in profile, walking toward a negotiation meeting, and was too "humble." A second version, also by Hou Yimin (completed in 1961), showing Liu full face and in the center of a group of miners, was accepted. Copies of this painting were widely circulated; as late as August 21, 1965, Li Zhaobing, director of the Museum of the Chinese Revolution, presented a volume of reproductions of historical paintings, including one of this painting, to foreign guests. The radicals asserted that Liu's part in the Anyuan miners' strikes was largely detrimental and capitulationist and that it was really Mao who led the Anyuan strikes.[66]

Further, in 1962 a film about the Anyuan strikes, *The Earth Is Burning*, featured Liu Shaoqi, with no mention of Mao whatsoever. In the film the sky is transformed by light when Liu appears, and "rosy hues of the dawn are seen in the east"; Liu was projected as the "sun" and the "leader." It was believed that the intent of this film was to prove that Liu was the leader of the workers, whom the CCP represents, while Mao was the peasant leader.[67]

In July 1967 students from Beijing universities and institutes helped prepare an exhibition called "Mao Zedong's Thought Illuminates the Anyuan Workers' Movement." One result was the oil painting *Chairman Mao Goes to Anyuan*, completed by October 1967. It received unprecedented publicity for a painting when on July 1, 1968, in commemoration of the founding of the CCP, major newspapers (*People's Daily*, *Liberation Army Daily*, and others) carried color reproductions of it.[68] Published concurrently with the painting were many articles outlining Liu Shaoqi's errors and failures in handling the Anyuan miners' strikes, and Mao Zedong's successes in "igniting the flame of revolution" among the workers there. In the articles, the publication of which extended throughout the next year, the workers of the Anyuan miners' strike became securely linked with the peasants of the Autumn Harvest Uprising of 1929, where, it is underscored, the Anyuan workers joined forces with the peasants, and then, as members of the First Division of the First Army of Chinese Workers' and Peasants' Revolutionary

65. Lynda Shaffer (Womack), "Anyuan: The Cradle of the Chinese Workers' Revolutionary Movement, 1921–1922," in *Columbia Essays in International Affairs*, ed. Andrew Cordier (New York: Columbia University Press, 1969), 5:166–167, after Li Rui, *Mao Zedong tongzhide chuqi geming huodong* (Beijing: Zhongguo qingnian, 1959), 189–190.

66. "Chanchu wei Liu Shaoqi shubeilizhuande daducao—fandong youhua 'Liu Shaoqi yu Anyuan kuanggong' chulongde qianqian houhou," *Meishu fenglei* 10–14.
67. Adrian Hsia, *The Chinese Cultural Revolution*, 130–131.
68. "A Splendid Work of Art Born of the Great Proletarian Cultural Revolution—the Large Oil Painting 'Chairman Mao Goes to Anyuan,'" PR, 19 July 1968, 7.

Red Army, followed Mao into the Jinggang Mountains.[69] The following statement by Chia Teh-ping, chairman of the Revolutionary Committee of the fourth coal-extraction section of the Kaokeng Coal Mine, is typical of the tailored synopses of history in essays devoted to the Anyuan question in 1968:

> Chairman Mao in his twenties traversed mountains and crossed rivers to go to Anyuan to sow the seeds of revolution. He led the miners in the fight against the feudal power and capitalists, lit the flame in Anyuan and later led some of the revolutionary miners to the Chingkang mountains, China's first revolutionary base, thus combining the workers' movement with the peasant movement. From Chingkang mountains to Yenan, and from Yenan to Peking, the revolution eventually advanced to victory. That was how we were liberated from a sea of bitterness and have become masters of the nation.[70]

The stress upon the worker-peasant merger of the late 1920s as the basis of Mao's strength had political value in 1968, for the intense media coverage of this painting coincided with an important development in the Cultural Revolution: Mao's switch from the students to the workers as the primary bearers of the Cultural Revolution. On July 27, 1968, worker-peasant work teams were sent into Qinghua University with the announcement that "the working class would now cooperate with (reinforce) the PLA fighter in directing the revolution in education and on a permanent basis."[71] On August 5 Mao's gift of mangoes to members of the Worker-Peasant Mao Zedong's Thought Propaganda Team was "a symbol of his great concern, education and encouragement for the workers, peasants and soldiers of China in their determination to carry the revolution through to the end."[72]

Chairman Mao Goes to Anyuan obliquely conveys two messages: Mao as undisputed leader of the strikes (and the CCP), and the shift of his reliance to the workers. Art is now truly a political weapon. To guarantee that the dual messages were properly understood, millions of copies of the painting were distributed throughout China. Peasants planted seedlings with the painting posted

nearby; Red Guards walked to Inner Mongolia with the portrait carried in the vanguard; study sessions in Xinjiang were held under the shadow of this picture. In September 1968 it was hailed as a "Great and Noble Image"[73] and, along with the piano music for the Beijing opera *The Red Lantern*, became one of the "two gems of art," thus putting it on the same footing with the eight model operas.[74]

The oil painting was collectively designed and planned by students from Beijing universities and institutes. It was realized by a twenty-four-year-old Red Guard named Liu Chunhua (b. 1944). Liu Chunhua wrote descriptions of his personal background and experiences in making the painting. From a poor peasant family in Heilongjiang, he was a student at the Central Academy of Industrial Arts in Beijing when he became involved in the preparation of "Mao Zedong's Thought Illuminates the Anyuan Workers' Movement." Although he had no training in oil-painting techniques per se, Liu Chunhua was assigned to make an oil painting of Mao on his way to the coal mines in the autumn of 1921. To further their work, Liu Chunhua and the other art students visited the Anyuan coal mines, talked with the miners, and studied Mao's writings and historical materials on the workers' movement. This convinced them that Mao, not Liu Shaoqi, was the hero of the Anyuan struggle. They felt intense hatred for Liu Shaoqi, who had arrogantly distorted history by claiming himself leader of the Anyuan strikes. In addition to understanding the correct circumstances of the Anyuan episode, in order to depict Mao's face, the students studied the few available photographs taken of Mao in his youth. When actual work on the painting got under way, Liu Chunhua "painted day and night." He says he "sought opinions from old workers and my comrades. Anyuan workers who took part in the struggles of early days volunteered to be our advisors.... Again and again I made changes in the painting, but it was collective wisdom and effort that decided the final composition and colour." Liu Chunhua explains the painting:

> We placed Chairman Mao in the forefront of the painting, tranquil, far-sighted and advancing towards us like a rising sun bringing hope to the people. We strove to give every line of his figure significance. His head held high and slightly turned conveys his revolutionary spirit, dauntless before

69. "Following Chairman Mao Means Victory," CR, 1969, no. 8:8.
70. "Great and Noble Image," CL, 1968, no. 9:45.
71. Dittmer, *Liu Shao-ch'i*, 282.
72. Caption to photograph of team with mangoes, CR, 1968, no. 10:1.

73. "Great and Noble Image," 45.
74. "Birth of Two Gems of Art," CL, 1968, no. 10:96–99.

Art during the Cultural Revolution

danger and violence, courageous in struggle and daring to win. His clenched fist depicts his revolutionary will, fearless of sacrifice, determined to surmount every difficulty to free China and mankind, confident in victory. The old umbrella under his arm reveals his style of hard work and plain living, travelling in all weather over great distances, across mountains and rivers, for the revolutionary cause. Striding firmly over rugged terrain, Chairman Mao is seen blazing the trail for us, breaking with past obstacles in the way of our advance and leading us forward in victory. The rising autumn wind, blowing his long hair and billowing his plain long gown, is the harbinger of the approaching revolutionary storm. A background of swift-moving clouds indicates that Chairman Mao is arriving in Anyuan at the moment of sharp class struggle, contrasting even more sharply with his calm and firm confidence.[75]

Chairman Mao Goes to Anyuan has direct antecedents in portraits by the great Western masters of the sixteenth through the eighteenth century: Velásquez, Van Dyck, Gainsborough, and Reynolds. To justify the use of a purely Western tradition in this depiction of Mao, Liu Chunhua claimed that oil painting had been monopolized by "a handful of bourgeois elements and kept from being used to serve the workers, peasants and soldiers." Under the guidance of Mao's dictum "Make the past serve the present and foreign things serve China," Liu continued, "We boldly broke away from foreign conventions...to create a 'fresh, lively Chinese style and spirit which the common people of China love.'" This was accomplished by combining Western oil techniques with the details characteristic of Chinese painting,

presumably the sprig of bamboo leaves at the lower right, which are outlined in typical Chinese painting technique with black pigment. Liu also related that, although ridiculed by the "so-called 'professionals' and 'experts,'" he and the art students persisted in their work with the approval of the revolutionary masses.[76]

Toward the conclusion of the article, Liu mentions Jiang Qing three times: "Comrade Chiang Ching encouraged us to dare to make innovations, not to be afraid of failure"; "credit for the painting's success must go to Chairman Mao's thinking ..., to Chiang Ching who has shown great care and warm support"; and "we are determined to look upon Comrade Chiang Ching as a glorious example."[77] In 1969 *Chairman Mao Goes to Anyuan* was singled out, along with the *Rent Collection Courtyard*, as a model work of art "produced under the guidance of Chiang Ching."[78] These paeans of praise for Jiang Qing suggest that she was instrumental in the promotion of this painting and that she had already concretely extended her sphere of influence from the stage to the visual arts. Indeed, by 1969 Jiang Qing was crystallizing in writing her directives on how to depict heroes on the stage. *Chairman Mao Goes to Anyuan* fits her visualizations of the hero and his setting perfectly: the "rising sun," the storm clouds, the calm and purposeful man in the center of it all. With the increase in Jiang Qing's personal power, she and her theater heroes would preside over the art world for the next six years.

75. Liu Chun-hua, "Painting Pictures of Chairman Mao Is our Greatest Happiness," CR, 1968, no. 11:5–6.

76. Ibid., 6.
77. Ibid.; a similar article by Liu, "Singing the Praises of Our Great Leader Is Our Greatest Happiness," is in CL, 1968, no. 9:32–40.
78. "Red Artist-Soldiers and the Revolution in Fine Arts Education," 88.

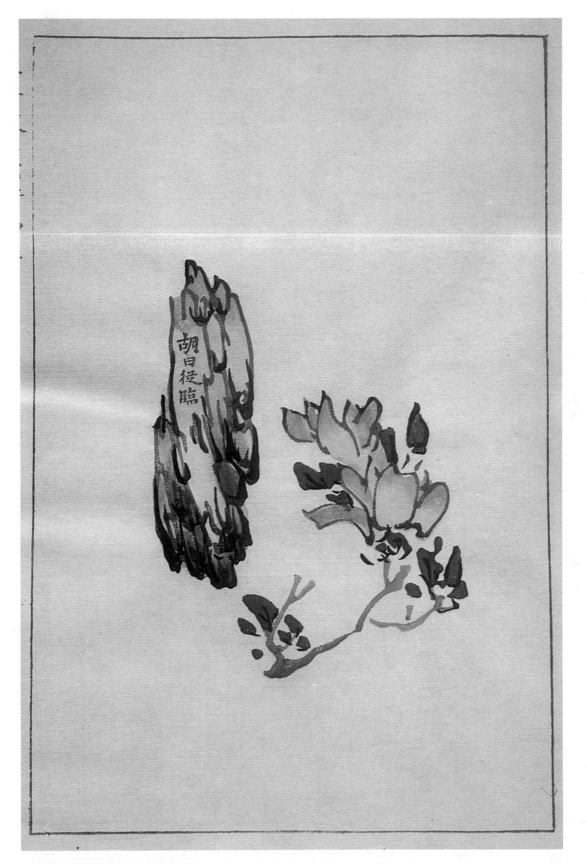

PLATE 1. Hu Zhengyan, *Ten
Bamboo Studio Letter Paper*, wood-
block print, ca. 1645.

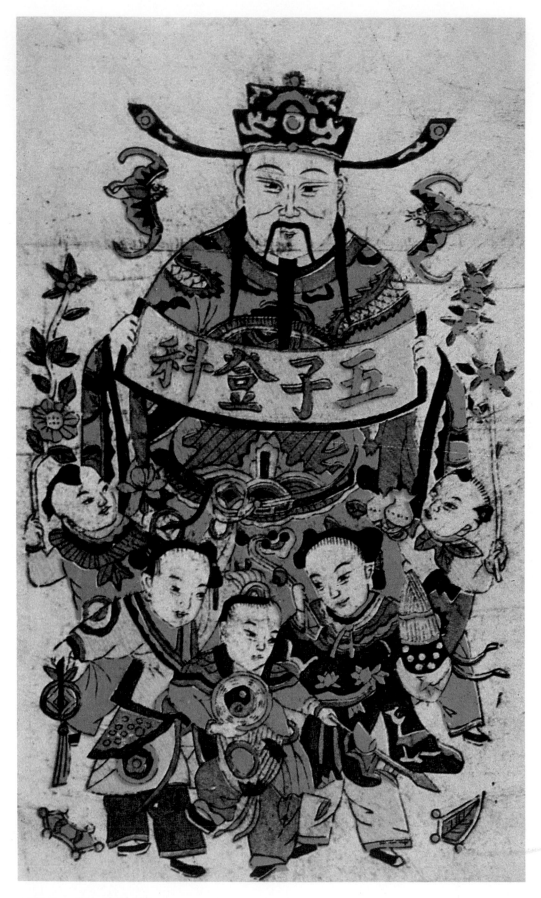

五子登科

PLATE 2. Anonymous, *Five Sons Successful in Examinations*, New Year's picture, woodblock print, nineteenth century.

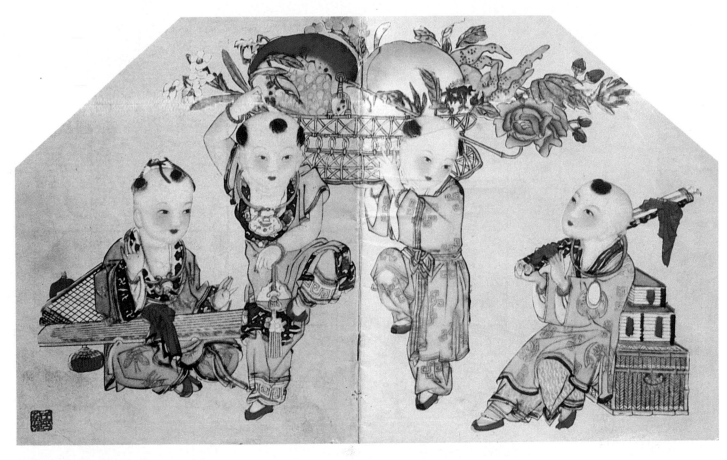

PLATE 3. Anonymous, *Four Boys and Fruits*, New Year's picture, woodblock print, nineteenth century.

PLATE 4. Li Qun, *Well-clothed and Fed*, woodblock print, 1944.

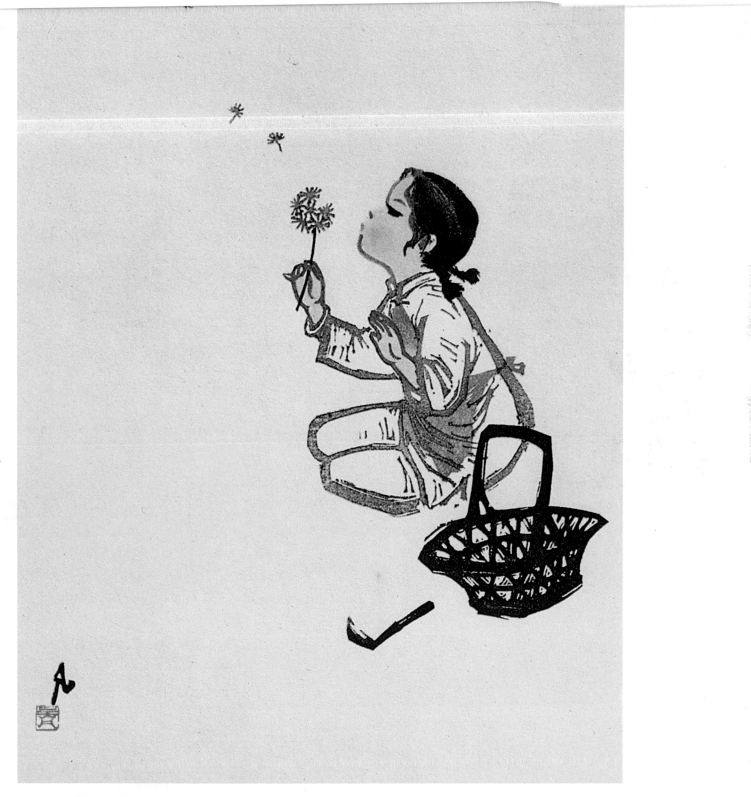

PLATE 5. Wu Fan, *Dandelion
Girl*, woodblock print, 1958.

PLATE 6. Fu Baoshi, *Volcano*, traditional-style Chinese painting, 1961, detail.

PLATE 7. Pan Tianshou, *Bathed in Dew*, traditional-style Chinese painting, 1959.

PLATE 8. Qian Songyan, *New City in the Mountains*, traditional-style Chinese painting, 1960. (Cropped at sides.)

PLATE 9. Gao Quan, *The Furnace Flames Are Really Red*, oil, ca. 1964.

PLATE 10. Zhang Ping, *To See the Green Hills Reeling like Waves, and the Dying Sun like Blood*, traditional-style Chinese painting, 1964.

PLATE 11. Anonymous, *Sailing the Seas Depends on the Helmsman, Making Revolution Depends on Mao Zedong Thought*, poster, 1969.

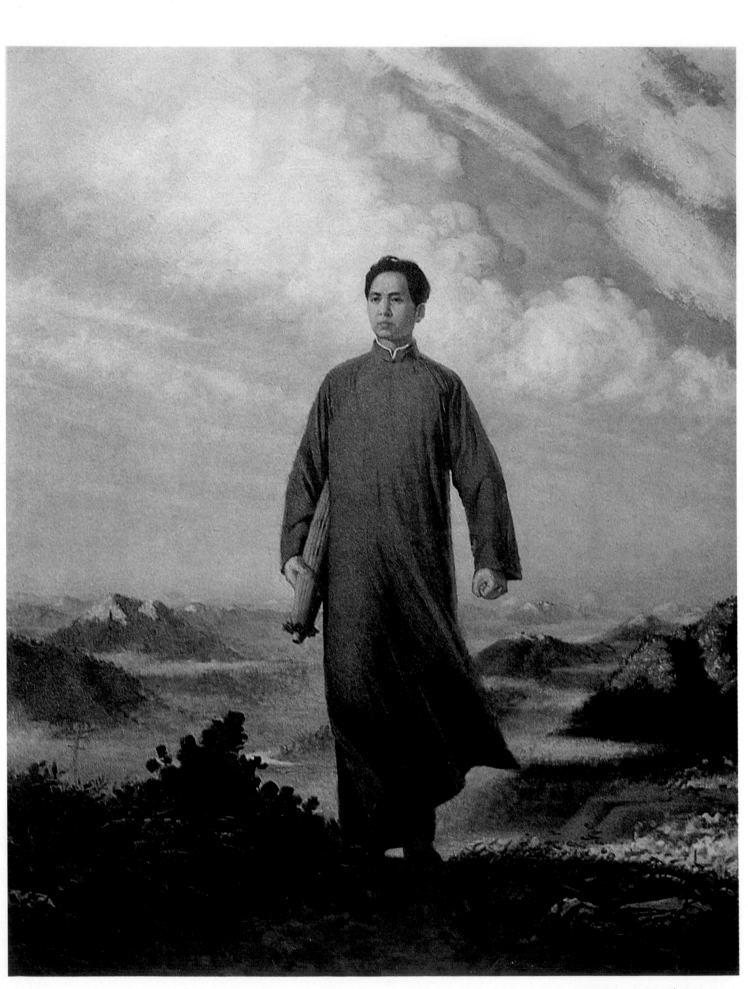

PLATE 12. Liu Chunhua,
Chairman Mao Goes to Anyuan, oil,
1967.

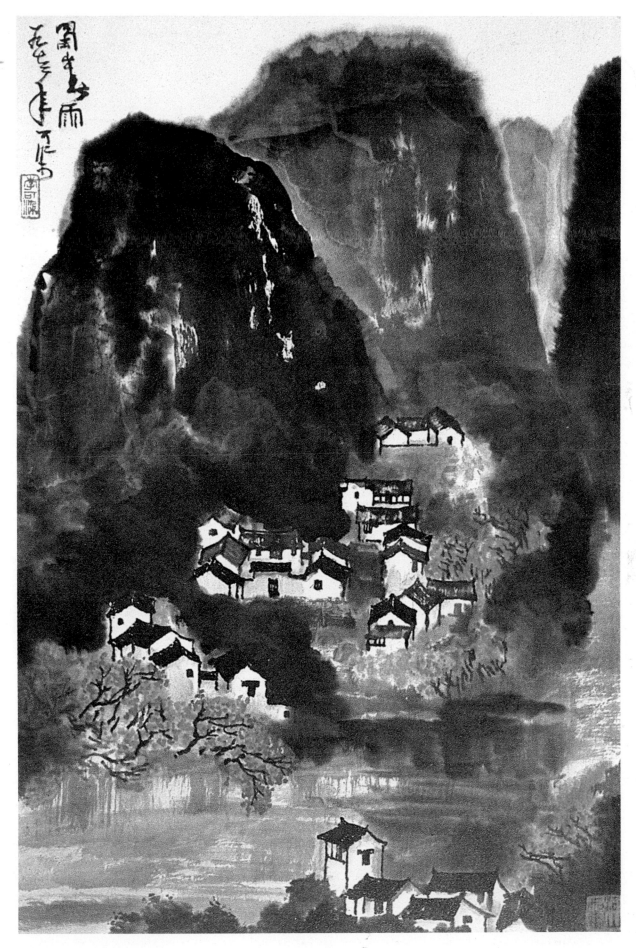

PLATE 13. Li Keran, *Mountain
Village after Rain*, traditional-style
Chinese painting, 1972.

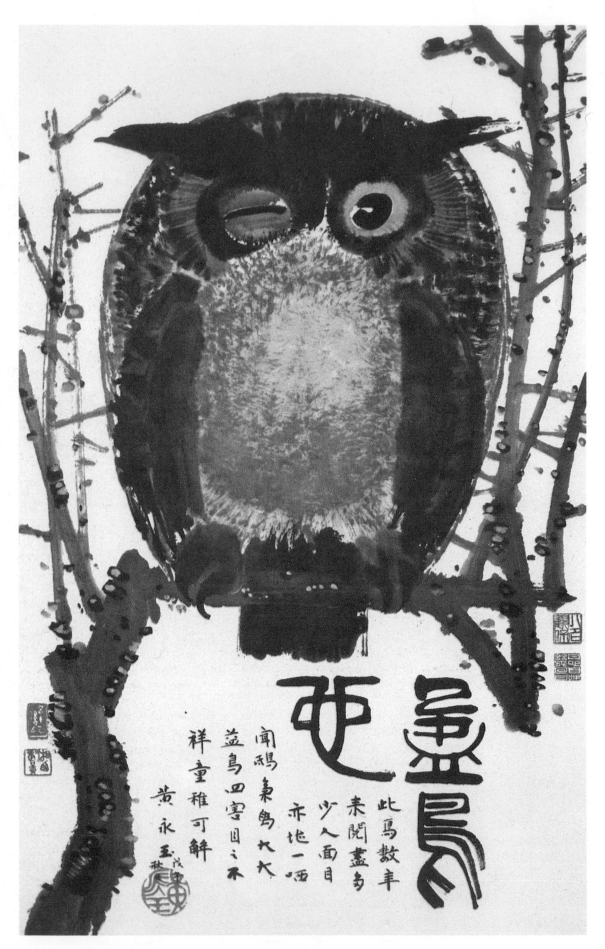

此鳥數年
來閱盡多
少人面目
亦祇一哂

聞鴉象鳥大大
益鳥四害目之不
祥童稚可解
黃永玉

PLATE 14. Huang Yongyu,
Winking Owl, traditional-style
Chinese painting, 1978 (presum-
ably based on a version done
ca. 1972).

Art under Jiang Qing, 1970-1976

Part One: In the Sunlight of Socialism

In 1969 the Ninth Party Congress confirmed the defense minister, head of the People's Liberation Army, first vice-chairman of the Party, Marshal Lin Biao, as successor-designate to Chairman Mao. In September 1971 Lin's alleged military coup d'etat failed and he apparently was killed when, trying to escape to the Soviet Union, his plane crashed in the People's Republic of Mongolia. The vanishing of Lin, coupled with Mao's advancing age, gave Mao's wife, Jiang Qing, room to maneuver. She and her three political supporters controlled the city of Shanghai, the national propaganda machines, and the cultural realm. The radical policies they pursued, however, had adversaries: the "thought" of the deceased Lin Biao and the paragon of moderation, Premier Zhou Enlai. A series of ideological campaigns were carried out between 1970 and 1976. One was designed to denigrate Lin Biao; it apparently was merged with one mounted by the radicals to dishonor Zhou Enlai. The result was the combined Criticize Lin Biao, Criticize Confucius campaign (Confucius being a "code-name" for Zhou Enlai, because Confucius referred frequently to the reign of the Duke of Zhou, and for a number of other associations).

To a large extent the dynamics of art during the Jiang Qing era hinge on continuing the Cultural Revolution, but now the recognized enemy is primarily the "thought of Lin Biao." On the other hand, abandoning the frenzied actions of the Cultural Revolution, the art scene after 1969 resumed a more orderly demeanor.

In 1972 the prestigious national art exhibitions, along with reviews of them, were reinstituted. All art works done between 1972 and 1976 displayed in these exhibits are exclusively political in content: the criticism campaigns, victories of the Cultural Revolution, new socialist phenomena, the successes in industry and other sectors in promoting production, and heroic images of workers, peasants, and soldiers.[1] Homage to Mao was still obligatory, as is attested by numerous pictures of him and by landscapes with red-sun symbolism, such as two anonymous works, *Red Sun over Yan'an*, or *Red Sun over the Oil Fields*.[2] A gigantic sculpture of Mao erected in Shenyang in 1971 also derived some of its impact from sun symbolism, as is discussed in a later chapter. By 1972 (after the disappearance of Lin Biao, considered the promoter of the Mao cult) the sun was reduced to sunshine. This modification may indicate a less frantic adulation of the leader, but the connotations remained intact. For example, an oil painting by Qin Wenmei, *Chairman Mao Is with Us*, depicting Mao chatting with peasants and cadres in a Yan'an cave during the war with

1. "Peking Fine Art and Photographic Exhibitions," CL, 1974, no. 10: 120−121.
2. Reproduced in CL, 1971, no. 6, opp. 58, and CL, 1971, no. 12, opp. 44.

Japan, elicited this interpretation: "The noble image of our leader here makes us realize his unremitting concern for the people and his close unity with them. The red charcoal flames and bright sunlight symbolize the warmth which he generates in their hearts."[3]

This chapter will examine the art of the Jiang Qing period by defining the visual characteristics of the approved art. The next chapter will explore some of the effects on art resulting from the conflicts between Jiang Qing and ideological deviations associated with Lin Biao and Zhou Enlai.

Guidelines

Underlying the facade of seemingly banal and innocuous political pictures is an elaborate reinforcement structure of art theory and policy distinctly unique to this era. During the period from 1970 until the autumn of 1976, Jiang Qing and her faction controlled the arts. Under their aegis, although occasionally invoking as artistic criteria "revolutionary realism and revolutionary romanticism," a term coined during the Great Leap Forward of 1958, emphasis is given to a different set of guidelines. Some of the fundamentals of these guidelines had been enunciated during the Cultural Revolution and hark back to Mao's 1942 Yan'an *Talks* and what is now called his "proletarian revolutionary line in literature and art." Other aspects of the rules are interpretative extensions of Mao's statements on art. Since the art of the Jiang Qing period cannot be properly discussed without a basic grasp of these guidelines, they will be presented at some length here.

Foremost among these guidelines are the answers to the questions of whom, and which class, art should serve: the proletariat or the bourgeoisie; and which class should art depict: the proletariat or the bourgeoisie. In Chinese Communist theory, a constant struggle is waged in the arts and elsewhere between proponents of these two classes because each class recognizes that when it controls the art, it can use art to promote its own ideas and to defeat its rivals. These questions were already answered in Mao's Yan'an *Talks* when he claimed that art must be for the people and should depict the people and that artists must have the correct class stance, that is, be proletarian, on the side of the masses, in their outlook. The following assertions pertaining to the theater help convey what were considered correct attitudes toward these questions:

It is inconceivable, she [Jiang Qing] said, that in our socialist country led by the Chinese Communist Party, the dominant position on stage should not be occupied by workers, peasants and soldiers who are the real creators of history and the true masters of our country. She pointed out that our chief task is to create the true images of the revolutionary heroes of our time.[4]

Elsewhere, the salient differences between the bourgeois and the proletarian "class stance" in painting are juxtaposed:

In feudal China paintings, whether of human figures, landscape or flowers and birds, reflected the life, views and sentiments of the feudal ruling class but ignored the major role of the labouring masses. This distortion of history has been corrected in modern Chinese paintings of the traditional school. The fundamental change apparent in this exhibition was that the themes of most paintings were working people going all out in socialist revolution and socialist construction under the leadership of the Chinese Communist Party and Chairman Mao.[5]

Exhortations like the following appear repeatedly in the press: "The most important task of revolutionary literature and art is to propagate the thought of Mao Tse-tung and to create the characters of life-like proletarian heroes armed with Mao Tse-tung's thought, thus educating and encouraging the people, and leading them forward."[6]

The stress upon the creation of proletarian "heroes" to the exclusion of all else is new, yet it is brought within Mao's 1942 dicta because creation of heroes and reflection of life "is not the mechanical transplanting or simple reproduction of life, but should be [quoting Mao] 'on a higher plane, more intense, more concentrated, more typical, nearer the ideal and therefore more universal than actual everyday life.'"[7] Or as is otherwise phrased: heroes are "the quintessence of thousands and thousands of heroes coming to the fore in revolutionary struggles."[8]

3. Pien Cheh, "A General Review of New Art Works," CL, 1972, no. 8:20–21. The painting is reproduced in this issue of CL.

4. Yu Hui-jung, "Let Our Theatre Propagate Mao Tse-tung's Thought for Ever," CL, 1968, no. 7/8:109.

5. Chi Cheng, "New Developments in Traditional Chinese Painting," CL, 1974, no. 3:114.

6. Yu Hui-jung, "Let Our Theatre," 114.

7. A frequent quote, for example, in Hsiao Luan, "Paintings of the Era and Art of Combat—After Seeing the 'National Fine Arts Exhibition,'" JMJP, 26 Nov. 1974, SCMP, no. 5759:11.

8. The "Taking Tiger Mountain by Strategy" Group of the Peking Opera Troupe of Shanghai, "Strive to Create the Brilliant Images of Proletarian Heroes—Appreciations in Creating the Heroic Images of Yang Tzu-jung and Others," PR, 26 Dec. 1969, 34 (also in CL, 1970, no. 1:60).

In addition to these goals the most qualified professional artists were those who, "tempered in the cultural revolution, plunged into the three great revolutionary movements of class struggle, the struggle for production and scientific experimentation, [and] integrated themselves with the workers, peasants and soldiers."[9]

Artistic creation was to be accomplished through mass criticism and joint discussion in the three-in-one policy involving the Party (as represented by the cadres), the experts (the professionals), and the worker-masses (worker or peasant critics), for art was undertaken with the aim of "creating for the workers, peasants and soldiers" and at the same time artists must strive "to repudiate the idea of personal fame and gain of the bourgeoisie and establish proletarian utilitarianism."[10]

And last, art directives were embodied in the well-worn phrases from Mao's Talks: "Make the past serve the present; make the foreign serve China; let the hundred flowers bloom and weed out the old to let the new emerge." One or all of these slogans is found in nearly every statement about art published during this era.

As it happened, the implementation of these varied goals had been solved by Jiang Qing in her reform of the Chinese stage and were promulgated in discussions of the model theatrical works. Appraisals of these model revolutionary operas in the West rarely go beyond seeing them as operas in which traditional Chinese stories, characters, and performance forms are replaced by plots of modern, political relevance presented in modern costume and with modern staging proffering the Maoist ideal of mankind. The model operas, however, had much more significance than this. Such productions were "model" because they not only set forth the "recommended" working methods, especially the tri-unity approach,[11] but also, and most important for our purposes, because their stage or cinematic versions provided a repository of correct visual images. Thus, as the peasants learned from the agricultural

model Dazhai or as workers learned from the industrial complex at the oil fields of Daqing, artists, it is endlessly reiterated, learned from the revolutionary model operas.[12] The substantial connections between stage and art will be demonstrated below.

While Jiang Qing was in power she insisted that all art portray the "heroic" and that her artistic theory of three prominences, developed in the theater, be applied to the visual arts. This theory, interestingly, is not as such explicitly found in Mao's Yan'an Talks of 1942, nor in any of his other writings on art, but perhaps is an extension of the "more intense, more concentrated" statement by Mao. The theory of the three prominences evolved out of Jiang Qing's refashioning of the Chinese theater and movies. It apparently was first articulated in 1968: "Of all the characters, stress the positive ones. Of the positive characters, stress the heroic ones. Of the main characters, stress the central one."[13]

Since Jiang Qing and Mao's niece Wang Mantian controlled the official cultural apparatus and organs (theater, cinema, opera, ballet, music), all paintings, woodcuts, and so forth that appeared in the public media or on exhibition were heavy with political messages and conformed to the three prominences. These works constituted the official, approved art in China.

The Theater Arts and the Visual Arts

The relationship between the theater and the visual arts is repeated constantly in the reports on art: good art clearly is that which displays "the heroic" correctly on the basis of techniques first worked out in Jiang Qing's model revolutionary theatrical productions.[14] Although the exact connections are rarely specified, the conventions are not at all difficult to grasp once a comparison is made between some of Jiang Qing's ideas for drama and how they are reflected in paintings of this era. In the following paragraphs, some of the

9. "National Fine Art Exhibition Opens in Peking," NCNA Peking, 23 May 1972, SCMP, no. 5147:8–9. Similar comments in Cultural Work Troupe, Shangjao District, Kiangsi Province, "Write About Heroes, Emulate the Heroes," JMJP, 5 March 1972, SCMP, no. 5095:165, and elsewhere.

10. CCP Mant'ung Hsien Committee, Kiangsu Province, "Push Mass Literary and Art Creation One Step Forward," KMJP, 23 May 1972, SCMP, no. 5146:149.

11. For an analysis of this approach, see Hua-yuan Li Mowry, Yang-pan Hsi—New Theater in China, Studies in Chinese Communist Terminology, no. 15. (Berkeley: University of California Center for Chinese Studies, 1973), chapter 3. For an explanation of the example of model plays and the questions they solved, see Ch'in Li, "Firmly Uphold Unity Between Politics and Art," JMJP, 17 May 1973, SCMP, no. 5384:56.

12. For example: Fu Wen, "Revolutionary Literature and Art Must Consciously Serve the Correct Line of the Party," KMJP, 5 June 1972, SCMP, no. 5157:48; "Peasant Art Exhibition in Fukien," CL, 1974, no. 9:114; "National Fine Arts and Photo Exhibitions Close in Peking," NCNA Peking, 2 Dec. 1974, SCMP, no. 5753:229.

13. Yu Hui-jung, "Let Our Theatre," 111.

14. "Jen-min Jih-pao Article on National and PLA Fine Arts Exhibitions," NCNA Peking, 24 July 1972, SCMP, no. 5188: 162; Wen Mei, "Chinese Paintings Should Have a Touch of the Times," JMJP, 14 Oct. 1973, SCMP, no. 5484:48; "Peasant Art Exhibition in Fukien," 114; Ma Ke, "Paintings of the Times," CR, 1975, no. 1:26.

new concepts for the theater will be presented first, then their application to art works.

The revised staging of *Taking Tiger Mountain by Strategy* (also known as *Taking the Bandit Stronghold*) "used rays of powerful sunlight through the forest to symbolize [the hero] Yang Tzu-jung's advance under the brilliance of Mao Tse-tung's thought." The play was simplified by the deletion of scenes or roles which detracted from the hero.[15] In another analysis of this same play it is emphasized that the hero occupies the center of the stage and stands on a high plane. Further, to create a heroic image, there had to be a "group of heroes who form the basis of the principal hero's existence and on whom the principal hero exerts his influence." It was essential that the setting be a suitable background for the hero. Earlier versions of the opera provided a mise-en-scène of drooping branches and gnarled trees, "which created a bleak and melancholy atmosphere" out of keeping "with the vigour, heroic spirit and fighting mood" of Yang. In the revised staging there are "sturdy, towering trees... especially [in] Scene Five, a forest of giant cloud-touching pines pierced by shafts of sunlight... heightens the dashing and firm, staunch and fearless, personality of Yang Tzu-jung." In Scene Eight the hero "stands firm like a green pine in the snow."[16]

The following extracts from an article on the making of the film of the *Red Detachment of Women* are also useful in understanding the relationship between stage and painting during this period:

The ballet the *Red Detachment of Women* integrates revolutionary realism with revolutionary romanticism, creating the towering image of Hung Chang-ching in typical circumstances. In the delaying action in the mountain pass, he is badly wounded while covering the moving out of his comrades. An approaching storm accompanied by a rumble of thunder in the distance introduces the scene where he faints from loss of blood and severe pain. While the Tyrant of the South approaches nervously with his men towards Hung, he suddenly opens his eyes and pushes aside the two enemy soldiers who try to seize him. At this moment a flash of lightning lights up the sky and with a violent crash of thunder emphasizes the towering stature of the hero in sharp contrast. (In the camera shots) the hero appears on

the screen like an ancient pine on the top of a mountain, at once lofty and magnificent.

In the execution scene:

Originally Hung walks from the side of the stage to the execution grounds, which is heavily guarded. In order to intensify the atmosphere and to show the hero's defiance and contempt for the enemy, he comes out onto a high platform overlooking the cringing Tyrant of the South and his men down below.... The following shots focus Hung's calmness and scorn for the enemy who try to force him to betray his comrades. Standing high above the foe he appears immensely tall, dominating and overshadowing the enemy, who appear dwarfed and insignificant. Hung is the image of the Communist who "is determined to vanquish all enemies and never to yield" (line in quotes also in bold type in original).[17]

Light and shade as well as warm or cold colors are skillfully used to emphasize the hero who, in one scene, "is brought out in red and bright lights to contrast sharply with the Tyrant of the South who is cast in cold grey."[18]

In summary, on Jiang Qing's stage sunlight and warm colors help enhance the hero, whereas somber colors are associated with evil. The background setting of rugged terrain or the violence of nature are foils for superbly calm heroes, who preferably are placed on a height at stage center, where they can be likened to pine trees. In reworkings of the original story or staging, careful simplification of plot or stage business leads to a heightening of the stage hero image.[19]

The situations and stances of the hero in the model *Red Detachment of Women* are precisely those which animate the heroes and heroines of the paintings: prominently placed in the center of the depiction, they are in the midst of violent storms, or on heights, or in dangerous or death-defying

15. "Grasp the *Talks* as Our Powerful Weapon in Portraying the Heroic Images of the Proletariat," in: Chiang Ch'ing, *On the Revolution of Peking Opera* (Peking: Foreign Languages Press, 1968), 21–23.
16. The "Taking Tiger Mountain by Strategy" Group, "Strive to Create the Brilliant Images," PR version, 38, 39; CL version 69, 72.

17. "The Film 'Red Detachment of Women,'" CL, 1971, no. 9: 108, 109.
18. Ibid., 111.
19. Calmness is an important attribute of literary heroines also, such as Sister Jiang, who in the novel *Red Crag* as she prepares to meet her death "was unusually calm, without agitation, fear or sorrow. The dawn was arriving, and the first rays of the morning sun could be seen.... as usual she unhurriedly combed her hair.... calm Sister Chiang always gave others the impression of high spirits and dignity." Or of the real-life army commander, Peng Dehuai, as portrayed during the assault on a strategic hill in the novel *Defense of Yenan*: "Chen could only hear [over the telephone] intermittently the calm and unhurried voice of P'eng Te-huai...." Joe C. Huang, *Heroes and Villains in Communist China: The Contemporary Chinese Novel as a Reflection of Life* (New York: Pica Press, 1973), 103, 170.

situations. Nevertheless, they remain clam, cool, serene. Despite adverse weather conditions, heroes are flooded with light. The emphasis upon the sunlight of socialism was such that nighttime, indoor, and even underground mining scenes were presented as drenched with natural light.

All paintings and woodcuts discussed at any length in articles published between 1972 and 1976 are lauded for one or more of the above characteristics. A few of these works, along with the remarks of Chinese commentators, will be used here to illustrate the visual nature of this art.

Interestingly, Liu Chunhua returned to the spotlight in 1972 to reaffirm the heroics in his oil painting *Chairman Mao Goes to Anyuan*: "The hills, sky, trees and clouds in the painting were means used artistically to throw his image into strong relief. Thus I painted turbulent clouds scudding past to convey how serenely Chairman Mao came to Anyuan at that time of sharp class struggle to bring revolutionary storm and victory to the miners." [20]

The landscape foil and the view from below, both of which enrich the sense of heroic quality, were used in the oil painting by Wu Yunhua (b. 1944) *Battling for Copper*. According to the description, it "depicts the rugged cliffs surrounding a copper mine to bring out the miners' resolute character... an experienced old miner coolly and accurately directs the work." [21] A woodcut titled *Creating New Things All the Time* by Ma Xueli (b. 1941) shows night work on a ship (fig. 72). "Viewed from a low angle, the hull of the ship rises up strong and magnificent to dominate the picture." [22] Another commentator adds: "An old worker in the middle is calmly yet eagerly directing operations [and]... though it is nighttime, the colors are vivid and bright." [23] Of an oil painting exhibited in the 1974 National Art Exhibition, *Where the Oil Is, There Is My Home* (by Zhang Hongzan, fig. 73), it was said: "Arduous living conditions contrast with worker exuberance, to bring out their revolutionary optimism.... To make the chief character stand out vividly, the artist presents a broad vista and depicts the hero as if seen from below. Thus the young worker's figure appears more imposing." [24]

Simplification was used in *Before Going to the University* by Wen Chengcheng. In working out the final version, extra figures and environment which did not matter much to the main theme were eliminated. This made the picture simple and clearcut and the characters more prominent. [25]

On the other hand, there is an elaboration of descriptive details in the setting of *Educating the Next Generation* (fig. 74), sometimes titled *The Red Sun Warms Generation after Generation* or *Lesson in Class Education*. Made by Kang Zuotian (b. 1941), it shows a peasant woman telling a classroom of children about her bitter life before Liberation. Each detail must contribute to the total message in a positive fashion: the beggar's basket evokes her "miserable life... in the old society," while the

neatly dressed woman, her face radiant, shows the sweetness of the new society. Through the statement "Chairman Mao is the people's liberator" she has written on the blackboard and the iron shovel near by, the artist gives a detailed illustration of her deep class feelings for the party and Chairman Mao, her love of collective productive labor and the next generation and her fine quality in teaching the children by both word and deed. [26]

Three figure paintings in the 1972 National Art Exhibition and the PLA Art Exhibition were widely admired: *I Am Seagull*, an oil painting by the PLA man Pan Jiajun (b. 1947), the traditional-style painting *All Clear* by Luan Wanchu (a Dalian worker) and Wen Zhongsheng, and Yang Zhiguang's (b. 1930) traditional-style painting *Newcomer to the Mine*.

I Am Seagull (fig. 75) is perhaps one of the best examples demonstrating the parallels existing between portrayals of the heroic on stage and the heroic mode in painting, as witness the following comments, a composite of two analyses of this picture. After successfuly making a repair in the line, the woman PLA linesman calls in her code name: Seagull. The crisscrossing electric lines above the slightly tilted electric poles enliven the painting and signify the advances made in the communication system. The low angle from which the woman is seen makes her appear taller, and there are comments on her robust health. The background perfectly serves the main theme and

20. Liu Chun-hua, "A Glorious Task," CL, 1972, no. 7: 116–117.
21. Pien Cheh, "A General Review," 21. The painting is reproduced in CL, 1972, no. 8, bet. 24 and 25.
22. "Luta's Worker-Artists," CR, 1973, no. 8: 31.
23. Chang Tien-fang, "Amateur Artists of a Coastal City," CL, 1974, no. 6: 82.
24. Wang Wu-sheng, "National Art Exhibition," CL, 1975, no. 1: 96.

25. Wang Hui, "Mold Heroic Images of Our Age," KMJP, 2 Aug. 1973, SCMP, no. 5437: 145. *Before Going to the University* is reproduced in CL, 1972, no. 11, opp. 78, and in CP, 1972, no. 8: 20.
26. "*Jen-min Jih-pao* Article on National and PLA Fine Arts Exhibitions," 162.

the main heroic figure: the swaying coconut tree in a driving rainstorm sets off the calmness and courage of a woman PLA linesman working high on the pole to ensure smooth telecommunications. The storm puts in relief the unyielding heroic spirit, like a green pine tree, of the female warrior. She reflects the vigor and vitality of revolutionary youth. Above the endless sea, seagulls fly without fear, symbolizing the spirit of the main figure. On the far side of the sea, a warm hue indicates that the tempest is clearing and that a bright future is coming.[27]

Of *All Clear* (fig. 76), the depiction of a signal woman reporting back to headquarters the successful repair of a broken communication line, one writer claimed that it was a "successful use of traditional style to depict a scene of labor. The snowflakes whirling in the wind…bring out the young woman's spirit of revolutionary optimism in the face of difficulties."[28] To this was added, "The train speeding through the snowy countryside provides an effective background to bring out the noble image of the girl; thus the theme is clearly projected."[29] Yang Zhiguang's *Newcomer to the Mine* (fig. 77), was especially extolled because it successfully blended Chinese traditional painting techniques and certain methods of Western painting, in particular that of depicting light and the use of perspective, and he "develops the broad strokes of Chinese traditional painting to bring out the girl's pride at becoming a miner against the background of morning sunshine."[30] Or as was said elsewhere: "The girl's pride at coming to work in a mine is brought out by her fearless bearing as she stands bathed in morning sunlight."[31]

Sunlight, in addition to providing an optimistic atmosphere, could also be used in very specific ways to enhance the message of the painting. This concept is evident in the comparison of two works in the 1974 National Art Exhibition which have as their subject the Criticize Lin Biao, Criticize Confucius campaign: *Fighting without Respite* by Shang Ding (fig. 78) and *Before the Lecture* by Li Binggang (fig. 79). Both pictures present a "typical image combined with strong individual characteristics." *Fighting* depicts a soldier seated beside a tank, writing a critique of Lin Biao and Confucius, using a package of dynamite as a lap desk.

He is of "fiery temperament," determined "to persist in fighting," "daring and hardworking"; therefore, the sun that shines on the soldier and his manuscript is bright and strong and goes along with his fiery temperament. In contrast, the soldier of *Lecture*, who has stayed up all night to prepare his notes for an anti–Lin Biao meeting, is deep in thought, and the sunlight, as "soft morning rays," goes with his "firmness and steadiness."[32]

To meet the demand that artists integrate themselves with workers and peasants, young artists and old often went directly to factories or farms to live and work with workers and peasants and to seek their criticisms for their paintings of worker and peasant life and heroes. They then, continuing a practice initiated long before the Cultural Revolution, wrote sort of "confessional" records about their experiences. Some essays tell of the very real discomforts or dangers encountered which led to a deeper appreciation of peasant or worker life.[33] In other reports artists explain how they or their art works were corrected by the worker or peasant.[34]

One of the more interesting of these chronicles is by Zhao Zhitian. He showed an initial draft of his *The Daqing Workers Know No Winter* to the workers. Their response after seeing themselves depicted in all their oily grime, was "Don't make us look like scarecrows. Make our clothes and faces cleaner." Zhao admitted that through this means he had hoped to add "exotic color" to his painting. He then ruminated about the hero of the revolutionary model opera *The Red Lantern*: "The creators of that opera did not limit themselves to real life. They did not emphasize how the hero, brutally tortured by the enemy, was covered with wounds. They only showed a wound on his temple and a few bloodstains on his clothes. They emphasized his lofty spirit and his courage." Zhao concludes that to delineate heroic characters "they must be based on real life but on a plane higher than real life." Thus, when he did the final painting (fig. 80), he "did not make the workers' faces and clothes so grimy."

27. Ibid., 160; Zhou Wei, "Yumeng qingsong ting, Haiyan chuan yunfei: ping youhua 'Wo shi "haiyan,"'" *Meishu ziliao*, 1973, no. 1:4.
28. "Luta's Worker-Artists," 30.
29. Chang Tien-fang, "Amateur Artists," 85.
30. "*Jen-min Jih-pao* Article on National and PLA Fine Arts Exhibitions," 163.
31. Pien Cheh, "A General Review," 23.

32. Chi Cheng, "Two Oil Paintings," CL, 1975, no. 4:112–113.
33. Zhao Zhitian was worried about his safety when in the course of a routine task he had to climb a vibrating oil derrick (Chao Chih-tien, "I Painted the Heroic Taching Oil Workers," CL, 1974, no. 9:105). Artists from the Shanghai Academy of Chinese Painting were impressed that ship welders worked in hot and suffocating watertight compartments (Creative Group of Academy of Chinese Painting of Shanghai, "Some Experiences in Creating the New in Chinese Painting," JMJP, 22 Aug. 1972, SCMP, no. 5208:10).
34. For example, Wang Hui, "How I Made the Painting 'The Young Worker,'" CL, 1974, no. 7:95–96.

Art under Jiang Qing

Significantly, through his description of his painting, Zhao also reveals how he applied the three-prominences theory as well as the idea that there should be a secondary group of heroes:

> There are five persons in the picture with emphasis on three in the foreground, particularly on the "iron-man" [Wang Jinxi]. My idea was through him to depict the revolutionary spirit and hard struggle of the working class at Taching.... The other people in the picture are young workers. Through them I wanted to convey the idea that his spirit is carried on from generation to generation, which makes it even greater. I decided to paint them at work in a freezing snow-storm as a contrast to their own inner fire.[35]

Accommodation to the demand that the artist engage in the third great revolutionary struggle, that of scientific innovation, was accomplished in two ways. The first was to depict workers or peasants who had made technological innovations in their workplace, as in *The Young Worker*.[36] The second way to fulfill this requirement was to experiment with painting techniques. Innovations here are especially prominent in traditional-style painting. They include Qian Songyan's invention of a new brushstroke shape appropriate for depicting the peculiar layered, undulating loess deposits near Yan'an in north China, and the use of traditional techniques plus a bird's-eye view in *Land of Abundance South of the Yangtze* (fig. 81), a pictorial idiom considered to be "a completely new method for the traditional school."[37] Also included is Yang Zhiguang's *Newcomer to the Mines* (fig. 77), where he "departed from the usual by incorporating Western use of light and shade to bring out the young woman's happiness at her new job,"[38] and a traditional-style painting where the woman's padded jacket is done with linework ordinarily employed in landscape depictions.[39]

Visualizing the heroic within the mandates of the three prominences and within the contours of "special effects" of the stage and film was rela-

tively easy to accomplish in figure depictions because there were no problems encountered in the transfer of formulas and principles from one medium to the other. Making landscape and bird-and-flower subjects heroic was an entirely different matter, for there were no ready-made, concrete examples or guidelines from the theater world to follow. It was, however, particularly important to solve the problem of how to make landscapes and birds-and-flowers heroic, because these were two mainstays of the traditional-style painter, who often specialized in one or another of these genre.

Jiang Qing had already voiced her low opinion about landscape in the traditional mode and its inability to convey political import. In 1964 she lamented that one could look at *This Land with So Much Beauty Aglow*, an illustration to Mao's poem *Snow* done jointly by Fu Baoshi and Guan Shanyue and installed in the Great Hall of the People (fig. 38), "for half the day and not see anything good."[40] Her comment apparently was based on the observation that no evidence of man or his presence is in this painting.

In the early 1970s commentaries about the works of three traditional-style landscape artists clarify that one of the requirements for a heroic landscape is that it display the changes wrought on the land by socialist construction. Qian Songyan's *Miyun Reservoir*, showing a "gigantic" artificial lake created by the labor of thousands of commune members, was lauded because it "depicts the heroism of...the commune members,"[41] while his projected scrolls of the "huge Nanking Yangtze River Bridge" would picture "a symbol of the heroism and wisdom of the Chinese working class."[42]

Guan Shanyue's *Great Green Wall* (fig. 82), a view of a reforested zone along the coast with a shore patrol on the beach, was acclaimed in 1973 because it "depicts the heroic efforts of armymen and civilians to transform nature and consolidate coastal defence."[43] This was amplified:

> The artist praises the working people for their hard struggle against windstorms in afforesting the beach and their fighting will in defending the fruits of socialist construction ... the lush green of the shelter-

35. Chao Chih-tien, "I Painted the Heroic Workers," 106–107.

36. Wang Hui, "How I Made the Painting." *The Young Worker* is reproduced in CL, 1974, no. 7, opp. 92.

37. "Chinese Painter Makes Traditional Art Serve Socialism," NCNA Nanking, 23 May 1973, SCMP, no. 5387:24 (similar information in "Traditional Chinese Painting Serves Socialism," PR, 27 July 1973, 22); Ch'ien Sung-yen, "Creating New Paintings in the Traditional Style," CL, 1972, no. 11:111–114; see also Michael Sullivan, "Art in Today's China: Social Ethics as an Esthetic," *Art News* 73 (Sept. 1974): 56.

38. Ying Tao, "Exhibition in Peking: New Art Works," CR, 1972, no. 10:21.

39. Chi Cheng, "New Developments," 116.

40. Shao Dazhen, "Jiang Qing weishenme yao fandui Zhongguohua 'Jiangshan ruci duojiao'?" *Meishu*, 1977, no. 1:15.

41. "Traditional Chinese Painting Serves Socialism," 22.

42. "Chinese Painter Makes Traditional Art Serve Socialism," 23.

43. "National Exhibition of Serial Pictures and Traditional Chinese Paintings Opens in Peking," NCNA Peking, 2 Oct. 1973, SCMP, no. 5475:107.

In the Sunlight of Socialism

belt which suggests thriving socialist construction ... the trees battling bitter wind from the sea [express] the fighting will of the people and their revolutionary successes achieved through hard struggle. The roaring wind, billowing waves and the marching militiamen suggest class struggle and the high vigilance of the revolutionary masses.[44]

In the artist's account of his experiences in the field gathering data for his *Green Great Wall*, he includes a note about his painting methods, revealing that he adapted an oil-painting technique in applying the malachite pigment for the green trees in layers "to create the effect of depth."[45] (This sort of thing also qualifies as "scientific innovation" and as carrying out the slogan "Make Western things serve China.")

The *Canal of Happiness* (fig. 83) by Bai Xueshi (b. 1915) and Hou Dechang was hailed as "a landscape in praise of the idea that man's will, not heaven, decides, and of the superiority of the people's communes."[46] Even more pertinent to understanding how this landscape satisfies the demands for the heroic is the following critique, which is worth quoting at length:

> Beyond the [canal] is a vast expanse of verdant fertile fields spreading far beyond the horizon.... The luxuriant verdure has swept away the gloomy and desolate atmosphere of the deserted mountains and barren peaks with withered rattan plants and old trees in the old landscape paintings.... We [see] the new vigorous outlook of the socialist countryside. They are no ordinary mountains and rivers but are the socialist mountains and rivers after the earth-shaking transformation and new arrangement made by the working people [for the canal has brought drinking and irrigation water to the people].[47]

In conceiving the painting, according to the same writer, "the painter has discarded many things in the mountains and rivers of the natural world which are not essential and prominently revealed the happiness which the [canal] water has brought to the people and typically reflected the brand new outlook of the splendid rivers and mountains of the socialist mother country!"[48]

Other landscapes done during this period are also vast panoramic vistas, and their subjects are usually, if not the already established themes based on revolutionary history, then clearly delineated motifs of socialist triumphs in public projects: bridges, busy ports, dams, reforestation, as seen in paintings by two older Chinese-style painters, Wei Zixi in a painting of 1973, *Nanjing Yangtze River Bridge* (fig. 84) (construction of which was once said to be impossible), or Song Wenzhi's *Dawn at Lake Tai*.[49] Typical of many landscape paintings done during this era is a distinct, at times rather harsh delineation or contouring of motifs, as in Li Keran's illustration of lines in a Mao poem, *To See the Green Hills Reeling like Waves, and the Dying Sun like Blood* of 1971 (fig. 85), picturing Loushan, one of the battle sites during the Long March. Here he presents a massive, almost ponderous, mountainscape, its cliffs insistent and strident, made brittle and stiff with hard-edged, determined shapes. Guan Shanyue's *Dawn over the Great Wall* (fig. 86) and his *Great Green Wall* (fig. 82), both done in 1973, are characterized by their panoramic sweep, their bright colors, and positive forms, the edges of which are highlighted with clear sunlight.

An obvious dilemma faced those who specialized in the bird-and-flower genre; one painter reportedly queried, "How can you make a chrysanthemum heroic?" Many bird-and-flower specialists simply stopped painting. Only a few paintings of fruits, as "symbols of a good agricultural year,"[50] were included in the national exhibitions. These are all similar in their arrangement of sprays of fruiting branches on the foreground plane of the picture, along with a narrative panorama in the background. One painting shows persimmons, golden blossoms, and bamboo in front of rows of granaries (all signifying agricultural bounty); another, in keeping with the "heroic" formula calling for contrast with nature, has cucumbers growing in a hothouse while through the windows are seen commune members delivering produce through a blizzard.[51]

On the other hand, the age-old Three Friends of Winter, bamboo, pine, and plum, once symbolizing Confucian moral values of flexibility, perseverance, and purity, have their traditional meanings strengthened or are given new meanings in the early 1970s. The traditional-style painting *Bamboo Harvest* (fig. 87) was done by three artists from the Zhejiang Art Academy: Yao Gengyun (b. 1931), Fang Zengxian (b. 1931), and

44. "New Works by Veteran Chinese Painter," NCNA Peking, 10 Dec. 1973, SCMP, no. 5519:102.
45. Kuan Shan-yueh, "An Old Hand Finds a New Path," CL, 1974, no. 3:120.
46. Ma Ke, "Paintings of the Times," 27.
47. Hsiao Luan, "Paintings of the Era," 12–13.
48. Ibid., 13.

49. Versions reproduced in CL, 1974, no. 4, opp. 60; *1973 quanguo lianhuanhua, Zhongguohua zhanlan: Zhongguohua xuanji* (Beijing: Renmin meishu, 1974): 44; and elsewhere.
50. Ma Ke, "Paintings of the Times," 27.
51. Ibid.; Chi Cheng, "New Developments," 117.

Lu Kunfeng (b. 1934). It was in the 1972 National Art Exhibition and had an entire article devoted to it in one of the journals. The author had nothing but praise for it on all counts.

> An original composition and lively brush-strokes throw into prominence rows of sturdy, lovely bamboos and conjure up the luxuriance of the bamboo plantation. By choosing to depict bamboos after rain, the artists bring out lush verdancy of the grove; and this is enhanced by the white mist on the river, which conveys a sense of space and freshness . . . bamboo rafts . . . floating . . . down the stream [indicate] the keenness with which commune members support socialist construction. . . . Feudal literati painted bamboo to express the sense of indolent leisure of individual scholars or of the exploiting classes, to convey their aloof detachment, [while here] the artists have critically assimilated certain features of Chinese landscape and flower-and-bird painting and imbued them with a new socialist content. [The composition is in traditional] horizontal scroll [form], the attention to detail [is] typical of traditional flower-and-bird paintings [while] the method of evoking atmosphere [is from] traditional landscape. [New is] the depiction in the foreground of sections of bamboo to convey the vigour and height of the whole grove, [and this] breaks one of the chief taboos in traditional painting, yet underlines the main theme, that of a good harvest. In the background the rafts in the distance floating downstream, suggesting an endless convoy, add to the breadth of the horizontal scroll.[52]

The reviewer continues with comments on the brushwork, the "vivid color," the contrasts of warm and cold shades, and the use of perspective. He also claims that because the artists lived among poor peasants in the mountains "who dare to transform nature to win a good harvest, they have been able to express the revolutionary drive and vitality of the labouring people through this depiction of a bamboo grove." He concludes by citing *Bamboo Harvest* as one of the "more successful attempts at creating something new in the school of flower-and-bird painting."[53]

By a shift of focus, the pine tree, although admittedly still done in traditional techniques, now symbolizes "the revolutionaries' dauntless integrity and militant aspirations"[54] or "the te-

nacity of our PLA fighters."[55] It might be recalled, as was mentioned earlier in this chapter, that the heroes of the model *Taking Tiger Mountain by Strategy* and *The Red Detachment of Women* are likened to pine trees, as is the woman in *I Am Seagull* (fig. 75). An image of Mao in an unpublished painting done in 1972 has him "striding on a peak of Lushan mountain against a background of scudding clouds and tall and sturdy pines under rays of morning sun."[56] This oil painting was titled *Beauty in Her Infinite Variety* (or in an alternate translation: *Highest Beauty in the Dangerous Peaks*). It illustrates lines in Mao's poem written *On a Photo Taken by Comrade Li Chin on the Cave of Immortals on Lu Mountain*, composed in September 1961:

> Strong pines in the gray glow of twilight,
> calm under a whirling chaos of clouds,
> Cave of Immortals, creation of nature:
> Highest beauty in the dangerous peaks.[57]

Presumably the new symbolic meaning comes from this poem by Mao, although such is not so said in any of the literature available to me. Heroic imagery is obvious in the poem. Notes accompanying the translation of the poem supply the idea that "the sturdy pines are, like China, undisturbed by the rioting clouds overhead" and the cave, a work of nature, "like the beautiful work of man in shaping a Communist China . . . exists in the midst of danger."[58] It might also be that Mao is likened to the pine. Undoubtedly the symbolic ramifications could be multiplied through additional interpretations.

From of old a sign of spring and rebirth, the plum blossom was now supplied with "heroic" connotations. This new association arose from the interpretation of another of Mao's poems, *Ode to the Plum Blossom*, composed in 1961, of which the critical lines are:

> Beautiful, not competing for spring,
> only calling that it is coming.
> When mountain flowers are in full bloom,
> she will be among them smiling.[59]

In 1973 this poem was interpreted as referring to revolutionary heroes who live and die before see-

52. Cheh Ping, "A New Style of Bamboo Painting," CL, 1973, no. 4:96–97.
53. Ibid., 97.
54. Fan Tseng, "Traditional Chinese Painting," PR, 21 July 1972, 19; similar comment in "A New Atmosphere in the Garden of Fine Arts—A Visit to the 'National Exhibition of Serial Pictures and Chinese Paintings' and the 'Exhibition of Peasants' Paintings from Hu-*hsien*,'" JMJP, 15 Oct. 1973, SCMP, no. 5487:183.

55. Ko Tien, "New Paintings by Soldiers," CL, 1976, no. 8:98.
56. "*Jen-min Jih-pao* Article on National and PLA Fine Arts Exhibitions," 161.
57. Hua-ling Nieh Engle and Paul Engle, *Poems of Mao Tse-tung* (New York: Dell, 1972), 124.
58. Ibid.
59. Ibid., 120.

In the Sunlight of Socialism

ing the fruition of their cause.[60] The plum blossom must by analogy also refer to the heroic martyrs of the model operas, most of whom lived and died before the establishment of the People's Republic of China. Guan Shanyue's *Red Plum Blossoms* (fig. 88) of 1973 was given as an exalted example in this genre. Guan himself explains some of his earlier attempts to paint plum blossoms and why they are inappropriate. He says that before Liberation he did a painting of plum blossoms, trying to recapture the spirit of the poem by the Song dynasty Lin Bu:

> Sparse twigs aslant shallow water
> Secret fragrance floats in the dusk under the
> moon.

His effort, however, with "shadows cast by the moonlight conveyed a sense of detached, aloof enjoyment."[61] In 1960 his illustration to Mao's poem *Plum Blossoms Welcome the Whirling Snow* he felt was a failure because he was still giving his main attention to form.[62]

In conclusion, under Jiang Qing's insistence,

the aesthetic principles governing her theatrical presentations were applied to painting. Of the three major genres (figures, landscapes, and birds-and-flowers) it was easiest to transfer these dictates to figure depictions, since they so readily paralleled the stage. Figure paintings could echo the theater in presenting heroes and heroines from among the peasants, workers, and soldiers often on heights bathed in light or against a stormy background. Landscape paintings were made "heroic" by their large scale and by their subject matter, which proclaimed the victory of socialist man over nature. Bird-and-flower painting suffered from an innate inability to carry "heroic" content. The few approved bird-and-flower pictures had magnified motifs placed, like the heroic figures, directly in the immediate foreground and sometimes against a background scene of adverse weather. The *Bamboo Harvest* was extolled as a new achievement because it was so radically different from bamboo paintings of the past by virtue not only of the greatly enlarged plants, but also by the bamboo rafts suggesting socialist work, a motif never before incorporated into bamboo paintings. Depictions of pines and plum blossoms became common under the aegis of Jiang Qing because their "heroic" status was derived from the use of these images in poems by Mao Zedong where they were given extended symbolic import of "heroic" dimensions.

60. "New Works by Veteran Chinese Painter," 103.
61. Kuan Shan-yueh, "An Old Hand," 120–121. This couplet is perhaps the most famous of all plum poetry; see Maggie Bickford, *Bones of Jade, Soul of Ice: The Flowering Plum in Chinese Art* (New Haven: Yale University Art Gallery, 1985), 24.
62. Kuan Shan-yueh, "An Old Hand," 120.

8

After the abortive coup attempt by Marshal Lin Biao, and his presumed demise, it was imperative that the "truth" be revealed about Mao's former successor. The ensuing campaign against Lin focused on his criminal actions, his ideology, and his military career. Accusations against him were pulled into the multifaceted Criticize Confucius campaign, with its various submovements and political targets, in which Lin was made out to be a devout, closet Confucian.

Art and the Criticize Lin Biao Campaign

Early in 1974 an outpouring of Criticize Confucius essays minutely criticized his life, teachings, and philosophy. Among the ideas claimed to be Confucian (even if somewhat strained in their interpretation) which have the greatest bearing on art are the theory of genius and its corollary the inequality of men. According to the American scholar Tien-wei Wu, who has thoroughly studied these Criticize Confucius documents, it was taken that "Confucius's idealism led him to advocate fatalism and apriorism. He advanced the concept of innate genius and together with his famous proponent Mencius, tended to advocate that talents or abilities were foreordained by heaven, so that human efforts could not change

what heaven had willed." [1] Elsewhere it was put forth that Lin Biao advocated the role of individual heroes or geniuses in the historical process. This concept was instrumental in his high-powered promotion of the Mao cult during the Cultural Revolution. In the Criticize Lin Biao campaign it was claimed that Mao resented Lin's efforts to apotheosize him and that the theory of genius denigrated the historical role of the people and of the Communist leadership. That "history is made by heroes" [2] was diametrically opposed to Mao's unshakable conviction in the strengths of the masses. The Confucian categorization of men into superior and mean, officials and people, intellectuals and workers was echoed in the claim that Lin peddled "the Confucian fallacy that 'the highest are the wise and the lowest are the stupid.'" [3]

There were other concepts supposedly espoused by Lin Biao, such as "art is for amuse-

1. Tien-wei Wu, *Lin Biao and the Gang of Four: Contra-Confucianism in Historical and Intellectual Perspective* (Carbondale and Edwardsville: Southern Illinois University Press, 1983), 26–27. In the following survey of the Lin Biao affair I have also been aided by Michael Y. M. Kau, ed., *The Lin Piao Affair: Power Politics and Military Coup* (White Plains, N. Y.: International Arts and Sciences, 1975).
2. "Lin Biao fandang jituande miaolun," *Wenhui pao*, Nov. 1973, tr. in Kau, *Liu Piao Affair*, 222–224, where the title is rendered as "The Fallacies Advocated by the Lin Piao Anti-Party Clique," 224.
3. Chun Wen, "Paintings by Workers, Peasants and Soldiers," PR, 3 Jan. 1975, 22.

ment," or the theory that art is created in a flash of inspiration. The "theory of inspiration," that art comes with a flash of inspiration rather than deriving from and reflecting integration with the masses and with using the life of the masses as the basic source for art,[4] clearly is a pernicious denial of Maoist thought. Further, Mao always insisted that the purpose of art was political education, not frivolous amusement.

For the arts, the so-called erroneous views of genius and inequality seem to have had their greatest impact on worker- and peasant-amateur art during the Jiang Qing period. Meanwhile, the professional practitioners of traditional Chinese painting were affected by the also erroneous conservative, "return to the good-old-days" attitudes of Confucius and ascribed also to Lin Biao. Of course, the ideas of art by inspiration and for amusement affected equally the amateur and professional spheres. All of these concepts (genius, inequality, inspiration, and amusement) are among those refuted in a number of articles published during this period, articles that primarily use Mao's 1942 Yan'an *Talks* as a basis for their arguments.

One of the questions raised in the writings is that of popularization and elevation. This dual principle, first put forth by Mao in 1942, proclaimed that art must be popularized, brought to the people, in forms they could comprehend, and that as a complementary action, the level of artistic standards must be raised. In the early 1970s some people believed that since art was brought to the people through the amateur art programs, an elevation of artistic standards was now needed. This was to be accomplished through the three-in-one process of combined imput of the Party (the local cadres), the professionals, who had the expertise to assist, and the worker or peasant, who had the correct class feeling, along with further study of Mao's writings on art.[5] Ultimately, large doses of training and coaching from professional artists helped raise the aesthetic level of the art of the masses. Further, a new art journal, *Meishu ziliao*, apparently modeled along the lines of the then defunct professional art magazine *Meishu*, carried illustrations and essays exclusively devoted to workers' art. This journal, published at least from 1973 to 1975, clearly served to elevate worker-amateur art.

Refutation of Lin's "erroneous ideas" was

undoubtedly a major factor contributing to the unprecedented rise of amateur worker and peasant painting under Jiang Qing, for one way to thwart the influence of Lin's thoughts was to provide visible, undeniable proof that the masses could produce art. Consequently, worker-amateur artists were catapulted into nationwide recognition, and peasant-amateurs into worldwide fame.

Worker-Amateur Art

Workers in the shipyards of Shanghai, the factories of Lüda, and the collieries of Yangquan had exhibitions of their works in traditional Chinese medium, in oils, gouaches, and woodcuts. In subject, some dealt directly with the Criticize Lin Biao, Criticize Confucius campaign, such as the woodcut *Dare to Trample on the "Analects" of Confucius*,[6] others by implication, as in the traditional-style painting where "workers standing before a giant ten-thousand-ton hydraulic press made by themselves are refuting the theory of genius peddled by Lin Piao and Confucius and the latter's saying 'The highest are the wise and the lowest are the stupid.'"[7]

As would be expected, the workers adhered to the current approved artistic criteria for their pictures. Factory and shipyard scenes are characterized by a limited number of bright, clashing colors, which are visually arresting and impart a sense of drama. Regardless of where the action is set—in the factory in Zhou Xiaoyun's *Battling with Both Gun and Pen* (fig. 89) (referring to the Criticize Lin Biao, Criticize Confucius campaign) or in the coal pits in *New Starting Point for Automation* (fig. 90), by Ma Hongqi, Ren Heping, and Wang Yonghui—it is always broad daylight or floodlight. No one is in shadow, everyone faces forward, all poses and actions are immediately intelligible. As was noted earlier, Ma Xueli's woodcut of a ship under construction (fig. 72) is seen from a low angle so that it "dominates the picture," and in many other examples height is emphasized through an exaggerated perspective.

4. "Lin Biao fandang," in Kau, *Lin Piao Affair*, 223–224.
5. Ch'in Yen, "Strive to Develop Amateur Literary and Art Creations by Workers, Peasants, and Soldiers," *Hung-ch'i*, no. 5, 1 May 1972, SCMM, no. 730:78.

6. Reproduced in *Shanghai Yangquan Lüda gongrenhua zhanlan zuopin xuanji* (Beijing: Renmin meishu, 1974), 22.
7. Hu Chin, "Paintings by Shanghai Workers," CL, 1974, no. 12:91, 92. The supposed quote from Confucius would appear to be a conflation of something like a statement from the *Analects* (XVI:9): "Those who are born wise are the highest type of people; those who become wise through learning come next; those who learn by overcoming dullness come after that. Those who are dull but still won't learn are the lowest type of people." Wm. Theodore de Bary, ed., *Sources of Chinese Tradition* (New York: Columbia University Press, 1960), 26.

The workers' pictures are also characterized by yet other formulae, in addition to those which glorify the sunlight of socialism. These additional standardizations are particularly apparent in composition and brushwork, and they spring from prototypes provided by the professionals who tutored the amateurs. For example, one composition popular among worker-amateurs is seen in *I'm Going to See Papa Off to the Frontier* (fig. 91) by three Shanghai workers: Chen Hongbing, Mu Yilin, and Yuan Keyi. It is nearly the same in composition as *Applying to Join the Party* (fig. 92) by the professional artist Liang Yan (b. 1943). The basic compositional arrangement demands the placement of objects in one corner, then something which points to the figure is put in the middle of the format and backed by a vertical. Such compositional similarities as these are also evidence of the deliberate dissolving of "class" differences between worker-amateur and intellectual-professional.

The second standardization is seen in the techniques used to represent figures in traditional Chinese medium. In the workers' pictures, figures are outlined in black, and broad swatches and irregular patches of ink with little tonal modulation represent shadows of folds in the garments. This rough and coarse approach to the art of painting is a very simplified approximation of the professionals' much more subtle and descriptive method of handling the brush and is indicative of what can occur when a sophisticated technique is downgraded, debased by reduction to popular levels. In addition, the delineation of faces is also formulaic; distinction is made between male and female and between the very young and the very old, but otherwise heads are interchangeable. The faces tend to be round and plump, everyone smiles the same smile, lips are parted just so much to reveal perfect teeth. One of the reasons for the similar drawing techniques and the routine faces was the availability of do-it-yourself copybooks prepared by professionals demonstrating step by step how to paint a workman's face or a young girl's head and dress.[8] Standardization of art was desirable as a means of quelling the rise of individualism or personal style (always an elitist, bourgeois idea). The robust, healthy physiques and the heavy, round faces of the workers are the antithesis of the enervated bodies and oval faces of upper-class "scholars and beauties" of traditional Chinese art.

Peasant-Amateur Art

Under Jiang Qing, the peasant-amateur received even more attention than the worker-amateur. Chinese peasants were first mobilized as painters during the Great Leap of 1958. At this time, although peasants throughout the country painted murals on their village and house walls, it was primarily works from Jiangsu province in the south which were lauded and exhibited in Beijing. As might be expected in 1958, untutored peasant-amateurs did naive or cartoon-like pictures, some of which have their own charm, as in the *Catching Moths* (fig. 36) or *Big Fish* (fig. 34), where a boat holds a gigantic fish, the folk symbol of plenty. Between 1959 and 1972 little is heard about peasant painters. Then, between 1972 and 1976, Jiang Qing lavished extraordinary promotion on the peasant painting done in Huxian county in Shaanxi province in north China. Not only were these paintings exhibited in Beijing, they also toured major Western cities, giving unknowledgeable Westerners a distorted view of contemporary Chinese art.[9] Aside from this, one aim of the peasant-painting propaganda within China was to quash Lin Biao's erroneous "theory of genius" and his view that the masses and the unlettered peasants cannot be creative. In addition, it is evident from written sources that Huxian was to become a model for peasant-painting. It was to be on a par with or parallel with the already established Dazhai brigade as the agricultural model to be emulated and the Daqing oil fields as the industrial model to be imitated.[10] Now, however, it was not the naive peasant painting of 1958 that was to be emulated. To achieve the dual goals of refuting Lin Biao and of making Huxian a peasant-painting model, a great deal of professional help was made available to the Huxian peasants.[11] This outside help accounts for the striking differences in conception, presentation, and skillful rendering between the unsophisticated 1958 *Big Fish* (fig. 34) and the slick 1974 *Commune Fish Pond* (fig. 93), also signifying abundance, done by the Huxian peasant Dong Zhengyi, with its dynamic curving compositional framework, its subtle

8. A later version of these manuals was published in Shanghai in 1977: *Zhongguohua renwu jifa ziliao*, with illustrations by Yang Zhiguang and two other professional artists (Shanghai: Shuhuashe, 1977).

9. *Peasant Paintings from Huhsien County* (Peking: Foreign Languages Press, 1974) is the catalogue prepared for the exhibition of these paintings in the West. See also, Ralph Croizier, "Chinese Art in the Chiang Ch'ing Era," *Journal of Asian Studies* 38 (Feb. 1979): 303–311.
10. For example, the peasants in Fujian were said to have learned from the experiences of Huxian peasant artists. "Peasant Art Exhibition in Fukien," CL, 1974, no. 9:114.
11. "Peasant Painters in Northwest China *Hsien*, NCNA Sian, 13 July 1972, SCMP, no. 5181:56.

colors and glittering fish, its figures which diminish in size as they recede into the background.

The peasants, like the workers in their art, also relied heavily upon the professionals for technical assistance in the composition of their pictures. To demonstrate this dependence, it is only necessary to make a series of three comparisons of peasant paintings with possible professional prototypes. Li Fenglan's *Spring Hoeing* (fig. 94) featuring a curved row of women working the fields and skillful diminution of figures may have been derived from a professional work done around 1958, Pan Jiezi's *Planting Rice Seedlings* (fig. 95). Liu Zhide's *Old Party Secretary* (fig. 96), which is cast into the standard compositional formula of a large object in one corner, figure in middle, and some vertical stabilizing element, could also have been based upon *Two Lambs*, made by Zhou Changgu in 1954 (fig. 29). Zhang Lin's *Diligence and Thrift* (fig. 97) is done in the socialist realist compositional mode as exemplified by many professional works, including Xu Beihong's *Tian Heng and His 500 Retainers* of 1928 (fig. 26). In most cases, like the worker-amateurs, the peasants' versions of the advanced professional compositional schemes tend to be vastly reduced and simplified.

Publication of commentaries by peasant painters describing their work methods, and the professed political educational value of their paintings, also served to contest Lin Biao's view that art was created in a flash of inspiration and was for amusement.[12]

In conclusion, as was reiterated in the press, the "working people of China not only produce material wealth . . . but are also creators of socialist culture and art";[13] their creations "constitute the foundation of a prosperous and developed socialist literature and art."[14]

Traditional-Style Painting Professionals

Traditional-style painters also participated in discrediting Lin Biao's art theories. In the case of traditional-style Chinese painting it was a matter of how to deal with an art recognized as a "unique national form," with "positive Chinese style and manner," and one "popular with the broad

masses."[15] Here the issue focuses not on manufacturing a "heritage" proving artistic creativity, but the very reverse: denying the legacy by developing the willingness to discard those undesirable trappings inherited with traditional-style painting in order to make it serve the new society. One can speculate that the political and ideological reforms of traditional-style artists associated with the debunking of Lin Biao could have been quite stringent, since Jiang Qing was completely aware of how dangerously susceptible to possible decadent tendencies traditional-style painting really was. After all, at the height of the Cultural Revolution, she had lashed out at the decadence she saw in Qi Baishi and at the Zhejiang Institute of Fine Arts in the work of Pan Tianshou.

Efforts to remold traditional-style painters were carried out in 1972 in Zhejiang, Canton, Shanghai, and presumably elsewhere. Articles written by groups of traditional-style artists from these three areas reveal to us the types of incorrect views, often even contradictory, toward traditional-style painting now to be ascribed to Lin Biao and his following. According to one report by artists from Guangdong, sometimes Lin and his ilk opposed "weeding through traditional Chinese art to produce something new"; at other times they "took a nihilistic attitude towards all traditional painting" or again urged the complete acceptance of everything from the past. Never, however, did Lin and his kind suggest that both the content and the form of traditional painting be reformed to suit new demands.[16] Another anti-Lin essay belittles the capacities of traditional-painting brushwork and color, along with its traditional subjects, such as "jagged rocks and withered branches," to portray the "heroic image of workers, peasants and soldiers," and calls for applying the lessons learned in the revolutionizing of Beijing opera by Jiang Qing and for going to the source of art: the lives of workers, peasants, and soldiers.[17] The results, presumably, of these reform programs in traditional Chinese painting are seen in such efforts as *Newcomer to the Mines* (fig. 77) by the Canton artist, Yang Zhiguang (discussed earlier), and *Bamboo Harvest* (fig. 87),

12. For a study of peasant painting, see Ellen Johnston Laing, "Chinese Peasant Painting, 1958–1976: Amateur and Professional," *Art International* 27, no. 1 (Jan.–March 1984): 1–12ff.
13. Chun Wen, "Paintings by Workers," 21.
14. Ch'in Yen, "Strive to Develop Amateur and Literary Art Creations," 75.

15. Chinese Creative Painting Group of Kwangtung, "Create the New Boldly During Repeated Practice," JMJP, 22 Aug. 1972, SCMP, no. 5208:6 (slightly different translation in CL, 1972, no. 11:106–114, under title "Innovations in Traditional Painting," 109).
16. Ibid., CL, 106; SCMP, no. 5208:4.
17. Members of the Chekiang Art College, "Our Artistic Heritage and Our New Art," CL, 1972, no. 8:16–17; see also Creative Group of Academy of Chinese Painting of Shanghai, "Some Experiences in Creating the New in Chinese Painting," JMJP, 22 Aug. 1972, SCMP, no. 5208:9–12.

made by three teachers at the Zhejiang Art Academy who might have been involved in the very reforms reported in the article just quoted.

Jiang Qing's supposedly monolithic hold over the arts, however, had its cracks. With all this effort expended in rectifying the traditional-style artists, she was understandably appalled at events that surfaced in 1974 and that crystallized in the so-called Hotel School.

To understand the significance, largely overlooked or misconstrued, of the Hotel School episode it is necessary to provide some brief political background.[18] After the thaw in international relations in 1971, the Ministry of Foreign Affairs realized that there would be not only new Chinese embassies abroad, but also many more dignitaries coming to China, living in the hotels, and dining in the restaurants. The appropriate interior decoration for these embassies, hotels, and restaurants became of grave concern. The ministry wanted traditional-style pictures done for them, an estimated ten thousand. The matter was taken to Zhou Enlai. He approved the idea. He thought it was an ideal opportunity to utilize the older generation of traditional artists (including many of those still in detention, or at least in disgrace, since the Cultural Revolution and those very artists who roused Jiang Qing's ire, being generally abhorred by her). Since they were going to paint for hotels but would not receive any additional stipend, they were to be allowed to live and eat in the hotels. This incidently would improve their living conditions and nutrition. Zhou declared that the subjects of the paintings should be birds-and-flowers and landscapes. There did not need to be pictures of peasants, workers, or soldiers with guns. Any subject was acceptable as long as it was not anti-Communist, feudalistic, superstitious, or erotic. Zhou claimed that there was an "inner" and an "outer" art. The former was for domestic Chinese, and the latter for foreign, international consumption. It is worthy of note that traditional Chinese paintings of traditional genres were selected to represent China on the international scene.

As a consequence, the famous, older traditional-style artists, as well as a few woodcut artists and oil painters equally proficient in the traditional-painting mode, were called back from rural cadre schools and villages or released from "ox-house" detention. They were to paint not only for hotels, embassies, and restaurants, but also for foreign trade, that is, for sale to the West. Groups of artists gathered in Beijing, Shanghai, Xi'an, and Canton to carry out this task of providing paintings for hotels and other establishments. More than forty-two men and women were involved; they worked from mid-1972 until late 1973. Gradually, the hotels where these artists worked became meccas for admirers of traditional art; other artists, intellectuals, and Chinese and foreign VIPs began to congregate there.

Jiang Qing finally learned about all this "unapproved" artistic activity and began to criticize the artists and their works as "the Hotel School," but it was not until the end of 1973 when Zhou Enlai was seriously ill and soon to be hospitalized that she was able to launch the Criticize Lin Biao, Criticize Confucius campaign, aimed at discrediting Zhou. She claimed there was no such thing as an "inner" art and an "outer" art; there was only one kind of art. She had the paintings collected from the hotels and exhibited them publicly as "black" or "revisionist" paintings. In the spring of 1974 an exhibition of 211 "black" paintings was held in Beijing. The works were condemned as "wild, strange, black, reckless." There were similar exhibitions elsewhere in the country. Painters were forced to confess their errors. Their houses and studios were searched, paintings were confiscated. The artists' movements were curtailed; several older artists died.

The works were criticized primarily for their subject or style, although other reasons might also be cause for censure. Chen Dayu's (b. 1912) *Welcome Spring* (fig. 98) depicting a rooster and forsythia was criticized because too much of the whites of the rooster's eyes showed. In traditional China, showing the whites of the eyes was a way of indicating scorn. Chen's picture "showed hostility toward newborn socialist matters."[19] He Zi depicted the heroine of the novel *Dream of the Red Chamber* in the famous episode where she buries dead flowers (fig. 99). This painting, mailed to He's daughter in Hong Kong, was confiscated at

18. The following account is based primarily upon information in three main sources: Wenhuabu Pipanzu, "Yige jingxin cehuade fandang yinmou—jielu 'sirenbang' pi 'heihua' de zhenxiang," RMRB, 22 May 1977; text also reprinted in *Jiefa pipan "sirenbang" wenxuan* (Hong Kong: San Lian, 1977), 3: 146–152, English translation as Mass Criticism Group, Ministry of Culture, "A Meticulously Planned Plot Against the Party—Exposing the Reality of the Gang of Four's Criticism of Sinister Paintings," in *Daily Report*, 31 May 1977, E4–E7; [Fang Dan?], "Zhou Zongli yu 'binguan huapai,'" *Mingbao yuekan*, June 1976, 87–88; Fang Dan, "'Pi heihua' yuanshi cailiao," *Nanbei ji*, Feb. 1979, 26–29; and additional articles by Fang Dan, Mo Yidian, and others in the Hong Kong periodical press from 1976 to 1980.

19. Mo Yidian, "Shenzhen duhua ji," *Mingbao yuekan*, Oct. 1977, 37.

In the Shadow of Revisionism

the post office. A special-case committee and "battle squad" were organized to investigate the situation. It was decided that the painting expressed, through the burial of the fading flowers, the artist's wish for the destruction of the Cultural Revolution.[20] Huang Zhou's pictures of donkeys were construed as referring to Jiang Qing and the others as asses.[21] A picture of eight lotus flowers and a bird was interpreted as a criticism of Jiang Qing's eight model operas under one dictator.[22] Stylistically, paintings by Cheng Shifa of sweet minority girls and their pets were too abstract, were splashy, and used too much black ink.[23] Li Keran's *Mountain Village after Rain* (plate 13) was castigated as "black mountains and black water."[24] Li got into further difficulty with Jiang Qing because of an interview he granted to a Yale University professor, Zhao Haosheng, in 1973. This interview was published in Hong Kong, and excerpts from it were circulated in China. Li in the interview defended Qi Baishi, who Jiang Qing had declared was greedy and stingy. Li was accused of intending to restore the empire through showing respect for the older artist.[25]

It has generally been assumed that the subjects of the maligned Hotel School paintings were totally innocent, devoid of political significance. This assumption, however, might be naive. Painted for a friend, Huang Yongyu's *Winking Owl* (plate 14), it was claimed by his detractors, scoffs at socialism.[26] But the implied political criticism is more acute than this. Although it was not mentioned in the published materials on Huang, the owl in Chinese popular lore and tradition is an ominous bird:[27] "The voice of the owl is univer-

sally heard with dread, being regarded as the harbinger of death."[28] The owl was considered "a transformation of one of the servants of the ten kings of the infernal regions, i.e., is a devil in the guise of a bird."[29] As a creature of darkness and ill omen, its power begins on the summer solstice, the day of the sun's greatest strength but also the day the sun begins to wane.[30] The ominous connotations of the owl and the symbolic association that might be made between Mao's waning years and Jiang Qing's waxing political power surely figured in the castigation of this painting and its maker. Further, Huang Yongyu had earlier (1962) gotten into trouble for his "counterrevolutionary" "Animal Crackers" poems in which he used animals to lampoon political figures.[31]

The titles of paintings or poems inscribed on them could also be given negative interpretations. For example, paintings titled *Late Autumn* or *First Snow* or *Walking at Midnight* were criticized because they did not portray the sunny side of socialist life.[32] The following couplet written on a painting: "Holding the brush in the wind, I think of the past and of memorable good times," was understood as an allusion to the artist's hostility to the new society.[33] A final example: a spray of plum blossoms extending from the top to the bottom of the picture, or "upside-down plum blossoms," known in Chinese as *daomei* 倒梅, was said to rhyme with *daomei* 倒霉, the mild expletive (damn it all!)—cursing the "national flower and Mao Zedong and Jiang Qing."[34] It is also entirely possible that inverted plum blossoms were read as a "thumbs down" to heroic martyrs and by extension to Jiang Qing's eight model operas.

The battle against black painting spilled over into the commercial world. Concurrent with the

20. He Zi, "Liangfu 'heihua,'" *Mingbao yuekan*, April 1979, 87–88.
21. Han Suyin, "Painters in China Today," *Eastern Horizons*, 1977, no. 6:20.
22. Mo Yidian, "Shenzhen duhua ji," 37.
23. Ellen Johnston Laing, "Contemporary Painting," in *Traditional and Contemporary Painting in China: A Report of the Visit of the Chinese Painting Delegation to The People's Republic of China*, Committee for Scholarly Communication with The People's Republic of China (Washington, D.C.: National Academy of Sciences, 1980), 59.
24. "Zhongguohuatan chunyi nong Han Suyin nüshi tan Zhongguo meishujie jinkuang," *Qishi niandai*, 1977, no. 4:22.
25. Fang Dan, "Keguizhe dan, suojiuzhe hun—Li Keran he tade meixue," *Nanbei ji*, June 1979, 91. Zhao Haosheng, "Li Keran, Wu Zuoren tan Qi Baishi," *Qishi niandai*, 1973, no. 12:60–66.
26. Fang Dan, "Qicai Huang Yongyu," part 3, *Nanbei ji*, April 1977, 62.
27. One of the earliest indications of the inauspicious nature of the owl occurs in 174 B.C. with Jia Yi's writing of his "Owl" prose-poem; see Burton Watson, *Records of the Grand Historian of China translated from the Shih chi of Ssu-ma Ch'ien* (New York and London: Columbia University Press, 1961), 1:511–515. Watson notes that owls are symbols of petty-minded slanders.

28. Nicholas B. Dennys, *The Folklore of China and Its Affinities with That of the Aryan and Semitic Races* (London and Hong Kong, 1876; Amsterdam: Oriental Press reprint, 1968), 34.
29. Justus Doolittle, *Social Life of the Chinese* (New York: Harper, 1865), quoted in Dennys, 35.
30. Wolfram Eberhard, *The Local Cultures of South and East China*, trans. Alide Eberhard (Leiden: E. J. Brill, 1968), 159, 161–162, 169–170. For additional information on the evil owl, see Gerald Willoughby-Meade, *Chinese Ghouls and Goblins* (London: Constable and Co., 1928), 135–136, 299–300, 328, and Jan J. M. de Groot, *The Religious System of China* (Leiden: E. J. Brill, 1892–1910), 5:641.
31. David S. G. Goodman, *Beijing Street Voices: The Poetry and Politics of China's Democracy Movement* (London and Boston: Marion Boyars, 1981), 20; Fang Dan, "'Pi heihua,'" 29.
32. Fang Dan, "Yigao renzheng—bei bojide binguan huajia Zhao Wangyun," *Nanbei ji*, Jan. 1979, 57; Ye Jian, "Yongxin xian'ede yichang naoju—chedi qingsuan 'sirenbang' zai Shaanxisheng dagao 'pi heihua' de zuixing," *Meishu*, 1978, no. 5:16.
33. Fang Dan, "'Pi heihua,'" 27.
34. Fang Dan, "Guaijie Shi Lu," *Nanbei ji*, April 1979, 92.

exhibitions of "black painting," an album of reproductions, *Traditional Chinese Painting*, designed for both domestic and foreign sale, outraged the cultural authorities because of the selection of subjects depicted. Apparently included in the album were reproductions of some of the "black paintings," such as Chen Dayu's *Welcome Spring*. The publication was scathingly condemned in vitriolic language by this faction.[35] Two painting stores in Beijing were also included in the black-painting campaign: Rongbaozhai and Heping huadian. These shops were criticized because they mounted "black paintings" and sold them to "black" customers and because they paid too much attention to conducting business with the wealthy and the foreign.[36]

The opinion of Jiang Qing and her supporters was summarized by Hsiao Luan:

> After the Lin Piao anti-Party clique had been smashed, a handful of people with ulterior motives in the fine arts circles continued to make use of paintings to stir up trouble, distort and vilify the realities of socialism and give vent to their dissatisfaction with and hatred of socialism. The sinister paintings exposed and criticized not long ago are trash of this kind. Under their pens, brightness has been turned into darkness and happiness into disaster.[37]

In conclusion, the Hotel School is not a "school" in the usual sense of the word, since artists worked in a wide variety of styles and in different geographical locations. Hotel School is simply a pejorative term applied to those artists who, under Zhou Enlai's sponsorship, prepared paintings for hotels, embassies, and other official buildings. These paintings are China's first public, acknowledged dissident paintings, because they were not approved by the official cultural-control apparatus and because in style and subject they were counter to the accepted themes. Last, and most important, is the fact that this was the first time that *Chinese-style painting* was used as a political weapon on a *nationwide* scale.

With this in mind, then, it is no wonder that in 1975, it is claimed as part of the Criticize Confucius campaign, the Confucians (here presumably referring to Zhou Enlai) advocated "taking the ancients as models" and insisted that "it is the ancient spirit which gives a painting value." The anti-Confucians continued their arguments by pointing out that an early critic of Confucius complained that Confucians of the day liked "to paint the men of old" and refused "to depict scholars of present times," thus "exalting the past and disparaging the present."[38]

PLA Artists

One way to fight the dangers of Lin's thought was through the art itself and especially through art from the very core of Lin Biao's powerbase: the People's Liberation Army. The National Art Exhibition of 1974 contained works reflecting the movements to criticize Lin and Confucius. Especially selected for praise and extended comments by reviewers were two paintings by PLA members: Shang Ding's *Fighting without Respite* and Li Binggang's *Before the Lecture* (figs. 78 and 79). In the former, a PLA soldier writes a critique of Lin Biao and Confucius; in the latter, one finishes his notes for a lecture on the struggle between Confucians and the Legalists. In other words, two paintings depicting members of the PLA criticizing their former commander were both done by painters from PLA ranks. It might also be observed here that these two paintings were perhaps used as a means of answering possible criticisms that the "heroic" mode of art resulted in stereotypes, for as was discussed in chapter seven, the thrust of an article devoted to these two paintings stresses the different character and personality of the two military men.[39]

Perhaps the most important of the anti–Lin Biao paintings was a history picture, *Only When We Keep in Step Can We Win Victory*. It was done by three men closely associated with the military and portrayed Chairman Mao in 1928 dictating to the army the Three Rules of Discipline and the Eight Points for Attention (fig. 100). Several decades later (1969), when Mao sought to rectify the army's work style, since he apparently felt that "the military was moving in the wrong direction," and when he wanted "to combat the

35. Jen Tu, "Is There Anything 'New' about 'New' Traditional Chinese Painting?: Comment on *Traditional Chinese Painting*, a Collection Compiled by Shanghai Municipal Arts and Crafts Branch Company," *Hsüeh-hsi yü p'i-pan* [Study and Criticism], no. 3, 1974, in SCMM supplement no. 62, 31 May 1974, 10–14. Apparently few if any copies of this publication are available in the West. See also Fang Dan, "Cheng Shifa he tade hua," part 2, *Nanbei ji*, Sept. 1978, 88–89.
36. Fang Dan, "Xu Linlu—Qi Baishide bimen dizi," *Nanbei ji*, Jan. 1977, 99; Fang Dan, "Hou Kai yu 'heihuadian'— manhua Rongbaozhai," *Nanbei ji*, Oct. 1979, 74–78; Dec. 1979, 65–69.
37. Hsiao Luan, "Paintings of the Era and Art of Combat— After Seeing the 'National Fine Arts Exhibition,'" JMJP, 26 Nov. 1974, SCMP, no. 5759:7.

38. Chiang Tien, "The Struggle Between the Confucians and Legalists in the History of Chinese Literature and Art," CL, 1975, no. 7:100–101.
39. Chi Cheng, "Two Oil Paintings," CL, 1975, no. 4:112– 113.

'arrogance and complacency' of armymen entrenched in their new positions...the Party also reissued the Three Main Rules of Discipline and the Eight Points for Attention of the old Red Army and singled them out as 'important teaching materials for education in ideology and political line.'" The effect of this was to demand "that the armymen 'obey [Party] orders in all actions.'" [40] The first Rule of Discipline is "obey orders in all your actions." In documents criticizing Lin Biao this was amplified to "obey orders in all your actions: march in step to win victory." [41] This, of course, was a clear directive to follow Mao rather than Lin. The appearance of a painting of this subject in 1974 carries the same message. An understanding of how this painting is to be "read" and interpreted can be gained from the following extracts from two review articles.

> The morning sunshine filtering through bamboo groves lights up the background as the chairman speaks. Gazing up at him, red armymen, red guards and the revolutionary masses listen with rapt attention. Portraying Chairman Mao's imposing stature, the artist effects a combination of the bright red flags, the light grey uniforms and the fresh green bamboo against the clear blue sky to bring out the warm harmonious atmosphere of a sunrise. The artist's meaningful touches convey the important message that, guided by Chairman Mao's revolutionary line, the contingents of the revolution must wage a unified struggle in order to march in step from victory to victory. [42]

The second review reads:

> The scene is the Shatien district of Kueitung County in the Chingkang Mountains revolutionary base. The sun has risen, mountains can be seen in the distance, and in a clearing before a bamboo grove Chairman Mao, in a Red Army uniform, is giving a lively description of revolutionary discipline to the soldiers and local people. Chairman Mao's kindly face conveys his high expectations of our people's fighters, while the soldiers and peasants around him are listening attentively to his instructions. The revolutionary truth "only when we keep in step can we win victory," like sunlight piercing the bamboo grove, irradiates the hearts of his hearers, inspiring the fighting men and civilians alike and

strengthening their confidence in winning victory. So each face is alight with joy. It is evident from the clothes they are wearing that here are worker and peasant Red Guards who have come to China's first rural revolutionary base built by Chairman Mao in the Chingkang Mountains. They have rallied round Chairman Mao with weapons to fight for the revolution. The painting also reminds us how poorly equipped the people's armed forces were in those days—apart from a very few artillery pieces and rifles, their weapons are for the most part swords and spears. Yet this people's army created and led by Chairman Mao, after being tested and steeled through the Second Revolutionary Civil War, the War of Resistance Against Japan and the War of Liberation, has grown steadily larger and more powerful. It defeated Chiang Kai-shek's eight million troops equipped with modern arms and won liberation for China in 1949. [43]

These quotations reveal that this oil, *Only When We March in Step Can We Win Victory*, is in some ways the equivalent of *Chairman Mao Goes to Anyuan*, done in 1967. Both paintings extol Mao's role and his leadership in revolutionary history to the complete exclusion of his opponents, Liu Shaoqi and Lin Biao. In addition, *Only When We March in Step Can We Win Victory* is a positive statement about the superiority of Mao's military tactics over those of Lin Biao.

The Tiananmen Incident

In January 1976 Zhou Enlai died. In April during the Qingming Festival, traditionally a time to clean and repair the ancestors' graves, a seemingly spontaneous demonstration honoring Zhou Enlai was held at the Monument to the People's Heroes in Tiananmen in Beijing. The demonstration was brutally suppressed, an action which did little to endear Jiang Qing to the people.

But the remaining days of Jiang Qing's power were few. After the death of Mao Zedong in September 1976, Jiang Qing and her three cohorts, now dubbed the Gang of Four, were arrested and an era came to a close.

Conclusion

Through her programs Jiang Qing provided a specific art plan, whereas in the past, guidelines

40. Michael Y. M. Kau, *Lin Piao Affair*, xlv–xlvi.
41. "Summary of Chairman Mao's Talks to Responsible Local Comrades During his Tour of Inspection Mid-August to Sept. 12, 1971," see Michael Y. M. Kau, *Lin Piao Affair*, 65, and another document translated on p. 140 of Kau. For the other rules and points, often listed, see Kau, 138.
42. "Oil Painting Serves Socialism in China," NCNA Peking, 26 Dec. 1974, SCMP, no. 5729:152.

43. Wang Wu-sheng, "National Art Exhibition," CL, 1975, no. 1:95–96; see also comments on these oil paintings in Hsiao Luan, "Paintings of the Era," 8.

and instructions about what constituted the proper art were vague, even if generous. In contrast, Jiang Qing's strict and rigidly defined policies provided easily followed prescriptions, but ones which were so specific as to be narrow and unyielding.

Although Jiang Qing did much to bring art to the people and the people to art through her programs for workers and peasants, her consistent disdain for the professional and for the traditional-style artist in particular, who as members of the intelligentsia were seemingly incorrigible and unable to conform to her artistic demands, accounts for her continued disparagement of them. It is generally agreed that her insistent requirement that art meet the demands of the heroic and that it be aligned with preestablished forms and patterns served only to limit subjects and inhibit artistic growth in China. The constant political campaigns and the continued demeaning of artists and their art also served to create a stultifying atmosphere.

The Political and Artistic Significance of the Chairman Mao Memorial Hall

9 The large public structures of the People's Republic of China may seem to express nothing but a vacuous giantism intended mainly to impress the citizenry with the unchallengeable power and permanence of the new state. A careful examination of some of these constructions, however, reveals that they often also possess a logical organization designed to convey very specific political and historical messages.

A description of the plaza in Shenyang, Manchuria, may be used to demonstrate this contention. The plaza, approximately in the center of the city, is circular and might better be termed a circus.[1] In the 1930s, under Japanese occupation, this circus was divided along its circumference into curved, parklike areas of trees and walkways. In the center was a small paved zone and, on an octagonal base, an obelisk memorial to Japanese soldiers. The centralized overall plan of the circus, with its concentric circles, resulted in a unified, visually consistent, and integrated design.[2] In 1970 a colossal sculpture of Chairman Mao, some sixty feet in height, was erected in the middle of this circular plaza, now named Red Banner Square. Other changes were made. The central paved sec-

tion was greatly expanded, virtually eliminating the trees and walks around the border. The figure of Mao is on a tall plinth, and the base of the whole sculpture is rectangular. By introducing a rectangular shape into the round plaza, the continuity of circular forms was destroyed, as was the visual integrity of the whole complex. By removing the trees and walks, the partial function of the circus as a municipal pleasure spot was sacrificed.

The title of the sculpture is carved on the front of the pedestal: *Long Live the Victory of Mao Zedong Thought*. On all four sides of the rectangular base are relief sculpture groups, eight in all. At the back of the pedestal, the sculptural scene shows the birth and growth of the Chinese Communist Party under Mao's leadership. On one side from right to left, the sculptures illustrate the following slogans: (1) A Single Spark Can Start a Prairie Fire, (2) Long Live the People's War, and (3) Carry the Revolution to the End. These subjects are paralleled by similar slogans on the opposite side: (1) Socialism Is Fine, (2) Long Live the Three Red Banners (socialism, the Great Leap, the people's communes), and (3) Carry the Great Proletarian Cultural Revolution through to the End. The subjects are arranged in chronological order and in thematic symmetry. At the front of the plinth, the sculpture group depicts a revolutionary committee and illustrates the slogan "Unite to Win Still Further Victories." All themes ob-

1. It should be noted, of course, that the idea of an open area in an urban setting which can serve as a public gathering place for pleasure or some other communal purpose is a Western concept.
2. For photographs of this circus, see *Manshū bojō* (Tokyo: Kenkōsha, 1971), 1:68; 2:44; *Manshū Teikoku taikan* (Tokyo: Seibundō Shinkōsha, 1937), 626.

viously relate to Mao's political and social revolutions.[3]

In addition to the balanced thematic program in the sculptures, the siting of the sculpture itself is also of importance. It is placed with the standing figure of Mao facing west, so that he is backlighted by the rising red sun of the new day. Thus, in some respects, the sculpture echoes Cultural Revolution imagery of Mao with a large glowing sun behind him.

Before turning to an explanation of the artistic and political significance of the Chairman Mao Memorial Hall in Tiananmen Square in Beijing, it is necessary to understand the reorganization and significance of Tiananmen Square under the PRC. During the Qing dynasty, Tiananmen Square was not a square at all but a T-shaped forecourt to the Imperial Palace (fig. 101). The shaft of the T had a central road and a series of gates and walled, colonnaded courtyards aligned on the south–north axis leading up to Tiananmen, the entrance to the Imperial Palace. On each arm of the T were gateways which prohibited free access to this area, so that east-west traffic had to detour around the square. According to Liang Sicheng, a leading modern architect, "The architectural treatment served merely to lengthen the central axis so as to impress the people with the emperor's dignity, power and mystery."[4] Another commentator states that "it was built to overawe the common people."[5] After the overthrow of the Qing empire in 1911 the gates were opened to permit the flow of traffic, and a warren of government buildings arose on either side of the stem of the T. During the ensuing decades Tiananmen was the locale of many political demonstrations, such as that on May 4, 1919, when students and others gathered here to protest the outcome of the Versailles Peace Conference ceding former German interests in Shandong to Japan; on May 30, 1925, demonstrations were staged here to protest the massacre in Shanghai's International Settlement (when police fired on a crowd protesting the shooting of a worker).

In 1949 Chairman Mao proclaimed the establishment of the People's Republic of China from Tiananmen Gate overlooking the square. In the succeeding decade several changes were introduced into the square. The three gateways were taken down in 1952, and in 1958 the encircling walls were demolished. Construction of the marble Monument to the People's Heroes, located just south of Tiananmen Gate, commenced in 1949 and was completed in May 1958. Since this Monument will be important to our argument later in this chapter, it is best to describe it in some detail here.

The Monument consists of a columnar shaft topped with a traditional Chinese roof design (fig. 102). On its northern face the cenotaph bears an inscription by Mao Zedong; its southern face has one by Premier Zhou Enlai. The shaft is placed on a double plinth, the upper one decorated with sculptured floral designs, stars, garlands, and other motifs, the lower plinth carries a series of ten bas-relief sculptures, arranged in chronological order beginning on the east side and going clockwise to the north. The reliefs depict the "revolutionary struggles of the Chinese people during the past hundred years."[6] On the east side the subjects are the nineteenth-century Opium Wars and the Taiping Rebellion; on the south side, the Wuchang Uprising (which led to the overthrow of the Qing imperial house in 1911), the May Fourth Movement of 1919, and the May Thirtieth Movement of 1925. The subjects of the reliefs on the west side include the Nanchang Uprising of 1927 and the War against Japan during 1937–1945. On the north side there is only one relief; the subject is the Crossing of the Yangtze River and the Liberation of Nanjing in 1949, which marked the beginning of the end of the War of Liberation and the ultimate victory of the Communists.[7] Writers on the topic of the Monument to the People's Heroes neglect to point out the connection between the north face of the Monument and Tiananmen. On the basis of observation, it is clear that to continue the chronological program of the subjects on the plinth of the Monument to the People's Heroes, the next logical extension involves a leap to Tiananmen Gate: the "birthplace" of the PRC.

In 1958 the Chinese undertook a massive building project on Tiananmen, the object of which was to convert the former "Imperial Way" into a people's plaza. The goal was to have it finished by 1959 in time for celebrating the tenth anniversary of the founding of the PRC. The central area was considerably widened, and on the shaft of the T, south of the Monument to the People's Heroes,

3. "The Sculpture 'Long Live the Victory of Mao Tsetung Thought' Completed," CL, 1971, no. 1:132–133.
4. Liang Szu-cheng, "Tien An Men Square," CL, 1960, no. 2:114–115.
5. "The New Tien An Men Square," PR, 1 Oct. 1959, 22.

6. Liu Kai-chu, "Monument to the People's Heroes," PR, 29 April 1958, 15; see also Wu Liangyong, "Renmin yingxiong jinianbeide chuangzuo chengjiu The Monument to the People's Heroes," Jianzhu xuebao Architectural Journal, 1978, no. 2:4–9.
7. Liu Kai-chu, "Monument to the People's Heroes," 15–16.

were planted expanses of evergreen shrubs, pines, maples, and willows.[8] Two gigantic buildings were constructed: The History Museum on the east and the Great Hall of the People on the west. Architecturally, according to the reports, the colonnaded facades of these halls were reminiscent of traditional Chinese architecture as well as of the buildings which had originally lined each side of Tiananmen Square.[9] Liang Sicheng claimed, "The New Tien An Men Square has been designed to serve the needs of socialism and communism."[10] He seems to be referring primarily to the Heroes Monument, the History Museum, and the Great Hall of the People, but leaves unstated the further ramifications and symbolic meanings of the new design. As of 1959 the monuments on Tiananmen collectively formed a unified political statement. From the rostrum of the Tiananmen Gate on the north, Mao had proclaimed the birth of the PRC; the Heroes Monument in the center memorializes those who gave their lives for revolutionary causes. The History Museum on the east houses and displays artifacts from the past which justify the PRC, and the Great Hall on the west, where the National People's Congress holds its sessions, substantiates the dictatorship of the people (fig. 103). Thus, Tiananmen had indeed become a people's plaza, and whenever Mao or other leaders stand on Tiananmen during, for example, National Day celebrations, they are surrounded by these political symbols.

The Chairman Mao Memorial Hall, finished in 1977, was designed by a committee of some seventeen people from eight municipalities and provinces under the guidance of Chairman Hua Guofeng and the Party Central Committee.[11] Built in six months, and occupying the space formerly the wooded public park south of the Monument to the People's Heroes, it was to be architecturally harmonious with the existing buildings on Tiananmen.[12] The Memorial Hall closes off

Tiananmen in terms of physical structure and layout (fig. 104). One observer asserted that the Memorial Hall, along with the other three buildings on Tiananmen Square re-create a traditional Chinese architectural layout of a temple plan where gateway, lecture halls, and image halls surround a courtyard.[13]

Numerous articles and one book have been devoted to the Chairman Mao Memorial Hall or an aspect of it.[14] These publications are immensely useful because they describe or picture the physical appearance of the Memorial Hall and its surroundings, yet none deals with the several programs of political iconography which tie the Memorial Hall to other buildings at the periphery of Tiananmen Square. Before explicating this at times rather complex iconography, it is important to have a general understanding of the various parts of the Memorial Hall.

The main entrance to the Chairman Mao Memorial Hall, contrary to traditional Chinese mausolea orientation, is on the north. The reason for this is so that the entrance will face the Monument to the People's Heroes.[15] Outside the Hall are four large, free-standing figural sculptures, two on the north side of the building and two on the south (fig. 105). Inside the three-storied Hall the main floor is divided from north to south into a vestibule, then a hall, next the chamber with Mao in his crystal casket, and finally the south hall (fig. 106). Along the sides are a number of rooms, including two large and two small reception lounges. These lounges have calligraphies of Mao's poems, paintings, and other art works on the walls.

The parts of the Chairman Mao Memorial Hall will be discussed below in sequence, beginning with the north facade, the side facing the Monument to the People's Heroes and Tiananmen. The two sculpture groups on the north side have themes of the past. On the east are subjects up to 1949 (such as the Anyuan miners, the struggle in the Jinggang Mountains, the Long March, the war against Japan, and the War of Liberation).[16]

8. "The New Tien An Men Square," 23.
9. Liang Szu-cheng, "The Great Hall of the People in Peking," CL, 1960, no. 3 : 121. In some respects this is a polite political fiction. The massive proportions of the building, its solidity, and its stone fabric are distinctly non-Chinese and more in keeping with Soviet neo-classical architecture. Further, the purity of the colonnade, apparently meant to reflect Chinese architectural prototypes, is marred by fluted capitals of distinctly ancient Egyptian flavor.
10. Liang Szu-cheng, "Tien An Men Square," 119.
11. "Cornerstone Ceremony Held for Mao's Memorial," NCNA Peking, 24 Nov. 1976, Daily Report, 1976, no. 229, 26 Nov. 1976, E1; "Mao Zhuxi jiniantang guihua sheji, Planning and Design of the Memorial Hall for Chairman Mao," Jianzhu xuebao Architectural Journal, 1977, no. 4 : 3.
12. "Mao Zhuxi jiniantang guihua sheji," 3, 13; "Chairman Mao Memorial Hall Building Completed," CR, 1977, no. 9 : 3.

13. R. Yin-Wang and Annette Kwok, "Le mausolée du président Mao," L'Architecture d'Aujourd'hui, no. 201 (Feb. 1979): 52.
14. Excellent color photographic coverage is in Mao Zhuxi jiniantang (Beijing: Zhongguo jianzhu gongye, 1978); another photographic essay is in CP, 1977, no. 9 : 4–13; still another in CP, 1977, no. 12 : 1–9 and 22–23. The most comprehensive set of photographs and drawings, including all kinds of details as well as rejected plans, is in "Mao Zhuxi jiniantang guihua sheji."
15. "Mao Zhuxi jiniantang guihua sheji," 13.
16. Chi Shu, "The Sculptures at the Chairman Mao Memorial Hall," CL, 1978, no. 2 : 115; "The Monument to Mao Tsetung," CR, 1977, no. 12 : 6–7.

The Chairman Mao Memorial Hall

Although it is not so stated in descriptions of these sculptures, these themes of the past, located as they are on the east side of Tiananmen, constitute a thematic connection between the Chairman Mao Memorial Hall and the History Museum, which is also on the east side of Tiananmen. The sculptural group on the west side of the Chairman Mao Memorial Hall is devoted to events since 1949 (socialist construction by workers, peasants, soldiers, the PLA defending the borders, learning from Dazhai and Daqing, and the Cultural Revolution).[17] Again, although unstated in the sources, these sculptures on the west, by virtue of their subjects, are related to the Great Hall of the People and progress since Liberation.

Architecturally, the Memorial Hall itself is said to be in "national style" showing "Chinese style and characteristics."[18] These national architectural characteristics include the placement of the building on a two-level podium, the use of exterior colonnades, and the double cornice, all of which echo structural features seen, for example, in the Taihedian in the former Imperial Palace.[19] Other details, such as the white marble balustrade with rounded post heads, and the placement of the array of symbolic motifs, also have imperial architectural and ornamental precedents.[20]

Despite these claims, however, there is a remarkable resemblance between the Chairman Mao Memorial Hall and the Lincoln Memorial in Washington, D.C. (fig. 107).[21] In addition, inside the north hall, a white marble sculpture of Chairman Mao seated in an armchair (fig. 108) is clearly reminiscent of the statue of Lincoln. Furthermore, both the Lincoln Memorial and the Mao Memorial face an obelisk: the Washington Monument and the Monument to the People's Heroes (figs. 109 and 110).[22] Behind the Mao sculpture is a huge tapestry panorama of China, and Mao himself faces Tiananmen Square, its monuments, and its buildings with all their historical and political import. The placement of Mao's mausoleum at the south side of the square serves visually to close off the square and to make its political significance complete. Tiananmen now presents a unified repository of political symbolism signifying a closed chapter in the history of the Chinese Communist Party and the People's Republic of China.[23]

Inside the Chairman Mao Memorial Hall, as was noted earlier, are four reception rooms or lounges. On their walls are paintings, art works, and calligraphies of Mao's poems (suggesting the traditional scholar's cultural pursuits of poetry, painting, and calligraphy).[24] Although these works are reproduced and discussed in the literature on Mao's Memorial Hall, the emphasis is on explaining the subjects depicted rather than the underlying organizational scheme and its rationale.[25] These works are arranged by subject in chronological sequence beginning in the small lounge at the southwest corner of the Memorial Hall. In the southwest small lounge, the painting is of Mao's

17. Chi Shu, "Sculptures"; "The Monument to Mao Tsetung," 6. Photographs of these sculptures on the north of the Hall, as well as those on the south (to be discussed below), are also reproduced in *Meishu*, 1977, no. 5.
18. "Peking Ceremony for Laying Cornerstone of Memorial Hall for Chairman Mao Tsetung," PR, 3 Dec. 1976, 5; "Workers Complete Building Chairman Mao Memorial Hall," NCNA Peking, 29 Aug. 1977, *Daily Report*, 1977, no. 168, 30 Aug. 1977, E1; "The Monument to Mao Tsetung," 3.
19. Yin-Wang and Kwok, "Le mausolée," 52–53.
20. Only Yin-Wang and Kwok comment on the connections with palace and religious architecture; all Chinese literature on the subject consistently ignores these associations in favor of something called a "national style." Clearly, nothing resembling a "people's style" of architecture and decoration (if such could be evoked) is involved here.
21. One Western observer sees a similarity between Chairman Mao's Memorial Hall and the John Fitzgerald Kennedy Center, a similarity superficial at best; see E. Constantine, "Mao's Mausoleum Echoes JFK Center," *Progressive Architecture* 60 (May 1979): 30–31.
22. Mao was also considered an emancipator. For example, "The most intense expressions of grief over Mao Tse-tung's death appeared to come from older people for whom Mao was a great emancipator." Frederic Wakeman, Jr., "Revolutionary Rites: The Remains of Chiang Kai-shek and Mao Tse-tung," *Representations* 10 (Spring 1985): 159.
23. An elaborate system of political significance is also present and understood in the complex of federal buildings and memorials in Washington, D.C. Henry Bacon, the designer of the Lincoln Memorial, said:

> Terminating the axis which unites it with the Washington Monument and the Capitol it has a significance which no other site can equal and any emulation or aspiration engendered by the Memorial to Lincoln and his great qualities is increased by the visual relation of the Memorial to the Washington Monument and the Capitol.
> Containing the National Legislature and judicial bodies, we have at one end of the axis a fine building, which is a monument to the United States Government. At the other end of the axis we now have a memorial to the man who saved that Government, and between the two is a monument to its founder. All three of these structures, stretching in one grand sweep from Capitol Hill to the Potomac River, will lend, one to the others, the associations and memories connected with each, and each will thereby have by a heightened value.

Edward F. Concklin, *The Lincoln Memorial, Washington*. Prepared under the direction of the Director of Public Buildings and Public Parks of the National Capital (Washington, D.C.: United States Government Printing Office, 1927), 40.
24. The Lincoln Memorial has two murals of allegorical figures symbolizing Lincoln's principles of freedom, liberty, justice, etc. Concklin, *The Lincoln Memorial*, 45–46. Lenin's mausoleum in Moscow was originally to have murals depicting revolutionary themes; see Nina Tumarkin, *Lenin Lives! The Lenin Cult in Soviet Russia* (Cambridge: Harvard University Press, 1983), 201–202.
25. Yuan Yun-fu, "Some Paintings in the Chairman Mao Memorial Hall," CL, 1978, no. 1:87–89; "Fine Arts of the Chairman Mao Memorial Hall," CP, 1977, no. 12:22–23; "The Monument to Mao Tsetung," 8; "Chairman Mao Memorial Hall Completed in Peking," NCNA Peking, 1 Sept. 1977, SCMP, no. 77-37:76; see also illustrations in *Mao Zhuxi jiniantang* and in *Meishu*, 1977, no. 6.

birthplace, Shaoshan, and the poem by Mao is "Changsha" (the city which was the center of Mao's early revolutionary activity), written in 1925; a lacquer painting shows the National Peasant Movement Institute. Continuing clockwise, the poem in the northwest corner lounge (fig. 111) is on the early Communist stronghold, "Jinggang Mountains" (1928), and there are two paintings: one of the Jinggang Mountains and the other depicting Zunyi (where the Party Central Committee Political Bureau held a meeting at which a new leadership headed by Mao Zedong was formed). In the northeast room, the poem is "The Long March," penned in 1935; a tapestry depicts the "Great Snow Mountains," one of the several natural barriers confronted and overcome by the marchers; and a painting shows the Date Garden in Yan'an, the Communist headquarters in Shaanxi, where the Long March ended. The last hall, that on the southeast, features the seaside resort of officials and bureaucrats, Beidaihe, in poem (1954) and painting, while a weaving depicts Zhongnanhai, Mao's Beijing residence.

The sequence of poems had to be arranged in clockwise order beginning at the southwest because the final poem in the series, permanently chiseled into marble and filled with gold, is located in the south hall, and it establishes the theme of the south facade of the Memorial Hall, the facade which, so to speak, opens to the world. In the south hall is Mao's 1963 poem "Reply to Guo Moruo" which concludes with these lines:

> Four Oceans storming,
> Clouds, waters raging;
> Five Continents rocking,
> Thunderstorm roaring.
> Sweep away all deadly insects:
> No enemy anywhere.[26]

This statement of continuing strength and invincibility of the Chinese Communists under Mao's leadership sets the theme which is carried out in the two sculptures on the south side of the Memorial Hall. These carvings depict the peoples of all minority groups in China, as well as workers, peasants, and members of the PLA studying Mao's writings, and who, along with others, under the guidance of Chairman Hua Guofeng, will "bring order across the land" and make China a powerful socialist country.[27] In other words, the sculptures refer to the future. To emphasize Mao's continuing influence, individuals portrayed at the rear of the sculptures face the Chairman Mao Memorial Hall, as if drawing inspiration and courage from him.

There is a distinct difference between the themes on the outside of the Memorial Hall and those inside the building. Battle scenes or social struggles are subjects presented externally in the sculpture groups. Inside the Memorial Hall all themes are peaceful and serene. More important, none of the art works hung in the four reception lounges was done by a peasant or a worker, Jiang Qing's paragons. There are no industrial scenes, no depictions of workers, no agricultural scenes.

Just as the architectural structure is in "national style," so too, the art works inside the Memorial Hall are in media associated with Chinese, rather than Western, traditions: traditional-style painting, lacquer painting, embroidery, and tapestry. The paintings are all landscapes, and all were created by veteran Chinese-style artists from such institutions as the Jiangsu Academy of Traditional Chinese Painting: Qian Songyen, Ya Ming, Qin Jianming (b. 1942), as well as Li Keran, Li Xiongcai, Lin Fengmian, Chen Dongting—the very artists lambasted, despised, and denigrated by Jiang Qing.[28] The landscape tapestry behind the marble sculpture of Mao in the north hall was designed by Huang Yongyu, another artistic bête noire of Jiang Qing's.[29] Moreover, each painting is done in a different style, so that the concept of individuality, which Jiang Qing endeavored to eradicate, is once again evident. One does not need to read the articles by the old masters, such as Qian Songyan and others, on the Memorial Hall paintings and the purge of the Gang of Four to understand the message conveyed by these works.[30]

26. Hua-ling Nieh Engle and Paul Engle, *Poems of Mao Tsetung* (New York: Dell, 1972), 153.
27. Chi Shu, "The Sculptures at the Chairman Mao Memorial Hall," 116; "The Monument to Mao Tsetung," 8.
28. According to Yuan Yun-fu, "Some Paintings in the Chairman Mao Memorial Hall," 87, eighteen artists were commissioned to design paintings for the Memorial Hall; eight artists from the Jiangsu Academy of Traditional Chinese Painting who did eight large pictures, were commended for their work and received by Guo Moruo. Nanking, Kiangsu Province Service in Mandarin, 7 Sept. 1977, *Daily Report* 23 Sept. 1977, E23. Obviously, not all the works prepared for the Hall were selected for display there.
29. Michael Sullivan, "New Directions in Chinese Art," *Art International* 25, 1–2 (1982): 42; Chinese media sources are less specific in identifying the creator of this tapestry; the usual statement is that the sketch was drawn by Beijing artists. ("*Jen-min Jih-pao* Carries Photos and Report on Art Works in Chairman Mao Memorial Hall," NCNA Peking, 16 Sept. 1977, SCMP, no. 77-39:87–88.)
30. Qian Songyan, "Zhongxin jing hui 'Zaoyuan shuguang,'" *Meishu*, 1977, no. 6:12; Cheng Wei, "Shanshuihua dayou wenzhang kezuo," *Meishu*, 1977, no. 6:13–14, 11.

This total ensemble of poems and paintings may also have served to reinforce notions of Mao's immortality and supreme sovereignty, notions which were still strong forces in 1976–1977. This interpretation is based on a consideration of the calligraphies and pictures in conjunction with the fact that Mao's casket, in a room near the center of the Memorial Hall, rests on a catafalque of black granite from Mount Tai, the sacred eastern mountain in the ancient scheme of five. The use of stone from Mount Tai for this purpose immediately places Mao amidst a context of beliefs long associated with this mountain. It was at this sacred mountain that Han dynasty emperors performed the *feng* and *shan* sacrifices in the hopes of attaining immortality. Later, the Tang dynasty emperors performed these rituals as a visible measure of their authority to rule China.[31] When seen in this perspective then, Mao, immortal and supreme, rests on Mount Tai. His poems, which are all placed on that wall of the lounge shared in common with the casket chamber, are perhaps like the immortal voice of the leader radiating outward. The vestibule tapestry behind the white sculpture of Mao (of which it was said, "The statue of Chairman Mao seems to be nestled in the embrace of China's magnificent scenery"),[32] plus the landscape pictures in the four lounges around the casket chamber, circle Mao with panoramas conveying the grandeur and the natural beauty of the China over which he ruled supreme.

Ultimately, the major artistic significance of the Chairman Mao Memorial Hall is that (1) these landscapes serve as important evidence of the rejection of Jiang Qing's repressive art policies; (2) they announce the reinstatement of traditional-style painting in the traditional mode; (3) they become an incontestable statement that the traditional medium is the most important; and (4) that of all subjects, as of old, landscape is the most valid and enduring. A few months later, 110 landscapes and bird-and-flower paintings in traditional style were exhibited in Beijing.[33]

The Chairman Mao Memorial Hall was not a carelessly designed building to house and display the leader's remains, but one in which every detail was carefully thought out to provide a comprehensive program of political meaning and artistic significance.

But the Chairman Mao Memorial Hall and what it symbolized politically was not to go unchallenged. Many people apparently felt that Premier Zhou Enlai had received little or no tribute for his contributions, certainly nothing approaching the scale and ostentation of Mao Memorial Hall. These feelings became explicit during the early phases of the demythologizing of Mao, a movement supported by Deng Xiaoping (b. 1904) and carried out in part by the pasting of wall posters on the so-called Democracy Wall near Tiananmen in Beijing. In late November 1978 one wall poster suggested that "a memorial hall and bronze statue be erected in honor" of Zhou Enlai in Tiananmen; another poster, seen in early January 1979, demanded a Zhou memorial and that Mao be removed from the Memorial Hall. The most interesting of these proposals is one from February 1979, which included a detailed drawing of Tiananmen with a memorial for Zhou Enlai (fig. 112). This deliberately cunning scheme proposed that the Zhou Memorial be placed directly flanking the south side of the Monument to the People's Heroes; it would share a common podium with the Monument.[34] It must have been evident to all that such a placement would bind Zhou to the Monument to the People's Heroes in a much more intimate fashion than Mao, seated many yards to the south. (It must be remembered that the People's Heroes Monument was the site of the Qingming demonstrations in 1976 honoring Zhou and denigrating Jiang Qing, a demonstration sometimes considered a major factor contributing to the downfall of Jiang Qing and the Gang of Four. This Qingming demonstration became known as the April Fifth Movement.) Being directly south of the Monument to the People's Heroes, Zhou's memorial would be enhanced by the presence of his inscription on the immediately adjacent south face of the cenotaph, as well as by the sculptured scenes on this side of the plinth: in particular, the May Fourth demonstration of 1919. This would recall by analogy its modern counterpart, the April Fifth demonstration of 1976. In the Chinese mind these two events were already linked, since in the Chinese method of stating months and days, these two movements are called the

31. See Howard J. Wechsler, *Offerings of Jade and Silk: Ritual and Symbol in the Legitimation of the T'ang Dynasty* (New Haven and London: Yale University Press, 1985), 170–175, 190–191.
32. "*Jen-min Jih-pao* Carries Photos and Report on Art Works in Chairman Mao Memorial Hall," 87.
33. "Exhibition of Traditional Paintings Held in Peking," CL, 1978, no. 2:117.

34. Helmut Martin, *Cult and Canon: The Origins and Development of State Maoism* (Armonk, N.Y.: M. E. Sharpe, 1982), 110ff.

The Chairman Mao Memorial Hall

5/4 and the 4/5 movements.[35] The placement of a Zhou memorial in this position would also interrupt (and presumably negate) Mao's "view" from the north hall of his Memorial Hall to the Monument to the People's Heroes and then beyond to the birthplace of the PRC, Tiananmen Gate. Had this plan been realized, it would have metaphorically projected Zhou Enlai into a position of prominence far above that of Mao Zedong.

By 1983 the Chairman Mao Memorial Hall was being "remodeled as a hall of fame," the leader's remains to be "joined by statues of the late Premier Chou En-lai, military strategist Chu Te, and other heroes."[36]

This clear deflation of Mao's once seemingly unassailable role as leader had parallels in the art world. The dogma that art must serve politics, the basis of Mao's 1942 *Talks* at the Yan'an Forum on Literature and Art, had already by 1979 been replaced by "art must serve socialism and the people," and a new set of guidelines, unprecedentedly liberal in tone and tolerance, was promulgated. Despite this officially sanctioned relaxation, persistent conservative political and ideological pressures continue to make creative life in post-Mao China uneasy.

35. David S. G. Goodman, *Beijing Street Voices: The Poetry and Politics of China's Democracy Movement* (London and Boston: Marion Boyars, 1981), 31–34.

36. Associated Press, *San Francisco Chronicle*, 17 Oct. 1983, quoted in Wakeman, "Revolutionary Rites," 146.

The Chairman Mao Memorial Hall

Illustrations

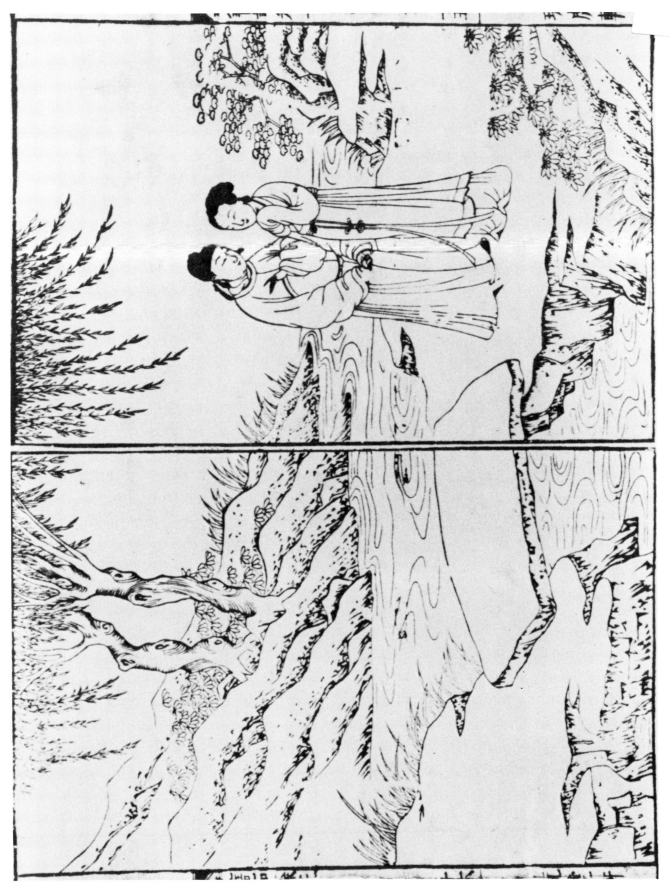

FIG. I. Anonymous, illustration
to *The Lute Story*, woodblock
print, seventeenth century.

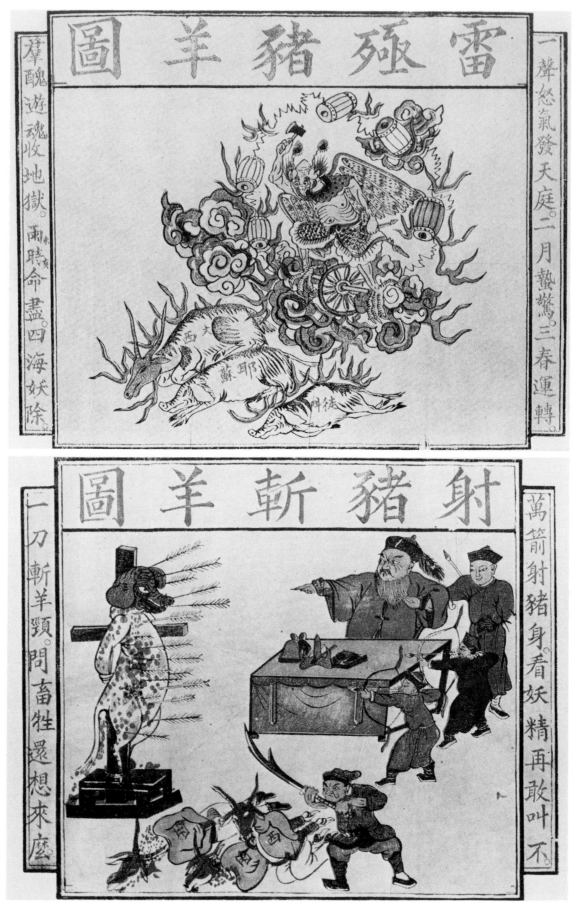

FIG. 2. Anonymous, *Anti-Christian Print*, woodblock print, ca. 1860.

FIG. 3. Anonymous, *Anti-Christian Print*, woodblock print, ca. 1860.

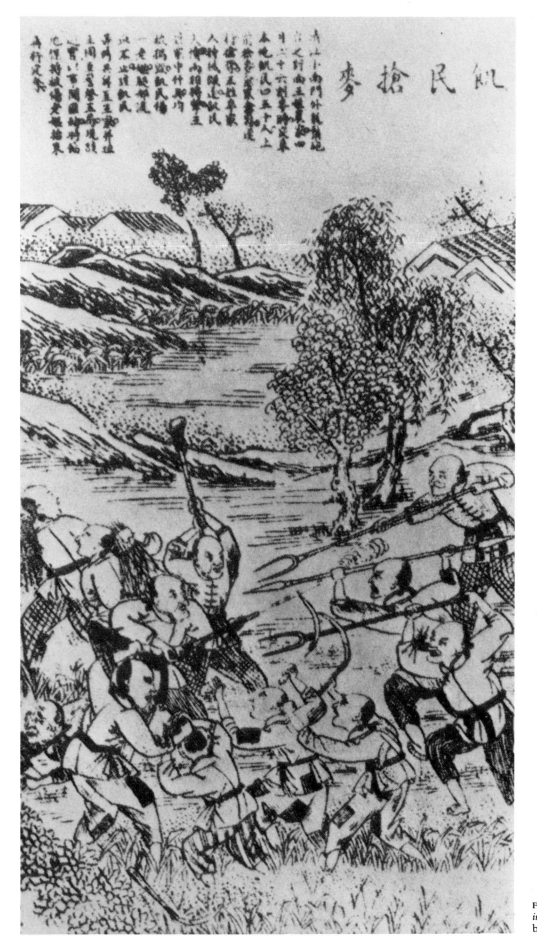

FIG. 4. Anonymous, *The Starving People Seize the Grain*, woodblock print, April 1910.

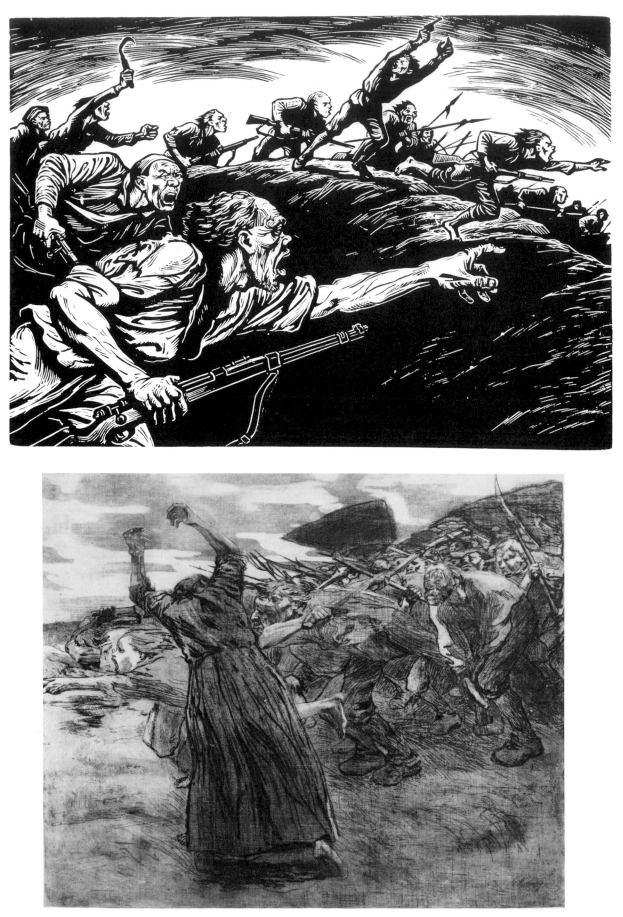

FIG. 5. Li Hua, *Arise*, wood-
block print, 1935.

FIG. 6. Käthe Kollwitz, *Out-
break (Ausbruch)*, #5 from the
Peasant War cycle, etching, 1903.

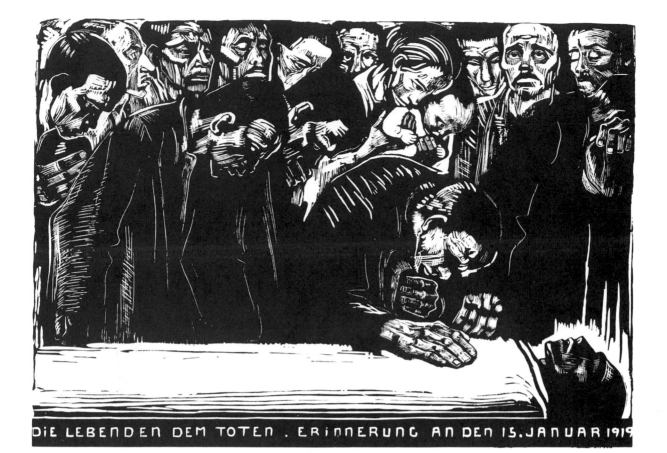

DIE LEBENDEN DEM TOTEN . ERINNERUNG AN DEN 15.JANUAR 1919

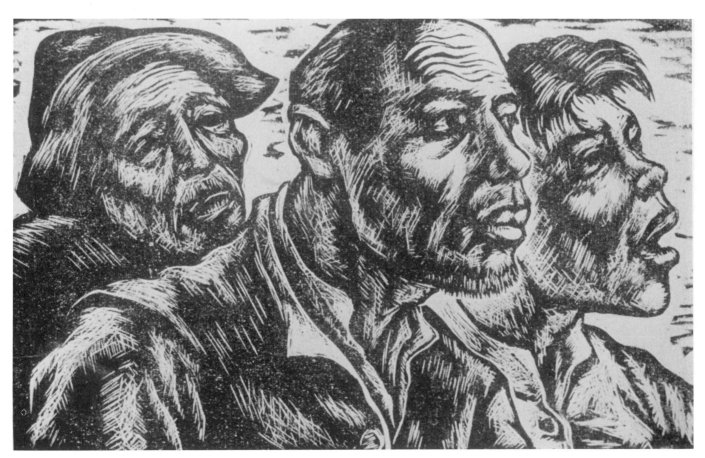

FIG. 7. Käthe Kollwitz, *Memorial to Karl Liebknecht* (*Gedenkblatt für Karl Liebknecht*), woodblock print, 1919–1920.

FIG. 8. Li Hua, *Figures*, woodblock print, ca. 1936.

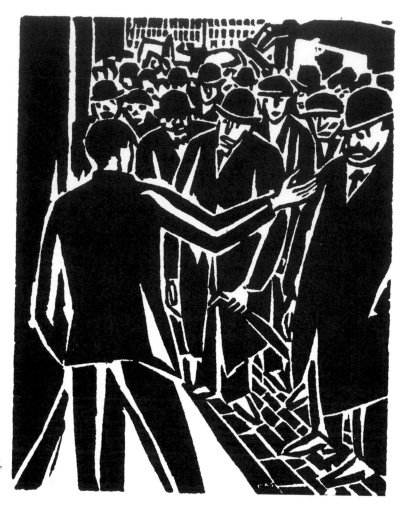

FIG. 9. Frans Masereel, *Untitled*, from *My Book of Hours*, wood-block print, ca. 1920.

FIG. 10. Chen Tiegeng, *Under the Threat of Bayonets*, woodblock print, 1933.

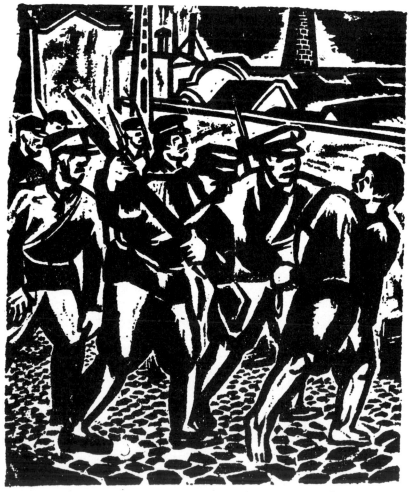

FIG. 11. Alexei Kravchenko,
Sluice on the Dnieper River Dam,
woodblock print, early twentieth
century.

FIG. 12. Huang Yan, *Searching
in the Ruins*, woodblock print,
ca. 1940.

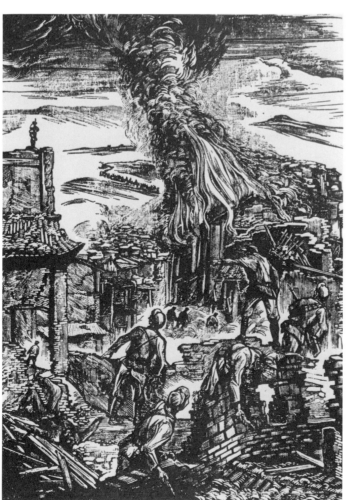

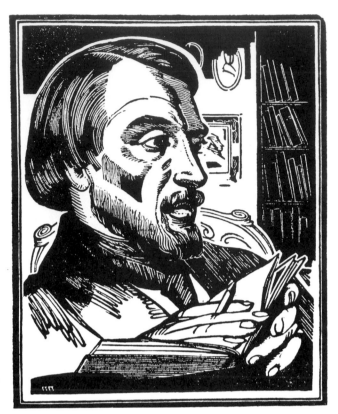

FIG. 13. Pavel Pavlinov, *Portrait of Belinsky*, woodblock print, early twentieth century.

FIG. 14. Li Qun, *Portrait of Lu Xun*, woodblock print. 1936.

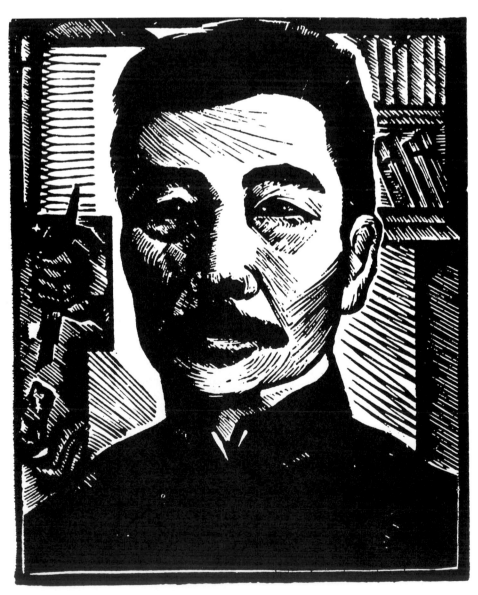

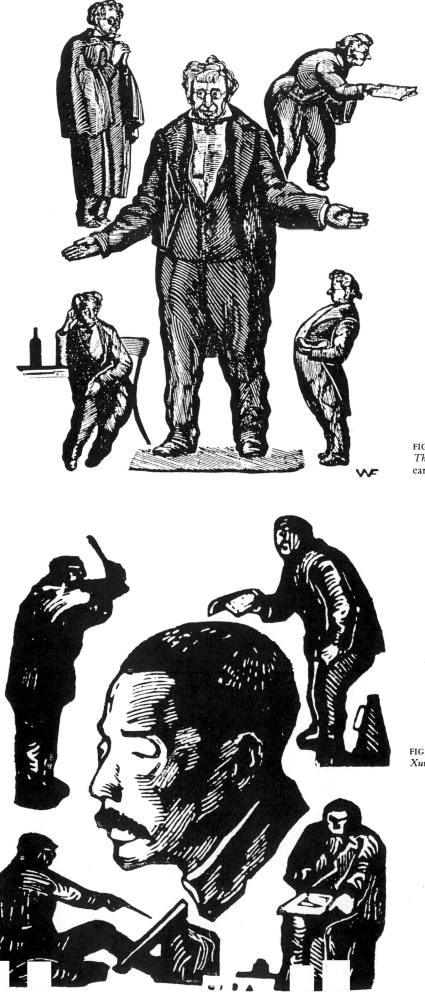

FIG. 15. Vladimir Favorsky,
The Actor Orlov, woodblock print,
early twentieth century.

FIG. 16. Ma Da, *Portrait of Lu
Xun*, woodblock print, ca. 1936.

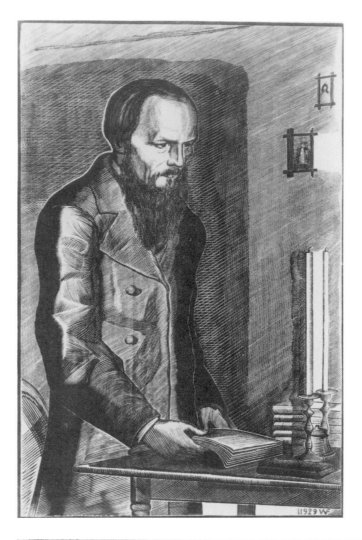

FIG. 17. Vladimir Favorsky, *Portrait of Dostoveski*, woodblock print, 1929.

FIG. 18. Huang Xinbo, *Call to Arms*, woodblock print, 1936.

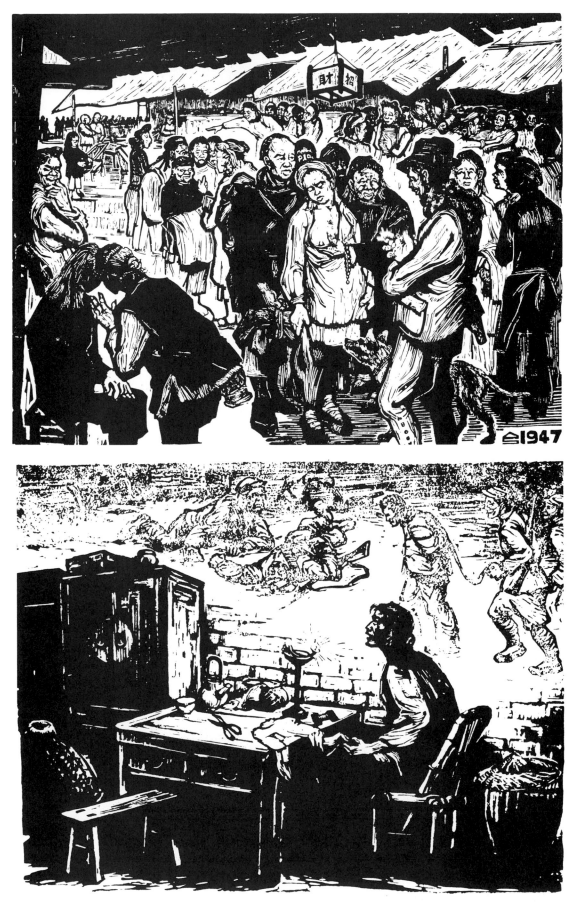

FIG. 19. Zhang Yangxi, *Human Market in Chengdu*, woodblock print, 1947.

FIG. 20. Shao Keping, *Late at Night When Everything Is Quiet*, woodblock print, 1948.

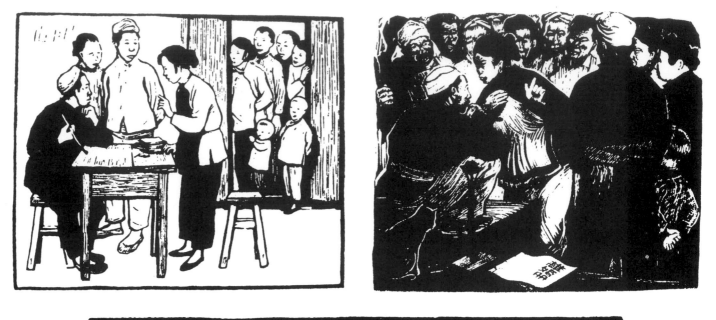

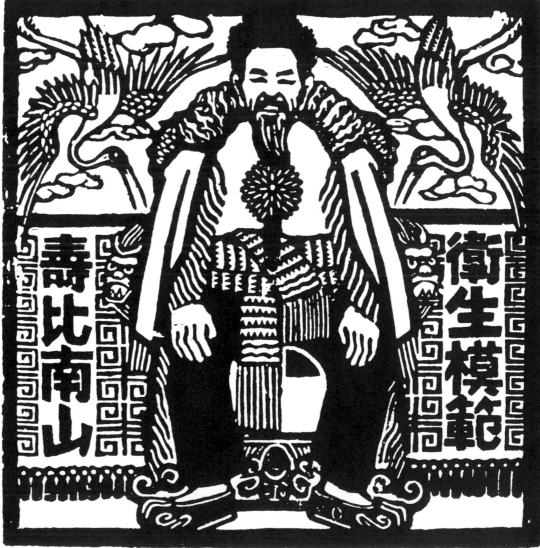

FIG. 21. Gu Yuan, *Divorce Registration*, woodblock prints; right: version done before 1942; left: version done after 1942.

FIG. 22. Luo Gongliu, *Hygiene Model*, woodblock print, ca. 1942.

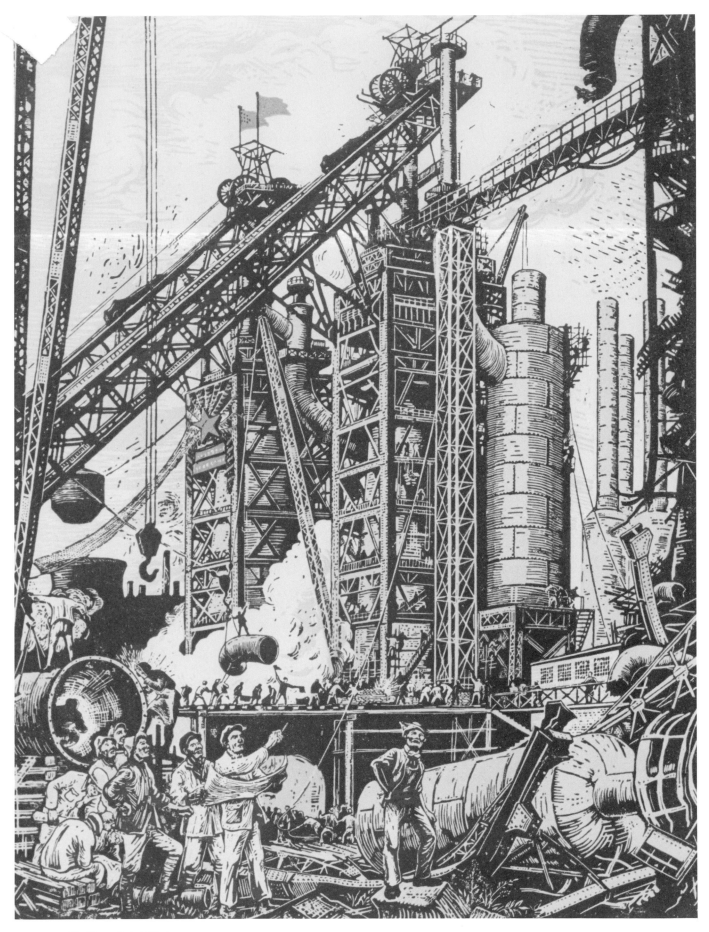

FIG. 23. Gu Yuan, *Rehabilitation
of the Anshan Steel Works*, wood-
block print, 1949.

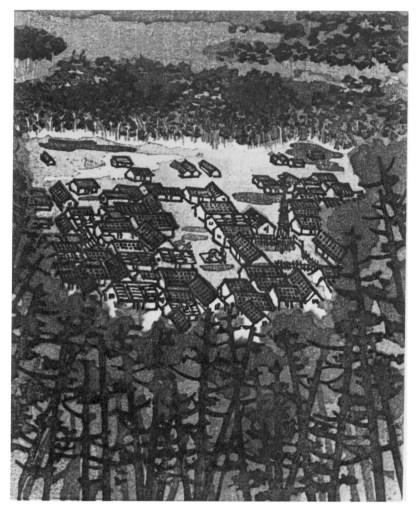

FIG. 24. Jiang Zhenghong, *New Settlement in the Forest*, woodblock print, 1958.

FIG. 25. Zhang Xinyou and Zhu Qinbao, *Autumn on the Plateau*, woodblock print, 1964. (Cropped at sides and top.)

FIG. 26. Xu Beihong, *Tian Heng and His 500 Retainers*, oil, 1928.

FIG. 27. Jiang Yan, *Examination for Mama*, traditional-style Chinese painting, 1953.

FIG. 28. Shi Lu, *Outside the Great Wall*, traditional-style Chinese painting, 1954.

FIG. 29. Zhou Changgu, *Two Lambs*, traditional-style Chinese painting, 1954.

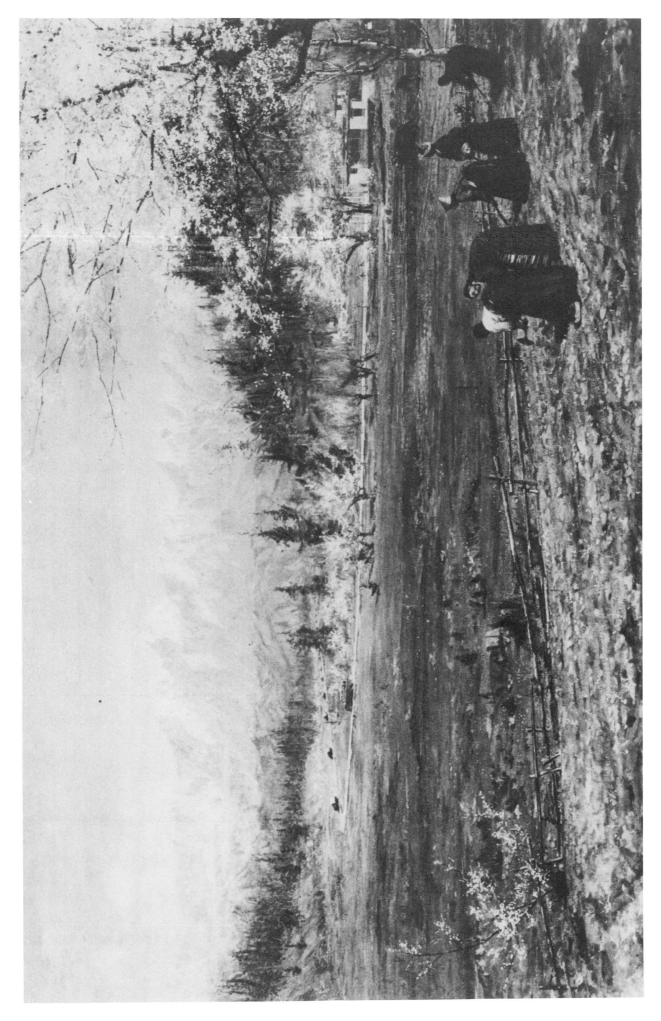

FIG. 30. Dong Xiwen, *Spring Comes to Tibet*, oil, ca. 1954.

FIG. 31. Song Wenzi and Jin Zhiyuan, *Digging a Canal through the Mountains*, traditional-style Chinese painting, 1958. (Cropped at bottom.)

FIG. 32. Li Shiqing, *Moving Mountains to Fill Valleys*, traditional-style Chinese painting, 1958.

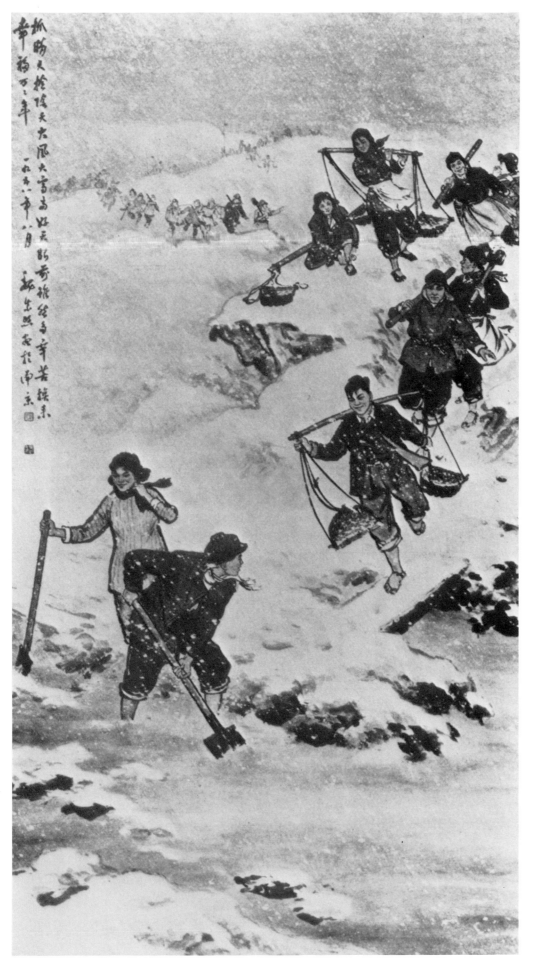

FIG. 33. Wei Zixi, *Undaunted by Wind and Snow*, traditional-style Chinese painting, 1958.

FIG. 34. Cai Jinbo, *Big Fish*,
gouache, ca. 1958.

FIG. 35. Anonymous, *More
Gears to the Wheels, More Water
to the Fields*, gouache, ca. 1958.

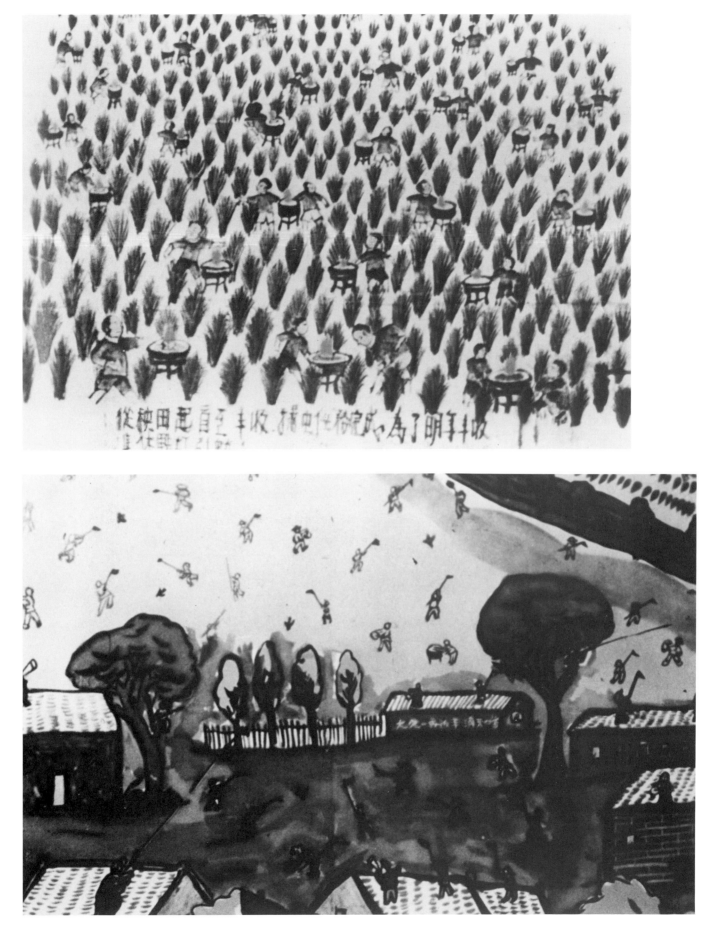

FIG. 36. Hu Guilian, *Catching Moths*, gouache, ca. 1958.

FIG. 37. Jiang Yonggen, *Killing Sparrows*, gouache, ca. 1958.

FIG. 38.　Fu Baoshi and Guan
Shanyue, *This Land with So Much
Beauty Aglow*, traditional-style
Chinese painting, 1959. In the
Great Hall of the People, Beijing.

FIG. 39. Hou Yimin, *Liu Shaoqi and the Anyuan Miners*, oil, 1961.

FIG. 40. Wang Xuyang, *On the Canal*, traditional-style Chinese painting, 1960.

FIG. 41. Xu Leng, *Night in the Wanda Mountains*, woodblock print, 1964.

FIG. 42. Dong Qizhong, *Autumn Colors on the Plateau*, woodblock print, ca. 1963.

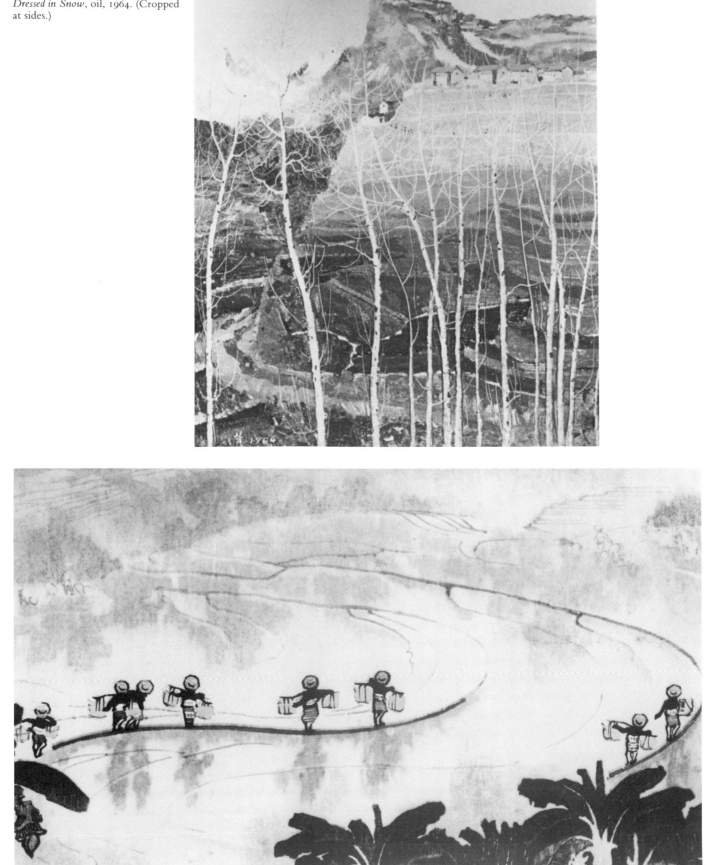

FIG. 43. Wu Guanzhong, *Spring Dressed in Snow*, oil, 1964. (Cropped at sides.)

FIG. 44. Tang Jixiang, *Spring Drizzle*, traditional-style Chinese painting, ca. 1964. (Cropped at sides and bottom.)

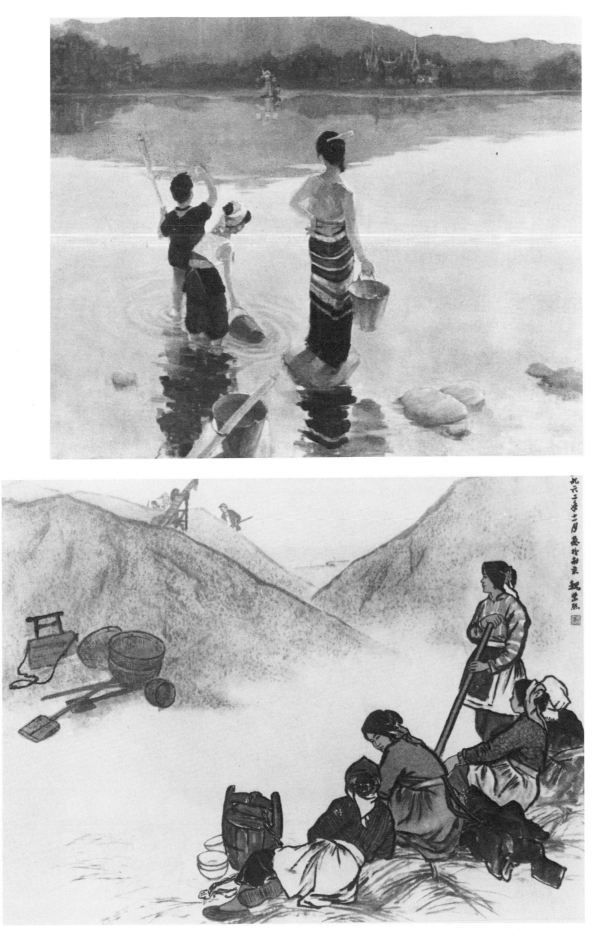

FIG. 45. Fan Xueli, *We All
Drink from the Same River*, oil,
ca. 1960.

FIG. 46. Wei Zixi, *Harvest*,
traditional-style Chinese painting,
1962.

FIG. 47. Yang Taiyang, *Rain*,
watercolor, ca. 1962.

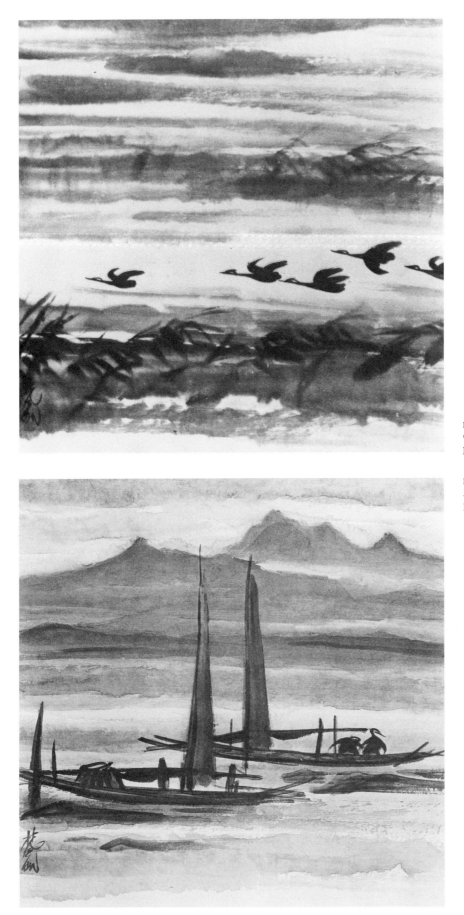

FIG. 48. Lin Fengmian, *Autumn Geese*, traditional-style Chinese painting, ca. 1960.

FIG. 49. Lin Fengmian, *Night Mooring*, traditional-style Chinese painting, ca. 1960.

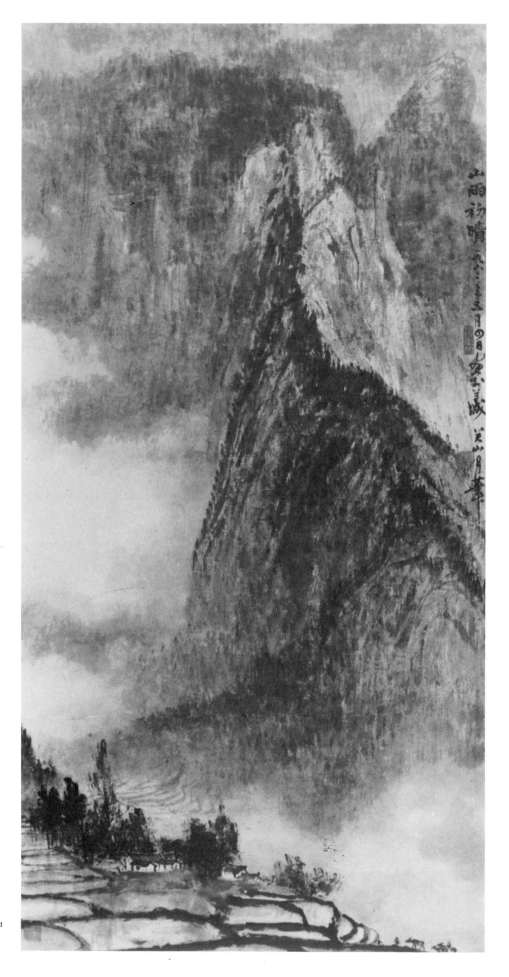

山雨初晴

FIG. 50. Guan Shanyue, *When the Rain Is Over*, traditional-style Chinese painting, 1962.

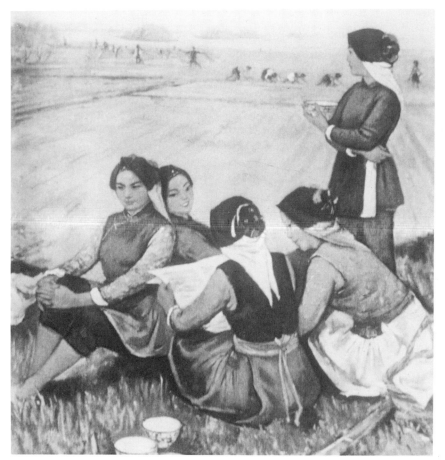

FIG. 51. Su Tianci, *Autumn Harvest South of the Yangtze*, oil, ca. 1963.

FIG. 52. Chao Mei, *Spring Returns*, woodblock print, 1964. (Cropped at left.)

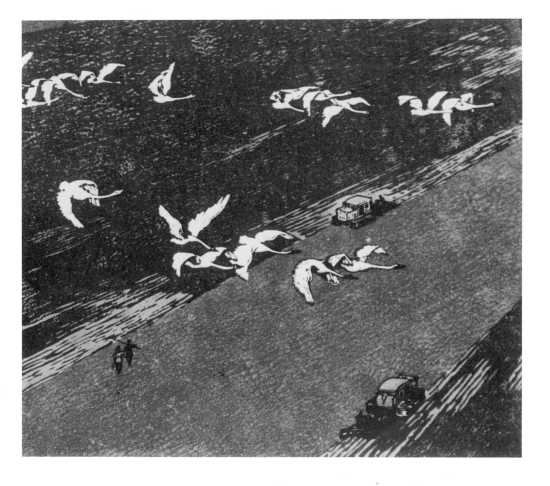

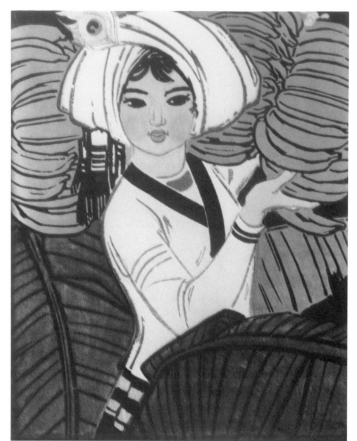

FIG. 53. Song Kejun, *The Bananas Are Ripe*, woodblock print, ca. 1964. (Cropped at sides and top.)

FIG. 54. Ma Xiguang, *Mountain Village Schoolmistress*, traditional-style Chinese painting, 1964.

FIG. 55. Huang Wenbo, *Spring Rain*, oil, ca. 1963.

FIG. 57. Han Yue, *The Fountain-head*, traditional-style Chinese painting, 1964.

FIG. 56. Yang Shengrong, *Ouyang Hai*, traditional-style Chinese painting, 1964.

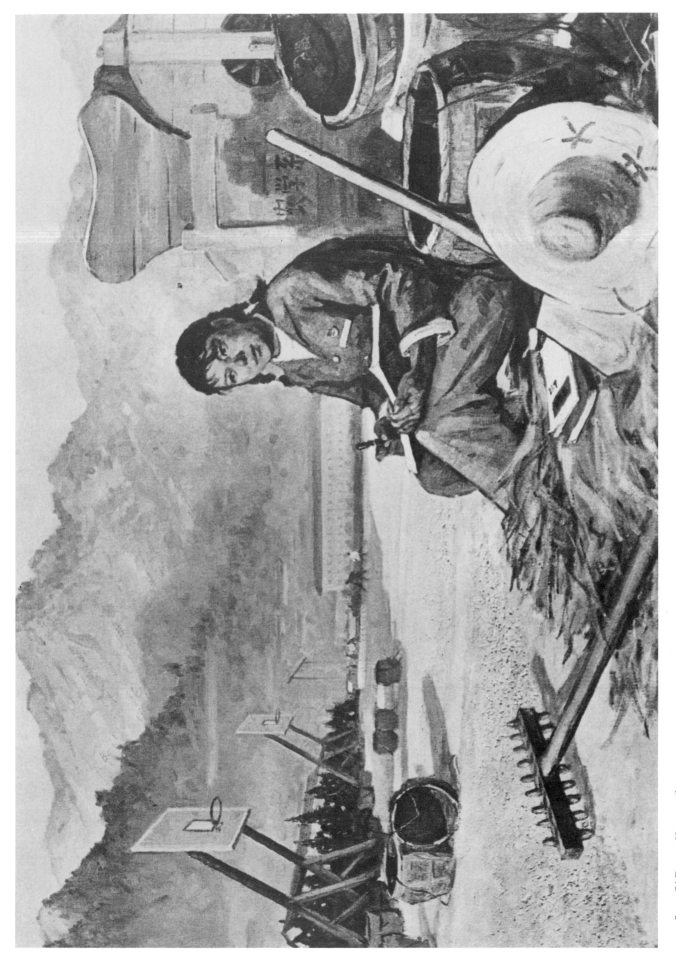

FIG. 58. Qi Deyan, *Harvest*, oil,
ca. 1964.

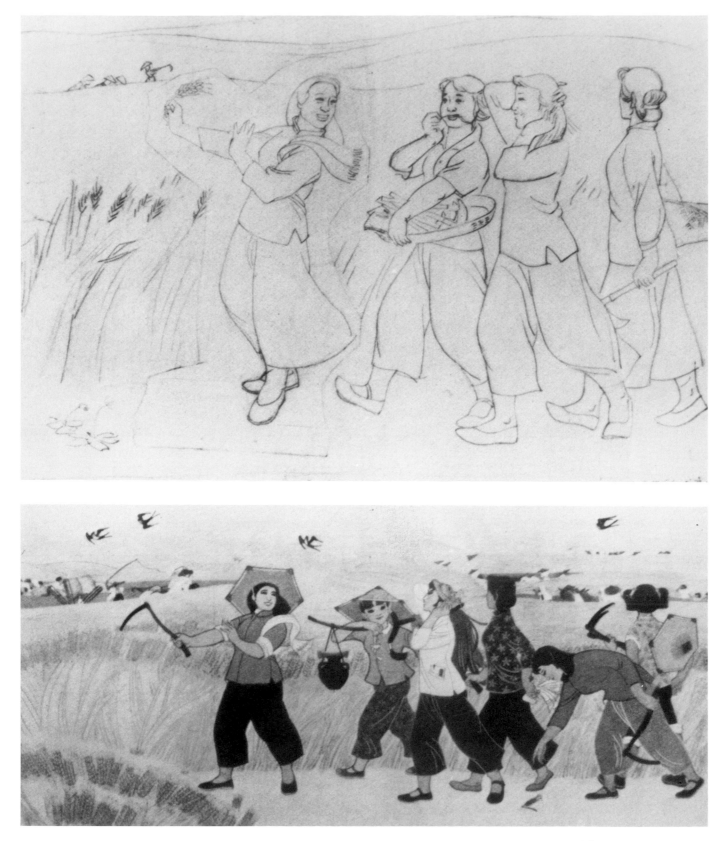

FIG. 59a. Li Baijun, *Wheat-harvesting Time*, New Year's picture, version one, sketch, 1963.

FIG. 59b. Li Baijun, *Wheat-harvesting Time*, New Year's picture, version two, 1963.

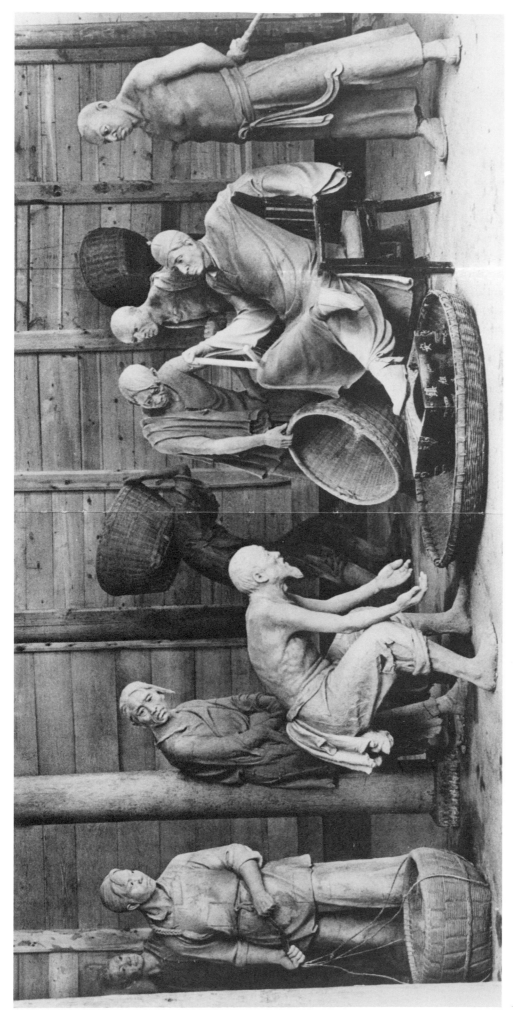

FIG. 60. *The Rent Collection Courtyard*, clay sculptures, 1965, portion.

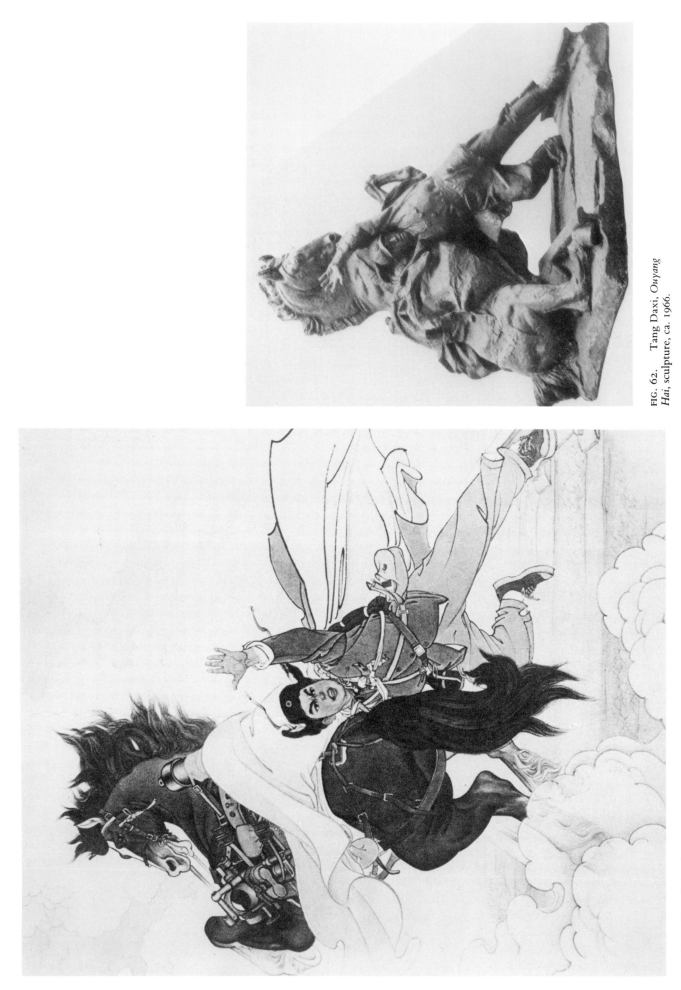

FIG. 62. Tang Daxi, *Ouyang Hai*, sculpture, ca. 1966.

FIG. 61. Chen Baiyi, *Ouyang Hai*, New Year's picture, 1965.

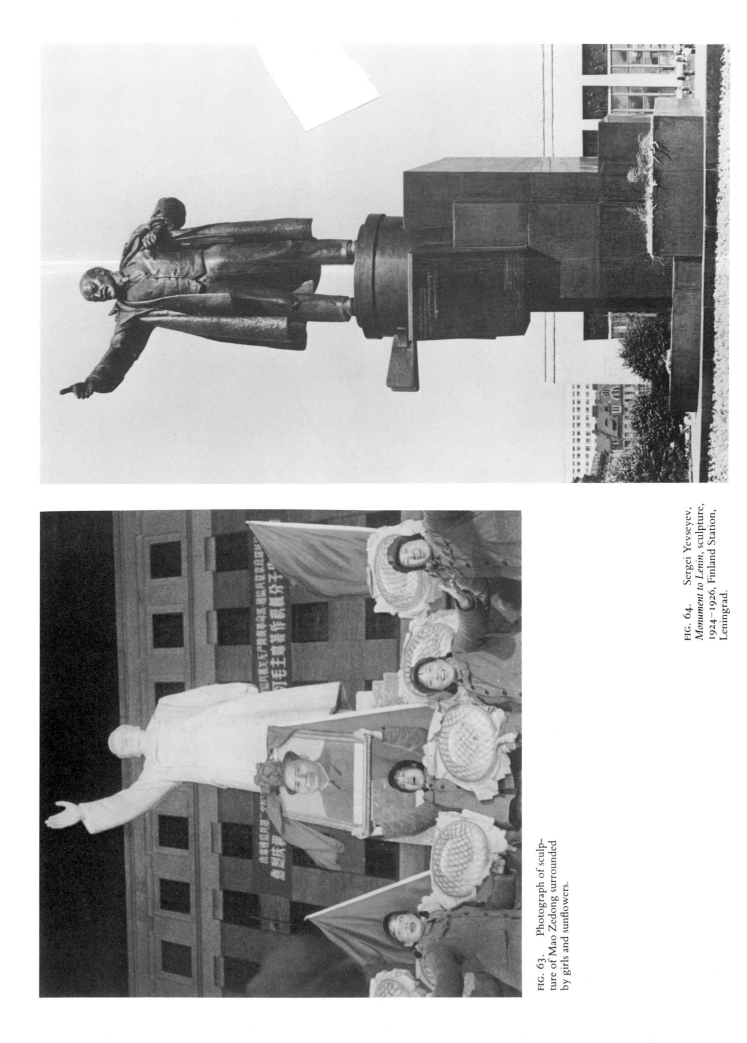

FIG. 63. Photograph of sculpture of Mao Zedong surrounded by girls and sunflowers.

FIG. 64. Sergei Yevseyev, *Monument to Lenin*, sculpture, 1924–1926, Finland Station, Leningrad.

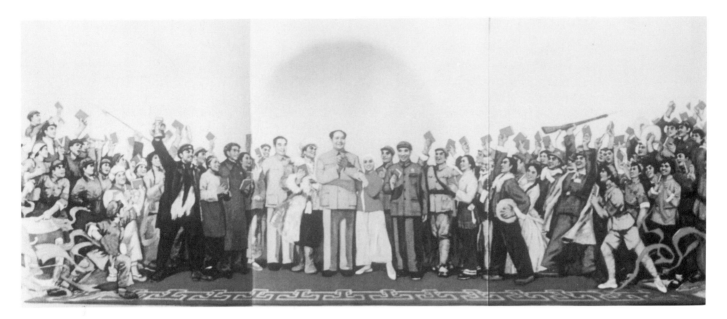

FIG. 65. Anonymous, *Mao
Zedong's Thought Illumines the
Theater*, poster, ca. 1968.

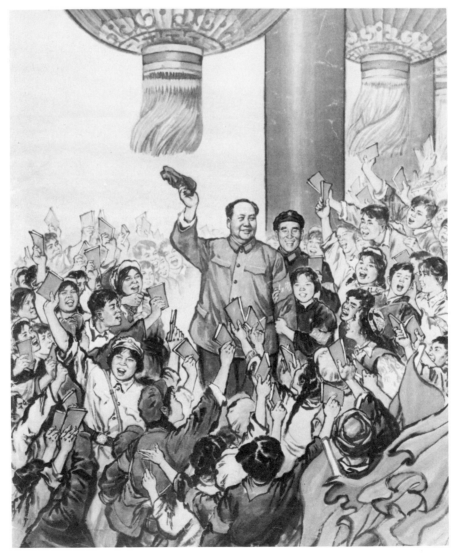

FIG. 66. Anonymous, *Chairman
Mao—the Reddest, Reddest Red
Sun in Our Hearts Is With Us*,
traditional-style Chinese painting,
1967.

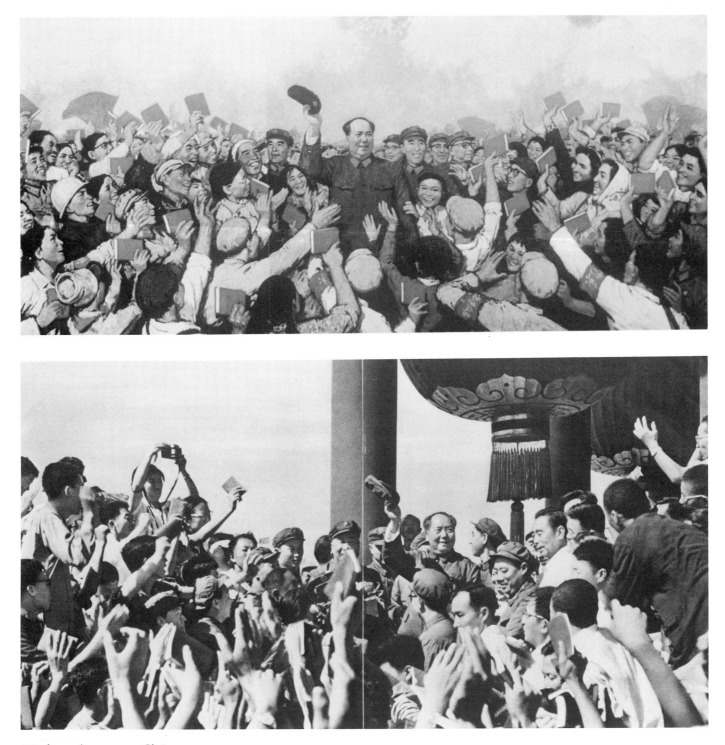

FIG. 67. Anonymous, *Chairman Mao Is the Never-setting Sun in Our Hearts*, oil, 1967.

FIG. 68. Photograph of Chairman Mao and others at Tiananmen, 1966.

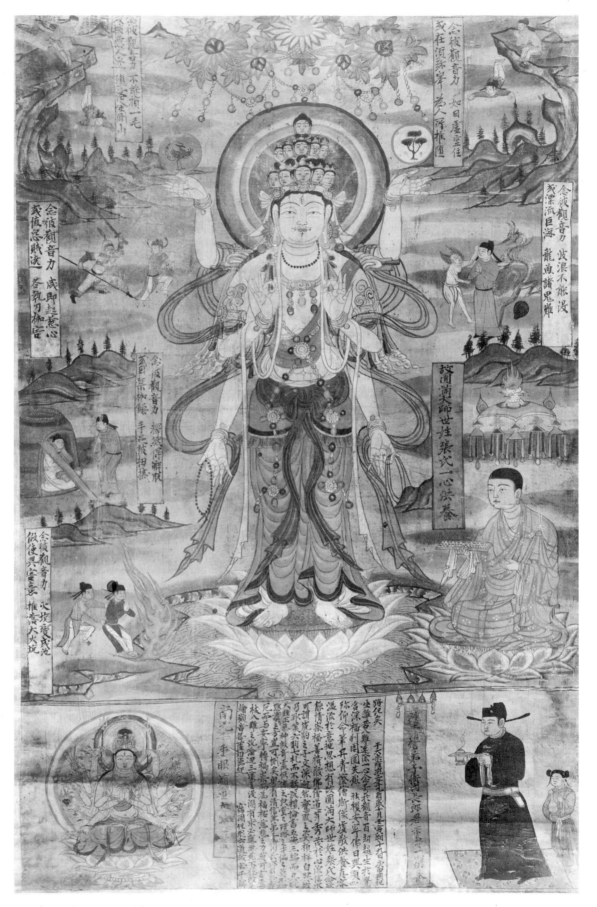

FIG. 69. Anonymous, *Eleven-
headed Guanyin Surrounded by quota-
tions and illustrations from Chapter 25
of the Lotus Sutra*, hanging scroll,
ink and color on silk, dated 985,
from Dunhuang.

FIG. 70. Anonymous, *Chairman
Mao on an Inspection Tour during
the Cultural Revolution*, oil, 1968.
(Cropped at left.)

FIG. 71. Anonymous, *Follow
Closely Chairman Mao's Great
Strategic Plan*, gouache, 1968.
(Cropped at left.)

FIG. 72. Ma Xueli, *Creating New Things All the Time*, wood-block print, ca. 1974.

FIG. 73. Zhang Hongzan, *Where the Oil Is, There Is My Home*, oil, ca. 1974.

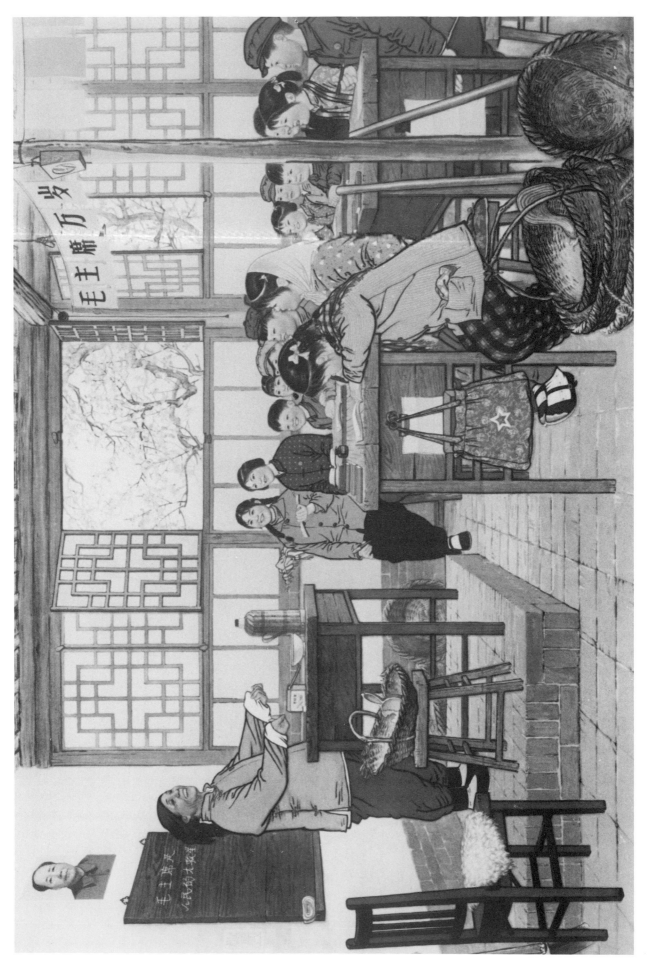

FIG. 74. Kang Zuotian, *Educat-ing the Next Generation*, traditional-style Chinese painting, ca. 1972.

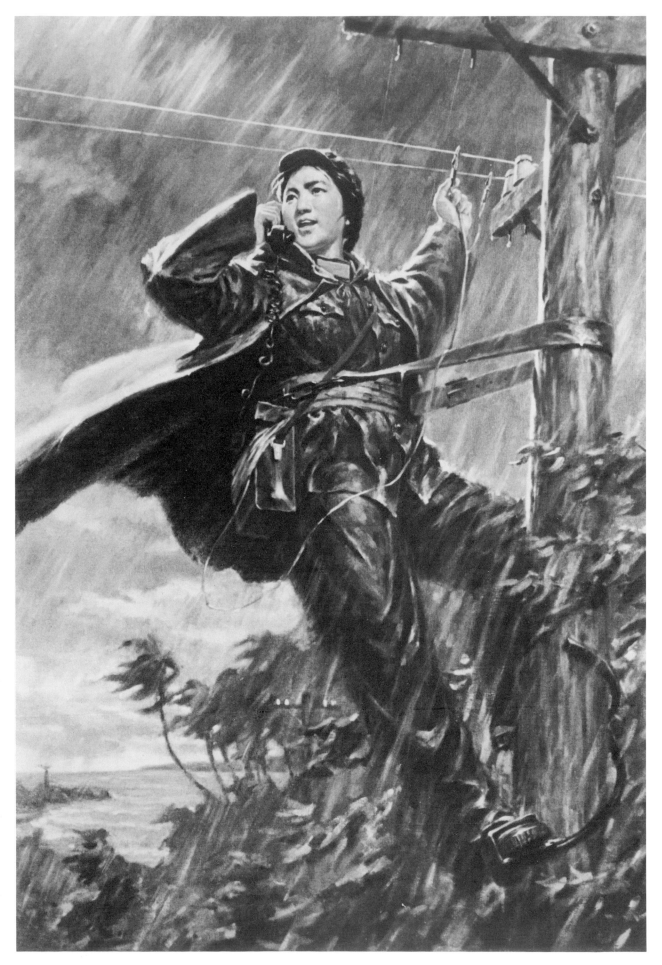

FIG. 75. Pan Jiajun, *I Am Sea-
gull*, oil, ca. 1972.

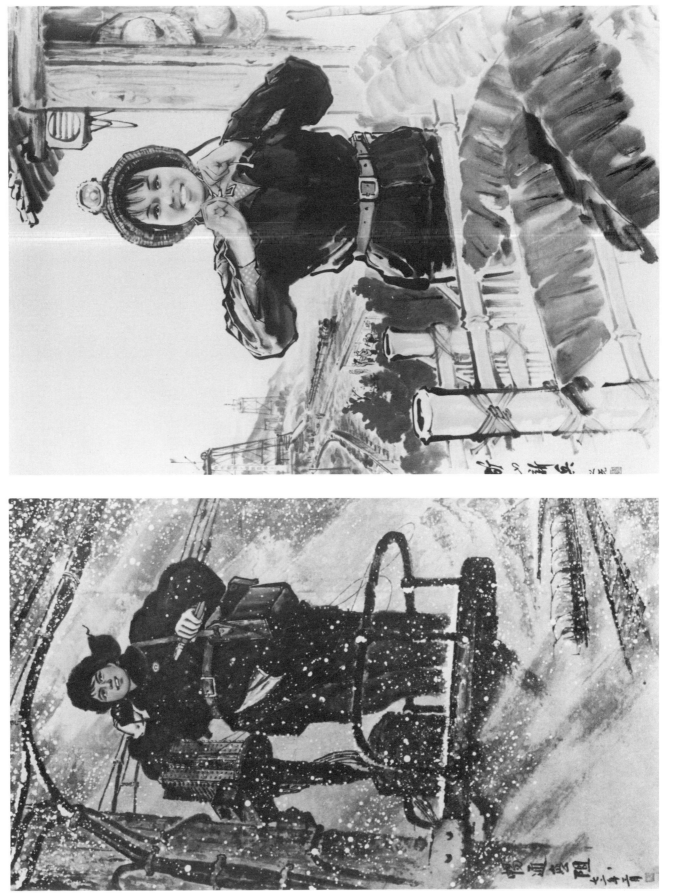

FIG. 77. Yang Zhiguang, *Newcomer to the Mine*, traditional-style Chinese painting, ca. 1972.

FIG. 76. Luan Wanchu and Wen Zhongsheng, *All Clear*, traditional-style Chinese painting, 1972.

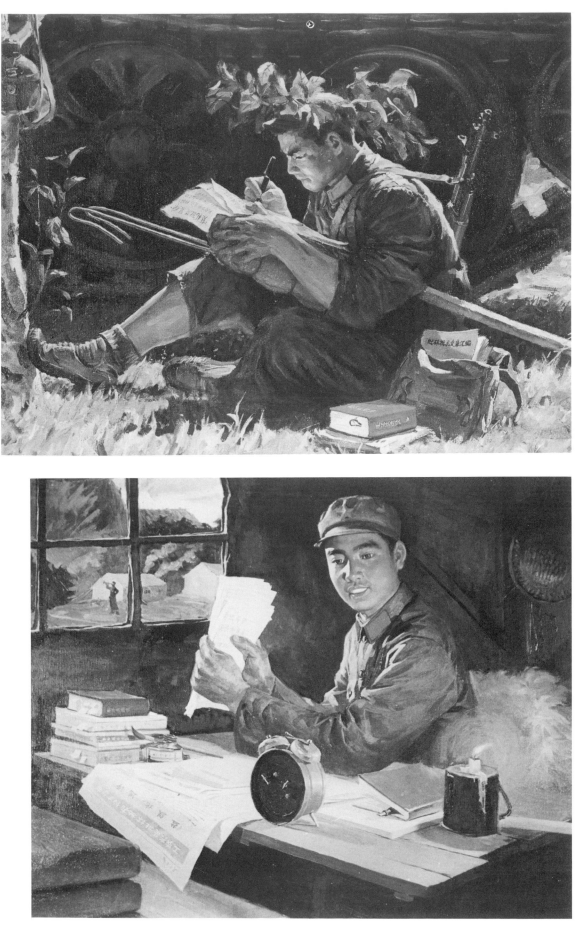

FIG. 78. Shang Ding, *Fighting without Respite*, oil, ca. 1974.

FIG. 79. Li Binggang, *Before the Lecture*, oil, ca. 1974.

FIG. 80. Zhao Zhitian, *The Daqing Workers Know No Winter,* traditional-style Chinese painting, 1973.

FIG. 81. Qian Songyan, *Land of Abundance South of the Yangtze,* traditional-style Chinese painting, 1972.

FIG. 82. Guan Shanyue, *Great Green Wall*, traditional-style Chinese painting, 1973.

FIG. 83. Bai Xueshi and Hou Dechang, *Canal of Happiness*, traditional-style Chinese painting, ca. 1974.

FIG. 84. Wei Zixi, *Nanjing Yangtze River Bridge*, traditional-style Chinese painting, 1973.

FIG. 85. Li Keran, *To See the Green Hills Reeling like Waves, and the Dying Sun like Blood,* traditional-style Chinese painting, 1971.

FIG. 86. Guan Shanyue, *Dawn over the Great Wall,* traditional-style Chinese painting, 1973.

FIG. 87. Yao Gengyun, Fang
Zengxian, and Lu Kunfeng, *Bamboo Harvest*, traditional-style
Chinese painting, 1972. Top:
whole; bottom: detail.

FIG. 88. Guan Shanyue, *Red
Plum Blossoms*, traditional-style
Chinese painting, 1973.

FIG. 89. Zhou Xiaoyun, *Battling with Both Gun and Pen*, traditional-style Chinese painting, 1974.

FIG. 90. Ma Hongqi, Ren Heping, and Wang Yonghui, *New Starting Point for Automation*, traditional-style Chinese painting, c. 1974.

FIG. 91. Chen Hongbing, Mu Yilin, and Yuan Keyi, *I'm Going to See Papa Off to the Frontier*, traditional-style Chinese painting, 1974.

FIG. 92. Liang Yan, *Applying to Join the Party*, traditional-style Chinese painting, 1973.

FIG. 93. Dong Zhengyi, *Commune Fish Pond*, gouache, ca. 1974.

FIG. 94. Li Fenglan, *Spring Hoeing*, gouache, ca. 1974.

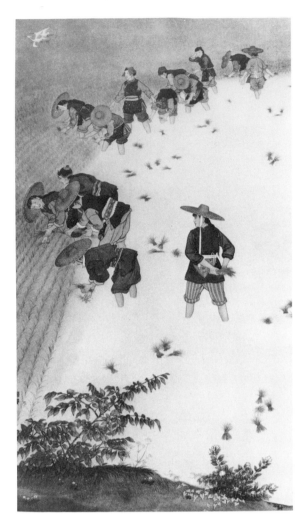

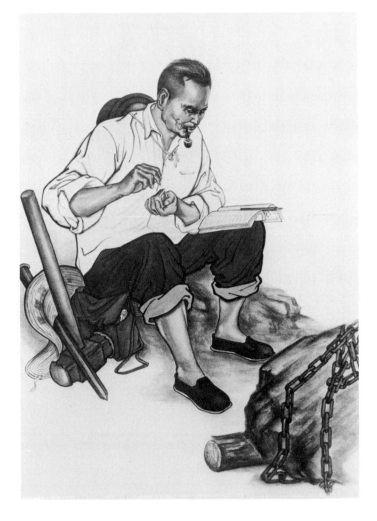

FIG. 95. Pan Jiezi, *Planting Rice Seedlings*, traditional-style Chinese painting, ca. 1958.

FIG. 96. Liu Zhide, *Old Party Secretary*, gouache, ca. 1974.

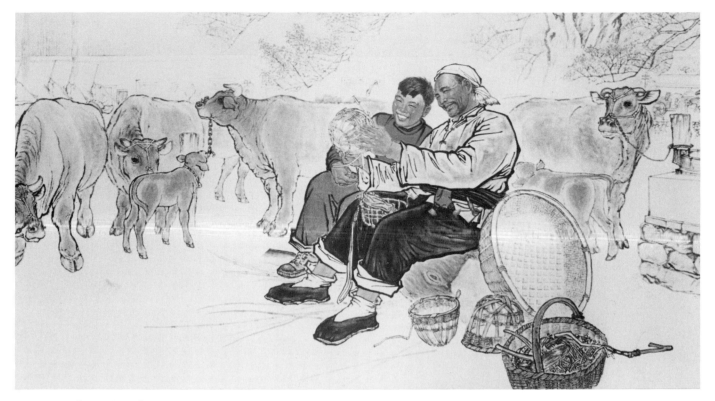

FIG. 97. Zhang Lin, *Diligence and Thrift*, gouache, ca. 1974.

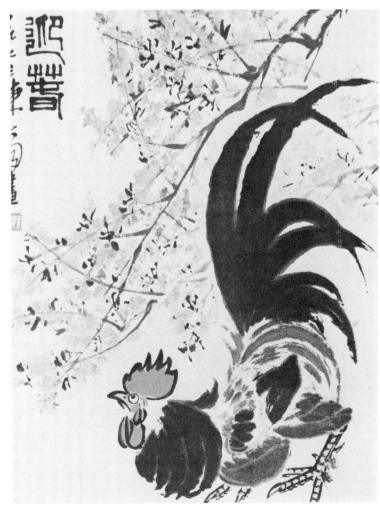

FIG. 98. Chen Dayu, *Welcome Spring*, traditional-style Chinese painting, 1973. (Cropped at left and bottom.)

FIG. 100. Gao Hong, Peng Bin, He Kongde, *Only When We Keep in Step Can We Win Victory*, oil, c. 1974.

皇　城

長安右門　　天安門　　長安左門

御河橋

通政司　登聞院　　　　宗人府　兵部　翰林院
　　　後府胡同　　　　　　吏部　工部
鑑儀衛　　　　　千　千　　　　　　　鴻臚寺　御
太常寺　中府胡同　步　步　戶部　　　欽天監　河
都察院　右府胡同　廊　廊　　　禮部　太醫院　會同館　河
刑部　製造庫　　　　　　　　　　　中御河橋
大理寺　左府胡同　大清門
　　　前府胡同　市棋　　　江　米　巷
江　米　巷　盤街　　　怡賢祠　庶常館
京畿道

正陽門

FIG. IOI.　*Plan of Tiananmen in the Qing Dynasty.*

FIG. IO2.　*The Monument to the People's Heroes, Tiananmen Square.*

FIG. 103. *Tiananmen Square,*
1959.

FIG. 104. *Tiananmen and the*
Chairman Mao Memorial Hall, from
the south.

FIG. 105. *South Facade of the*
Chairman Mao Memorial Hall.

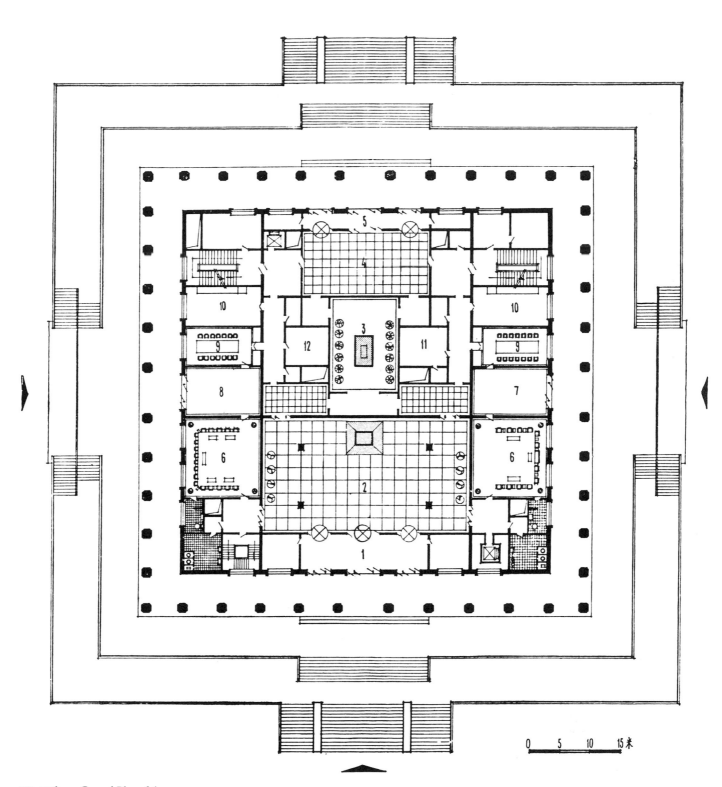

FIG. 106. *Ground Plan of the*
Chairman Mao Memorial Hall. Key:
1. North Vestibule; 2. North Hall;
3. Coffin Hall; 4. South Hall; 5.
South Vestibule; 6. Large Lounge;
7, 8. Vestibules; 9. Small Lounge;
10, 11, 12. Service and Work
Rooms.

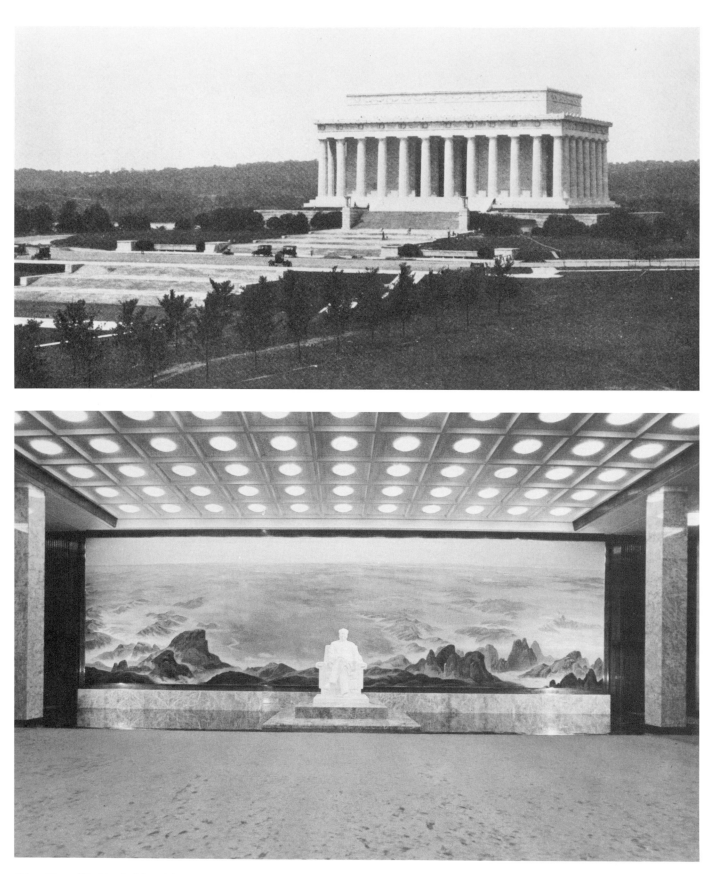

FIG. 107. *The Lincoln Memorial,*
from the northeast, Washington
D.C.

FIG. 108. *North Hall, the Chair-
man Mao Memorial Hall.*

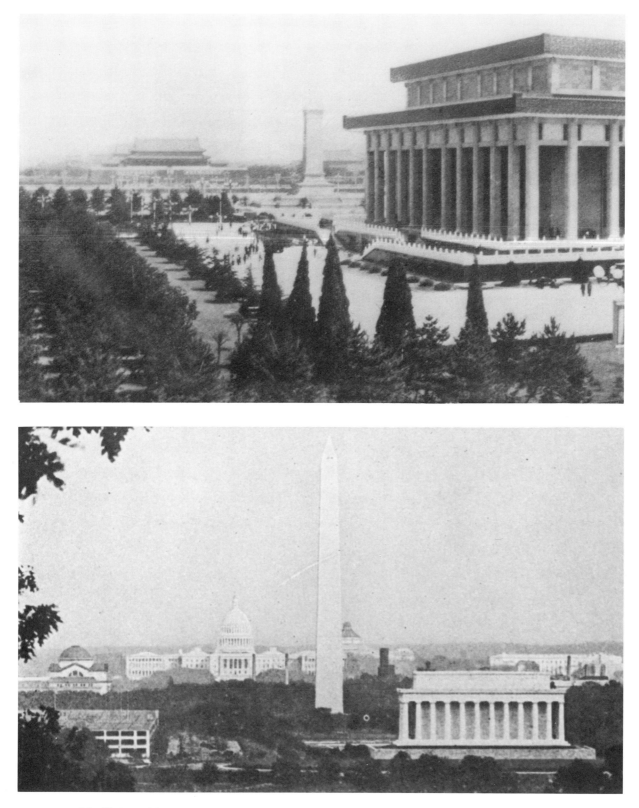

FIG. 109. The Chairman Mao
Memorial Hall, the Monument to
the People's Heroes, and Tianan-
men Gate.

FIG. 110. The Lincoln Memo-
rial, the Washington Monument,
and the Capitol Building, from the
slopes of Arlington.

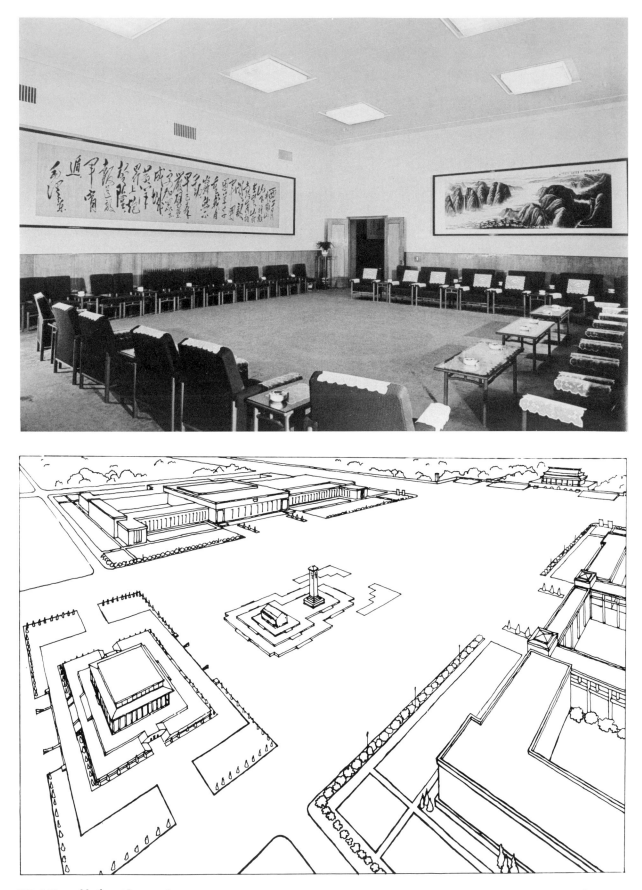

FIG. 111. *Northwest Lounge, the*
Chairman Mao Memorial Hall.

FIG. 112. A Beijing wall poster
from February 1979 showing the
Mao Memorial Hall with pro-
jected Zhou Enlai Mausoleum next
to the Monument to the People's
Heroes. Drawing.

Plates

1. Hu Zhengyan, *Ten Bamboo Studio Letter Paper*, woodblock print, ca. 1645. After Hu Zhengyan, *Shizhuzhai jianpu*, Beijing: Rongbaozhai reprint, 1952.
2. Anonymous, *Five Sons Successful in Examinations*, New Year's picture, woodblock print, nineteenth century. After Zhu Wanli, *Zhonghua minsu banhua*, Taibei: National Museum of History, 1977.
3. Anonymous, *Four Boys and Fruits*, New Year's picture, woodblock print, nineteenth century. After CR, 1958, no. 1.
4. Li Qun, *Well-clothed and Fed*, woodblock print, 1944. After CR, 1977, no. 10.
5. Wu Fan, *Dandelion Girl*, woodblock print, 1958. After *Shinian Zhongguo huihua xuanji 1949–1959*, Beijing: Renmin meishu, 1961.
6. Fu Baoshi, *Volcano*, traditional-style Chinese painting, 1961, detail. After *Fu Baoshi Guan Shanyue Dongbei xiesheng huaxuan*, Shenyang?: Liaoning meishu, 1964.
7. Pan Tianshou, *Bathed in Dew*, traditional-style Chinese painting, 1959. After CL, 1961, no. 10.
8. Qian Songyan, *New City in the Mountains*, traditional-style Chinese painting, 1960. After CL, 1964, no. 9. (Cropped at sides.)
9. Gao Quan, *The Furnace Flames Are Really Red*, oil, ca. 1964. After *Xiandai meishu zuopin xinshang*, Beijing: Renmin meishu, 1965, vol. 4.
10. Zhang Ping, *To See the Green Hills Reeling like Waves, and the Dying Sun like Blood*, traditional-style Chinese painting, 1964. After CL, 1965, no. 7.
11. Anonymous, *Sailing the Seas Depends on the Helmsman, Making Revolution Depends on Mao Zedong Thought*, poster, 1969. After CL, 1969, no. 7.
12. Liu Chunhua, *Chairman Mao Goes to Anyuan*, oil, 1967. After CP, 1968, no. 9.
13. Li Keran, *Mountain Village after Rain*, traditional-style Chinese painting, 1972. After CL, 1979, no. 10.
14. Huang Yongyu, *Winking Owl*, traditional-style Chinese painting, 1978 (presumably based on a version done ca. 1972). After CR, 1979, no. 8.

Figures

1. Anonymous, illustration to *The Lute Story*, woodblock print, seventeenth century. After Higuchi Hiroshi, *Chūgoku hanga shūsei*, Tokyo: Mito Sho-oku, 1967.
2. Anonymous, *Anti-Christian Print*, woodblock print, ca. 1860. After *The Cause of the Riots in the Yangtse Valley: A "Complete Picture Gallery,"* Hankow: 1881.
3. Anonymous, *Anti-Christian Print*, woodblock print, ca. 1860. After ibid.
4. Anonymous, *The Starving People Seize the Grain*, woodblock print, April 1910. After *Zhongguo jindaishi cankao tupianji*, Shanghai: Shanghai Education Press, 1958.
5. Li Hua, *Arise*, woodblock print, 1935. After *Zhongguo xinxing banhua wushinian xuanji*, Shanghai: Renmin meishu, 1981, vol. 1.
6. Käthe Kollwitz, *Outbreak (Ausbruch)*, #5 from the *Peasant War* cycle, etching, 1903. The Vivian and Gordon Gilkey Graphic Arts Collection, Portland Art Museum, Portland, Oregon.
7. Käthe Kollwitz, *Memorial to Karl Liebknecht (Gedenkblatt für Karl Liebknecht)*, woodblock print, 1919–1920. The Vivian and Gordon Gilkey Graphic Arts Collection, Portland Art Museum, Portland, Oregon.
8. Li Hua, *Figures*, woodblock print, ca. 1936. After *Jiaoyubu dierci quanguo meishu zhanlan huizhuanji*, N.p.: Commercial Press, 1943, vol. 3.
9. Frans Masereel, *Untitled*, from *My Book of Hours*, woodblock print, ca. 1920. The Vivian and Gordon Gilkey Graphic Arts Collection, Portland Art Museum, Portland, Oregon.
10. Chen Tiegeng, *Under the Threat of Bayonets*, woodblock print, 1933. After CR, 1955, no. 3.
11. Alexei Kravchenko, *Sluice on the Dnieper River Dam*, woodblock print, early twentieth century. After Zhang Wang, *Lu Xun lun meishu*, Beijing: Renmin meishu, 1956.
12. Huang Yan, *Searching in the Ruins*, woodblock print, ca. 1940. After *Kangzhan banian muke xuanji Woodcuts of Wartime China 1937–1945*, Shanghai: Kaiming, 1946.
13. Pavel Pavlinov, *Portrait of Belinsky*,

woodblock print, early twentieth century. After *Lu Xun bianyin huaji jicun*, Shanghai: Renmin meishu, 1981, vol. 3.

14. Li Qun, *Portrait of Lu Xun*, woodblock print, 1936. After *Zhongguo xinxing banhua*, vol. 1.

15. Vladimir Favorsky, *The Actor Orlov*, woodblock print, early twentieth century. After *Sulian banhua ji Soviet Graphics*, Shanghai: Liang You, Fook Shing, 1940.

16. Ma Da, *Portrait of Lu Xun*, woodblock print, ca. 1936. After Zou Ya and Li Pingfan, eds., *Jiefangqu muke*, Beijing: Renmin meishu, 1962.

17. Vladimir Favorsky, *Portrait of Dostoevski*, woodblock print, 1929. After Oleg Sopotsinsky, comp., *Art in the Soviet Union*, Leningrad: Aurora Art Publishers, 1978.

18. Huang Xinbo, *Call to Arms*, woodblock print, 1936. After PC, 1953, no. 9.

19. Zhang Yangxi, *Human Market in Chengdu*, woodblock print, 1947. After *Zhongguo xinxing banhua*, vol. 1.

20. Shao Keping, *Late at Night When Everything Is Quiet*, woodblock print, 1948. After Yan Lichuan and Zhang Mingyuan, comps., *Zhongguo jindai meishu baitu*, Tianjin: Renmin meishu, 1981.

21. Gu Yuan, *Divorce Registration*, woodblock prints; right: version done before 1942; left: version done after 1942. After *Banhua yishu*, 1980, no. 1.

22. Luo Gongliu, *Hygiene Model*, woodblock print, ca. 1942. After Zou Ya and Li Pingfan, eds., *Jiefangqu muke*.

23. Gu Yuan, *Rehabilitation of the Anshan Steel Works*, woodblock print, 1949. After ibid.

24. Jiang Zhenghong, *New Settlement in the Forest*, woodblock print, 1958. After *Zhongguo xinxing banhua*, vol. 2.

25. Zhang Xinyou and Zhu Qinbao, *Autumn on the Plateau*, woodblock print, 1964. After CL, 1964, no. 8. (Cropped at sides and top.)

26. Xu Beihong, *Tian Heng and His 500 Retainers*, oil, 1928. After Yan Lichuan and Zhang Mingyuan, comps., *Zhongguo jindai meishu baitu*.

27. Jiang Yan, *Examination for Mama*, traditional-style Chinese painting, 1953. After *Shinian Zhongguo huihua xuanji*, Beijing: Renmin meishu, 1961.

28. Shi Lu, *Outside the Great Wall*, traditional-style Chinese painting, 1954. After *Shi Lu huaji*, Beijing: Renmin meishu, 1980.

29. Zhou Changgu, *Two Lambs*, traditional-style Chinese painting, 1954. After *Shinian Zhongguo huihua*.

30. Dong Xiwen, *Spring Comes to Tibet*, oil, ca. 1954. After ibid.

31. Song Wenzhi and Jin Zhiyuan, *Digging a Canal through the Mountains*, traditional-style Chinese painting, 1958. After CR, 1959, no. 11. (Cropped at bottom.)

32. Li Shiqing, *Moving Mountains to Fill Valleys*, traditional-style Chinese painting, 1958. After *Shinian Zhongguo huihua*.

33. Wei Zixi, *Undaunted by Wind and Snow*, traditional-style Chinese painting, 1958. After *Jiangsu shinian meishu xuanji*, Nanjing: Jiangsu wenyi, 1959.

34. Cai Jinbo, *Big Fish*, gouache, ca. 1958. After ibid.

35. Anonymous, *More Gears to the Wheels, More Water to the Fields*, gouache, ca. 1958. After CR, 1959, no. 7.

36. Hu Guilian, *Catching Moths*, gouache, ca. 1958. After ibid.

37. Jiang Yonggen, *Killing Sparrows*, gouache, ca. 1958. After *Jiangsu shinian*.

38. Fu Baoshi and Guan Shanyue, *This Land with So Much Beauty Aglow*, traditional-style Chinese painting, 1959. In the Great Hall of the People, Beijing. After *Shinian Zhongguo huihua*.

39. Hou Yimin, *Liu Shaoqi and the Anyuan Miners*, oil, 1961. After *Meishu*, 1961, no. 4.

40. Wang Xuyang, *On the Canal*, traditional-style Chinese painting, 1960. After *Meishu*, 1960, no. 8/9.

41. Xu Leng, *Night in the Wanda Mountains*, woodblock print, 1964. After *Banhua yishu*, Shanghai: Renmin meishu, 1964, vol. 2.

42. Dong Qizhong, *Autumn Colors on the Plateau*, woodblock print, ca. 1963. After ibid., vol. 1.

43. Wu Guanzhong, *Spring Dressed in Snow*, oil, 1964. After CL, 1965, no. 2. (Cropped at sides.)

44. Tang Jixiang, *Spring Drizzle*, traditional-style Chinese painting, ca. 1964. After CL, 1964, no. 2. (Cropped at sides and top.)

45. Fan Xueli, *We All Drink from the Same River*, oil, ca. 1960. After *Meishu*, 1961, no. 5.

46. Wei Zixi, *Harvest*, traditional-style Chinese painting, 1962. After *Meishu*, 1963, no. 1.

47. Yang Taiyang, *Rain*, watercolor, ca. 1962. After *Meishu*, 1962, no. 5.

48. Lin Fengmian, *Autumn Geese*, traditional-style Chinese painting, ca. 1960. After *Meishu*, 1961, no. 5.

49. Lin Fengmian, *Night Mooring*, traditional-style Chinese painting, ca. 1960. After *Lin Fengmian huaji*, Shanghai: Renmin meishu, 1979.

50. Guan Shanyue, *When the Rain Is Over*, traditional-style Chinese painting, 1962. After *Guan Shan-*

yue huaji, N.p.: Guangdong renmin, 1979.

51. Su Tianci, *Autumn Harvest South of the Yangtze*, oil, ca. 1963. After *Meishu*, 1964, no. 2.

52. Chao Mei, *Spring Returns*, woodblock print, 1964. After *Chao Mei banhua xuan*, Beijing: Renmin meishu, 1979. (Cropped at left.)

53. Song Kejun, *The Bananas Are Ripe*, woodblock print, ca. 1964. After CL, 1964, no. 7. (Cropped at sides and top.)

54. Ma Xiguang, *Mountain Village Schoolmistress*, traditional-style Chinese painting, 1964. After CL, 1965, no. 9.

55. Huang Wenbo, *Spring Rain*, oil, ca. 1963. After *Meishu*, 1963, no. 5.

56. Yang Shengrong, *Ouyang Hai*, traditional-style Chinese painting, 1964. After *Meishu*, 1964, no. 4.

57. Han Yue, *The Fountainhead*, traditional-style Chinese painting, 1964. After *Jinian Mao Zhuxi "Zai Yan'an wenyi zuotanhuishangde jianghua" fabiao sanshizhounian meishu zuopin xuan*, Beijing: Renmin meishu, 1973.

58. Qi Deyan, *Harvest*, oil, ca. 1964. After *Meishu*, 1965, no. 2.

59a. Li Baijun, *Wheat-harvesting Time*, New Year's picture, version one, sketch, 1963. After CR, 1966, no. 1.

59b. Li Baijun, *Wheat-harvesting Time*, New Year's picture, version two, 1963. After ibid.

60. *The Rent Collection Courtyard*, clay sculptures, 1965, portion. After *Rent Collection Courtyard: Sculptures of Oppression and Revolt*, Peking: Foreign Languages Press, 2nd ed., 1970.

61. Chen Baiyi, *Ouyang Hai*, New Year's picture, 1965. After *Meishu*, 1965, no. 5.

62. Tang Daxi, *Ouyang Hai*, sculpture, ca. 1966. After CR, 1966, no. 7.

63. Photograph of sculpture of Mao Zedong surrounded by girls and sunflowers. After CP, 1968, no. 5.

64. Sergei Yevseyev, *Monument to Lenin*, sculpture, 1924–1926, Finland Station, Leningrad. After Oleg Sopotsinsky, comp., *Art in the Soviet Union*.

65. Anonymous, *Mao Zedong's Thought Illumines the Theater*, poster, ca. 1968. After CL, 1968, no. 11.

66. Anonymous, *Chairman Mao—the Reddest, Reddest Red Sun in Our Hearts Is With Us*, traditional-style Chinese painting, 1967. After CP, 1967, no. 11.

67. Anonymous, *Chairman Mao Is the Never-setting Sun in Our Hearts*, oil, 1967. After CL, 1967, no. 10.

68. Photograph of Chairman Mao and others at Tiananmen, 1966. After CP, 1966, no. 9, special issue.

69. Anonymous, *Eleven-headed Guanyin Surrounded by quotations and*

illustrations from Chapter 25 of the Lotus Sutra, hanging scroll, ink and color on silk, dated 985, from Dunhuang. Courtesy of The Harvard University Art Museums (Arthur M. Sackler Museum), Bequest of Grenville L. Winthrop.

70. Anonymous, *Chairman Mao on an Inspection Tour during the Cultural Revolution*, oil, 1968. After CL, 1968, no. 7/8. (Cropped at left.)

71. Anonymous, *Follow Closely Chairman Mao's Great Strategic Plan*, gouache, 1968. After CL, 1969, no. 1. (Cropped at left.)

72. Ma Xueli, *Creating New Things All the Time*, woodblock print, ca. 1974. After *Shanghai Yangquan Lüda gongrenhua zhanlan zuopin xuanji*, Beijing: Renmin meishu, 1975.

73. Zhang Hongzan, *Where the Oil Is, There Is My Home*, oil, ca. 1974. After CL, 1975, no. 1.

74. Kang Zuotian, *Educating the Next Generation*, traditional-style Chinese painting, ca. 1972. After *Jinian Mao Zhuxi "Zai Yan'an wenyi zuotanhui."*

75. Pan Jiajun, *I Am Seagull*, oil, ca. 1972. After ibid.

76. Luan Wanchu and Wen Zhongsheng, *All Clear*, traditional-style Chinese painting, 1972. After CR, 1973, no. 8.

77. Yang Zhiguang, *Newcomer to the Mine*, traditional-style Chinese painting, ca. 1972. After *Jinian Mao Zhuxi "Zai Yan'an wenyi zuotanhui."*

78. Shang Ding, *Fighting without Respite*, oil, ca. 1974. After *Qingzhu Zhonghua renmin gongheguo chengli ershiwu zhounian quanguo meishu zuopin zhanlan: zuopin xuanji*, Beijing: Renmin meishu, 1975.

79. Li Binggang, *Before the Lecture*, oil, ca. 1974. After ibid.

80. Zhao Zhitian, *The Daqing Workers Know No Winter*, traditional-style Chinese painting, 1973. After *1973 quanguo lianhuanhua, Zhongguohua zhanlan: Zhongguohua xuanji*, Beijing: Renmin meishu, 1974.

81. Qian Songyan, *Land of Abundance South of the Yangtze*, traditional-style Chinese painting, 1972. After *Jinian Mao Zhuxi "Zai Yan'an wenyi zuotanhui."*

82. Guan Shanyue, *Great Green Wall*, traditional-style Chinese painting, 1973. After *Chinese Painting—A New Series Chinesische Malerei—Eine neue Serie*, Beijing: Foreign Languages Press, 1977.

83. Bai Xueshi and Hou Dechang, *Canal of Happiness*, traditional-style Chinese painting, ca. 1974. After *Qingzhu Zhonghua renmin gongheguo chengli ershiwu zhounian.*

84. Wei Zixi, *Nanjing Yangtze River Bridge*, traditional-style Chinese painting, 1973. After *Chinese Painting New Series.*

85. Li Keran, *To See the Green Hills Reeling like Waves, and the Dying Sun like Blood*, traditional-style Chinese painting, 1971. After CP, 1972, no. 4.

86. Guan Shanyue, *Dawn over the Great Wall*, traditional-style Chinese painting, 1973. After CL, 1973, no. 10.

87. Yao Gengyun, Fang Zengxian, and Lu Kunfeng, *Bamboo Harvest*, traditional-style Chinese painting, 1972. Top: whole; bottom: detail. After *Jinian Mao Zhuxi "Zai Yan'an wenyi zuotanhui."*

88. Guan Shanyue, *Red Plum Blossoms*, traditional-style Chinese painting, 1973. After *1973 quanguo lianhuanhua, Zhongguohua.*

89. Zhou Xiaoyun, *Battling with Both Gun and Pen*, traditional-style Chinese painting, 1974. After *Shanghai Yangquan Lüda gongren.*

90. Ma Hongqi, Ren Heping, and Wang Yonghui, *New Starting Point for Automation*, traditional-style Chinese painting, ca. 1974. After ibid.

91. Chen Hongbing, Mu Yilin, and Yuan Keyi, *I'm Going to See Papa Off to the Frontier*, traditional-style Chinese painting, 1974. After *Shanghai gongren meishu zuopin xuan*, Shanghai: Renmin meishu, 1974.

92. Liang Yan, *Applying to Join the Party*, traditional-style Chinese painting, 1973. After *1973 quanguo lianhuanhua, Zhongguohua.*

93. Dong Zhengyi, *Commune Fish Pond*, gouache, ca. 1974. After *Peasant Paintings from Huhsien County*, Peking: Foreign Languages Press, 1974.

94. Li Fenglan, *Spring Hoeing*, gouache, ca. 1974. After ibid.

95. Pan Jiezi, *Planting Rice Seedlings*, traditional-style Chinese painting, ca. 1958. After *Shoudu Zhongguohua xuan*, Beijing: Beijing chubanshe, 1959.

96. Liu Zhide, *Old Party Secretary*, gouache, ca. 1974. After *Peasant Paintings from Huhsien County.*

97. Zhang Lin, *Diligence and Thrift*, gouache, ca. 1974. After ibid.

98. Chen Dayu, *Welcome Spring*, traditional-style Chinese painting, 1973. After *Mingbao yuekan* 1977, no. 4. (Cropped at left and bottom.)

99. He Zi, *Heroine of Dream of the Red Chamber*, traditional-style Chinese painting, ca. 1973. After *Mingbao yuekan* 1979, no. 4. (Cropped at top.)

100. Gao Hong, Peng Bin, He Kongde, *Only When We Keep in Step Can We Win Victory*, oil, ca. 1974. After *Qingzhu Zhonghua renmin gongheguo chengli ershiwu zhounian.*

101. *Plan of Tiananmen in the Qing Dynasty.* After Dong Jianhong, comp., *Zhongguo chengshi jianshe fazhan shi*, Taibei: Mingwen, 1984.

102. *The Monument to the People's Heroes*, Tiananmen Square. After CP, 1973, no. 8.

103. *Tiananmen Square*, 1959. After PR, 1 Oct. 1959.

104. *Tiananmen and the Chairman Mao Memorial Hall*, from the south. After *Mao Zhuxi jiniantang*, Beijing: Zhongguo jianzhu gongye, 1978.

105. *South Facade of the Chairman Mao Memorial Hall.* After ibid.

106. *Ground Plan of the Chairman Mao Memorial Hall.* After *Jianzhu xuebao Architectural Journal*, 1977, no. 4.

107. *The Lincoln Memorial*, from the northeast, Washington, D.C. After Edward F. Concklin, *The Lincoln Memorial, Washington*, Washington, D.C.: U. S. Government Printing Office, 1927.

108. *North Hall, the Chairman Mao Memorial Hall.* After *Mao Zhuxi jiniantang.*

109. *The Chairman Mao Memorial Hall, the Monument to the People's Heroes, and Tiananmen Gate.* After CR, 1977, no. 9.

110. *The Lincoln Memorial, the Washington Monument, and the Capitol Building*, from the slopes of Arlington. Photograph by Horydczak. After Society of American Military Engineers, *The Washington Monument*, 2nd ed., Washington, D.C., 1929.

111. *Northwest Lounge, the Chairman Mao Memorial Hall.* After *Mao Zhuxi jiniantang.*

112. A Beijing wall poster from February 1979 showing the Mao Memorial Hall with projected Zhou Enlai Mausoleum next to the Monument to the People's Heroes. Drawing by Ju-i Yuan after photograph reproduced in Helmut Martin, *Cult and Canon: The Origins and Development of State Maoism*, Armonk, N.Y.: M. E. Sharpe, 1982.

Key

CL: *Chinese Literature*.

Laing: Ellen Johnston Laing, *An Index to Reproductions of Paintings by Twentieth-Century Chinese Artists*, Eugene: University of Oregon, Asian Studies Program Publications no. 6, 1984.

MSNJ: Wang Yichang, ed. 王衣昌, *Zhonghua minguo sanshiliunian Zhongguo meishu nianjian* 中華民國三十六年中國美術年鑑 *China Art Yearbook 1946–47*, Shanghai: Shanghai Municipal Cultural Movement Committee, 1948.

Yu: Yu Jianhua 俞劍華, *Zhongguo meishujia renming cidian* 中國美術家人名辭典, Shanghai: Renmin meishu, 1981.

ZGYSJ: *Zhongguo yishujia cidian, xiandai* 中國藝術家辭典現代. 4 vols., Changsha: Hunan renmin, 1981–1984.

ZGXXBH: *Zhongguo xinxing banhua wushinian xuanji* 中國新興版畫五十年選集, 2 vols., Shanghai: Renmin meishu, 1981.

Biographical Notices

Ai Zhongxin 艾中信. B. 1915; from Shanghai; oil painter; began art career as cartoonist; student of Xu Beihong and Wu Zuoren; with the Central Art Academy. ZGYSJ, 2:471–472.

Bai Xueshi 白雪石. B. 1915; from Beijing; traditional-style painter; landscapes; with the Central Arts and Crafts Academy. Laing, 327–328.

Cai Jinbo 蔡金波. Peasant painter from Pixian, Jiangsu; active ca. 1958.

Cai Ruohong 蔡若虹. B. 1910; from Jiangxi; cartoon-ist; once a head of the Chinese Artists' Association. Yu, add. 1, 47.

Chao Mei 晁楣. B. 1931; from Shandong; woodcut artist; in 1949 joined PLA; in 1958 went to Heilong-jiang. ZGYSJ, 1:511–512.

Chen Baiyi 陳白一. B. 1926; from Hunan; traditional-style painter, also does New Year's pictures. Laing, 55; ZGYSJ, 2:515.

Chen Banding 陳半丁. B. ca. 1875, d. 1970; from Zhejiang, lived in Shanghai and Beijing; traditional-style painter; flowers, landscapes; with the Beijing Chinese Painting Academy. Laing, 52–53.

Chen Dayu 陳大羽. B. 1912; from Guangdong or Fujian; traditional-style painter; flowers, birds; student of Qi Baishi; active in Beijing; after 1949 with the Nanjing Art Academy. Laing, 61.

Chen Dongting 陳洞庭. B. 1929; from Guangdong; traditional-style painter; figures, landscapes; with the Guangdong Painting Academy. Laing, 62.

Chen Hongbing 陳紅兵. Shanghai worker; traditional-style painter; figures; active ca. 1974. Laing, 50.

Chen Jiayong 陳嘉坍. Woodcut artist; active ca. 1960.

Chen Shaomei 陳少梅. B. 1909, d. 1954; from Hunan; traditional-style painter; landscapes, figures, animals; in 1953 with Beijing Chinese Painting Academy. Laing, 64.

Chen Tiegeng 陳鐵耕. B. 1908, d. 1970; from Guang-dong; woodcut artist; worked in Shanghai and Yan'an; after 1949 at Shenyang Lu Xun Art Academy and Canton Art Academy. ZGXXBH, 2:29.

Cheng Shifa 程十髮. B. 1921; from Shanghai; illustra-tor and traditional-style painter; figures of minority peoples, animals, flowers; in 1952 on staff of Shang-

hai People's Art Press; in 1956 with the Shanghai Chinese Painting Academy. Laing, 69–73; ZGYSJ, 2:551–552.

Cui Zifan 崔子范. B. 1915; from Shandong; traditional-style painter; flowers, birds; student of Qi Baishi; with the Beijing Painting Academy. Laing, 386; ZGYSJ, 2:545–547.

Deng Wen 鄧文. B. 1932; from Guangdong; traditional-style painter; landscapes; with the Guangdong Painting Academy. Laing, 376.

Ding Cong 丁聰. B. 1916; from Shanghai; decorator, cartoonist, and illustrator, noted for pictures of opera characters. Laing, 380; ZGYSJ, 1:434–436.

Dong Qizhong 董其中. B. 1935; from Jiangxi; woodcut artist; 1958 graduate of Beijing Art Normal School; now with the Shanxi Art Academy. ZGXXBH, 2:44.

Dong Shouping 董壽平. B. 1904; from Shanxi; calligrapher and traditional-style painter; plum, bamboo, landscapes, especially of Mt. Huang; with Rongbaozhai in Beijing. Laing, 390; ZGYSJ, 4:515–517.

Dong Xiwen 董希文. B. 1914, d. 1973; from Zhejiang; oil painter; studied in Suzhou, Hangzhou, and Shanghai; copied murals at Dunhuang Buddhist caves in 1943–1945; from 1949 until death with the Central Art Academy. ZGYSJ, 4:517–519.

Dong Zhengyi [characters not available]. Huxian peasant painter; active in early 1970s.

Fan Xueli 范學蠡. Oil painter; active ca. 1960.

Fang Jizhong 方濟衆. B. 1923; from Shaanxi; traditional-style painter; landscapes; student of Zhao Wangyun; active in Shaanxi. Laing, 130–131; ZGYSJ, 1:437–438.

Fang Rending 方人定. B. 1903, d. 1975; from Canton; traditional-style painter; figures, birds, and flowers; associated with Lingnan School of painting; studied in Japan and United States; after 1949 at Hua'nan People's Art Academy and vice-director of the Canton Painting Academy. Laing, 132; ZGYSJ, 3:458–460.

Fang Zengxian 方增先. B. 1931; from Zhejiang; traditional-style painter; figures; now with the Zhejiang Art Academy. Laing, 133; ZGYSJ, 4:431–432.

Fu Baoshi 傅抱石. B. 1904, d. 1965; from Jiangxi; traditional-style painter; landscapes, figures; studied in Japan; taught at National Central University; after late 1950s served as director of the Jiangsu Chinese Painting Academy. Laing, 141–146.

Gao Hong 高虹. B. 1926; from Hebei; oil painter with political department of the Chinese Military Museum. Yu, add. 1, 25.

Gao Quan 高泉. B. 1936; from Anhui; oil painter; with the PLA Art Academy. Yu, add. 1, 25.

Gu Yuan 古元. B. 1918; from Guangdong; woodcut artist and watercolorist; in 1939 in Yan'an at Lu Xun Art Academy, graduated in 1940; in 1979 vice-director of Central Art Academy. ZGYSJ, 2:473–475.

Guan Liang 關良. B. 1900; from Guangdong; traditional-style painter; opera figures; studied Western art in Japan; taught in Shanghai and elsewhere; with the Shanghai Chinese Painting Academy. Laing, 231–232.

Guan Shanyue 關山月. B. 1912; from Guangdong; traditional-style painter; landscapes; figures; associated with the Lingnan School; studied in Japan; now head of the Canton Art Academy. Laing, 233–237; ZGYSJ, 1:454–456.

Guo Weiqu 郭味蕖. B. 1909, d. 1971; from Shandong; traditional-style painter; birds, flowers, bamboo, plum; first studied Western painting, later on staff of Palace Museum; after 1959 taught Chinese painting at Central Art Academy. Laing, 243.

Han Yue 韓樾. B. 1933; from Shandong; oil painter; with the PLA Art Academy. Laing, 148.

He Kongde 何孔德. B. 1925; from Sichuan; oil painter with the Chinese Military Museum. ZGYSJ, 2:502–503.

He Tianjian 賀天健. B. 1890, d. 1977; from Jiangsu; traditional-style painter; landscapes; active in Shanghai; with the Shanghai Chinese Painting Academy. Laing, 153–155; ZGYSJ, 3:515–517.

He Yunlan [characters not available]. B. 1938; woman; from Zhejiang; 1962 graduate of Graphic Arts Department at Central Art Academy in Beijing. CL, 1964, no. 1, 78.

He Zi 何子. From Shanghai; traditional-style painter; figures. Laing, 155.

Hou Dechang 侯德昌. Traditional-style painter; active ca. 1974. Laing, 158–159.

Hou Yimin 侯一(逸)民. B. 1930; from Hebei; oil painter; with the Central Art Academy. Yu, add. 1, 19.

Hu Guilian 胡奎連. Zhejiang peasant painter; active ca. 1958.

Hu Kao 胡考. B. 1912; from Zhejiang; cartoonist; active in Shanghai and Yan'an; on staff of *People's Pictorial*. Laing, 192.

Hu Peiheng 胡佩衡. B. 1892, d. 1962; from Hebei; traditional-style artist; landscapes; lived in Beijing. Laing, 190–192; Yu, 621.

Hua Junwu 華君武. B. 1915, d. 1982; from Jiangsu; cartoonist; began career in Shanghai in 1933; did cartoons for *Jiefang ribao* in Yan'an; from 1950–1966 head of art department of *Renmin ribao*; a head of Chinese Artists' Association. ZGYSJ, 1:448–449.

Hua Tianyou 滑田友. B. 1901; from Jiangsu; sculptor; with the Central Art Academy. Yu, add. 1, 41.

Huang Binhong 黃賓虹. B. 1865, d. 1955; from Anhui, born in Zhejiang; calligrapher, art historian, traditional-style painter; landscapes; active in Beijing, Shanghai, and Nanjing; after 1949 with Central Art Academy branch in Hangzhou. Laing, 197–202; ZGYSJ, 3:527–529.

Huang Miaozi 黃苗子. B. 1913; from Guangdong; calligrapher and art critic; with the People's Art Press. Yu, add. 1, 38.

Huang Wenbo 黃文波. Oil painter; in 1963, fourth-year student at Guangdong Art Academy. *Meishu*, 1963, no. 5:8.

Huang Xinbo 黄新波. B. 1916, d. 1980; from Guangdong; woodcut artist; in 1932 joined Communist Youth League and began to make woodcuts; in 1935 in Japan; in the late 1930s and early 1940s in Guilin and Hong Kong; in 1949 returned to Canton; in 1963 director of Guangdong Painting Academy. ZGYSJ, 1:520–521.

Huang Yan 荒烟. B. 1921; from Guangdong; self-taught woodcut artist; member of various woodcut societies in 1930s; after 1950 art editor for *Guangming ribao*. ZGXXBH, 2:39.

Huang Yongyu 黄永玉. B. 1924; from Hunan; Tujia nationality; woodcut artist, cartoonist, and traditional-style painter; with the Central Art Academy. Laing, 209–211.

Huang Zhou 黄胄. B. 1925; from Hebei; moved to Xi'an; traditional-style painter; figures, animals; studied with Zhao Wangyun in 1940; in 1945 went with Zhao to Dunhuang Buddhist caves; in 1948 joined PLA, went to Gansu, Qinghai, Xinjiang; in 1955 with political section of PLA in Beijing; in 1975 with the Light Industry Bureau, Arts and Crafts Company. Laing, 173–175; ZGYSJ, 3:524–525.

Jiang Feng 江丰. B. 1910, d. 1982; from Shanghai; art educator and theorist; woodcut artist; joined Lu Xun's woodcut movement; in 1932 joined the Chinese Communist Party, the same year with Ai Qing and others formed the Spring Land Painting Society; when it was broken up by GMD, he was jailed; in 1938 in Yan'an, worked with propaganda teams in Eighth Route Army; in 1939 head of art section of Lu Xun Art Academy; after 1949 vice-chairman of Chinese Artists' Association and vice-director of Central Art Academy; in 1979 director of the Central Art Academy. ZGYSJ, 2:491–492.

Jiang Hanting 江寒汀. B. 1903, d. 1963; from Jiangsu; traditional-style painter; birds and flowers; active in Shanghai; with the Shanghai Chinese Painting Academy. Laing, 89.

Jiang Yan 姜燕. B. 1919, d. 1958; woman; from Beijing; traditional-style painter; figures; graduate of Beijing Art School. Laing, 92.

Jiang Yonggen 蒋永根. Jiangsu peasant painter; active ca. 1958.

Jiang Zhaohe 蒋兆和. B. 1904; from Sichuan; traditional-style painter; figures; also studied oil painting, sketching, and sculpture; worked in Nanjing, Shanghai, and Beijing; after 1949 with Central Art Academy. Laing, 86–88; ZGYSJ, 3:535–536.

Jiang Zhenghong 蒋正鸿. B. 1936; from Zhejiang; woodcut artist; in 1956 studied graphic art at Central Art Academy; in 1960 professor at Central Minorities Academy; in 1977 with mural department of Central Arts and Crafts Academy. ZGXXBH, 2:44.

Jin Zhiyuan 金志远. B. 1930; from Jiangsu; traditional-style painter; figures, landscapes; studied at Central Art Academy; now with the Jiangsu Chinese Painting Academy. Laing, 107.

Kang Zuotian 亢佐田. B. 1941; from Shanxi; active in Yanbei area of Shanxi. Laing, 216.

Li Baijun 李百钧. B. 1941; from Shandong; specialist in New Year's pictures; with the Shandong Art Academy. Yu, add. 1, 12.

Li Binggang 李秉刚. Oil painter with the military; active ca. 1974.

Li Fangbai 李方白. B. 1915; from Hebei; traditional-style painter; landscapes; with the Beijing Art Company. Laing, 261.

Li Fenglan 李凤兰. Woman; Huxian peasant painter; active in early 1970s.

Li Hua 李桦. B. 1907; from Guangdong; 1926 graduate of Canton Municipal Art School; in 1930 studied in Japan; in 1930s participated in woodcut movement; in 1947 taught in Beijing; in 1953 became head of the graphic department of the Central Art Academy. ZGYSJ, 1:460–461.

Li Keran 李可染. B. 1907; from Jiangsu; traditional-style painter; landscapes, herdboys, and buffaloes; student of Qi Baishi, Huang Binhong, and Lin Fengmian; in 1929 at National West Lake Art Academy in Hangzhou; in 1940 in Sichuan; in 1946 in Beijing with Xu Beihong at National Art Academy; now with the Central Art Academy. Laing, 255–260; ZGYSJ, 2:494–496.

Li Kuchan 李苦禅. B. 1898, d. 1983; from Shandong; traditional-style painter; birds and flowers; also studied Western painting; student of Qi Baishi and Xu Beihong; in 1930 taught at National West Lake Art Academy in Hangzhou; after war with Japan moved to Beijing; with the Central Art Academy. Laing, 267–271; ZGYSJ, 3:479–481.

Li Qiu 李秋. B. 1899, d. 1971; woman; from Zhejiang; traditional-style painter; landscape, figures, flowers; with the Shanghai Chinese Painting Academy. Laing, 248.

Li Qun 力群. B. 1912; from Shanxi; woodcut artist; in 1927 studied sketching and watercolor in Taiyuan; in 1931 entered National Hangzhou Art School; in 1933 with Left-wing Artists' League; jailed; in 1935 released from jail, went to Shanghai; in 1940 in Yan'an, taught at Lu Xun Art Academy; after Liberation assistant editor of *Meishu* and *Banhua*; now works in Shanxi. ZGYSJ, 2:452–455.

Li Shiqing 李硕卿. B. 1908; from Fujian; traditional-style painter, also trained in Western art in Shanghai; student of Wang Geyi and Pan Tianshou; now in Quanzhou. Laing, 264; ZGYSJ, 2:497–500.

Li Xiongcai 黎雄才. B. 1910; from Guangdong; traditional-style painter; landscapes; studied in Japan; associated with the Lingnan School; with the Guangdong Art Academy. Laing, 251–252.

Li Yimin 李(?)逸民. PLA general; traditional-style painter; birds and flowers; active ca. 1959. Laing, 253.

Liang Yan 梁岩. B. 1943; from Shandong; traditional-style painter; figures; now with Henan People's Art Hall. Laing, 276.

Lin Fengmian 林风眠. B. 1900; from Guangdong; traditional-style painter, also works in Western styles; studied painting in Paris in 1922–1923; from

1949 until 1953 in Hangzhou, relieved of his post here and moved to Shanghai; now active in Shanghai. Laing, 278–282.

Lin Ximing 林曦明. B. 1926; from Zhejiang; traditional-style painter; landscapes, figures, animals; also a paper-cut artist; active in Shanghai; with the Shanghai Chinese Painting Academy. Laing, 283.

Liu Chunhua 劉春華. B. 1944; from Heilongjiang; born into a poor peasant family, studied at middle school attached to Lu Xun Fine Arts Academy in Shenyang; in 1966 a student at Central Academy of Arts and Crafts in Beijing. CL, 1972, no. 7:112–114.

Liu Haisu 劉海粟. B. 1896; from Jiangsu; traditional-style painter and oil painter; landscapes and cityscapes; founder of the Shanghai Art Academy in 1912; traveled in Europe in the 1930s; now with the Nanjing Art Academy. Laing, 291–294; ZGYSJ, 4:450–453.

Liu Mengtian 劉蒙天. B. 1918; from Zhejiang; traditional-style painter and graphic artist; in 1938 in Yan'an; now with the Shaanxi Art Academy. Laing, 299; ZGYSJ, 1:545.

Liu Zhide 劉志德. Peasant painter in Huxian; active in early 1970s.

Liu Zonghe 劉宗河. B. 1928; from Henan; graphic artist, also does New Year's prints; in 1950–1953 studied in Sichuan; now with Guizhou Provincial Art Museum. ZGYSJ, 4:447–448.

Lu Kunfeng 盧坤峰. B. 1934; from Shandong; traditional-style painter; now with the Zhejiang Art Academy. Laing, 310–311.

Lu Zhixiang 陸志庠. B. 1910; from Shanghai; with the People's Literature Press. Yu, add. 1, 33.

Luan Wanchu [characters not available]. Traditional-style painter; electrician in the Dalian Railway Bureau; active ca. 1972. Laing, 316; CL, 1974, no. 6:85.

Luo Gongliu 羅工柳. B. 1916; from Guangdong; oil painter and woodcut artist; in 1936 studied painting at the Hangzhou Art School; in 1938 in Yan'an at the Lu Xun Art Academy, worked in Taihang Mountains; in 1949 in Beijing; in 1955 went to the Soviet Union to study Western oil painting, returned to China in 1958; became vice-director of the Central Art Academy. ZGYSJ, 2:520–521.

Luo Qi 羅祺. Traditional-style painter, in PLA. Laing, 304–305.

Ma Da 馬達. B. 1903, d. 1978; from Guangxi; woodcut artist; participated in woodcut movement in 1930s; in 1938 in Yan'an, taught at the Lu Xun Art Academy; after Liberation active in Tianjin. ZGXXBH, 2:24.

Ma Hongqi 馬洪琪. Yangquan worker; traditional-style painter; active in early 1970s. Laing, 319.

Ma Xiguang 馬西光. B. 1932; from Shanxi; in 1952 a cultural worker in the armed forces; in Qinghai. Laing, 319.

Ma Xueli 馬學禮. B. 1941; from Shandong; woodcut artist; worker in Dalian. Yu, add. 1, 25.

Mi Gu 米谷 (Zhu Wushi 朱吾石). B. 1919; from Zhejiang; cartoonist; graduate of Lu Xun Art Academy in Yan'an; now with the Chinese Art Hall. CL, 1963, no. 1:101; Yu, add. 1, 7.

Mu Yilin 穆益林. Shanghai worker; traditional-style painter; figures; active ca. 1974. Laing, 324.

Ni Yide 倪貽德. B. 1901, d. 1970; from Zhejiang; oil and watercolor painter; 1922 graduate of Shanghai Art Academy; studied in Japan; taught in Shanghai. Yu, 654.

Pan Jiajun 潘嘉(家)峻. B. 1947; from Guangdong; oil painter; with the PLA in Hunan. Yu, add. 1, 47.

Pan Jiezi 潘絜兹. B. 1915; from Zhejiang; traditional-style painter; gongbi figures; in 1932–1936 studied art in Beijing with Wu Guangyu and Xu Yansun; in 1945 at Dunhuang, copied Buddhist murals there; in 1951 head of art division of Chinese History Museum; in 1956–1957 visited Poland and elsewhere to study cultural objects preservation and mural restoration; served on editorial board of Meishu and other art journals; taught at Central Art Academy and Central Arts and Crafts Academy, Central Drama Academy, now with the Beijing Painting Academy. Laing, 329; ZGYSJ, 1:529–530.

Pan Tianshou 潘天授. B. 1897, d. 1971; from Zhejiang; calligrapher, art historian; traditional-style painter; birds and flowers, landscapes; in 1928 teaching at National West Lake Art Academy in Hangzhou; after 1949 vice-chairman of Chinese Artists' Association and other posts in Zhejiang; head of Zhejiang Art Academy. Laing, 331–336; ZGYSJ, 1:526–529.

Pang Xunqin 龐勳琴. B. 1906; from Jiangsu; Western-style and traditional-style painter; studied in Paris in late 1920s; studied Chinese painting and gongbi in Shanghai; in 1936 moved to Beijing to teach at National Beijing Art School; during war with Japan in southwest China; in 1949 taught at Hangzhou branch of Central Art Academy; in 1956 vice-director of Central Arts and Crafts Academy. Laing, 337; ZGYSJ, 2:526–527.

Peng Bin 彭彬. B. 1927; from Jiangsu; oil painter with the Chinese Military Museum. Yu, add. 1, 36.

Pu Songchuang 溥松窗. B. 1912; from Beijing; traditional-style painter; horses, flowers, and birds; member of former Imperial family; now with Beijing Painting Academy. Laing, 341–342.

Qi Baishi 齊白石. B. 1863, d. 1957; from Hunan; calligrapher, seal-cutter, and traditional-style painter; flowers and insects, birds, figures, landscapes; at age 12 studied carpentry, at 15 studied woodcarving; began formal study of painting at age 27; at age 50 moved to Beijing to teach at Beijing Art School; remained in Beijing. Laing, 74–85; ZGYSJ, 3:470–472.

Qi Deyan 漆德琰. From Jiangxi; oil painter; active ca. 1964.

Qian Songyan 錢松嵒. B. 1899, d. 1985; from Jiangsu; traditional-style painter; landscapes; with Jiangsu Chinese Painting Academy. Laing, 95–100; ZGYSJ, 1:512–513.

Qin Jianming 秦劍銘. B. 1942; from Jiangsu; traditional-style painter; landscapes; with Jiangsu Chinese Painting Academy. Laing, 111.

Qin Wenmei 秦文美. Primarily an oil painter; active in early 1970s. Laing, 112.

Ren Heping 任和平. Yangquan worker; traditional-style painter; active in early 1970s. Laing, 214.

Ren Yi 任意. B. 1925; from Zhejiang; works in crafts; with Shanghai Education Press. Yu, add. 1, 7.

Shang Ding 尚丁. Oil painter; soldier; active in early 1970s.

Shao Keping 邵克萍. B. 1916; from Zhejiang; woodcut artist; studied in Shanghai; during war with Japan served as editor of *Minzu ribao* in Zhejiang and began to study woodcuts; after 1949 with Cultural Bureau in Shanghai and with Shanghai Art Press. ZGYSJ, 4:484–485.

Shao Yiping 邵一萍. B. 1910, d. 1963; woman; from Zhejiang; traditional-style painter; birds and flowers; studied Chinese painting with her cousin; during war with Japan traveled in Fujian, Jiangxi, Guangdong, Guangxi, and Sichuan; studied with Huang Junbi and Zhao Shaoang; after Liberation in Changsha; taught at Hunan Provincial Handicraft Academy and elsewhere. Laing, 346–347; ZGYSJ, 3:496–497.

Shao Yu 邵宇. B. 1919; from Liaoning; does serials and woodcuts; studied in Shenyang and Beijing; before Liberation did revolutionary work; after Liberation, head of art division of *Renmin ribao* and on editorial board of *Renmin huabao*; with People's Art Press. Laing, 347–348; ZGYSJ, 1:484–485.

Shi Lu 石魯. B. 1919, d. 1982; from Sichuan; graduate of Chengdu Art School; in 1942 in Yan'an as a woodcut artist; after 1949 began painting in Chinese style; worked in Xi'an. Laing, 137–138; ZGYSJ, 3:460–462.

Song Kejun 宋克君. B. 1922; from Guilin; Moslem; cartoonist and woodcut artist; during 1940s in Sichuan; now active in Chongqing. ZGXXBH, 2:35.

Song Wenzhi 宋文治. B. 1918; from Jiangsu; traditional-style painter; landscapes; with Jiangsu Chinese Painting Academy. Laing, 363–365.

Su Guang 蘇光. B. 1919; from Shanxi; cartoonist and woodcut artist; in 1940 studied at the Lu Xun Art Academy in Yan'an; now active in Shanxi. ZGYSJ, 3:474–475.

Su Tianci 蘇天賜. B. 1922; from Guangdong; oil painter; with the Nanjing Art Academy. Yu, add. 1, 53.

Tang Daxi 唐大禧. B. 1936; from Guangdong; sculptor; with the Guangdong Sculpture Studio. Yu, add. 1, 22.

Tang Jixiang 唐集祥. B. 1939; from Guangdong; primarily a woodcut artist; 1962 graduate of Guangdong Institute of Fine Arts; now with the Guangdong Painting Academy. Laing, 368.

Tang Yihe 唐一和. B. 1905, d. 1944; from Hubei; oil painter; in 1925 studied art in Beijing; in 1930 entered the Paris Art Academy; in 1934 returned to China; taught in Wuchang. ZGYSJ, 3:521–522.

Tang Yingwei 唐英偉. From Guangdong; woodcut artist and traditional-style painter; studied Chinese painting at the Canton Art School and in 1932 joined the woodcut movement. MSNJ, 53.

Tang Yun 唐雲. B. 1910; from Zhejiang; traditional-style painter; flowers, birds, figures, landscapes; in 1938 moved to Shanghai; now with the Shanghai Chinese Painting Academy. Laing, 371–373; ZGYSJ, 2:535–536.

Tao Yiqing 陶一清. B. 1914; from Beijing; traditional-style painter; landscapes; with the Central Art Academy. Laing, 373–374.

Wang Geyi 王个簃. B. 1896; from Jiangsu; traditional-style painter; birds, flowers; in 1928 went to Japan, later taught in Shanghai and elsewhere; now with the Shanghai Chinese Painting Academy. Laing, 407; ZGYSJ, 4:421–423.

Wang Qingfang 王青芳. B. after 1900, d. 1956; spent life in Beijing; traditional-style painter; birds, flowers, fish; student of Qi Baishi and Xu Beihong. Laing, 402.

Wang Xuyang 王緒陽. B. 1932; from Liaoning; with the Lu Xun Art Academy in Shenyang. Laing, 408.

Wang Yonghui 王永惠. Yangquan worker; traditional-style painter; active in early 1970s. Laing, 426.

Wei Zixi 魏紫熙. B. 1915; from Henan; traditional-style painter; landscapes; graduate of Henan Normal School; with the Jiangsu Chinese Painting Academy. Laing, 427–428.

Wen Chengcheng 溫承誠. Traditional-style painter; active in early 1970s; possibly same as Wen Zhongsheng. Laing, 428.

Wen Zhongsheng [characters not available]. Traditional-style painter; active in early 1970s; possibly same as Wen Chengcheng.

Wo Zha 沃渣. B. 1905, d. 1974; from Zhejiang; woodcut artist; studied in Shanghai, joined woodcut movement; in 1938 in Yan'an at the Lu Xun Art Academy; after 1950 in Beijing in charge of the People's Art Press work studio, also associated with Rongbaozhai. ZGXXBH, 2:35.

Wu Fan 吳凡. B. 1924; from Sichuan; does serials, illustrations, cartoons, and woodcuts; in 1944 entered Chinese Painting department of Chongqing National Art School; in 1946 began to study Western painting in Hangzhou with Ni Yide; here also studied Chinese painting with Pan Tianshou and Li Keran; now active in Chongqing. ZGYSJ, 1:477–478.

Wu Guanzhong 吳冠中. B. 1919; from Jiangsu; oil and traditional-style painter; studied at Hangzhou Art Academy; in 1947 went to France, returned to China in 1950; now with the Central Art Academy. Laing, 444–445; ZGYSJ, 1:480.

Wu Jingting 吳鏡汀. B. 1904, d. 1972; spent life in Beijing; traditional-style painter; landscapes; with the Central Minorities Art Research Institute and Beijing Painting Academy. Laing, 441.

Wu Qiangnian 吳強年. B. 1937; from Guangdong; woodcut artist; 1958 graduate of Central Art Academy school; now active in Sichuan. ZGXXBH, 2:31.

Wu Yunhua 吳雲華. B. 1944; from Liaoning; oil painter with the Liaoning Art Gallery. Yu, add. 1, 10.

Wu Zuoren 吳作人. B. 1908; from Anhui; oil painter and traditional-style painter; studied in Shanghai and Nanjing in late 1920s; student of Xu Beihong; studied in Europe; returned to China in 1935 to teach in Nanjing; in 1937 went to Chongqing; since Liberation at the Central Art Academy, rising to posts of vice-director and director. Laing, 449–451; ZGYSJ, 4:470–472.

Xia Zhu 夏朱. Oil painter; active ca. 1960.

Xiu Jun 修軍. B. 1925; from Shandong; woodcut artist; studied art in Beijing; in 1952 went to Korea; now active in Shaanxi. ZGYSJ, 3:508–509.

Xu Beihong 徐悲鴻. B. 1895, d. 1953; from Jiangsu; oil painter and traditional-style painter; figures, landscapes; in 1917 studied in Japan; in 1921 in Berlin; taught at many schools in China; after 1949 head of the Central Art Academy. Laing, 178–184; ZGYSJ, 4:508–510.

Xu Leng 徐楞. B. 1929; from Zhejiang; after 1949 in army; now in Heilongjiang as propaganda cadre. ZGXXBH, 2:41.

Xu Yansun 徐燕孫. From Hebei; traditional-style painter; figures. Laing, 186.

Ya Ming 亞明. B. 1924; from Anhui; in 1939 joined the New Fourth Army and did propaganda work as a cartoonist; after 1949 at the Jiangsu Chinese Painting Academy. Laing, 469–471; ZGYSJ, 2:480–482.

Yan Di 顏地. B. 1920, d. 1979; from Shandong; traditional-style painter; landscapes; influenced by Fu Baoshi and Li Keran; with the Beijing Chinese Painting Academy. Laing, 473–474.

Yan Han 彥涵. B. 1916; from Jiangsu; woodcut artist and traditional-style painter; student of Lin Fengmian and Pan Tianshou; in 1938 in Yan'an at the Lu Xun Art Academy; now with the Central Art Academy. Laing, 472; ZGYSJ, 1:508–510.

Yang Shengrong 楊勝榮. B. 1928; from Hunan; Tujia nationality; traditional-style painter; with military in Lanzhou. Laing, 462.

Yang Taiyang 陽太陽. B. 1909; from Guangxi; art educator and traditional-style painter; landscapes, birds, flowers, fish; in 1928 at the Shanghai Art Academy; in 1935 studied in Japan; now active in Guilin; head of the Guangxi Calligraphy and Painting Academy. ZGYSJ, 4:457.

Yang Zhiguang 楊之光. B. 1930; from Guangdong; traditional-style painter; figures; studied with Gao Lun, Xu Beihong, and Ye Qianyu; with the Guangdong Art Academy. Laing, 456–457; ZGYSJ, 1:471–472.

Yao Gengyun 姚耕雲. B. 1931; from Shanghai; traditional-style painter; with Zhejiang Art Academy. Laing, 465.

Ye Qianyu 葉淺予. B. 1907; from Zhejiang; cartoonist and traditional-style painter; taught in Beijing; now with the Central Art Academy. Laing, 467–468; ZGYSJ, 4:467–468.

Yu Feian 于非闇. B. 1888, d. 1959; from Hebei or Shandong; traditional-style painter; flowers and birds, orchids, bamboo, narcissus; worked in *gongbi* style; after 1949 with the Beijing Painting Academy. Laing, 477–479.

Yu Feng 郁風. B. 1916; woman; from Zhejiang; decorator and critic; now with the Chinese Art Hall. Yu, add. 1, 21.

Yu Tongfu 余彤甫. Traditional-style painter; landscapes; with the Jiangsu Provincial Chinese Painting Academy. Laing, 483–484.

Yuan Keyi 袁可儀. Shanghai worker; traditional-style painter; figures; active ca. 1974. Laing, 487.

Zhang Anzhi 張安治. B. 1911; from Jiangsu; oil painter and traditional-style painter; student of Xu Beihong at National Central University; in 1947–1948 in England; after 1949 with the Central Art Academy. Laing, 1–2.

Zhang Deyu 張德育. B. 1931; from Henan; primarily an illustrator; with the Tianjin People's Art Press. Laing, 18.

Zhang Ding 張仃. B. 1919; from Liaoning; in 1939 in Yan'an at Lu Xun Art Academy; in 1981 president of Central Arts and Crafts Academy. Laing, 19.

Zhang Guangyu 張光宇. B. 1900, d. 1965; cartoonist and illustrator; traditional-style painter; figures and ladies; graduate of Shanghai Fine Arts Academy; after 1949 at the Central Art Academy and Central Arts and Crafts Academy. Laing, 10.

Zhang Hongzan 張洪贊. Oil painter and New Year's pictures designer; active ca. 1974.

Zhang Lin 張林. Huxian peasant painter; active in early 1970s.

Zhang Ping 張凭. B. 1934; from Henan; traditional-style painter; landscapes; 1961 graduate of the Central Art Academy; student of Li Keran and Qian Songyan. Laing, 14.

Zhang Wang 張望. B. 1916; from Guangdong; woodcut artist; studied Western art in Shanghai; joined the MK Woodcut Society; in 1933 began to publish his woodcuts; fled Shanghai when the MK Woodcut Society was broken up by the GMD; in 1938 went to Yan'an; later to Sichuan, worked for *Xinhua ribao*; in 1941 returned to Yan'an to work at Lu Xun Art Academy and with Eighth Route Army in Shaan-Gan-Ning Border Areas; after Liberation, active in Shenyang; in 1978 director of Lu Xun Art Academy in Shenyang. ZGXXBH, 2:31.

Zhang Xinyou 張新予. B. 1932; from Jiangsu; woodcut artist; worked in art department of various newspapers; 1958 graduate of graphics department of Zhejiang Art Academy; from 1960 to present in charge of graphics at the Jiangsu Provincial Art Hall. ZGXXBH, 2:32.

Zhang Yangxi 張漾兮. B. 1912, d. 1964; from Sichuan; in 1926 entered Sichuan Private Art School; after graduation did ads and cartoons; in 1937 joined

Shishi xinbao editorial staff; during war with Japan in Sichuan; in 1948 went to Hong Kong; in 1949 returned to Beijing; then became teacher at the Hangzhou branch of the Central Art Academy; in 1954 became head of graphics department there. ZGYSJ, 3:491–492.

Zhang Zhengyu 張正宇. B. 1904, d. 1976; from Jiangsu; active in theater and newspaper worlds in Shanghai; did paintings and sketches of theater; with Central Art Academy. Laing, 2; ZGYSJ, 4:39–40.

Zhang Zuoliang 張作良. B. 1927; from Shandong; woodcut artist; joined the revolution in 1944; in 1950 went to Korea; in 1952 with art department of *Jiefangjun huabao*; in 1958 went to Heilongjiang and began to do graphics; since 1975 in Tianjin. ZGYSJ, 3:489–490.

Zhao Wangyun 趙望雲. B. 1906, d. 1977; from Hebei; traditional-style painter; figures, landscapes; in 1925 studied in Beijing; taught there and in Shanghai; later active in Xi'an. Laing, 37–38; ZGYSJ, 3:505–507.

Zhao Zhitian 趙志田. Traditional-style painter; figures; active in early 1970s. Laing, 30.

Zhou Changgu 周昌谷. B. 1929; from Zhejiang; studied with Lin Fengmian; turned to traditional-style painting; with the Zhejiang Art Academy. Laing, 115; ZGYSJ, 1:500–501.

Zhou Lingzhao 周令釗. B. 1919; from Hunan; illustrator and cartoonist; studied art in Changsha; did anti-Japanese propaganda posters; after 1949 with the Central Art Academy. ZGYSJ, 2:522–523.

Zhou Xiaoyun 周小筠. Shanghai worker; traditional-style painter; figures; active in early 1970s. Laing, 116.

Zhu Qinbao 朱琴葆. B. 1934; woman; from Jiangsu; woodcut artist; in 1953–1958 studied in graphics department of Zhejiang Art Academy; in 1961 in charge of graphic creations at the Jiangsu Provincial Art Hall. ZGXXBH, 2:28.

Chinese and Japanese Sources

1973 quanguo lianhuanhua, Zhongguohua zhanlan: Zhongguohua xuanji 1973 全國連環畫中國畫展覽中國畫選集 [Selection of Chinese paintings from the 1973 national exhibition of serials and Chinese paintings]. Beijing: Renmin meishu, 1974.

Banhua congshu 版畫叢書 [Print anthology]. Vol. 1, *Yangliuqing banhua* 楊柳青版畫 [Prints from Yangliuqing]. Taibei: Xiongshi, 1976.

"Beijing meishu zhanlan jianshu" 北京美術展覽簡述 [Report on Beijing art exhibitions]. *Meishu*, 1956, no. 11:12.

"Beijing meishujia huoyue zai shisanling shuiku gongdi" 北京美術家活躍在十三陵水庫工地 [Beijing artists active at the Thirteen Tombs Reservoir worksite]. *Meishu*, 1958, no. 6:3–4.

"Beijing meishujia jihui piping wenhuabu ji meixie lingdao" 北京美術家集會批評文化部及美協領導 [Beijing artists meet to criticize Culture Bureau and Artists' Association leadership]. *Meishu*, 1957, no. 6:6–9.

"Beijing Zhongguohua huajiade yijian" 北京中國畫畫家的意見 [The views of Beijing Chinese painting artists]. *Meishu*, 1957, no. 6:4–6.

"Chanchu wei Liu Shaoqi shubeilizhuande daducao—fandong youhua 'Liu Shaoqi yu Anyuan kuanggong' chulongde qianqian houhou" 鏟除爲劉少奇樹碑立傳的大毒草—反動油畫'劉少奇與安源礦工'出籠的前前后后 [Uproot the whole story about the appearance of the great poisonous weed and reactionary oil painting *Liu Shaoqi and the Anyuan Miners* done to glorify Liu Shaoqi]. *Meishu fenglei*, 10–14.

"Chang suo yu yan hua 'zhengming'" 暢所欲言話 '爭鳴' [Speaking out freely about "contending"]. *Meishu*, 1956, no. 8:11.

Chen Kai 陳開. "Dui 'Xiandai shanshuihua xuan' de yijian" 對 '現代山水畫選' 的意見 [Views about *Selection of Contemporary Landscapes*]. *Meishu*, 1964, no. 5:45–46.

[Chen] Shuliang 陳叔亮. "Cong Yan'ande xinnianhua yundong tanqi" 從延安的新年畫運動談起 [Talking about the Yan'an new New Year's picture movement]. *Meishu*, 1957, no. 3:36–37.

———. "Huiyi Luyi" 回憶魯藝 [Recalling the Lu (Xun) Art (Academy)], in *Jiefangqu muke*. Edited by Zou Ya and Li Pingfan, 1–5. Beijing: Renmin meishu, 1962.

Cheng Wei 成威. "Shanshuihua dayou wenzhang kezuo" 山水畫大有文章可作 [Landscape painting has great interpretative potential]. *Meishu*, 1977, no. 6:13–14.

Dianshizhai huabao 點石齋畫報 [Dianshizhai Pictorial]. Shanghai, 1885–1895. Reprint. 2 vols. Hong Kong: Guangquejing, 1983.

Fang Dan 方丹. "Cheng Shifa he tade hua" 程十髮和他的畫 [Cheng Shifa and his painting]. Part 2. *Nanbei ji*, Sept. 1978, 88–90.

———. "Guaijie Shi Lu" 怪傑石魯 [The un-
usual Shi Lu]. Parts 1, 2. *Nanbei ji*, March 1979,
54–61; April 1979, 89–94.

———. "Hou Kai yu 'heihuadian'—manhua
Rongbaozhai" 侯愷與「黑畫店」—漫話榮
寶齋 [Hou Kai and the "black painting shop"
—on Rongbaozhai]. Parts 1, 2. *Nanbei ji*, Oct.
1979, 74–78; Dec. 1979, 65–69.

———. "Keguizhe dan, suojiuzhe hun—Li
Keran he tade meixue" 可貴者胆所求者魂—
李可染和他的美學 [Boldness is valued, spirit
is sought—Li Keran and his art]. Part 2.
Nanbei ji, June 1979, 91–97.

———. "'Pi heihua' yuanshi cailiao" 批黑畫原
始材料 [Original materials on "criticizing
black painting"]. *Nanbei ji*, Feb. 1979, 26–29.

———. "Qicai Huang Yongyu" 奇才黃永玉
[The genius Huang Yongyu]. Part 3. *Nanbei ji*,
April 1977, 59–63.

———. "Xu Linlu—Qi Baishide bimen dizi"
許麟廬—齊白石的閉門弟子 [Xu Linlu—Qi
Baishi's protégé]. Parts 1, 2. *Nanbei ji*, Dec.
1976, 84–88; Jan. 1977, 94–99.

———. "Yigao renzheng—bei bojide binguan
huajia Zhao Wangyun" 藝高人正—被波及的
賓館畫家趙望雲 [Lofty art upright person—
on an artist involved with the Hotel School,
Zhao Wangyun]. Parts 1, 2. *Nanbei ji*, Jan.
1979, 57–59; Feb. 1979, 54–58.

——— (?). "Zhou Zongli yu 'binguan huapai'"
周總理與'賓館畫派' [Premier Zhou and the
"Hotel Painting School"]. *Mingbao yuekan*,
June 1976, 87–88.

Fu Baoshi 傅抱石. "Sixiang bianle, bimo jiu
buneng bubian—da yourende yifengxin" 思想
變了筆墨就不能不變—答友人的一封信
[When ideology changes, brushwork cannot
but change—reply to a friend's letter]. In
Renmin ribao wenyi pinglun xuanji 人民日報文
藝評論選集 [Collected selection of commen-
taries on literature and art from the *People's
Daily*]. Vol. 1, 362–369. Beijing: Renmin
ribao, 1962. First published in RMRB, 26 Feb.
1961. English version in PR, 17 March 1961,
14–17, under title "A New Ideology Needs a
New Brushwork."

*Fu Baoshi Guan Shanyue Dongbei xiesheng hua-
xuan* 傅抱石關山月東北寫生畫選 [Selec-
tion of paintings of the Northeast by Fu Baoshi
and Guan Shanyue]. Shenyang (?): Liaoning
meishu, 1964.

Ge Lu 葛路. "Pixian bihua xinshang duanpian"
邳縣壁畫欣賞短篇 [A brief appreciation of

murals from Pixian]. *Meishu*, 1958, no. 9:22–
24.

"Gedi meishu zhanlan dongtai" 各地美術展覽
動態 [Trends in art exhibitions throughout the
country]. *Meishu*, 1956, no. 12:58.

"Gedi meishu zhanlan xiaoxi" 各地美術展覽
消息 [News of art exhibitions throughout the
country]. *Meishu*, 1956, no. 11:14.

"Gedi meishujia xiafang canjia laodong duan-
lian" 各地美術家下放參加勞動鍛煉
[Throughout the country artists "go down" to
participate in tempering themselves through
manual labor]. *Meishu*, 1958, no. 2:46.

Guan Shanyue 關山月. "Dui Zhongguohua
chuangzuo guanche baihua qifang, tuichen
chuxinde fangzhende tihui" 對中國畫創作貫
徹百花齊放, 推陳出新的方針的體會 [Lessons
from implementing the policies of the hundred
flowers bloom and weed through the old to
bring forth the new in Chinese painting
works]. *Meishu*, 1960, no. 8/9:37–39.

He Zhen'gang 何振綱. "Beijing Rongbaozhai
kanhua yougan" 北京榮寶齋看畫有感 [Reac-
tions to paintings at Rongbaozhai in Beijing].
Meishu, 1964, no. 2:39.

He Zi 何子. "Liangfu 'heihua'" 兩幅'黑畫'
[Two "black paintings"]. *Mingbao yuekan*,
April 1979, 87–88.

Hou Yimin 侯逸民. "'Liu Shaoqi tongzhi he
Anyuan kuanggong' de gousi" '劉少奇同志和
安源礦工'的構思 [The conception of *Comrade
Liu Shaoqi and the Anyuan Miners*]. *Meishu*,
1961, no. 4:21–24.

Hu Peiheng 胡佩衡. "Dierjie quanguo guohua-
zhan pingxuan gongzuozhongde ganxiang"
第二屆全國國畫展評選工作中的感想 [Im-
pressions from work critiquing selections
for the Second National Chinese Painting
Exhibition]. *Meishu*, 1956, no. 7:9–10.

Hu Yichuan 胡一川. "Huiyi Luyi muke gong-
zuotuan zai dihou" 回憶魯藝木刻工作團在
敵後 [Reminiscences of the Lu (Xun) Art
(Academy) woodcut artists' team behind
enemy lines]. *Meishu*, 1961, no. 4:45–48.

"Huiyi Yan'an" 回憶延安 [Remembering
Yan'an]. *Meishu*, 1962, no. 3:21–24.

"Jiang Feng shi meishujiede zonghuo toumu"
江豐是美術界的縱火頭目 [Jiang Feng is
the chief arsonist of the art world]. *Meishu*,
1957, no. 8:11–13, 15.

"Jiangsusheng wenyijie jiefa pipan youpaifenzi
Liu Haisu" 江蘇省文藝界揭發批判右派分子
劉海粟 [The Jiangsu Province literary and art

world exposes and criticizes the rightist Liu Haisu]. *Meishu*, 1957, no. 11:40–41.

Jin Kejun 金克浚. "'Yunhe shang'" '運河上' [*On the Canal*]. *Meishu*, 1960, no. 8/9:53.

Li Keran 李可染. "Tan yishu shijianzhongde kugong" 談藝術實踐中的苦功 [The practice of art is hard work]. In *Renmin ribao wenyi pinglun xuanji* 人民日報文藝評論選集 [Collected selection of commentaries on literature and art from the *People's Daily*]. Vol. 1, 14–15. Beijing: Renmin ribao, 1962. First published in RMRB, 26 April 1962. English-language version in CL, 1961, no. 7:120–125 as "Art Is Achieved by Hard Work."

Li Lang 黎朗. "Nongmin kanhua ji" 農民看畫記 [Records of peasants' opinions of paintings]. *Meishu*, 1964, no. 6:3–7.

Li Qun 力群. "Tan banhuajia Gu Yuan" 談版畫家古元 [On the print artist Gu Yuan]. *Banhua yishu*, 1980, no. 1:3–5.

Li Rui 李銳. *Mao Zedong tongzhide chuqi geming huodong* 毛澤東同志的初期革命活動 [Comrade Mao Zedong's early revolutionary activities]. Beijing: Zhongguo qingnian, 1959.

"Lin Fengmian huazhan guanzhong yijian zhailu" 林風眠畫展觀衆意見摘錄 [Excerpts from the opinions of viewers at Lin Fengmian's painting exhibition]. *Meishu*, 1963, no. 4:37–38.

Lu Xun bianyin huaji jicun 魯迅編印畫集輯存 [Collection of pictures published by Lu Xun]. 4 vols. Shanghai: Renmin meishu, 1981.

Luo Gongliu 羅工柳. "Luyi muke gongzuotuan zai dihoufang" 魯藝木刻工作團在敵后方 [The Lu (Xun) Art (Academy) woodcut artists' team behind enemy lines]. *Banhua*, 1960, no. 3:31–40.

Manshū bojō 滿洲慕情 [Manchurian nostalgia]. 2 vols. Tokyo: Kenkōsha, 1971.

Manshū Teikoku taikan 滿洲帝國大觀 [A survey of the Manchurian Empire]. Tokyo: Seibundō Shinkōsha, 1937.

Mao Zhuxi jiniantang 毛主席紀念堂 [The Chairman Mao Memorial Hall]. Beijing: Zhongguo jianzhu gongye, 1978.

"Mao Zhuxi jiniantang guihua sheji 毛主席紀念堂規劃設計 Planning and Design of the Memorial Hall for Chairman Mao." *Jianzhu xuebao Architectural Journal*, 1977, no. 4.

Meishu 美術 [Art]. Beijing: 1954–1966; 1977–.

Meishu fenglei 美術風雷 [Art storm]. Beijing, 1967.

Meishu shenghuo 美術生活 Art and Life. Shanghai, 1934–1937.

Meishu ziliao 美術資料 [Art materials]. Shanghai, 1973–1975.

"Meishujia xuexi jiefangjun meishu" 美術家學習解放軍美術 [Artists emulate PLA art]. *Meishu*, 1964, no. 4:23–24.

"Meishujie dayuejin" 美術界大躍進 [The Great Leap Forward in the art world]. *Meishu*, 1958, no. 3:4–5.

Mi Gu 米谷. "Wo ai Lin Fengmiande hua" 我愛林風眠的畫 [I love Lin Fengmian's paintings]. *Meishu*, 1961, no. 5:50–52. English-language version in CL, 1963, no. 1:101–108, as "Lin Feng-mien's Paintings."

Mo Yidian 莫一點. "Shenzhen duhua ji" 深圳讀畫記 [Looking at paintings in Shenzhen]. *Mingbao yuekan*, Oct. 1977, 35–38.

Na Di 那狄. "Budui meishu gongzuo geminghuade daolu" 部隊美術工作革命化的道路 [The armed forces art workers' revolutionary road]. *Meishu*, 1964, no. 4:4–7.

Pan Jiezi 潘絜兹. "Rang huar kaide gengmei gengsheng" 讓花兒開得更美更盛 [Let the flowers bloom more beautifully, more abundantly]. *Meishu*, 1956, no. 8:14–18.

Qian Songyan 錢松嵒. "Zhongxin jing hui 'Zaoyuan shuguang'" 衷心敬繪'棗園曙光' [With wholehearted respect I painted *Dawn in the Date Garden*]. *Meishu*, 1977, no. 6:12.

"Shanghai meishujie xianqi shangshan xiaxiang rechao" 上海美術界掀起上山下鄉熱潮 [Shanghai art world starts up to the mountains, down to the villages campaign]. *Meishu*, 1957, no. 12:10.

Shanghai Yangquan Lüda gongrenhua zhanlan zuopin xuanji 上海陽泉旅大工人畫展覽作品選集 [Selection of works from the exhibition of paintings by workers in Shanghai, Yangquan, and Lüda]. Beijing: Renmin meishu, 1974.

Shao Dazhen 邵大箴. "Jiang Qing weishenme yao fandui Zhongguohua 'Jiangshan ruci duojiao'?" 江青爲甚麼要反對中國畫'江山如此多嬌' [Why did Jiang Qing oppose the Chinese painting *This Land with So Much Beauty Aglow*?]. *Meishu*, 1977, no. 1:14–15.

Shen Peng 沈鵬. "Lu huo zheng hong" 爐火正紅 [*The Furnace Flames Are Really Red*]. In *Xiandai meishu zuopin xinshang* 現代美術作品欣賞 [Appreciation of contemporary art works], vol. 4. Beijing: Renmin meishu, 1965.

Shi Chongming 石崇明. "Weishenme taozui?—dui 'Wo ai Lin Fengmiande hua' yiwende yijian" 爲甚麼陶醉?—對'我愛林風眠的畫'

一文的意見 [Why intoxicated?—An opinion on the essay " I love Lin Fengmian's paintings"]. *Meishu*, 1964, no. 4:41–44.

"Soshū hanga tokushū" 蘇州版畫特輯 [Special collection of Suzhou prints]. *Yamato Bunka*, no. 58 (Aug. 1973).

Su Guang 蘇光. "Zai shenghuode turangzhong shenggen faya" 在生活的土壤中生根發芽 [Sprouts take root in the soil of life]. *Meishu*, 1966, no. 1:44–45.

Sulian banhua ji 蘇聯版畫集 *Soviet Graphics*. Shanghai: Liang You, Fook Shing, 1940.

Tianjinshi yishu bowuguan 天津市藝術博物館. *Yangliuqing nianhua* 楊柳青年畫 [Yangliuqing New Year's pictures]. Tianjin: Wenwu, 1984.

Wang Bomin 王伯敏. *Zhongguo banhua shi* 中國版畫史 [History of Chinese prints]. Shanghai: Renmin meishu, 1961.

Wang Chunli 王春立. "Ping jifu biaoxian yingxiong xingxiangde youhua" 評幾幅表現英雄形象的油畫 [Critique of some oil paintings depicting heroic images]. *Meishu*, 1964, no. 1: 42–44.

Wang Jingxian 王靖憲. "Xikan Qian Songyande xin shanshui" 喜看錢松嵒的新山水 [Enjoying Qian Songyan's new landscapes]. *Meishu*, 1964, no. 3:18–21.

Wang Shucun 王樹村. "Guanyu Bailang guo Qinchuande yifu banhua" 關於白朗過秦川的一幅版畫 [On the print of Bailang going through Qinchuan]. *Wenwu*, 1964, no. 10: 31–32.

———. "Lu Xun yu nianhuade shouji he yanjiu" 魯迅與年畫的收集和研究 [Lu Xun and the collection and study of New Year's pictures]. *Meishu yanjiu*, 1982, no. 1:55–58.

Wang Yichang, ed. 王衣昌. *Zhonghua minguo sanshiliunian Zhongguo meishu nianjian* 中華民國三十六年中國美術年鑑 *China Art Yearbook 1946–47*. Shanghai: Shanghai Municipal Cultural Movement Committee, 1948.

"Wei zhengqu meishu chuangzuode gengda chengjiu er nuli" 爲爭取美術創作的更大成就而努力 [Make efforts to strive for greater achievements in art works]. *Meishu*, 1955, no. 5:9–11.

Wenhuabu Pipanzu 文化部批判組. "Yige jingxin cehuade fandang yinmou—jielu 'sirenbang' pi 'heihua' de zhenxiang" 一個精心策劃的反黨陰謀—揭露'四人幫'批'黑畫'的真相. In *Jiefa pipan "sirenbang" wenxuan* 揭發批判'四人幫'文選 [Selected essays exposing and criticizing "The Gang of Four"],

vol. 3, 146–152. Hong Kong: San Lian, 1977. First published in RMRB, 22 May 1977. Translation as Mass Criticism Group, Ministry of Culture, "A Meticulously Planned Plot Against the Party—Exposing the Reality of the Gang of Four's Criticism of Sinister Paintings," *Daily Report*, 31 May 1977, E4–E7.

Wu Liangyong 吳良鏞. "Renmin yingxiong jinianbeide chuangzuo chengjiu 人民英雄紀念碑的創作成就 The Monument to the People's Heroes." *Jianzhu xuebao Architectural Journal*, 1978, no. 2:4–9.

"Xiaxiang xiaoxi" 下鄉消息 [News from down in the villages]. *Meishu*, 1958, no. 3:35.

Xu Ling 徐靈. "Jin-Cha-Ji dihou muke yundong" 晉察冀敵后木刻運動 [The woodcut movement behind enemy lines in the Jin-Cha-Ji area]. In *Jiefangqu muke*, edited by Zou Ya and Li Pingfan, 12–17. Beijing: Renmin meishu, 1962.

———. "Kangzhan shiqi Jin-Cha-Ji dihou meishu huodong" 抗戰時期晉察冀敵后美術活動 [Art activities behind enemy lines in the Jin-Cha-Ji areas during the war against Japan]. *Meishu yanjiu*, 1959, no. 4:49–53.

———. "Zhandoude nianhua—huiyi Jin-Cha-Ji kang Ri genjudide nianhua chuangzuo huodong" 戰鬧的年畫—回憶晉察冀抗日根據地的年畫創作活動 [Combat New Year's pictures—remembering the New Year's pictures creative activities in the base areas in Jin-Cha-Ji during the war against Japan]. *Meishu*, 1957, no. 3:37–38.

Yan Han 彥涵. "Yi Taihangshan kang Ri genjudide nianhua he muke huodong" 憶太行山抗日根據地的年畫和木刻活動 [Recalling the New Year's picture and woodblock print activities in the anti-Japanese base areas in the Taihang Mountains]. *Meishu*, 1957, no. 3:33–35.

Yang Han 楊涵. "Banhua huodong zai xinsijun" 版畫活動在新四軍 [Print activities in the New Fourth Army]. In *Jiefangqu muke*, edited by Zou Ya and Li Pingfan, 18–25. Beijing: Renmin meishu, 1962. Another version published in *Banhua*, 1957, no. 8:16–18.

Ye Jian 葉監. "Yongxin xian'ede yichang naoju—chedi qingsuan 'sirenbang' zai Shaanxisheng dagao 'pi heihua' de zuixing" 用心險惡的一場鬧劇—徹底清算'四人幫'在陝西省大搞'批黑畫'的罪行 [An intentionally sinister farce—a thorough expose of "The Gang of Four's" crime in promoting the "criticism of black

paintings" in Shaanxi Province]. *Meishu*, 1978, no. 5:14–36.

Ye Wenxi 葉文西. "Lu Xun yu minjian muban nianhua" 魯迅與民間木版年畫 [Lu Xun and popular woodblock New Year's pictures]. *Banhua yishu*, 1980, no. 1:23–24.

Yi Bo 易波. "Rongbaozhaide muban shuiyin-hua" 榮寶齋的木版水印畫 [Rongbaozhai's woodblock water print pictures]. *Meishu*, 1955, no. 10:20.

Yu Feng 郁風. "Kan 'Shanhe xinmao' huazhan suiji" 看'山河新貌'畫展隨記 [Notes on the "Face of Our Land" painting exhibition]. *Meishu*, 1961, no. 4:63.

———. "Tan 'Gongshe fengguang' meizhande bufen zuopin" 談'公社風光'美展的部份作品 [On some works in the "Commune Scenes" exhibition]. *Meishu*, 1964, no. 2:20–23.

Zhang Tiexian 張鐵弦. "Lüetan wan Qing shiqide shiyin huabao" 略談晚清時期的石印畫報 [A sketch of late Qing period litho-graphed pictorials]. *Wenwu*, 1959, no. 3:1–3.

Zhang Wang 張望. "Yan'an meishu huodong huigu" 延安美術活動回顧 [Remembering art activities in Yan'an]. *Meishu yanjiu*, 1959, no. 4:54–58.

Zhang Wenjun 張文俊. "'Jiangshan ruci duo-jiao'" '江山如此多嬌' [*This Land with So Much Beauty Aglow*]. *Meishu*, 1960, no. 8/9:51.

Zhao Haosheng 趙浩生. "Li Keran, Wu Zuoren tan Qi Baishi" 李可染吳作人談齊白石 [Li Keran and Wu Zuoren talk about Qi Baishi]. *Qishi niandai*, 1973, no. 12:60–66.

Zheng Hongcang 鄭弘藏. "Tigao renshi yu tigao chuangzuo" 提高認識與提高創作 [Improve understanding and improve creative works]. *Meishu*, 1963, no. 5:8–13.

Zhong Ling 鍾靈. "Baihuayuanli xi xin ya—Guangzhou meishuxueyuan xuesheng xia-xiang chuangzuo zhanlan guan'gan" 百花園裏喜新芽—廣州美術學院學生下鄉創作展覽觀感 [Welcome new sprouts in the Hundred Flowers garden—Impressions of the exhibition of works by students from the Guangzhou Art Academy who went to the villages]. *Meishu*, 1963, no. 5:22–24.

Zhongguo chuantong banhua yishu tezhan 中國傳統版畫藝術特展 *Special Exhibition Collector's Show of Traditional Chinese Woodblock Prints*. Taibei: Council for Cultural Planning and Development, Executive Yuan, 1983.

Zhongguo meishu quanji 中國美術全集 [Collec-tion of Chinese arts] *Huihua bian* 繪畫編 [Section on painting]. Vol. 21, *Minjian nian-hua* 民間年畫 [Popular New Year's pictures]. Beijing: Renmin meishu, 1985.

"Zhongguo renminjiefangjun jianjun sanshizhou-nian jinian meishu zhanlanhui jiang zai 'bayi' juxing" 中國人民解放軍建軍三十週年紀念美術展覽會將在'八一'舉行 [The art exhibi-tion commemorating the thirtieth anniversary of the founding of the Chinese People's Libera-tion Army to open on August 1]. *Meishu*, 1957, no. 1:51.

Zhongguo xinxing banhua wushinian xuanji 中國新興版畫五十年選集 [Collection of fifty years of new prints in China]. 2 vols. Shanghai: Renmin meishu, 1981.

Zhongguohua renwu jifa ziliao 中國畫人物技法資料 [Materials for Chinese painting figure de-piction techniques]. Shanghai: Shuhuashe, 1977.

"Zhongguohuatan chunyi nong Han Suyin nüshi tan Zhongguo meishujie jinkuang" 中國畫壇春意濃韓素音女士談中國美術界近況 [The new beginnings in the field of Chinese paint-ing, Han Suyin talks about recent develop-ments in the world of Chinese art]. *Qishi niandai*, 1977, no. 4:19–26.

Zhou Wei 周偉. "Yumeng qingsong ting, Haiyan chuan yunfei: ping youhua 'Wo shi "haiyan"'" 雨猛青松挺, 海燕穿雲飛：評油畫'我是"海燕"' [The green pine stands firm in the fierce rain, the seagull flies through the clouds: a critique of the oil painting *I Am Seagull*]. *Meishu ziliao*, 1973, no. 1:4.

Zou Ya 鄒雅. "Jin-Ji-Lu-Yu jiefangqude muke huodong" 晉冀魯豫解放區的木刻活動 [Woodcut activities in the Jin-Ji-Lu-Yu liber-ated areas]. In *Jiefangqu muke*. Edited by Zou Ya and Li Pingfan, 6–11. Beijing: Renmin meishu, 1962.

Zou Ya and Li Pingfan 李平凡, eds. *Jiefangqu muke* 解放區木刻 [Woodcuts in the liberated areas]. Beijing: Renmin meishu, 1962.

Western-language Sources

"Academy of Arts and Crafts Inaugurated." NCNA Peking, 1 Nov. 1956, SCMP, no. 1405:12.

Ahn Byung-joon. *Chinese Politics and the Cultural Revolution: Dynamics of Policy Processes*. Seattle and London: University of Washington Press, 1976.

"An Album of Wu Tso-jen's Paintings." CL, 1963, no. 2:121–122.

180

"Albums of Contemporary Artists." PR, 11 Oct. 1963, 22–23.

"Another Example of Revolutionizing Literary and Art Work—A Short Commentary, *Jen-min Jih-pao.*" JMJP, 2 Aug. 1964, SCMP, no. 3285:16–17.

"Art Exhibition Hailed as Victory for Chairman Mao's Revolutionary Line." NCNA Peking, 30 Nov. 1967, SCMP, no. 4072:21–23.

"Art from the Army." PR, 1 Mar. 1960, 21–22.

"Art Institute Director Denounced." NCNA Peking, 28 July 1957, SCMP, no. 1598:49–51.

"Art: Szechuan Woodcuts." PR, 18 June 1965, 31.

"Art that Serves Proletarian Politics." CR, 1968, no. 2:18–25.

"Artists of Armed Forces Set Examples of Revolutionization for Literary and Art Circles." JMJP, 2 Aug. 1964, SCMP, no. 3285:13–15.

"Artists, Writers Go to Rural Areas." PR, 10 Jan. 1964, 26–27.

Bai Liu. *Cultural Policy in the People's Republic of China: Letting a Hundred Flowers Bloom.* Paris: UNESCO, 1983.

"Before and After the Publication of 'Ten Points on Literature and Art.'" *Issues and Studies* 9, no. 1 (Oct. 1972): 70–81.

Bickford, Maggie. *Bones of Jade, Soul of Ice: The Flowering Plum in Chinese Art.* New Haven: Yale University Art Gallery, 1985.

"Biggest Peking Traditional Chinese Paintings Exhibition Opens." NCNA Peking, 22 June 1959, SCMP, no. 2044:3–4.

"Chairman Mao Memorial Hall Building Completed." CR, 1977, no. 9:2–5.

"Chairman Mao Memorial Hall Completed in Peking." NCNA Peking, 1 Sept. 1977, SCMP, no. 77-37:75–77.

Chang An-chih. "The Painter Chien Sung-yen." CL, 1964, no. 9:103–111.

Chang, Arnold. *Painting in the People's Republic of China: The Politics of Style.* Boulder, Colo.: Westview Press, 1980.

Chang Chih-ching. "A Hundred Schools Contend." CR, 1957, no. 1:7–9.

Chang Keng. "The Scenic Beauties of Kweilin—and Some Thoughts on the Beauty of Nature." JMJP, 2 June 1959, SCMP, no. 2037:1–9.

Chang Lu. "Art Grown in Virgin Soil." CR, 1962, no. 5:21.

Chang Tien-fang. "Amateur Artists of a Coastal City." CL, 1974, no. 6:81–85.

Chang Wen-tsun. "Fu Pao-shih's Paintings." CL, 1962, no. 7:96–101.

Chao Chih-tien. "I Painted the Heroic Taching Oil Workers." CL, 1974, no. 9:104–107.

Chao Hui. "An Art Programme Serving the Restoration of Capitalism." CL, 1967, no. 4:123–127.

Cheh Ping. "A New Style of Bamboo Painting." CL, 1973, no. 4:96–97.

Chen, Jack. "Picasso in Peking." PC, 1 Jan. 1957, 41.

Ch'en, Jerome. *Mao and the Chinese Revolution.* New York: Oxford University Press, 1967.

Chen, Theodore H. E. *Thought Reform of the Chinese Intellectuals.* Hong Kong: Hong Kong University Press, 1960.

Cheng Ming. "Art Tours." PR, 15 Dec. 1961, 28–29.

Chesneaux, Jean. *The Chinese Labor Movement 1919–1927.* Translated from the French by H. M. Wright. Stanford: Stanford University Press, 1968.

Chi Cheng. "New Developments in Traditional Chinese Painting." CL, 1974, no. 3:113–117.

———. "Two Oil Paintings." CL, 1975, no. 4: 112–113.

Chi Shu. "The Sculptures at the Chairman Mao Memorial Hall." CL, 1978, no. 2:114–116.

"Chiang Feng's Anti-Party Group Unmasked." NCNA Peking, 14 Aug. 1957, SCMP, no. 1607:13–15.

Chiang Tien. "The Struggle Between the Confucians and Legalists in the History of Chinese Literature and Art." CL, 1975, no. 7:94–102.

Ch'ien Sung-yen. "Creating New Paintings in the Traditional Style." CL, 1972, no. 11:111–114.

Chih Ko. "Kuan Shan-yueh's Paintings." CL, 1964, no. 2:108–114.

Ch'in Li. "Firmly Uphold Unity Between Politics and Art." JMJP, 17 May 1973, SCMP, no. 5384:54–56.

Ch'in Yen. "Strive to Develop Amateur Literary and Art Creations by Workers, Peasants, and Soldiers." *Hung-ch'i,* no. 5, 1 May 1972, SCMM, no. 730:74–80.

"China Training Young People in Fine Arts." NCNA Peking, 26 Sept. 1961, SCMP, no. 2590:16.

Chinese Creative Painting Group of Kwangtung. "Create the New Boldly During Repeated

Bibliography

Practice." JMJP, 22 Aug. 1972, SCMP, no. 5208:4–8. English language version in CL, 1972, no. 11:106–114, under title "Innovations in Traditional Painting."

"Chinese Painter Makes Traditional Art Serve Socialism." NCNA Nanking, 23 May 1973, SCMP, no. 5387:22–24.

"Chinese Paintings from Hongkong." NCNA Peking, 20 Dec. 1956, SCMP, no. 1439:39.

"Chinese Writers, Artists Live Among People." NCNA Peking, 14 Feb. 1966, SCMP, no. 3641:21–23.

Ch'iu, A. K'ai-ming. "The Chieh Tzu Yüan Hua Chuan (Mustard Seed Garden Painting Manual): Early Editions in American Collections." *Archives of the Chinese Art Society of America* 5 (1951): 55–69.

Chou Yang [Chow Yang]. "For More and Better Works of Literature and Art." PC, 1 Nov. 1953, 3–10.

Chou Yang. "The Important Role of Art and Literature in the Building of Socialism." CL, 1957, no. 1:179–188.

———. "Mao Tse-tung's Teachings and Contemporary Art." PC, 16 Sept. 1951, 5–8.

———. "The Path of Socialist Literature and Art in Our Country: Report Delivered to the Third Congress of Chinese Literary and Art Workers on July 22, 1960." CL, 1960, no. 10:12–64.

Chow Tse-tsung. *The May Fourth Movement: Intellectual Revolution in Modern China.* Cambridge: Harvard University Press, 1960; Stanford: Stanford University Press, 1967.

Chuang, H. C. *The Great Proletarian Cultural Revolution: A Terminological Study.* Studies in Chinese Communist Terminology, no. 12. Berkeley: University of California Center for Chinese Studies and Institute of International Studies, 1967.

Chun Wen. "Paintings by Workers, Peasants and Soldiers." PR, 3 Jan. 1975, 21–23.

"Circular of Central Committee of Chinese Communist Party (May 16, 1966)." PR, 19 May 1967, 6–9.

Cohen, Paul A. *China and Christianity: The Missionary Movement and the Growth of Chinese Antiforeignism 1860–1870.* Cambridge: Harvard University Press, 1963.

Communist China 1955–1959: Policy Documents with Analysis. Foreword by Robert R. Bowie and John K. Fairbank. Cambridge: Harvard University Press, 1962.

Concklin, Edward F. *The Lincoln Memorial, Washington.* Prepared under the direction of the Director of Public Buildings and Public Parks of the National Capital. Washington, D.C.: United States Government Printing Office, 1927.

Constantine, E. "Mao's Mausoleum Echoes JFK Center." *Progressive Architecture* 60 (May 1979): 30–32.

"Cornerstone Ceremony Held for Mao's Memorial." NCNA Peking, 24 Nov. 1976, *Daily Report,* 26 Nov. 1976, E1–2.

"Creating Figures of Contemporary Heroes." CP, 1964, no. 10, n.p.

Creative Group of Academy of Chinese Painting of Shanghai. "Some Experiences in Creating the New in Chinese Painting." JMJP, 22 Aug. 1972, SCMP, no. 5208:9–12.

Croizier, Ralph. "Chinese Art in the Chiang Ch'ing Era." *Journal of Asian Studies* 38 (Feb. 1979): 303–311.

"Crop From the Countryside." PR, 3 Jan. 1964, 44.

Cultural Work Troupe, Shangjao District, Kiangsi Province. "Write About Heroes, Emulate the Heroes." JMJP, 5 Mar. 1972, SCMP, no. 5095:165–168.

"Culture and Art Must Serve the Countryside Still Better." JMJP editorial, 25 Mar. 1963. PR, 19 April 1963, 21–23. Also in SCMP, no. 2958:2–6.

Das, Naranarayan. *China's Hundred Weeds: A Study of the Anti-Rightist Campaign in China [1957–1958].* Calcutta: K P Bagchi and Company, 1979.

De Bary, Wm. Theodore, ed. *Sources of Chinese Tradition.* New York: Columbia University Press, 1960.

"Decision of the Central Committee of the Communist Party of China Concerning the Great Proletarian Cultural Revolution (Adopted on August 8, 1966)." PR, 12 Aug. 1966, 6–11.

Dennys, Nicholas B. *The Folklore of China and Its Affinities with That of the Aryan and Semitic Races.* London and Hong Kong, 1876; Amsterdam: Oriental Press reprint, 1968.

Dittmer, Lowell. *Liu Shao-ch'i and the Chinese Cultural Revolution: The Politics of Mass Criticism.* Berkeley and Los Angeles: University of California Press, 1974.

Doolittle, Justus. *Social Life of the Chinese.* New York: Harper, 1865.

182

Eastman, Lloyd E. *The Abortive Revolution: China under Nationalist Rule, 1927–1937*. Cambridge: Harvard University Press, 1974.

Eberhard, Wolfram. *The Local Cultures of South and East China*. Translated by Alide Eberhard. Leiden: E. J. Brill, 1968.

Ecke, Tseng Yu-ho. *Chinese Folk Art in American Collections, Early 15th Through Early 20th Centuries*. New York: China Institute in America, 1976.

Engle, Hua-ling Nieh, and Paul Engle. *Poems of Mao Tse-tung*. New York: Dell, 1972.

"Excerpts from Speech by Comrade Chiang Ch'ing on May 19 in an interview with Chang Yung-sheng, Vice Chairman of Chekiang Provincial Revolutionary Committee." Canton *Huo-chü t'ung-hsün* [*Torch Bulletin*], no. 1, July 1968, SCMM, no. 622:6–10.

"Exercising a Powerful Proletarian Dictatorship in the Realm of Culture—Workers, Peasants and Soldiers Commemorate First Anniversary of the Publication of the 'Summary of the Forum on the Work in Literature and Art in the Armed Forces with which Comrade Lin Piao Entrusted Comrade Chiang Ch'ing.'" PR, 21 June 1968, 5–7.

"Exhibition of British Graphic Art." CL, 1956, no. 3:206–207.

"Exhibition of Chinese Painting in Peking." NCNA Peking, 16 Sept. 1953, SCMP, no. 653:22.

"Exhibition of Commune Scenes." CL, 1964, no. 5:123.

"Exhibition of Mexican Graphic Art." CL, 1956, no. 3:209–210.

"Exhibition of the Newly Reproduced Clay Sculptures 'Compound Where Rent Was Collected.'" CL, 1967, no. 4:138–139.

"Exhibition of Traditional Painting." CL, 1957, no. 1:191–192.

"Exhibition of Traditional Paintings Held in Peking." CL, 1978, no. 2:117.

Fan Tseng. "Traditional Chinese Painting." PR, 21 July 1972, 18–19.

Fang Chi. "A Myriad Hills Tinged with Red—Introducing Li Ko-jan's Ink and Water-colour Landscapes." CL, 1963, no. 11:78–88.

"The Film 'Red Detachment of Women.'" CL, 1971, no. 9:99–111.

"Fine Arts of the Chairman Mao Memorial Hall." CP, 1977, no. 12:22–23.

Fokkema, D. W. *Literary Doctrine in China and Soviet Influence 1956–1960*. London, The Hague, and Paris: Mouton & Co., 1965.

———. *Report from Peking: Observations of a Western Diplomat on the Cultural Revolution*. London: C. Hurst, 1971.

"Following Chairman Mao Means Victory." CR, 1969, no. 8:5–8.

"Foreign Art Exhibitions in Peking." CL, 1957, no. 1:195–198.

"Forum on the Clay Sculptures 'Family Histories of Airmen.'" CL, 1968, no. 3:106–123.

"Forum on Traditional Chinese Painting." PC, 1 Sept. 1956, 38–39.

Fu Pao-shih. "The New Face of Our Land." CL, 1961, no. 8:121–124.

———. "A New Ideology Needs a New Brushwork." PR, 17 Mar. 1961, 14–17. Translation of Fu Baoshi, "Sixiang bianle, bimo jiu buneng bubian—da yourende yifengxin." In *Renmin ribao wenyi pinglun xuanji*, vol. 1, 362–369. Beijing: Renmin ribao, 1962. First published in RMRB, 26 Feb. 1961.

Fu Wen. "Revolutionary Literature and Art Must Consciously Serve the Correct Line of the Party." KMJP, 5 June 1972, SCMP, no. 5157:45–52.

"Full Text of Speech by Kuo Mo-jo, Chairman of the China Federation of Literary and Art Circles, at the 3rd National Congress of Writers and Artists." NCNA Peking, 22 June 1960, SCMP, no. 2311:1–6.

Goldman, Merle. *China's Intellectuals: Advise and Dissent*. Cambridge: Harvard University Press, 1981.

———. *Literary Dissent in Communist China*. Cambridge: Harvard University Press, 1967.

Goodman, David S. G. *Beijing Street Voices: The Poetry and Politics of China's Democracy Movement*. London and Boston: Marion Boyars, 1981.

"Graduates from Academy of Fine Arts in East China." NCNA Hangchow, 26 Aug. 1962, SCMP, no. 2811:1–10.

"Grasp the *Talks* as Our Powerful Weapon in Portraying the Heroic Images of the Proletariat." In Chiang Ch'ing, *On the Revolution of Peking Opera*, 20–23. Peking: Foreign Languages Press, 1968.

"Great and Noble Image." CL, 1968, no. 9:41–47.

Groot, Jan J. M. de. *The Religious System of China*. 6 vols. Leiden: E. J. Brill, 1892–1910.

Bibliography

"Hail Victory of Mao Tse-tung Line on Literature and Art." NCNA Peking, 27 May 1967, SCMP, no. 3950:11–15.

Han Suyin. "Painters in China Today." *Eastern Horizons*, 1977, no. 6:15–20.

Hatred from Water Dungeon. Story by Chen Tse-yuan and Liu Chih-kuei, illustrated by Hsu Heng-yu. Peking: Foreign Languages Press, 1977.

"A History of Blood and Tears—On the Art Works of the Three Stones Museum in Tientsin." CL, 1969, no. 11/12:121–140.

Ho Chi-fang. "Guide for China's Revolutionary Literature and Art." CR, 1962, no. 5:2–5.

Ho Yung. "Art and Artists in 1958." PR, 6 Jan. 1959, 25–26.

"Hold High the Great Red Banner of the Thought of Mao Tse-tung and Take an Active Part in the Great Socialist Cultural Revolution." *Chieh-fang-chün Pao* editorial, 18 April 1966; JMJP, 19 April 1966, SCMP, no. 3687:4–15.

Hsia, Adrian. *The Chinese Cultural Revolution*. Translated by Gerald Onn. New York: Seabury Press, Continuum Books, 1972.

Hsiang Ta. "European Influences on Chinese Art in the Late Ming and Early Ch'ing Periods." Translated by Wang Te-chou. *Renditions*, no. 6 (Spring 1976): 152–178.

Hsiao Luan. "Paintings of the Era and Art of Combat—After Seeing the 'National Fine Arts Exhibition.'" JMJP, 26 Nov. 1974, SCMP, no. 5759:6–13.

Hsin Ping. "Tsai Jo-hung Is the Ring-leader of the Anti-Party Gang in the Field of Art." CL, 1967, no. 4:128–132.

Hsiung, Y. T. *Red China's Cultural Revolution*. New York: Vantage Press, 1968.

Hu Chin. "Paintings by Shanghai Workers." CL, 1974, no. 12:91–95.

Hua Hsia. "The Paintings of Shih Lu." CL, 1962, no. 1:91–97.

Huang, Joe C. *Heroes and Villains in Communist China: The Contemporary Chinese Novel as a Reflection of Life*. New York: Pica Press, 1973.

Hung Wen and Hsueh Ch'ing. "Always Advance Courageously Along Chairman Mao's Revolutionary Line for Literature and Art—Some Considerations in the Study of 'Summary of Forum on Literary and Art Work in the Armed Forces Convened by Comrade Chiang Ch'ing at the Request of Comrade Lin Piao.'"
JMJP, 17 Mar. 1969, SCMP, no. 4384:4–10; slightly different translation in PR, 16 May 1969, 9–12.

Hung Yu. "Hua Chun-wu Is an Old Hand at Drawing Black Anti-Party Cartoons." CL, 1967, no. 4:133–136.

"'The January Revolution'—an Exhibition of Paintings by Workers, Peasants and Soldiers of Shanghai." CL, 1967, no. 10:136–137.

Jaquillard, Pierre. "Gravures chinoises du XVIIIe siècle." *Étude Asiatiques* 23, no. 2/3 (1969): 89–117.

Jen Tu. "Is There Anything 'New' About 'New' Traditional Chinese Painting?: Comment on *Traditional Chinese Painting*, a Collection Compiled by Shanghai Municipal Arts and Crafts Branch Company." *Hsüeh-hsi yü p'i-pan* [Study and Criticism], no. 3, 1974, SCMM supplement, no. 62 (May 31, 1974): 10–14.

"*Jen-min Jih-pao* Article on National and PLA Fine Arts Exhibitions." NCNA Peking, 24 July 1972, SCMP, no. 5188:160–164.

"*Jen-min Jih-pao* Carries Photos and Report on Art Works in Chairman Mao Memorial Hall." NCNA Peking, 16 Sept. 1977, SCMP, no. 77-39:87–88.

Kai Hsieh. "Pan Tien-shou's Art." PR, 30 Nov. 1962, 37–39.

Kao Mayching Margaret. "China's Response to the West in Art: 1898–1937." Ph.D. diss., Stanford University, 1972.

Karnow, Stanley. *Mao and China: From Revolution to Revolution*. New York: Viking Press, Viking Compass paperback, 1972.

Kau, Michael Y. M., ed. *The Lin Piao Affair: Power Politics and Military Coup*. White Plains, N.Y.: International Arts and Sciences Press, 1975.

"Kiangsu Academy of Traditional Chinese Painting." PR, 17 Mar. 1961, 18–19.

Ko Lu. "New Peasant Paintings." PR, 23 Sept. 1958, 18–19.

Ko Tien. "New Paintings by Soldiers." CL, 1976, no. 8:95–99.

Kuan Shan-yueh. "An Old Hand Finds a New Path." CL, 1974, no. 3:118–121.

Kuo Mo-jo. "Romanticism and Realism." PR, 15 July 1958, 7–11. First published in *Hongqi* (*Red Flag*), 1 July 1958.

Laing, Ellen Johnston. "Chinese Peasant Painting, 1958–1976: Amateur and Professional." *Art International* 27, no. 1 (Jan.–Mar. 1984): 1–12ff.

184

———. "Contemporary Painting." In *Traditional and Contemporary Painting in China: A Report of the Visit of the Chinese Painting Delegation to the People's Republic of China*, 54–67. Committee for Scholarly Communication with the People's Republic of China. Washington, D.C.: National Academy of Sciences, 1980.

"'Landscape Painting.'" PR, July 1962, 18.

Lau Yee-fui, Ho Wan-yee, and Yeung Sai-cheung. *Glossary of Chinese Political Phrases.* Hong Kong: Union Research Institute, 1977.

Lee Hong Yung. *The Politics of the Chinese Cultural Revolution: A Case Study.* Berkeley and Los Angeles: University of California Press, 1978.

Lee, Leo Ou-fan, ed. *Lu Xun and His Legacy.* Berkeley and Los Angeles: University of California Press, 1985.

"Letter to Li Hua." CL, 1978, no. 8:105–106.

Li Chi-yen. "Second National Art Exhibition." PR, 1 Sept. 1955, 14–17.

Li Chu-tsing. *Trends in Modern Chinese Painting (The C. A. Drenowatz Collection).* Artibus Asiae Supplementum 36. Ascona, Switzerland: 1979.

Li Chun. "New Chinese Woodcuts." PC, 16 May 1955, 25–27.

Li Hua. "Modern Woodcuts in China 1931–1949." CP, 1962, no. 3:34–36.

Li Ko-jan. "Art Is Achieved by Hard Work." CL, 1961, no. 7:120–125. (First published as Li Keran, "Tan yishu shijianzhongde kugong," RMRB, 26 April 1961. Reprinted in *Renmin ribao wenyi pinglun xuanji*, vol. 1, 14–15. Beijing: Renmin ribao, 1962.)

———. "The Third P.L.A. Art Exhibition: Something New in Traditional Painting." CL, 1964, no. 10:80–85.

Li Pai-chun. "How I Painted 'Wheat-harvesting Time.'" CR, 1966, no. 1:24–25, after her article in RMRB. (Also published as "Birth of a New Year Picture," PR, 19 Oct. 1965, 30–31.)

Liang Szu-cheng. "The Great Hall of the People in Peking." CL, 1960, no. 3:119–127.

———. "Tien An Men Square." CL, 1960, no. 2:112–119.

Lifton, Robert Jay. *Revolutionary Immortality: Mao Tse-tung and the Chinese Cultural Revolution.* New York: Vintage Books, 1968.

Lin Yutang. *The Chinese Theory of Art: Translations from the Masters of Chinese Art.* New York: G. P. Putnam's Sons, 1967.

Link, Perry, ed. *Roses and Thorns: The Second Blooming of the Hundred Flowers in Chinese Fiction 1979–1980.* Berkeley and Los Angeles: University of California Press, 1984.

"Literary and Art Workers Go to the Countryside and to Factories for Participation in the Three Great Revolutionary Movements, Reforming and Revolutionizing Themselves in the Smelting Furnace of Struggle—Acting on Chairman Mao's Instructions and Wholeheartedly Uniting Themselves with the Workers, Peasants and Soldiers." JMJP, 22 Feb. 1966, SCMP, no. 3649:4–6.

"Literary and Art Workers, Go to the Countryside to Temper Yourselves!" JMJP editorial, 22 Feb. 1966, SCMP, no. 3649:1–4.

"Literature and Art Workers Hold Rally for Great Proletarian Cultural Revolution." PR, 9 Dec. 1966, 5–12.

Liu Chun-hua. "A Glorious Task." CL, 1972, no. 7:112–118.

———. "Painting Pictures of Chairman Mao Is our Greatest Happiness." CR, 1968, no. 11: 2–6.

———. "Singing the Praises of Our Great Leader Is Our Greatest Happiness." CL, 1968, no. 9:32–40.

Liu Kai-chu. "Monument to the People's Heroes." PR, 29 April 1958, 15–17.

Liu Yi-fang. "Artists Go to the People." CR, 1958, no. 11:16–17.

———. "Chinese Woodcuts—Old and New." CR, 1955, no. 3:14–15.

"'Long Live Mao Tse-tung's Thought!' Pictorial Exhibition." CL, 1967, no. 12:120.

"The Long March Scroll." PC, 1 Aug. 1957, 42–43.

"Looking at Flowers." PR, 17 June 1958, 5.

"Luta's Worker-Artists." CR, 1973, no. 8:29–31.

Ma Ke. "Paintings of the Times." CR, 1975, no. 1:23–27.

Ma Keh. "New Images in Chinese Woodcuts." CL, 1964, no. 10:85–89.

McDonald, Angus W., Jr. *The Urban Origins of Rural Revolution: Elites and the Masses in Hunan Province, China, 1911–1927.* Berkeley and Los Angeles: University of California Press, 1978.

McDougall, Bonnie S. *Mao Zedong's "Talks at the Yan'an Conference on Literature and Art": A Translation of the 1943 Text with Commentary.*

Michigan Papers in Chinese Studies, no. 39. Ann Arbor: University of Michigan Center for Chinese Studies, 1980.

MacFarquhar, Roderick. *The Hundred Flowers Campaign and the Chinese Intellectuals.* New York: Frederick A. Praeger, 1960.

————. *The Origins of the Cultural Revolution.* Vol. 1: *Contradictions Among the People 1956–1957.* New York: Columbia University Press, 1974.

McKnight, Brian E. *The Quality of Mercy: Amnesties and Traditional Chinese Justice.* Honolulu: University Press of Hawaii, 1981.

Mao Tse-tung, *On Literature and Art.* Peking: Foreign Languages Press, 1967.

Martin, Helmut. *Cult and Canon: The Origins and Development of State Maoism.* Armonk, N.Y.: M. E. Sharpe, 1982.

Mass Criticism Group, Ministry of Culture. "A Meticulously Planned Plot Against the Party—Exposing the Reality of the Gang of Four's Criticism of Sinister Paintings." *Daily Report,* 31 May 1977, E4–E7. First published in RMRB, 22 May 1977. Reprinted in *Jiefa pipan 'sirenbang' wenxuan,* vol. 3, 146–152. Hong Kong: San Lian, 1977.

Mei Tang. "Graphic Art Exhibition." PR, 8 Dec. 1959, 16–17.

Meisner, Maurice. *Mao's China: A History of the People's Republic.* New York: Free Press, 1977.

Members of the Chekiang Art College. "Our Artistic Heritage and Our New Art." CL, 1972, no. 8:11–19.

Mi Ku. "Lin Feng-mien's Paintings." CL, 1963, no. 1:101–108. English-language version of Mi Gu, "Wo ai Lin Fengmiande hua," *Meishu,* 1961, no. 5:50–52.

"Minutes of Forum on Literature and Art in the Armed Forces Convened by Comrade Chiang Ch'ing on Comrade Lin Piao's Request—Document of the CCP Central Committee (April 10, 1966)." SCMP, no. 3956:1–15.

"The Monument to Mao Tsetung." CR, 1977, no. 12:2–9.

Mowry, Hua-yuan Li. *Yang-pan Hsi—New Theater in China.* Studies in Chinese Communist Terminology, no. 15. Berkeley: University of California Center for Chinese Studies, 1973.

Murase, Miyeko. "Kuan-yin as Savior of Men: Illustrations of the Twenty-fifth Chapter of the Lotus Sutra in Chinese Painting." *Artibus Asiae* 33 (1971):39–74.

Na Ti. "Soldier Artists." CR, 1965, no. 11: 11–13.

Nanking Kiangsu Province Service in Mandarin, 7 Sept. 1977. *Daily Report,* 23 Sept. 1977, E-23.

"National Conference of China's Writers and Artists." NCNA Peking, 21 May 1963, SCMP, no. 2986:2–5; also in CL, 1963, no. 8:3–10, as "A Conference of Writers and Artists—On the Militant Task of China's Literature and Art Today."

"National Exhibition of Serial Pictures and Traditional Chinese Paintings Opens in Peking." NCNA Peking, 2 Oct. 1973, SCMP, no. 5475: 105–108.

"National Fine Art Exhibition Opens in Peking." NCNA Peking, 23 May 1972, SCMP, no. 5147:8–9.

"National Fine Arts and Photo Exhibitions Close in Peking." NCNA Peking, 2 Dec. 1974, SCMP, no. 5753:229–230.

"A New Atmosphere in the Garden of Fine Arts—A Visit to the 'National Exhibition of Serial Pictures and Chinese Paintings' and the 'Exhibition of Peasants' Paintings from Hu-hsien.'" JMJP, 15 Oct. 1973, SCMP, no. 5487: 180–186.

"New Szechuan Clay Sculptures: 'Compound Where Rent Was Collected.'" PR, 3 Dec. 1965, 26–27.

"The New Tien An Men Square." PR, 1 Oct. 1959, 22–24.

"New Vitality in Traditional Chinese Paintings." NCNA Peking, 24 May 1962, SCMP, no. 2750:21–23.

"New Water-Colour Paintings." PR, 21 July 1961, 21.

"New Works by Veteran Chinese Painter." NCNA Peking, 10 Dec. 1973, SCMP, no. 5519:102–103.

"New Year Holiday Attractions." PR, 1 Jan. 1966, 31.

"'New Year Pictures' An Old Custom Serves the New China." CR, 1953, no. 2:26–27.

Ni Yi-teh. "Pan Tien-shou's Paintings." CL, 1961, no. 10:100–106.

"Note on Conference of Chinese Writers and Artists." SCMP, no. 2992:20.

"Oil Painting Serves Socialism in China." NCNA Peking, 26 Dec. 1974, SCMP, no. 5729: 152–154.

"On the Question of Beauty." CL, 1961, no. 8: 112–120.

Ouyang Tsai-wen. "Intellectuals and Land Reform." PC, 31 Aug. 1950, 22–23.

Paine, Robert Treat, Jr. "The Ten Bamboo Studio: Its Early Editions, Pictures and Artists." *Archives of the Chinese Art Society of America* 5 (1951): 39–54.

Pan Chieh-tzu. "Traditional Painting Reflects Today's Life." CR, 1960, no. 9:22–24.

Parker, Fan, and Stephen Jan Parker. *Russia on Canvas: Ilya Repin.* University Park and London: Pennsylvania State University Press, 1980.

Pearson, Michael. *The Sealed Train.* New York: G. P. Putnam's Sons, 1975.

"Peasant Art Exhibition in Fukien." CL, 1974, no. 9:114–115.

"Peasant Painters in Northwest China *Hsien.*" NCNA Sian, 13 July 1972, SCMP, no. 5181: 56–57.

Peasant Paintings from Huhsien County. Peking: Foreign Languages Press, 1974.

"Peking Art Exhibition Shows Victory of Chairman Mao's Revolutionary Line." CL, 1968, no. 1:118–120.

"Peking Ceremony for Laying Cornerstone of Memorial Hall for Chairman Mao Tsetung." PR, 3 Dec. 1976, 4–6.

"Peking Churches Shut and Defaced." *New York Times,* 24 Aug. 1966, 1.

"Peking Fine Art and Photographic Exhibitions." CL, 1974, no. 10:120–121.

"Peking Studio of Traditional Painting Opens." NCNA Peking, 14 May 1957, SCMP, no. 1533:2.

Petrucci, R. *Encyclopédie de la peinture chinoise.* Paris: H. Laurence, 1918.

Pien Cheh. "A General Review of New Art Works." CL, 1972, no. 8:20–24.

Poems of Mao Tse-tung. Translated and annotated by Wong Man. Hong Kong: Eastern Horizon Press, 1966.

"Promote Revolutionization of Cultural Forces by Studying Chairman Mao's Works." KMJP editorial, 27 Feb. 1966, SCMP, no. 3654:8–11.

"Red Artist-Soldiers and the Revolution in Fine Arts Education." CL, 1969, no. 9:87–100.

"'The Red Sun' Painting Exhibition." CL, 1968, no. 4:114–115.

Rent Collection Courtyard: Sculptures of Oppression and Revolt. Second ed. Peking: Foreign Languages Press, 1970.

"A Revolution in Sculpture." CR, 1966, no. 3: 30–31.

"Revolutionization of Pictorial Art." PR, 14 Aug. 1964, 35–36.

Rinden, Robert Watland. "The Cult of Mao Tse-tung." Ph.D. diss., University of Colorado, 1969.

"The Sculpture 'Long Live the Victory of Mao Tsetung Thought' Completed." CL, 1971, no. 1:132–133.

"Second All-China Conference of Writers and Artists Closed." NCNA Peking, 6 Oct. 1953, SCMP, no. 663:14–16.

"Serve the Broadest Masses of the People." *Jen-min jih-pao* editorial, 23 May 1962, *Current Background* no. 685:1–6.

Shaffer (Womack), Lynda. "Anyuan: The Cradle of the Chinese Workers' Revolutionary Movement, 1921–1922." In *Columbia Essays in International Affairs.* Edited by Andrew Cordier, vol. 5, 166–201. New York: Columbia University Press, 1969.

Shaffer, Lynda. *Mao and the Workers: The Hunan Labor Movement, 1920–1923.* Armonk. N.Y.: M. E. Sharpe, 1982.

"Shanghai Starts to Solve Labor Remuneration Problem of Artists of Chinese Painting." NCNA Shanghai, 23 Aug. 1956, SCMP, no. 1372:17–18.

Sheridan, James E. *China in Disintegration: The Republican Era in Chinese History, 1912–1949.* New York: Free Press, 1975.

"Sketches by Four Artists." PR, 8 Sept. 1961, 18–19.

Snow, Louise Wheeler. *China On Stage.* New York: Random House, 1972.

Spence, Jonathan D. *The Gate of Heavenly Peace: The Chinese and Their Revolution.* New York: Viking Press, 1981.

"A Splendid Work of Art Born of the Great Proletarian Cultural Revolution—the Large Oil Painting 'Chairman Mao Goes to Anyuan.'" PR, 19 July 1968, 7–9.

Starr, John Bryan. *Ideology and Culture: An Introduction to the Dialectic of Contemporary Chinese Politics.* New York: Harper and Row, 1973.

"Statue of Chairman Mao Unveiled at Tsinghua University." PR, 12 May 1967, 5–6.

"Studio of Traditional Painting Opened in Peking." CL, 1957, no. 4:179–180.

"Studying 'Talks at the Yenan Forum on Lit-

erature and Art.'" CR, 1966, no. 9 : 10–19.

Su Kuang. "Artists in a Village." CR, 1966, no. 6 : 20–21.

Sullivan, Michael. "Art in Today's China: Social Ethics as an Esthetic." *Art News* 73 (Sept. 1974): 55–57.

———. *Chinese Art in the Twentieth Century.* London: Faber and Faber, 1959.

———. "New Directions in Chinese Art." *Art International* 25, no. 1–2 (1982): 40–58.

———. "Some Possible Sources of European Influence on Late Ming and Early Ch'ing Painting." In *Proceedings of the International Symposium on Chinese Painting*, 595–610. Taipei: National Palace Museum, 1970.

"Summary of the Forum on the Work in Literature and Art in the Armed Forces with which Comrade Lin Piao Entrusted Comrade Chiang Ch'ing." SCMP, no. 3951 : 10–17; also in PR, 2 June 1967, 10–16.

Sun, Shirley Hsiao-ling. "Lu Hsün and the Chinese Woodcut Movement: 1929–1936." Ph.D. diss., Stanford University, 1974.

Sun, Shirley. *Modern Chinese Woodcuts.* San Francisco: Chinese Culture Foundation, 1979.

The "Taking Tiger Mountain by Strategy" Group of the Peking Opera Troupe of Shanghai. "Strive to Create the Brilliant Images of Proletarian Heroes—Appreciations in Creating the Heroic Images of Yang Tzu-jung and Others." PR, 26 Dec. 1969, 34–39, and CL, 1970, no. 1 : 58–74.

T'ao Chu. "Literature and the Arts for the Countryside—Speech Given at Meeting of Literary and Art Circles of Kwangtung and Canton on March 9, 1963." Canton *Nan-fang jih-pao*, 19 April 1963, SCMP, no. 2992 : 1–12.

The Team Which Made the "Rent Collection Courtyard." "First Revolutionize One's Mind, Then Revolutionize Sculpture." PR, 16 Dec. 1966, 22–27, 33.

Teiwes, Frederick C. *Politics & Purges in China: Rectification and the Decline of Party Norms 1950–1965.* New York: M. E. Sharpe, 1979.

"The Tempestuous Combat on the Literary and Art Front—A Chronicle of the Struggle Between Two Lines on the Literary and Art Front (1949–1966) (*Shou-tu hung-wei-ping* [Capital Red Guards] compiled by the Congress of Red Guards of the Universities and Colleges of the Capital, June 7, 1967)." *Current Background*, no. 842 : 17–32.

"'Ten Points on Literature and Art.'" *Issues and Studies* 8, no. 10 (July 1972): 98–104, and no. 11 (Aug. 1972): 73–83.

Teng Wen. "The Chinese Style in Art—A Review of the National Exhibition of Art." CL, 1960, no. 10 : 179–184.

Tien Chu. "Fruits of the Cultural Revolution." PR, 15 Oct. 1965, 5–7.

Topping, Audrey. "'The Rent Collection Courtyard': Art for Another Public." *Art in America* 62 (May 1974): 69–74.

"Traditional Chinese Painting Serves Socialism." PR, 27 July 1973, 22.

"Traditional Painting Is Linked with Industrial Art." CL, 1958, no. 5 : 140–141.

Tsai Jo-hung. "New Year's Pictures—A People's Art." PC, 16 Feb. 1950, 12–18.

Tso Hai. "The Painter Wu Tso-jen." CL, 1964, no. 7 : 94–103.

Tsui Tzu-fan. "Two Flower-and-Bird Painting Exhibitions." PR, 11 Aug. 1961, 20.

Tuan Chang. "Art Exhibition of the People's Liberation Army." CL, 1960, no. 7 : 131–135.

Tumarkin, Nina. *Lenin Lives! The Lenin Cult in Soviet Russia.* Cambridge: Harvard University Press, 1983.

Valkenier, Elizabeth. *Russian Realist Art, The State and Society: The Peredvizhniki and Their Tradition.* Ann Arbor, Mich.: Ardis, 1977.

Wakeman, Frederic, Jr. *The Fall of Imperial China.* New York: Free Press, 1975.

———. *History and Will: Philosophical Perspectives of Mao Tse-tung's Thought.* Berkeley and Los Angeles: University of California Press, 1973.

———. "Revolutionary Rites: The Remains of Chiang Kai-shek and Mao Tse-tung." *Representations* 10 (Spring 1985): 146–193.

Wang Chang-ling. "Overt and Covert Struggles between Mao and Liu over Literature and Art." *Issues and Studies* 4, no. 3 (Dec. 1967): 1–12.

Wang Chao-wen. "Traditional Painters Find New Themes." CR, 1954, no. 2 : 23–25.

———. "Wall Paintings by Peasant Artists." CL, 1959, no. 1 : 194–198.

Wang Chi. "Modern Chinese Woodcuts." PC, 1 May 1953, 23–27.

Wang Hui. "How I Made the Painting 'The Young Worker.'" CL, 1974, no. 7 : 93–96.

——. "Mold Heroic Images of Our Age." KMJP, 2 Aug. 1972, SCMP, no. 5437:143–145.

Wang Leh. "Peking's Art." PR, 3 Nov. 1959, 20–21.

Wang Wu-sheng. "National Art Exhibition." CL, 1975, no. 1:94–99.

Watson, Burton. *Records of the Grand Historian of China translated from the Shih chi of Ssu-ma Ch'ien.* 2 vols. New York and London: Columbia University Press, 1961.

Wechsler, Howard J. *Offerings of Jade and Silk: Ritual and Symbol in the Legitimation of the T'ang Dynasty.* New Haven and London: Yale University Press, 1985.

Welch, Holmes. "The Deification of Mao." *Saturday Review,* 19 Sept. 1970, 25, 50.

Wen Mei. "Chinese Paintings Should Have a Touch of the Times." JMJP, 14 Oct. 1973, SCMP, no. 5484:47–50.

Willoughby-Meade, Gerald. *Chinese Ghouls and Goblins.* London: Constable and Co., 1928.

Witke, Roxane. *Comrade Chiang Ch'ing.* Boston: Little, Brown, 1977.

"Workers Complete Building Chairman Mao Memorial Hall." NCNA Peking, 29 Aug. 1977, *Daily Report,* 30 Aug. 1977, E1–2.

Wrath of the Serfs—A Group of Life-size Clay Sculptures. Peking: Foreign Languages Press, 1976.

Wu, K. T. "Colour Printing in the Ming Dynasty." *T'ien-hsia Monthly* 11 (1940): 30–44.

Wu Pin. "Traditional Chinese Paintings." PR, 28 July 1959, 19–21.

Wu Tien-wei. *Lin Biao and the Gang of Four: Contra-Confucianism in Historical and Intellectual Perspective.* Carbondale and Edwardsville: Southern Illinois University Press, 1983.

Wu Tso-jen. "A Reflection on Landscape Painting." CL, 1962, no. 7:102–105.

Wu, Victor, comp. *Contemporary Chinese Painters.* Vol. 1. Hong Kong: Hai Feng, 1982.

Yeh Sheng-tao. "Chinese Colour Wood-block Printing." PC, 1 Sept. 1954, 25–28.

Yi Niu. "New Wood-block Prints by Jung Pao Chai." PR, 9 Feb. 1960, 19–20.

Yin-Wang, R., and Annette Kwok. "Le mausolée du président Mao." *L'Architecture d'Aujourd'hui,* no. 201 (Fall 1979): 51–53.

Ying Tao. "Exhibition in Peking: New Art Works." CR, 1972, no. 10:17–21.

Yu, Diana. "The Printer Emulates the Painter— The Unique Chinese Water-and-ink Wood-block Print." *Renditions,* no. 6 (Spring 1976): 95–101.

Yu Feng. "Art of the Socialist Countries." PR, 9 Dec. 1958, 20–21.

——. "New Things in an Old Art." PR, 22 Mar. 1963, 26–27.

——. "New Year Pictures." PC, 1 Mar. 1953, 12–14.

Yu Hui-jung. "Let Our Theatre Propagate Mao Tse-tung's Thought for Ever." CL, 1968, no. 7/8:107–115.

Yu Wen. "Labour and Painting—The Exhibition of Art from the Northern Wasteland." CL, 1961, no. 3:151–154.

Yuan Yun-fu. "Some Paintings in the Chairman Mao Memorial Hall." CL, 1978, no. 1:87–89.

"Zhou Enlai on Literature and Art." BR, 30 Mar. 1979, 9–16. Full text translated in *Daily Report,* 8 Feb. 1979, E2–E20.

Index

Designer: Steve Renick
Compositor: Asco Trade Typesetting, Ltd.
Text: 10/12 Bembo
Display: Bembo
Printer: Malloy Lithographing, Inc.
Binder: John H. Dekker & Sons